A R T
DECO
STYLE

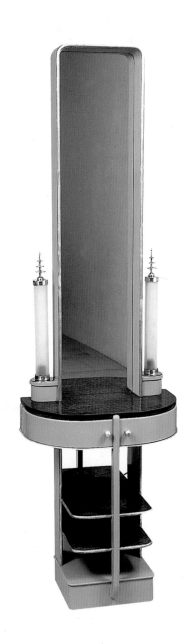

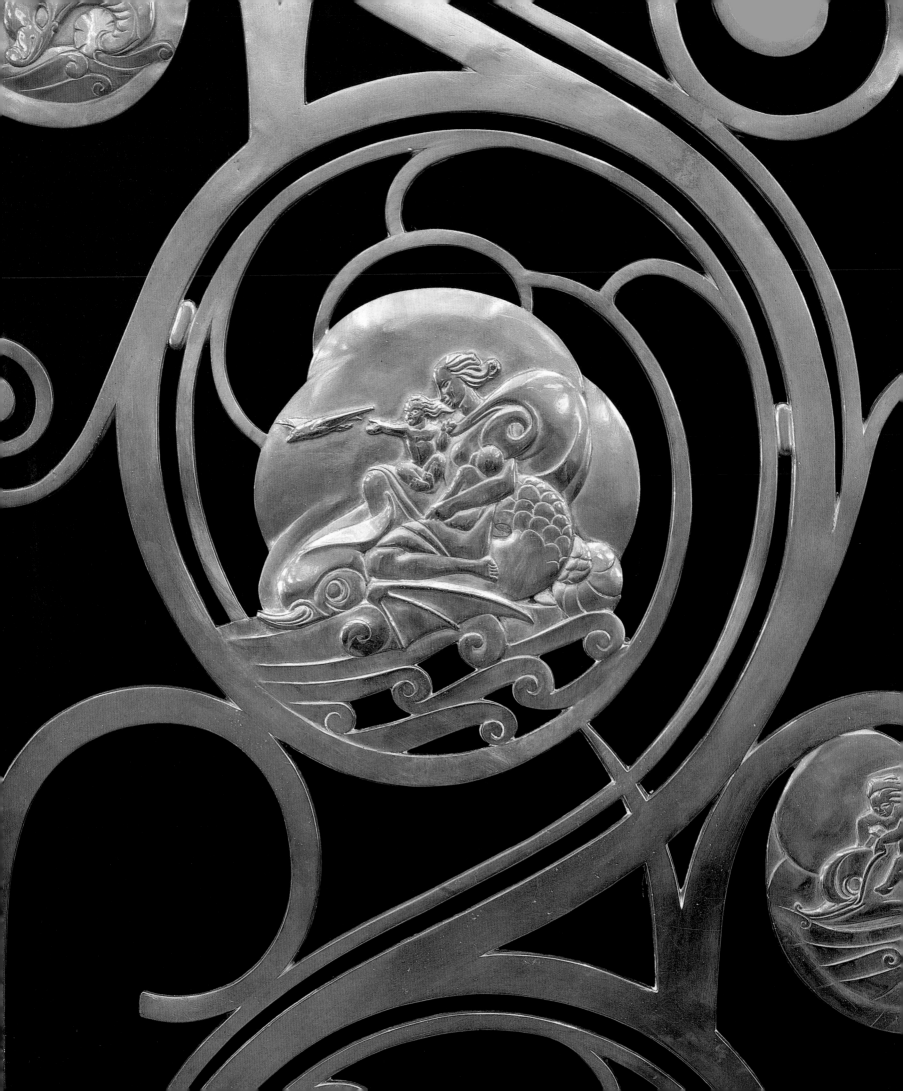

ART DECO STYLE

BEVIS HILLIER

STEPHEN ESCRITT

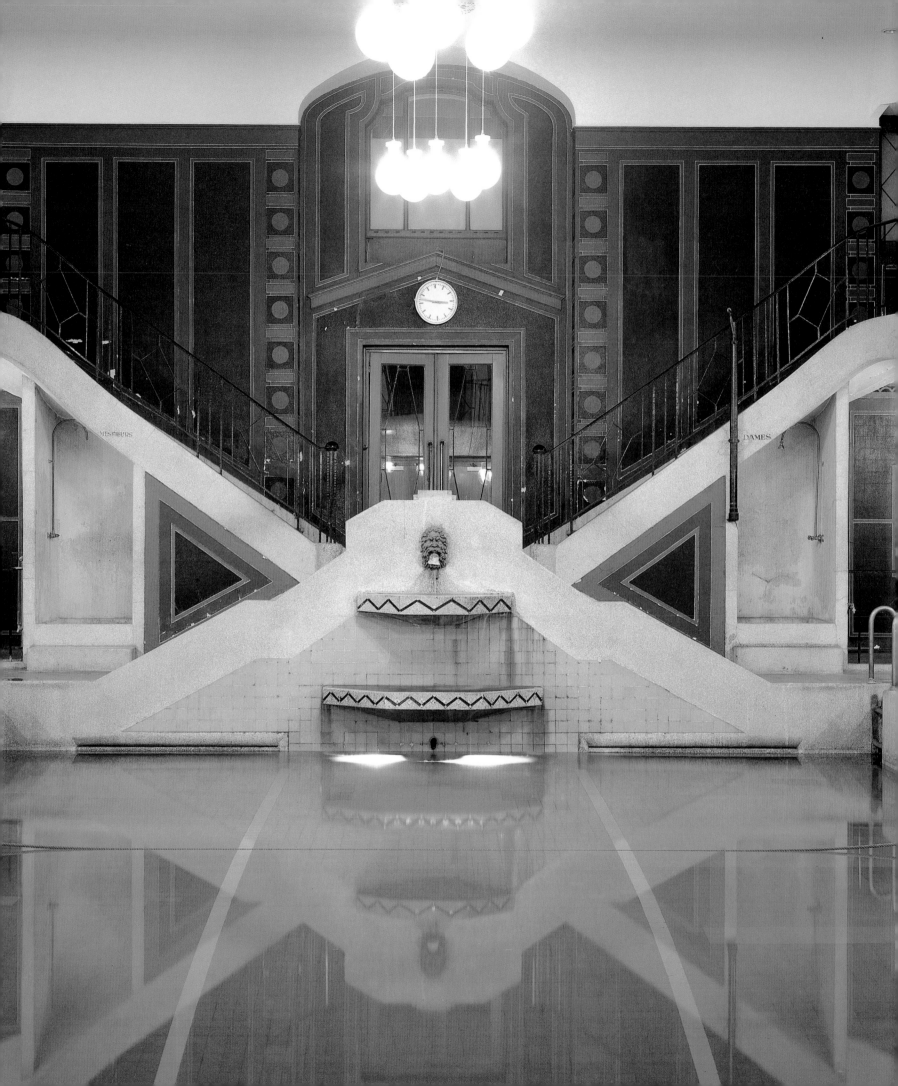

CONTENTS

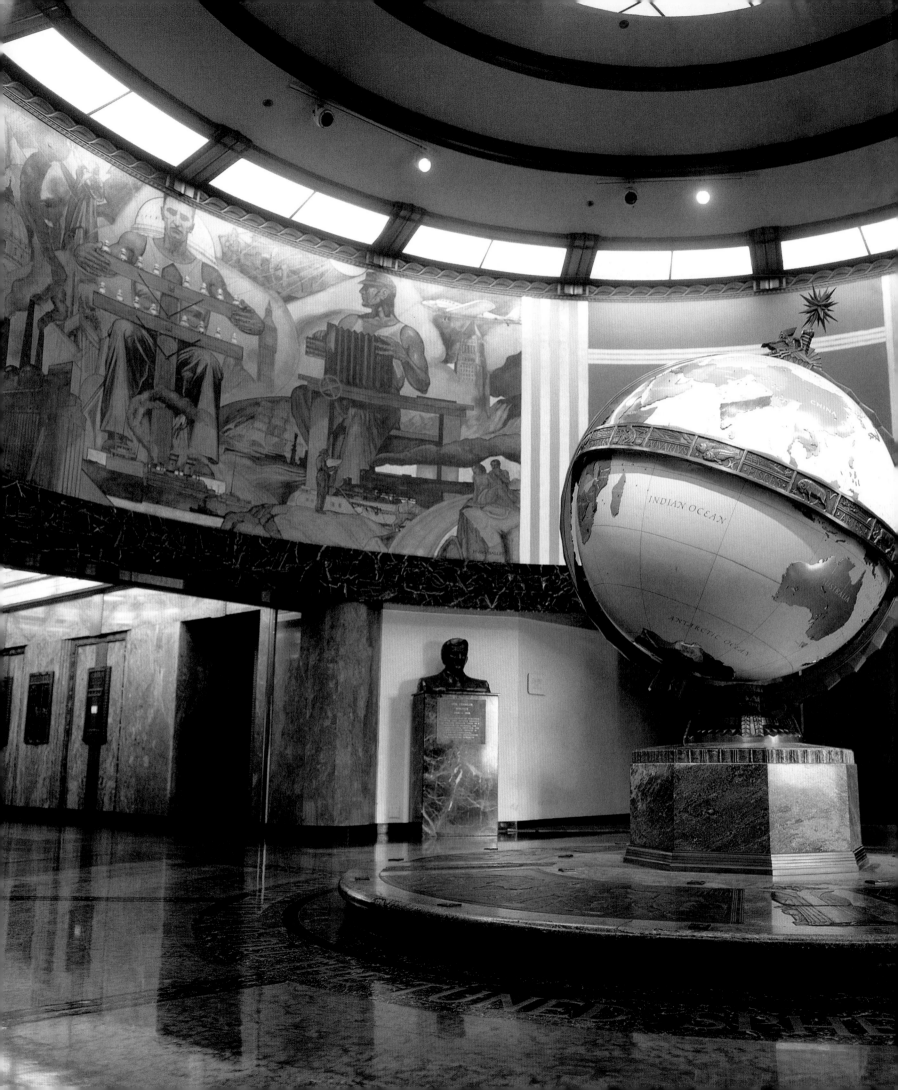

f you want to pioneer a theory in history, or art history, you should do so when young. That way, you get to see what the next generation makes of your ideas; better still, you have the chance, as I have done in this book, to meet the next generation face-to-face and to thrash out your arguments together. I was twenty-eight when my first book on Art Deco was published. Since then, Art Deco scholarship has moved on a long way and the style has turned out not to be just the camp fashion that some of my 1968 reviewers dismissed it as. Instead, it has become a preserve of decorative-art historians, a quarry – in both senses – for museums and an abiding love of collectors. Doughty monographs have been devoted to its recognized masters. Auction-room prices have soared. Societies have been formed to study and protect its surviving architecture. As this book shows, it has been, with neo-classicism, a prime ingredient in post-modernism.

The first hint that a revival of interest in 1920s and 1930s style might be impending came in Angus Wilson's short story 'Totentanz' in *Such Darling Dodos* (1950): when an interior decorator refurbishes a Portman Square mansion, 'his greatest triumph of all was a large lavatory with tubular furniture, American cloth, and cacti in pots. "Let's have a dear old pre-war lav. in the nice, old-fashioned Munich style," he had said and the Cappers, wondering, agreed.' Wilson also wrote *For Whom the Cloche Tolls* (1953); Margaret Drabble's biography of Wilson has revealed how he became panicky after Simon Raven suggested, in a *Listener* review, that Edith Sitwell was the sibylline 'Sybil Clamber' satirized in the book (she was, of course). But all was well: Edith Sitwell, writing to thank Wilson for the copy he had sent her, said it was a '*perfect* study of the age' – 'How strange it is to look back on the behaviour of certain people in the 1920s. I think it explains the Maenads' orgies – a drunkenness brought on by the fumes of spilt blood.'

The dialogue and incidental descriptions in Agatha Christie's crime novels are a good index to the taste of an intelligent English lay person in any given year. In *They Do It with Mirrors* (1952), one sympathetic young woman allows that Victorian architecture, while 'hideous', can be 'fun', can even be regarded with affection; perhaps the proselytizing of John Betjeman was beginning to have an effect. In *Destination Unknown,* published in 1954, the year after Angus Wilson's *Cloche*, there is evidence that Art Deco architecture was at least being noticed. In one scene, a wizened old man, Mr Aristides, shows a young woman the sights of Fez in Morocco, and contrasts the openness of Wallis, Gilbert & Partners' architecture with the 'hidden, dark' houses of Fez:

'Do you know what I think of, Madame, when I walk through the streets of Fez?'
'No?'

The entrance hall of the Los Angeles Times Building, designed by Gordon B. Kaufmann, Los Angeles, 1931. The globe is a modern replacement of the original.

8

'I think of your Great West Road in London. I think of your great factory buildings lit throughout with their neon lighting and the people inside, that you see so clearly from the road as you drive along in your car. There is nothing hidden, there is nothing mysterious. There are not even curtains to the windows. No, they do their work there with the whole world observing them if it wants to do so. It is like slicing the top off an anthill.'

The term 'Art Deco' was not current in the 1920s and 1930s. It was first given respectability, in English, in November 1966 as the heading to an article by Hilary Gelson in *The Times* – still then a dignified Establishment paper, in spite of having put news on the front page for the first time that year. (I was then a *Times* reporter.) Osbert Lancaster's *With an Eye to the Future* in 1967 marked the first use of the term in an English book. My own book of 1968 helped, I think, to popularize the name on both sides of the Atlantic. Though rearguard actions were fought on behalf of 'Jazz Age' and 'Moderne' by, respectively, Martin Battersby and the American authors David Gebhard and Hariette von Breton, Art Deco won the battle of the names. The term has passed into the English language as a noun and an adjective. The lexicographers were slow to accept the name, but now 'Art Deco' has taken its rightful place in the *Oxford English Dictionary*, rubbing shoulders with 'Art Brut' and 'Art Nouveau'.

People like Osbert Lancaster and John Betjeman were hostile to Art Deco; they were lovers of traditional architecture and saw the new jazzy Odeons and hotels as brash, incongruous intruders into the High Street. From a quite different perspective, the architects of the Modern movement deplored 'Jazz Modern' for its gimcrack ornament and its bastardization of their purist style. Betjeman later changed his tune on Art Deco. I met him at a lunch party in 1971 and brought along, to give to him, the catalogue of the Art Deco show which David Ryan and I had organized at the Minneapolis Institute of Arts that summer. I also brought with me, in a rather schoolboyish way, a copy of his *Collected Poems* for him to sign. He wrote an amusing inscription in ink, but after riffling through the Minneapolis catalogue he seized the poetry book back and added, in pencil: '& I am now entirely changed as to modern and pro-moderne & jazz & Wallis Gilbert & Partners'. I think he realized that I was trying to do for Art Deco what he had done with more distinction for Victorian decorative art and architecture – to rehabilitate a despised style. He knew from experience what an uphill task that could be. Only recently (not long before he was knighted) a woman had approached him at some gathering and said, 'Oh, Mr Betjeman, I saw something absolutely *hideous* last week – I know you'll love it!'

My taste for Art Deco, like Betjeman's for Victoriana, partly originated in a voyeurish interest in the period before my birth – that feeling of having missed out on something. My 1968 book began, with the sublime *chutzpah* that only the very young can carry off: 'I was born in England's Finest Hour.' I was in fact conceived in the 1930s – a genuine Art Deco product – and born in the 1940s:

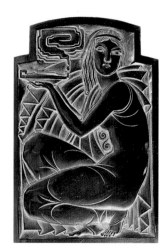

Detail of the elevator doors in the lobby of the City Bank Farmers' Trust Company Building, designed by Cross & Cross, New York, 1931. The doors are of monel (nickel and brass).

conceived in peace and born into war. I did not grow up in a Deco setting, but in a succession of small Victorian houses in Surrey. But from quite early on I developed a feeling for the relics of the 1920s and 1930s that lay about me in my infancy. Our wireless set, for example, which had been presented to my father by his insurance firm when he got married in 1938, was very like the radio I illustrated in *Art Deco*, with a ziggurat-shaped cabinet in bird's-eye maple. Then there was the Redhill Odeon, in its way a Deco masterpiece with a white-tiled façade and an outriding vertical sign-column – as it were, a flying buttress that had flown. Outwardly the building still has some of its 1920s panache, though the interior has been gutted of its chromium-plated sofas and pillar-ashtrays, and turned into a night-club.

In 1966, the publisher George (now Lord) Weidenfeld asked me to write a book on pottery and porcelain. The advance was so large that I was able to resign from *The Times* and devote myself to research for the book. By the time I had finished writing it, I still had quite a lot of the advance left over. It was enough to live on while I wrote another, shorter book. I decided to write on what I then thought of as 'Thirties Style'. When my mother or my sister was driving me around, I would yell: 'Stop! Stop! Look – Thirties!' And indeed, most of the architecture that interested me *was* 1930s, the style that some people call Modernist, not the somewhat effete early 1920s style of lozenge-shaped blossoms cascading from cornucopias.

I recruited illustrations as I went along. At that time, not only were there no books on Art Deco (beyond the catalogue of an exhibition staged by the Musée des Arts Décoratifs in Paris in 1966), but virtually no museum had any holding of Deco objects. I had to rely on the very few dealers then selling artefacts of the 1920s and 1930s. The 'chryselephantine' sculpture *Les Amis de Toujours* – a woman with two borzois – by Demêtre Chiparus was in the window of a stage-props hire firm in Regents Park Road, London. I was allowed to borrow it and have it photographed. On returning it I asked, out of curiosity, whether they would be prepared to sell it, and if so for how much. The answers were yes and £8, but I could not afford £8 for this luxury. In Sotheby's 1988 sale of Elton John's collection (which included much Deco), three models of *Les Amis de Toujours*, of differing sizes, made prices of £4,200, £6,500 and £14,000 respectively.

Much must be forgiven pioneers. I will admit to the sometimes arbitrary and casual way that I came to use the term 'Art Deco' for the decorative arts of the 1920s *and* 1930s. When my book appeared it had some good reviews, but it also had a few stinkers. My most acid critic wrote: 'Those of more mature age who imagined that Art Deco petered out around 1925 will be surprised to find that all through the 1930s they were surrounded by it, according to Bevis Hillier.'

It was not just that bad review that made me realize that my applying the phrase 'Art Deco' to both decades might be controversial. In 1969, when Martin Battersby's *The Decorative Twenties* finally saw the light of day, Norbert Lynton

wrote: 'There will have to be some agreement about nomenclature before any of us get much further.' The debate continued – most fruitfully, perhaps, in *Art Deco News*, the official publication of the Art Deco Society of New York, which asked its readers to contribute their own definitions of Art Deco. Some took the narrowest possible definition. Others suggested that the phrase had become a 'catch-all' term. Others again took my side, including Lynn Abbie, president of the Chicago Art Deco Society, who wrote: 'As Bevis Hillier has pointed out, Deco design did not start one Sunday afternoon and end abruptly at a certain time on a certain day in a certain year.' Well, I didn't actually write that – but I couldn't have put it better myself. I am unrepentant at having helped to popularize this phrase which so conveniently covers the inter-war decorative arts. (There is a precedent in the use of 'Art Nouveau' both for the 'whiplash' sinuosities of Alphonse Mucha and the rectilinear designs of Charles Rennie Mackintosh and Josef Hoffmann.)

By the time my Art Deco book appeared, money was beginning to run out, so I took a new job as the first-ever public relations officer at the British Museum. One day, the front desk telephoned to say there was a gentleman to see me called Mr Clark. He turned out to be Anthony Clark, director of the Minneapolis Institute of Arts. Rather than make him run the gauntlet of the locked door, dark corridors and Eiffel Tower steps, I came down to the front hall to meet him. We sat near the Rosetta Stone. He said: 'My curator of exhibitions, David Ryan, has read your Art Deco book. He is very excited and wants to stage an Art Deco exhibition. And we would like you to organize it with him. We would appoint you as a guest curator.'

The exhibition and its catalogue gave me the chance to restate my views on Art Deco, with some amendments. But the immediate result of accepting Clark's invitation was that I left the British Museum and went to the United States for the first time. The exhibition was to open in the summer of 1971, so in 1970 I travelled to New York to recruit exhibits. A helpful dealer took me round the Deco buildings: they were a revelation. When I was shown the Chrysler Building, the Chanin Building, the Empire State Building, the Waldorf-Astoria Hotel and Radio City Music Hall, I wondered how on earth I could have written a book on Art Deco which omitted all mention of these great monuments – these shrines, almost, of the style. I began to see what that critic had meant when he wrote of my book, 'One can only hope that somewhere an angel is preparing to tread the same ground.'

Wherever I walked in New York, I had to keep stopping to look at details of 1920s and 1930s architecture. For all its dynamism, the city struck me as oddly old-fashioned. By contrast, London, renowned in America for its traditionalism – bowler hats, stuffed shirts and rolled umbrellas – seemed a blaze of with-it modernity. Much of the old City of London had been destroyed by bombs and in place of those buildings new ones had arisen, in eggbox style. But New York

Pair of chests of drawers by Paul Theodore Frankl with ebonized trim and green lacquer interiors, late 1920s. Frankl's furniture of this period epitomized the iconic status of the skyscraper as a symbol of modernity.

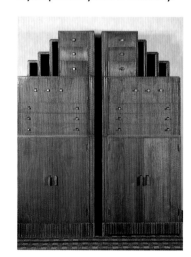

in the 1970s was not markedly different from the New York seen in 1920s and 1930s movies. Its skyline of ziggurats had changed little. The Fred Astaire Dance Studio was still standing (it has gone now). Even the hotel in which I was staying, the Saint Moritz on Central Park South, was Art Deco in every last detail. I don't think a single thing had been changed since the late 1920s, including the lady cashier.

I realized then that, in the 1920s, before the Crash of 1929, America was so rich and powerful that she was able to take the lead in the decorative arts – just as she took the lead in literature with Hemingway and Scott Fitzgerald, Eliot and Pound. The initial impulse had come from France, in particular from the 1925 Paris Exposition, and from Germany and the Bauhaus; but America had invented the skyscraper; and the Deco skyscrapers of New York seemed to me the most developed and majestic expressions of the style.

While working on the Minneapolis show, I made the pleasing discovery that the words 'Art Deco' are an anagram of 'Redcoat'; and that fact in turn reminded me of Harold Rosenberg's brilliant essay of 1959 on what he called 'Redcoatism' in American art. He pointed out how, during the American War of Independence, the Americans had finally beaten the British – who marched about in their red-and-white uniforms, with parade-ground vulnerability – not by mimicking them, but by dressing in coonskins and becoming guerrillas. But in art, Rosenberg suggested, Americans had practised a slavish Redcoatism – imitating the history painting of Sir Joshua Reynolds, the rococo style, neo-classical frigidity or whatever came next from Europe.

Rosenberg saw Jackson Pollock as ending that mimetic tendency: but I believe it ended earlier. In spite of the undoubted French and German origins of Art Deco, I think you can claim that, during the 1920s, America for the first time took the initiative in the decorative arts, certainly in Deco architecture. At the very least, America did it with more panache and on a bigger scale than anybody else. It is appropriate to recall here that some people at the time called the style 'Jazz Modern'. No one has ever tried to deny the American-ness of jazz – although, like Cubism, jazz had African antecedents.

The Minneapolis exhibition was by no means run on a shoestring. In 1970, the recession had not yet hit America. There seemed to be unlimited funds for borrowing, insuring and shipping exhibits. Also, the catalogue was going to be just as lavish as we wished. For every photograph that was eventually used, we ordered about nine. I remember with a gloating, if slightly sheepish and rueful, pleasure – as one might remember caviar-and-champagne suppers in the austerities of wartime – the abandon with which I prepared to spend the Institute's money.

I went to Paris to borrow exhibits. The main lenders were the dealers Ileana Sonnabend and Alain Lesieutre. I think it was my deplorable French that persuaded Madame Sonnabend to lend. By the time I had finished explaining

what I wanted, she was in such uncontrollable fits of laughter that she more or less felt bound to accede to my requests by way of apology. Alain Lesieutre lent the beautiful Bénédictus carpet from his own drawing-room floor and also a silver bracelet that Raymond Templier had designed for his (Templier's) wife, together with a velvety black-and-white photograph of Madame Templier wearing it. It was a chunky, masculine-looking ornament, the kind of thing an Aztec chief might have worn.

To me, the most memorable encounter in the quest for exhibits was one that David Ryan and I made together in New York. We had been told by the director of the Cooper-Hewitt Museum that there existed a 12 x 8 ft batik mural of *The History of Radio*, designed by Arthur Gordon Clark in 1934. At its centre, we were told, was a portrait of the singer Jessica Dragonette, who had been billed as 'America's Beloved Soprano'. It was thought the mural was still in Miss Dragonette's possession. So we went to see her. She lived in a 1920s apartment block in Manhattan; with a sinister, Addams-family touch, the window grilles were black metal spiders' webs. Dragonette shared a vast Spanish Hollywood apartment there with her sister, Nadea Dragonette Loftus. Mrs Loftus had done for her sister what Miss Havisham did for herself. She had devoted her life to nurturing Jessica's career and garnering its memorabilia. She had saved every photograph, every gramophone record, every programme and press cutting of America's Beloved Soprano. Here was a photograph of Jessica being made Chief Singing Bird by an Indian tribe; there a letter from a five-star general thanking the singer for giving his troops a recital. Whatever the opposite of sibling rivalry is, Nadea Loftus had it. It was she who had commissioned the batik mural in the early 1930s. And yes, the mural was in the flat, a Deco masterpiece, full of electric flashes, zeppelins, ocean liners and allegorical figures. Jessica Dragonette herself was depicted in the Worth gown which she had worn when she sang at the party to celebrate the fiftieth anniversary of Edison's invention, the electric light bulb.

I was avid to secure the mural for the exhibition and did not hesitate to promise the sisters that it would be given pride of place. When we left the spider's web apartment, David Ryan admonished me: 'This is America, Bevis. If you promise something, you are expected to do it.' It is true that the British are brought up never to say what they really think. If an Englishman says, 'Are you sure you can't stay?' he means 'Get out!' But I really did want to give the mural a place of honour. Perhaps what Ryan was suggesting, with his own brand of tact, was that, as a co-organizer, I should have consulted him before making rash promises.

Ryan and I were building up our list of prospective lenders very satisfactorily, when we had a piece of bad news. Elayne Varian, curator of the contemporary wing at Finch College of Art, New York, was also organizing an Art Deco exhibition. Mrs Varian had approached – as she had every right to do – many

'Jazz' carpet from the Radio City Music Hall, Rockefeller Center, New York, 1930s. 'Jazz Modern' was one of the array of contemporary names by which Art Deco was known. Here the instruments of jazz are stylized to form a modern abstraction.

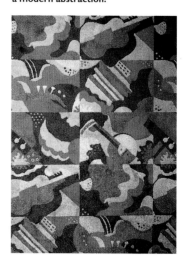

of the same people as we had. Because her show was less ambitious than ours, it would open first and could steal our thunder disastrously. The only thing to do was to come to a pact with Mrs Varian – who was, indeed, extremely pleasant and accommodating. She would hold her show; then we would absorb into our show all the Finch exhibits that the owners were prepared to lend. All the same, David Ryan, as a Minneapolis staff man, was worried that our exhibition would be thought of as no more than a re-run of the Finch show.

In the event, our exhibition was so gargantuan – 1,441 exhibits – and the catalogue, with its magnificent Deco Revival cover by Bentley/Farrell/Burnett was so sumptuous, that I don't think anybody could have confused the two shows. The art critic of the *New York Times*, John Canaday, came out to Minneapolis and gave us a big review. He thought the exhibition good *qua* exhibition, though he found many of the exhibits 'painful'. (He had lived through the Deco period.) Hence the headline above his article – 'No, Sir, That's Not My Baby Now'. Local press coverage in Minneapolis was also broadly favourable, though one columnist recorded the alleged comment, 'Art Deco? Wasn't he the guy who used to give tango lessons at Breezy Point?' Another local columnist, Don Morrison, recalled that when, as a child, he had started a baseball game in the living-room and had broken an Art Deco lamp treasured by his mother, his father had not punished him because he was delighted to see it go. 'That was the *worst!*' Morrison's father said.

There were two terrible postscripts to the Minneapolis exhibition. First, Christopher Mendez, assured by me that our packers and shippers were the best in the business, had very kindly lent his 'clocktail cabinet', a Deco grandfather clock which opened to reveal winking bottles and soda-siphons. It returned as *matchwood* – the only piece in the show that got damaged except for one other. The final crates were delivered back to my flat in Chelsea. One of them, I knew, contained a hideous giant plaster greyhound – the sort of thing that might have been won at a fair – which I had included merely as an example of down-market, 'demotic' Deco. So without bothering to open the crate, I left it out for the dustmen. It was only later, when a further crate arrived and I found it contained the ghastly greyhound, that I realized I had in fact thrown away an important Shelley porcelain tea-service belonging to the Victoria and Albert Museum. (It should have been returned direct to the Museum.) I have never confessed to this crime until now. At the time, the V&A curator concerned said she was glad of the insurance money, but would much rather have had the service back.

In 1973, I became editor of *The Connoisseur* magazine, founded in 1901 and bought in 1927 by William Randolph Hearst, 'Citizen Kane'. The main interests of its readers were old mahogany furniture and Chelsea porcelain, but I managed to smuggle in two or three Deco articles. One was the first major article on the Michelin Building of 1911 – that marvellous transitional building half-way between Nouveau and Deco. It is hard to believe that, at that time, it was threatened with

demolition. Next, I asked the photographer Angelo Hornak to go to New York and photograph the Chanin Building for a feature. To my amazement, he found the building's architect and owner, Mr Chanin, still living on the top floor; the skyscraper had been built in 1928. Hornak's pictures of Chanin's Deco bathroom and of the elevator doors have appeared in most books on Art Deco since then. Other Deco masters were also wonderfully long-lived. I could have met Donald Deskey, designer of the sleek furnishings of Radio City; Eileen Gray, whose lacquer screens we covered in *The Connoisseur*, and the potter Susie Cooper. I did meet Sonia Delaunay (who was pictured, in a Cubistic coat, in the Minneapolis catalogue); thinking I was a rich American, she tried to sell me a very expensive portfolio of her lithographs, which sadly I could not afford. I·met the American ceramicist Schreckengost at an Art Deco symposium in Washington, DC in 1986, and he pulled out of his pocket a newspaper cutting about a golf coach who really did have the name Art Decko. And, when he was in his nineties, I met Erté, the great Deco draughtsman and costume designer, who drew a self-portrait for me on the fly-leaf of Lytton Strachey's *Ermyntrude and Esmeralda*, which my friend Michael Holroyd had edited and Erté had illustrated with suitable decadence.

In the 1970s I wrote an introduction to a book on the potter Clarice Cliff by Peter Wentworth-Sheilds, and another introduction to a book called *Façade*, which consisted of colour photographs by Tony and Peter Mackertich of Art Deco buildings, mainly by Wallis, Gilbert & Partners. The book was published by Mathews, Miller & Dunbar, a firm which had earlier had a success with a book called *Sunrise*, depicting the Deco sunrise motif on everything from suburban garden gates to gramophone-needle cases. The first illustration in *Façade* was of the Firestone Building, the 1928 tyre factory by Wallis, Gilbert & Partners. I little knew, when the book appeared in 1976, what a stir that building's fate was soon to cause.

Three years later, Marcus Binney, Simon Jenkins and I founded the Thirties Society (now the Twentieth Century Society) and I became its chairman. The first event which really brought our cause to public notice was the wanton destruction of the Firestone Building, literally overnight, just before (as its owners well knew) a preservation order was due to come into force. Every movement needs a martyr. The destruction of the Firestone Building did for our Society what the demolition of the Euston Arch, in 1961 had done for the fledgling Victorian Society (founded 1957). People said: 'This must never be allowed to happen again.' Thanks to the Thirties Society and its successor, several twentieth-century buildings have been listed; though, as *Times* leaders used to say on virtually any subject, in my day, 'vigilance must never be relaxed'.

In 1984, I became a columnist on the *Los Angeles Times*. My friend Peter Conrad, author of *Imagining America*, wrote to me: 'You really are living your dream, aren't you?' He meant, of course, that I was going to live amid the architectural relics of Hollywood's golden age. The very building in which I worked was a splendid Deco edifice of 1935 and commanded a good view of the same

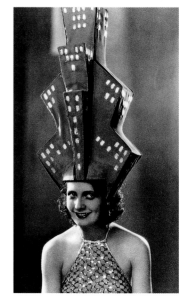

Still from the film *Broadway*, 1929. Taking the skyscraper craze too far?

architect's City Hall. I was in Los Angeles for almost five years and I very much wanted to write a book called *Hollywood Deco*. But while many publishers would have accepted a completed book with that title, none was prepared to put up the money to finance the top-class photography needed. So the book did not get written; and during the time I was there, several of the best buildings, which would have been star illustrations, were destroyed or ruined.

The saddest case was the Pan Pacific Auditorium of 1935, an extraordinary aerodynamic building with a horizontal rather than vertical silhouette. Even when I arrived in LA, I could see that it was falling into decay. I wrote an article in my paper in which I said, 'Angelenos clearly don't give a damn about their heritage', drawing attention particularly to the sad state of the Auditorium. This produced a smarmy letter from Ed Edelman, Supervisor of the city's Third District, who was responsible for the building's welfare. May his name be held in everlasting execration. He assured me that he and his team had every intention of restoring and preserving the building; but within a year it was covered in gang-warfare graffiti and in 1988 it was gutted by fire. Another victim of arson was the city's public library, a fine, if eccentric, example of King Tut revival of the 1920s. My guess is that some cute developer wanted the site for a towering modern block. Luckily the arsonists did not make a proper job of it, even though they had a second try. To its credit the city restored the library. But the Beverly Theater, with its coconut topknot of plasterwork, was demolished. 'The Darkroom', that delightful photographic shop on Wilshire Boulevard in the form of a Leica camera, was turned into a Bangladeshi restaurant and its chromium lettering dismantled. The El Rey Theater, also on Wilshire, was painted shocking pink and turned into a motor-cycle park – luckily, not before I had had it brilliantly photographed a few weeks earlier by the photographer husband of a *Los Angeles Times* colleague, personally scrubbing the forecourt to bring out the colours of the floor. On the credit side, the Wiltern Theater, not unlike our own New Victoria inside, was gloriously restored. But Bullocks Wilshire store, which during my years in LA remained virtually unchanged as a magnificent 1920s department store, with its original light fittings, murals and elevator doors, was horribly vandalized in the 1992 race riots. (It has now been turned into the law library of Southwestern University School of Law.) There is scope for a book called *Lost Angeles*. If LA means anything to the tourist, it means Hollywood and the age of Art Deco. What madness to allow such desecration. All over LA are ritzy little antique shops selling Deco on a miniature scale – enamelled powder compacts, Lalique glass vases and so on. In the mid-1980s, when the Pan Pacific Auditorium, though dilapidated, was still savable, the photographer Tim Street-Porter did a photo-feature on it, to which he gave the bitterly sarcastic heading, 'Too Big To Be A Collectible'.

I left Los Angeles in 1988. In compensation for Hollywood Lost, I was to enjoy one further great American Deco experience. John Betjeman had agreed that I should be his authorized biographer (he died in 1984). In 1957, he had

done a stint as a poetry professor at the University of Cincinnati, Ohio. So in 1989 I went to Cincinnati in the hope of meeting some of the academics and students who had known him. My publisher thought the trip was an expensive luxury, but in fact I did meet several people with memories of the poet, including a professor's widow whose late husband had kept a diary throughout the Betjeman visit, with much about his antics on the platform. Also, of course, I explored Cincinnati. Betjeman, on his return to England, had written an article about the city's architecture; it says much for the independence of his views and the catholicity of his taste, that in 1957, when Art Deco was totally out of fashion, he expressed admiration for the Carew Tower, whose interior was, and is, decorated with brilliant tiles of the local Rookwood pottery in high Deco style. Other magnificent Deco buildings in 'Cinti' are the Netherlands Hotel, the *Times Star* and *Enquirer* newspaper offices and the amazing half-moon-shaped Cincinnati Rail Terminal, on which I had commissioned a two-part article for *The Connoisseur* in the mid-1970s. Cincinnati, suspended between the old North and South of America, is not a fashionable metropolis, not a natural habitat for the voguish. That Art Deco could have been so extravagantly established in this provincial centre by the late 1920s (and the same is just as true of, say, Minneapolis and Cleveland) shows how all-pervasive it was. A total style.

In his memoirs, *The Bonus of Laughter* (1987), Alan Pryce-Jones, formerly editor of the *Times Literary Supplement*, describes how, instead of giving his son David a Grand Tour of architectural monuments, he gave him a Grand Tour of 'human monuments' in the early 1950s. They stayed at the Villa Mauresque with Somerset Maugham; went on to Max Beerbohm at Rapallo; then to Bernard Berenson and to Percy Lubbock at Lerici. My own father did not have that kind of acquaintance; but I realize now that I managed to meet some prime examples of what might be called human Art Deco.

Because Edward James, the eccentric millionaire and collector, had been the first publisher of Betjeman's poems, I needed to meet him. The chance came when he sold his Surrealist paintings. Usually he lived in Mexico, in an extraordinary jungle palace of his own design; but to promote the Christie's sale he came to Europe and stayed with a friend (a builder of fantastic sand-castles) in Amsterdam, where I met him. James is best known from the brilliantined back of his head, painted in a famous double-image by Magritte. But, when I met him, he was a grizzled, bearded *magus* in a kaftan. He talked fascinatingly in a canal-side café – about his friend Rex Whistler, the rococo-pastiche artist; about Betjeman and the poet's wife Penelope; and about Salvador Dalí, who had designed the 'lobster telephone' and the 'Mae West lips sofa' for James. Some of the other surrealists had ostracized Dalí for the growing fascism of his views in the 1930s, but he told James, 'If I dream about Hitler, as a surrealist I have to be true to my dream.' He also confided, 'The reason the Germans liked Hitler was that, in his brown uniform, he reminded them of a gingerbread man.'

Brooch in silver and black enamel by Raymond Templier, 1929. Templier was a founder member of the Union des Artistes Modernes in 1929, and his jewellery represented the flirtation with the aesthetic of functionalism which affected many French designers in the 1930s, despite their continuing loyalty to the principles of luxury and decoration.

I got to know Lady Diana Cooper, who was the goddess of British Art Deco – still a sort of beauty in the 1970s, though men had stood on tables to look at her when she arrived at parties in 1912. You can see her likeness in her husband's bookplate by Rex Whistler; and you walk over her face, in mosaics by Boris Anrep, every time you enter the National Gallery. I first met John Betjeman in 1971, at the same lunch party where I first met Lady Diana. Though much of his life was devoted to rehabilitating the Victorians, he was in many ways a typical 1920s man; and his poem 'Indoor Games Near Newbury', with its Hupmobiles, Lagondas, Delages and the new Victrola gramophone playing, is one of the best evocations I know of Deco England – at least, the upper middle-class stratum of it. Betjeman's friend, Osbert Lancaster, had actually been to the 1925 Paris exposition and anatomized the style – and how acutely – in books and caricatures. He became President of the Thirties Society in 1979.

Edward James, Diana Cooper, John Betjeman, Osbert Lancaster, Sonia Delaunay, Erté – all these were either rich or famous, or both. You could hardly consider them a cross-section of inter-war society. However, my parents and their many brothers and sisters were born between 1900 and 1918, and could recall the less affluent side of life in the 1920s and 1930s. Their memories were rose-tinged, because it was the time of their youth and above all the time before the war, before bombs and rationing. But they recalled the Slump, hunger marches and Oswald Mosley rallies as well as cinema-going and singing in youth clubs. In 1968, I was aware that my fascination with the inter-war period expressed an envious nostalgia for the time just before my birth. When I was at primary school in the 1940s, we sang, to a haunting tune, Robert Louis Stevenson's poem 'Where Go the Boats?'. It is about children setting toy boats afloat on a long, dark river. The poem ends:

Away down the river,

A hundred miles or more

Other little children

Shall bring my boats ashore.

I feel that, in this book, my co-author Stephen Escritt has plucked out of the water the frail craft which I sent skimming down the river in 1968 and 1971; has put them in dry dock, caulked several holes, and relaunched the vessels with strong new sails and a lick of paint. I could not be happier with what has been achieved. To vary the metaphor a little: John Betjeman was fond of saying, 'Cast thy bread upon the waters, and it shall return unto thee – *buttered*.'

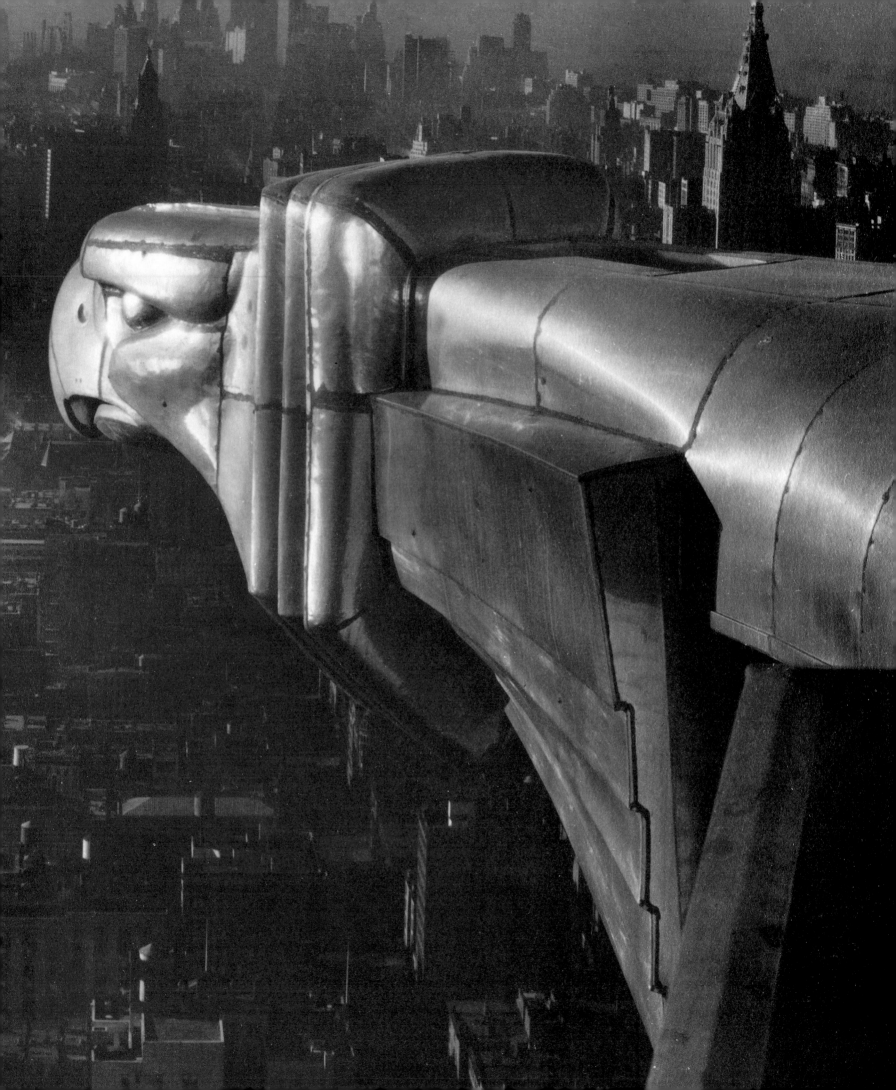

ART DECO: A TOTAL STYLE?

A book about a style should start with a definition – unfortunately definitions of Art Deco tend to be either over-simplistic or bafflingly complex. Art Deco never had a set of rules to serve as a bench-mark for interpretation, so in many ways the best route to definition is through example. One hopes that the wide variety of objects and buildings represented in this book will in themselves convey the themes and complexities of Art Deco, but to begin with it will be useful to consider the popular perception of the style – the objects which have almost become the icons of Art Deco. Architecturally many would cite either the Chrysler Building in Manhattan or the Hoover Factory in west London; in terms of furniture, perhaps a luxuriously veneered cabinet from the atelier of the French maker Emile-Jacques Ruhlmann, or a streamlined chair by the Californian designer Kem Weber; in the home, a mass-produced Bakelite radio or a 'Vogue' tea-set from Shelley; in the street, a railway poster by Cassandre. Each of these objects might in turn be seen as the embodiment of Art Deco: all seven are decorative and modern, employing a broad vocabulary of angular chevrons or smooth curves, stylized representation and Cubistic patterning or futuristic streamlining of form. Their modernity is reflected in the technology of their construction and production, or in features inspired by the aesthetic of mechanization. In the case of the Ruhlmann table – the antithesis of the ethic of mass-production – the very fact that it represents a departure from the historical styles which had dominated nineteenth-century design is itself a symbol of modernity.

For many, Art Deco represents a romantic vision of the inter-war world of the 1920s and 1930s – a world still seduced by the promises of progress in the face of the rising spectre of totalitarianism. For others, it is as much an ethic as an aesthetic, often seen to be at best frivolous, at worst immoral. Such romantic celebration and pious condemnation, coupled with the lack of a rigorous art-historical definition, has held back the development of serious study.

The revival of interest in the decorative idiom of the inter-war years dates from the 1960s. What it signified then is encapsulated by the humorist and cartoonist Osbert Lancaster in this description of Cannes in the 1930s:

Unlike Monte Carlo, [Cannes] possessed no period charm whatever; it was as contemporary as George Gershwin or the Blue Train and even the statue of Lord Brougham failed to evoke the faintest whiff of nostalgia. All the new buildings, such as the summer Casino, were in what was then known as 'Art Deco', a style deriving from the Exposition des Arts Décoratifs *in 1925, characterized by an abundance of peach coloured glass sandblasted with vaguely cubist designs, gold backed murals in the manner of José Maria Sert and a frequency of tapestry*

Detail of one of the eagle gargoyles protruding from the 59th floor of the Chrysler Building, New York, 1929, designed by William Van Alen. Photograph by Margaret Bourke-White, 1934.

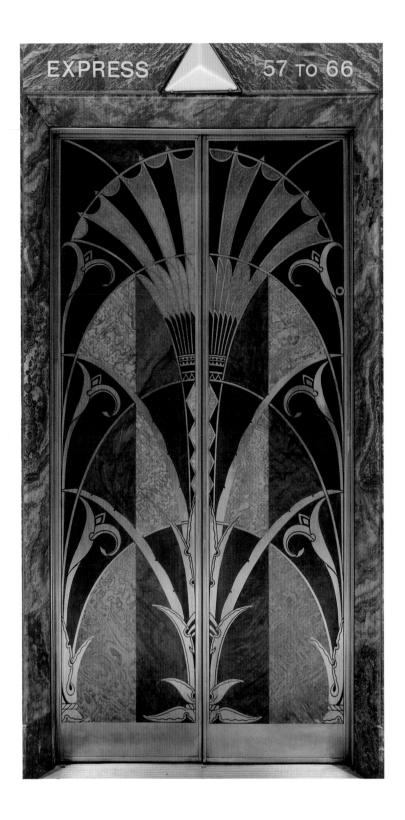

Elevator doors in the Chrysler Building, New York, 1929.

panels usually a long way after Lurçat. Against this background there paraded an extraordinary collection of peers, pimps, playboys, tycoons, film stars, celebrated mannequins (the term 'model' was not yet current), American princes and Australian Ranees.[1]

Lancaster's memory deceives him here in one important respect: the decorative modern aesthetic he refers to was not known as 'Art Deco' to its contemporaries, a fundamental point in understanding the history of this global stylistic phenomenon. Coined in the mid-1960s, the term 'Art Deco' was not in the vocabulary of the designers or consumers of its own age. Although the words are derived from a contemporary event, the 1925 Paris Exposition that Lancaster refers to, they were not used to describe the decorative arts of the inter-war period until 1966, when the Parisian exhibition of objects from the period, 'Les Années 25', was subtitled 'Art Deco'.

'Art Deco' now conjures up a multiplicity of meanings for different people. To the strict connoisseur of the decorative arts the term may still have a limited application: as Lancaster suggests, it concerns the objects, designs and architecture of, or stylistically similar to those of, the great *Exposition Internationale des Arts Décoratifs et Industriels Modernes* held in Paris in the summer of 1925. To the non-specialist, a broader definition would serve. For many 'Art Deco' has become the term synonymous with the design and architecture of the 1920s and 1930s. Clearly not everything produced in the inter-war years can lay claim to the description; but those things popularly perceived as being stylistically typical of the period have inherited the label. This distinctly un-academic inheritance might at first be dismissed as the unhelpful generalization of a complex web of influences, movements and realities. But if the term 'Art Deco' can be seen as an anachronism, it is nevertheless a useful one. In its broader sense it brings together an occasionally disparate range of objects, buildings and attitudes which provide an essential approach to a full understanding of twentieth-century culture and ideas.

While the term 'Art Deco', like all stylistic labels, is a generalization which helps us to understand our visual history, certain questions still need to be answered. How can Art Deco be defined? How did it evolve stylistically and spread on an international scale? What were its contemporary meanings and what does it mean today? It is these fundamental questions that this book will attempt to answer.

In arriving at a definition of Art Deco, it is useful to consider contemporary descriptions. The objects and architecture with which this book concerns itself were called many things by their contemporaries: 'modernistic', 'Moderne', 'jazz-modern' or 'zig-zag' were the most common, the shared theme being one of modernity. Susan Sontag has stated that 'the visibility of styles is itself a product of historical consciousness. Were it not for departures from or experimentation with previous artistic norms … we could never recognize the profile of a new style'.[2] If Art Deco was anything, it was self-consciously new. It evolved in an atmosphere of historical consciousness, one of disillusion with continued historicism

The ultimate Art Deco symbol: the gleaming stainless-steel sunburst at the top of the Chrysler Building.

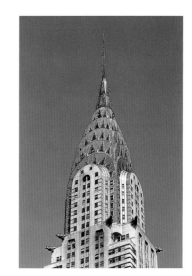

in design and a concern that the new century should produce an 'appropriate' style, just as the Renaissance had done, but as the nineteenth century had apparently failed to.

It should also be remembered that Art Deco was certainly not the only aesthetic response to this challenge of modernity. By 1925, the radical purist functionalism of the burgeoning Modern movement was promoting itself as the only appropriate aesthetic for the mechanized age. Here was an aesthetic which associated itself with radical political reform and, in allying itself to machine technology, spurned decoration as unnecessary. Into the 1930s, neo-classicism was surfacing in the totalitarian states of Europe, as well as in Scandinavia, as an alternative expression of modernity: in the case of the Fascist states, it encapsulated both the traditionalist and futuristic aspects of their regimes. Art Deco shared common ground with both Modernism and neo-classicism, yet it can be characterized by a unique combination of features. Like Modernism it allied itself to the machine, but its machine-aesthetic was not minimalist or purely functional; it incorporated decoration and the stylization of images rather than relying solely on the purity of form, line and volume. While Modernism was a self-defined movement driven by radical social theory, Art Deco was never more than a tendency in design most frequently defined by its detractors. Art Deco was often described as 'modernistic' by self-professed Modernists, generally in terms of disgust. To them Art Deco was a bastardization of true Modernism and was unashamedly commercially driven. Although this traditional dichotomy between

Desk and chair by Maurice Dufrène, from the mid-1920s. Angularity is combined with the richness of exotic walnut and stylized floral designs inlaid in ivory to provide a definitive example of modern decoration. The shapes are uncompromising but the luxury undeniable.

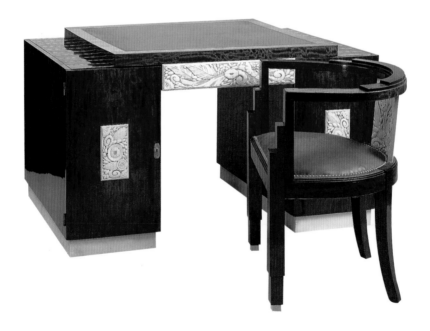

Art Deco and Modernism is being increasingly questioned as the reality of the Modern movement is assessed more closely, there is nevertheless a rich anecdotal seam of Modernist hatred for the perceived dilution and popularization of modernity which Art Deco was seen to represent. In July 1932, Michael Dugdale, a colleague of Berthold Lubetkin's in the Tecton group, wrote a poem on 'jazz-modern' style called 'Ornamentia Paecox'. Its satire was pointedly aimed at Wallis, Gilbert & Partners, architects of the Hoover Factory on the Great West Road in west London. Three of Dugdale's nine stanzas ran:

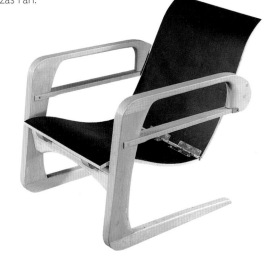

Leave no space undecorated:
Hide those ugly wheels and pipes.
Cover them with noughts and crosses,
Mess them up with stars and stripes.

Now for curves and now for colour
Swags and friezes, urns and jars.
Now for little bits of faience
Now for giddy glazing bars.

Whoops! Tra-la! let's all go crazy.
Tirra-lirra! let's go gay.
Sanity may come tomorrow,
Ornament is in today.[3]

Thus the modernity of Art Deco was often seen in terms of frivolous commercial novelty, in stark opposition to Modernism's pious reforming zeal. Art Deco was a more overtly emotive, less apparently doctrinal, more popular and populist interpretation of 'modern' than that offered by Modernism. Despite this perceived opposition, however, there were points of contact: Modernism was often more emotive, and certainly more luxurious than its more fervent ideologues suggested. And it remains ironic that, despite Modernism's glorification of mass production, when commercially produced items of the inter-war period did aspire to a modern aesthetic, they tended to be modernistic as opposed to Modernist (and thus closer to the Art Deco idiom, despite the popular association of Art Deco with luxury).

While Art Deco was a reaction against historicism, it nevertheless acknowledged historical influence, a feature it shared with contemporary neo-classicism. Certain manifestations of Art Deco were themselves overtly derivative of a superficial classicism, while the Parisian *décorateurs* of the 1920s saw themselves as continuing a long tradition of fine French furniture. Art Deco designers embraced an eclecticism typified by the 1925 Paris Exposition, which was often abhorred as vulgar by the Modern movement. From this brief set of

Kem Weber's 'Airline Chair', 1934–5, in wood, metal and naugahide. Born in Vienna, Weber was one of several European-trained designers who achieved success in the United States.

24

characteristics a picture emerges of Art Deco as a decorative, popular, commercial style, sometimes politically reactionary yet still fundamentally modern. It is a notion of Art Deco as a stylization of modernity, a decorative response to modernity, which will run throughout this book and provide the link between the luxurious, traditionally inspired furniture of Ruhlmann and the avant-garde interiors of Kem Weber; between the eclectic excess of much on offer at the Exposition in 1925 and the sleek lines of Walter Dorwin Teague, Raymond Loewy and the fantasy vision of the future presented at the 1939 World's Fair in New York.

If we are to accept 'Art Deco' as a catch-all phrase for these broad stylistic tendencies, what justification do we have for arguing, as Bevis Hillier did in 1968, that it was 'a total style'? Clearly its dominance was not complete. Modernism and neo-classicism were concurrent international styles; and on a domestic level in Britain, for example, the predominance of 'Tudor-bethan' mock wooden beams among the suburban sprawl which grew out of London in the inter-war years is testimony to the visual pluralism of the period. Art Deco as a style was not without its critics and stylistic alternatives, yet it *was* total in three ways. Firstly, it can be thought of as international, a pre-war equivalent of the corporate modernism of the International style of the 1950s. Countries as diverse as Poland, Yugoslavia and Japan exhibited at Paris in 1925, and Art Deco is manifest in countless architectural forms, from the cinemas of suburban England to the public sculpture of Argentina. New apartments were erected in the style from Bombay to New Zealand; towering office blocks from New York to Johannesburg.

Secondly, the style transcended social class. While the objects and interiors displayed at Paris in 1925 were out of reach for the majority, the increasing role of methods of mass production, which were alluded to in many of the new designs shown in Paris, led to the greater availability of cheap consumables. Thirdly, Art Deco was a style which could unite architecture, fine decorative arts and the cheapest consumer goods. Many commercial products adopted a modern aesthetic of which one of the defining motifs was the 'speed line'. Speed lines usually came in threes and appear repeatedly in the 'Moderne' industrial design of 1930s America. In 1940, the *Architectural Forum* remarked on the 'curious cult of the "three little lines"… few objects have escaped the plague of this unholy trinity'.[4] Art Deco influenced the appearance of everything from packaging and posters to vehicle design and building. It was 'total' geographically, socially and in the objects which it characterized.

This book, then, will follow the development of Art Deco as a stylization of modernity in many different areas of design as well as across national and class

Blue glass and chrome circular radio, designed by Walter Dorwin Teague, 1934. Teague was one of a group of American industrial designers who came to prominence in the 1930s as their designs covered the messy internal workings of modern machines with slick futuristic streamlining.

boundaries. Its interaction with design traditions around the world will be assessed, and its ideological appeal will be considered, especially in terms of its predominance in the public buildings of many countries. In attempting to explain its global spread and its cultural impact, areas of mass communication such as film, graphics and advertising will be explored, as will the impact of Art Deco on industrial design. Likewise, the conscious striving for modernity in fashion, popular interior decoration and high-street retailing will help explain the broad social spread of a new aesthetic. The transformation of the style between the major exhibitions in Paris in 1925 and New York in 1939 will reveal both the changes and continuities in different visual interpretations of modernity. A constant backdrop will be the development of what Nikolaus Pevsner called 'pioneer modernism' and the tension between this 'purist' modernism and its more populist manifestations. Art Deco's relationship to the other visual expressions of modernity will be explored, beginning with the antecedents of Art Deco during the first quarter of the twentieth century. This will offer a history of the tradition of modern decoration in which Art Deco can be placed. At the other end of the time-span, Art Deco's influence beyond the inter-war period will be traced through its revival as a style from the 1960s onwards, its influence on the development of post-modern design, and its recognition by the growing movement for heritage and architectural conservation. Thus, the history of a style traditionally seen to have had a brief yet colourful flowering in the 1920s and 1930s emerges as a story spanning the twentieth century.

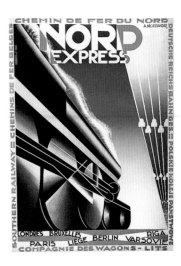

Cassandre's 1927 poster for the French railways, 'Le Nord Express'. Graphic artists such as Cassandre produced stylized designs and aggressive new typefaces which brought modern commercial art to the high street.

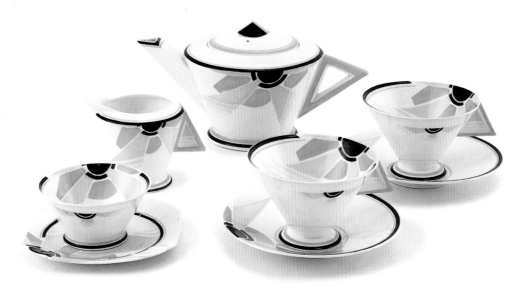

'Shelley' porcelain tea service for two people, made by Royal Doulton, c.1930.

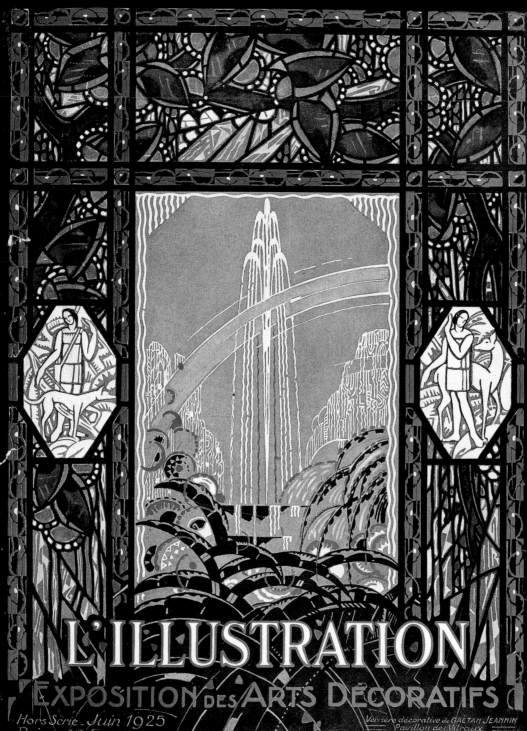

L'ILLUSTRATION
EXPOSITION DES ARTS DÉCORATIFS

Hors Série - Juin 1925
Prix : 10 Francs

Verrière décorative de GAËTAN JEANNIN
Pavillon des Vitraux
Composition de Clément Mazard

STRICTLY MODERN: THE 1925 PARIS EXPOSITION AND THE STATE
OF EUROPEAN DECORATION

Works admitted to the Exposition must show new inspiration and real originality. They must be executed and presented by artisans, artists and manufacturers who have created the models, and by editors, whose work belongs to modern decorative and industrial art. Reproductions, imitations and counterfeits of ancient styles will be strictly prohibited.

The Information Handbook of the *Exposition Internationale des Arts Décoratifs et Industriels Modernes*, 1925[1]

The Paris exhibition is like a city in a dream, and the sort of dream that would give the psychoanalysts a run for their money.

Vogue [London], August 1925[2]

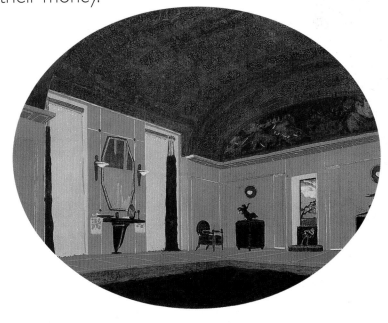

The cover of the June 1925 issue of the French periodical *L'Illustration* heralds the opening of the *Exposition Internationale des Arts Décoratifs et Industriels Modernes* in Paris. Lalique's celebrated glass fountain is surrounded by stylized plants within a geometric border.

Right: Jacques-Emile Ruhlmann, Salon design for the Paris Exposition, 1925.

28

It has become customary to explain the stylistic impact of the *Exposition Internationale des Arts Décoratifs et Industriels Modernes*, held in Paris in the summer of 1925, in one of two ways. For those who see Art Deco strictly in terms of the luxury decorative arts of the 1920s, the Exposition represents the apogee of the style, a high point which was never eclipsed throughout the inter-war years. For those who take a broader stylistic view, the 1925 Paris Exposition represents the inception of a style: it was the first time modern designers took to the international stage, heralding a revolutionary new aesthetic which was to become synonymous with the inter-war period. Both of these explanations have some truth, the emphasis changing with the preferred definition of Art Deco. Yet these definitions need not be mutually exclusive. They can be reconciled by accepting that Art Deco has two contrasting yet intimately related paradigms. The Exposition can be seen both as a culmination of Art Deco as a tradition of modern European decoration developing from around 1900, and the inception of Art Deco as a version of this tradition which spread across the globe as an international style. The reconciliation of both these definitions of Art Deco can begin with their shared acceptance of the contemporary rhetoric which surrounded the Exposition: the rhetoric of novelty.

Visitors to the 1925 Paris Exposition were promised a grand spectacle. The British magazine *Vogue* was emphatic in its proclamation that, 'Bold experiments have been made and curious and fantastic conceptions are here materialised.'[3] The Paris correspondent of *Drawing and Design* described how, 'On entering the grounds of the exhibition, the general impression is one of generosity of form and colour, of sumptuousness and spaciousness, and one is struck with the brightness and force which are the keynotes of this great venture.'[4] The exhibition was as much a theme park as a trade fair: 'Unexpected, colourful, bright, it has all the elements of fun and all the effects of a cocktail. As an exhibition it is a thorough success.'[5] The Exposition covered a large central site straddling the Seine. The right bank of the river was given over to the foreign pavilions, while the Pont Alexandre III was transformed by Maurice Dufrène into a Venetian bridge with a double row of shops. The French pavilions included those devoted to Parisian department stores, the salons and the great state factories, as well as displays from the provinces. Visitors passed through the towering gateway of La Porte d'Honneur towards the Grand Palais to enter a fantasy world:

> Enormous fountains of glass play among life size cubist trees, and cascades of music wash down upon the alleys from the dizzy summits of four gargantuan towers. Enter the pavilions and ... you find furniture of startling and unprecedented shape, decoration of every imaginable design on walls, floors and ceilings. The great Anarch, Fancy governs all.[6]

In many quarters then, it was a loud fanfare which greeted the arrival of Art Deco on the international stage. It is certainly true that the displays were a

Four views of the Paris Exposition. Top Left: The pavilion of Galeries Lafayette was one of the numerous buildings erected by the great Parisian department stores. Combining classically inspired fluted columns, geometric form and stylized decoration, it embodies the Art Deco aesthetic of 1925. Top Right: Ruhlmann's Pavillon du Collectionneur, designed by Patout, reflects both the sobriety and the traditional luxury of the furniture within it. Bottom Left: The Porte de la Concorde was one of the monumental entrances to the exhibition site. Bottom Right: A view of the Esplanade des Invalides with the Grand Palais in the background.

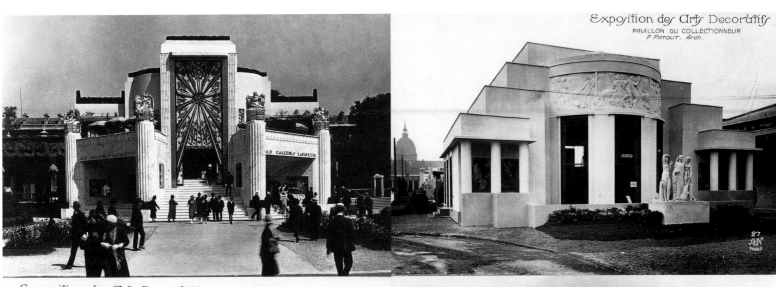

Exposition des Arts Decoratifs
PAVILLON DU COLLECTIONNEUR
P. PATOUT. Arch.

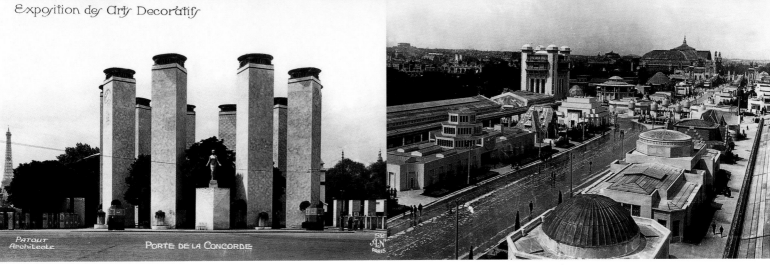

Exposition des Arts Decoratifs

PATOUT
Architecte

PORTE DE LA CONCORDE

30

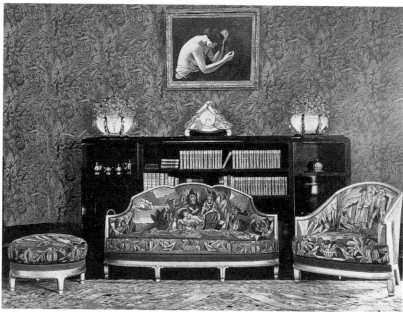

Left: Drawing room in Louis Süe and André Mare's Museum of Contemporary Art at the Paris Exposition, 1925. The form of the bergere and settee draw on the tradition of French furniture while the upholstery carries stylized exotic design.

Below: René Lalique's glass fountain in the Perfume Pavilion became a symbol of the 1925 Paris Exposition.

revelation for the more conservative among the Anglo-American commentators, who were unfamiliar with trends within European decorative arts and architecture since the turn of the century. In July 1925, *Country Life* likened the Exposition to the birth of the goddess Athena:

> The Paris 1925 exhibition is an organised attempt to break with the traditions of decorative art and to substitute forms absolutely new and owing nothing to association. Pallas [Athena] sprang into being fully formed from the brain of Jupiter; but can designers similarly give birth to a complete system of art? … Can anything good be spontaneously evolved, or must all lasting progress be a gradual adaptation of traditional ideas, in harmony with what past ages have left us, yet comfortable to our changing requirements and human desire for freshness.[7]

These are perhaps unsurprising sentiments, given the essentially conservative nature of a magazine like *Country Life*. Yet they typify the perceptions of radicalism and modernity which surrounded the Exposition, perceptions which have come to characterize Art Deco. But it would be a fallacy to suggest that everything on show in 1925 would fit easily into what we now regard as Art Deco in its broadest sense, and indeed the aesthetic of the Exposition was far from unified. The twenty-two international pavilions took up a relatively small proportion of the Exposition in comparison with France's dominant representation, yet their variety is testimony to the lack of an overriding style. The styles on show ranged from the radical Constructivism of the Soviet pavilion, with its workers' recreation showpiece, to the conservative pseudo-ecclesiastical displays in the British pavilion. The pavilions of the Central European countries exemplify the negotiation between nationalism and internationalism which all the individual

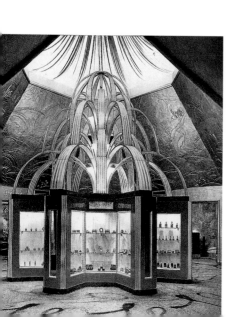

Right: Study designed by Djo Bourgeois, 1925. While it is overtly modern in its proportions, forms and sense of space and light, fabrics and textiles are used to retain a sense of plush luxury, allowing the modern and the decorative to be combined in a way which would have appalled radicals such as Le Corbusier. **Below Right: Salon de réception by André Fréchet, Lahalle and Lévard, 1925.** Art Deco was capable of the heights of whimsy as well as muscular angularity, as the panel behind the settee illustrates.

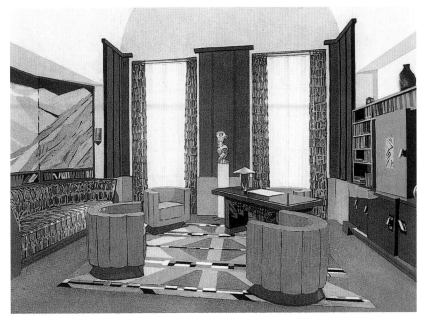

national pavilions were attempting to varying extents. The Polish and Czech pavilions were universally praised in the British design press for their modernity, yet many of the objects and interiors expressed a strong desire to revive a folk tradition. Similar themes presented themselves in the Yugoslav pavilion. The creation of these three nations in the geographical melting pot of Europe after the end of World War I in 1918 led to attempts to identify a national tradition, independent of the old Central European empires. Yet at the same time, this retrospective search for national identity had to be couched in terms of modernity. Modernity was a condition of entry, as the Exposition handbook proclaimed, but it was also an opportunity to present a strong progressive national image in an international arena. Aesthetic modernity was the international language of progress; nevertheless it manifested itself in contrasting design themes. *Vogue's* correspondent noted that 'contemporary styles of decorative art are innumerable, and criticism can hardly deal with such profusion and variety'. From the sparse minimalism of Le Corbusier's Pavillon de l'Esprit Nouveau to the lavish *ensembles* by Maurice Dufrène in the French embassy building, the entries may have had to convince the exhibition authorities of their modernity, yet the resultant visual experience was one of eclecticism.

Despite this, certain stylistic features evident at the 1925 Exposition have been retrospectively labelled 'Art Deco'. These are the themes which evolved into the second, international definition of Art Deco. Perhaps typical are the heavy rounded shapes of Ruhlmann's luxurious furniture, the stylized patterning of Louis Süe and André Mare's upholstery, and the cascading glasswork of René Lalique. The ensembles of Paul Follot, Maurice Dufrène, Tcherniack and Englinger

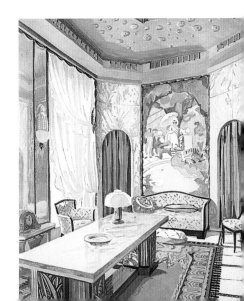

32

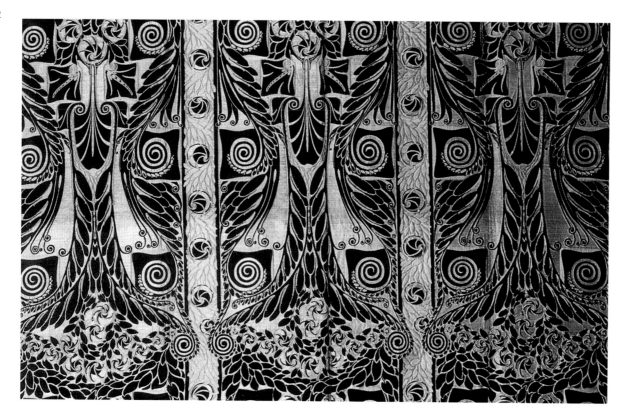

Fabric designed by Maurice Dufrène, c.1925–30. The development of the organic naturalism of Art Nouveau into an often symmetrical but flowing version of the Art Deco idiom is inherent in designs such as this.

incorporated such definitive features as simplistic curves of finely veneered woods, outlandish lighting, zig-zag patterning and angular furniture. There was certainly some sense of unity, particularly evident, it seems, to those who took exception to it: one American critic lamented, 'the dreary iteration of angles, cubes, octagons, squares and rectangles [which] does not so much create a spirit of revolt as one of amusement'. It was through the development and adaptation of these forms that a popular and international evolution of Art Deco took place; these defined the versatile vocabulary of 'the last of the total styles'.[8]

A failure to accept a dualistic definition of Art Deco – embracing both the luxury decorative arts aesthetic and a populist, international style – has in the past led to an oversimplification of its roots. It has often been considered enough to refer to three, undoubtedly crucial, influences: Parisian Cubist painting, the art of the Ballets Russes which came to Paris before World War I, and the exoticism of Egyptian and Native American imagery.

The Cubist movement in painting developed under the leadership of Pablo Picasso and Georges Braque in Paris from around 1907. Cubist painting broke with the tradition of showing objects from a single fixed viewpoint, creating images built up from multiple angular facets. After 1911, Cubism spread beyond Picasso's and Braque's circle through the propaganda of the critic Guillaume Apollinaire.

Like Art Deco it was a reaction, primarily against Impressionism – what Fernand Léger called 'la peinture d'intention'. Like contemporary designers, the Cubists were enemies of revivalism. Wassily Kandinsky had written in 1910 that, 'such imitation resembles the antics of apes. Externally, the animal's movements are almost like those of human beings … but there is no sense of meaning in any of these actions.' Apollinaire confirmed the drive towards an appropriate art for a rapidly changing world when, in 1918, he wrote of Braque, 'The painter composes his pictures in absolute devotion to newness.' Nevertheless, while Art Deco was a response to

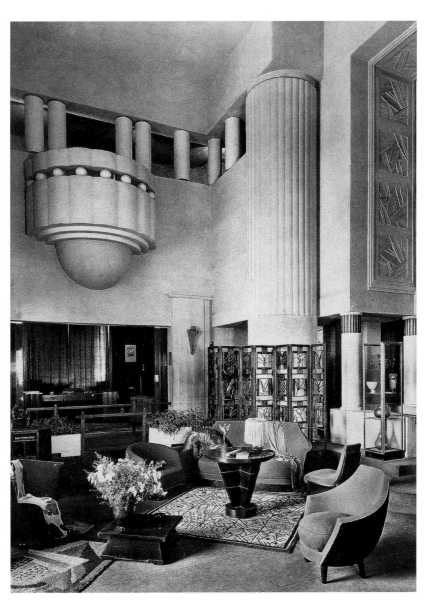

The hall in the Pavillon Primavera, designed by A. Lévard, at the 1925 Paris Exposition.

34

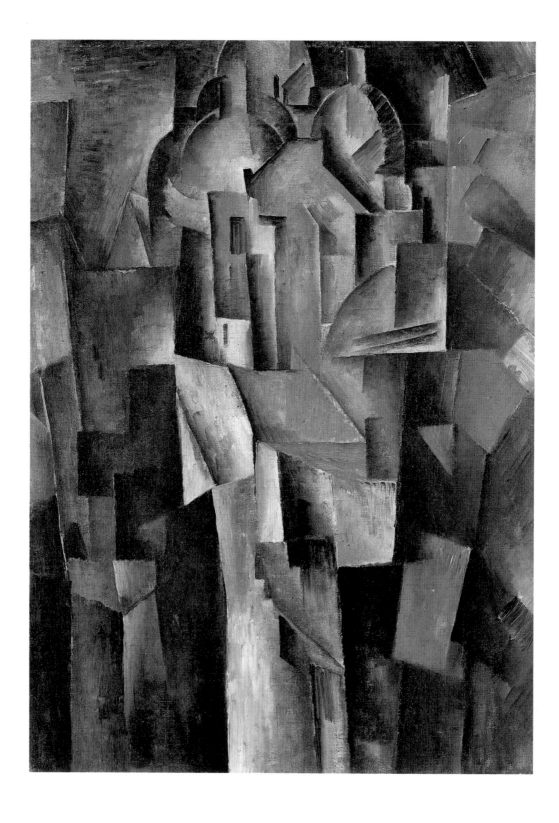

One of Léon Bakst's set designs for Thamar, 1912.

Georges Braque, *Le Sacré-Coeur de Montmartre*, 1910. Oil on canvas, 55 x 40.5 cm. Musée d'Art Moderne, Villeneuve d'Ascq. In 1911 the poet and critic Soffici argued that Braque and Picasso had founded a movement, 'worthy and capable of a glorious future'. However, among other Salon artists he also identified the practice of 'deforming, geometrizing, and cubifying randomly, without aim or purpose, perhaps in the hope of hiding their ... fatal banality ... behind triangles and other shapes'. Precisely the same criticisms were levelled at those in the applied arts who used the manifestation of an art theory for decorative means.

a largely similar set of circumstances, its relationship to Cubism is not as straightforward as it is sometimes portrayed. There was certainly considerable cross-over between the fine and decorative arts, as Apollinaire noted in his review of the Salon d'Automne in 1913:

Unfortunately it is towards decorative art that French artistic energies are being diverted. It is a settled matter. Artists who in the major pictorial arts ruled over the whole world, are intent on carrying out or controlling the work of the craftsmen. What a pity! I'm told that artists are becoming craftsmen because there was a shortage of craftsmen. Well, let some be trained quickly, and let the artists return to their easel and the craftsmen to their workbench.[9]

The influence of Cubism in Art Deco is undeniable; the direct adoption of cubist-inspired decoration is evident in upholstery, fabrics, wood veneers and architectural detail. But new approaches in the decorative arts were also being shaped by changing realities specific to the decorative arts. In France, as we shall see, these factors included economic nationalism, in particular concerns over the challenge of Germany and Austria to the tradition of French dominance in the field. In other countries, a preoccupation is evident with expressing national identity in terms of the new internationalism in design.

The same arguments hold when considering the other influences claimed for Art Deco: the Ballets Russes and the various examples of exoticism. Sergei Diaghilev's Russian Ballet came to Paris in 1911, and according to Osbert Lancaster soon had an impact on interiors of upper-middle-class London:

So far-reaching were the changes that this remarkable theatrical venture brought about in the drawing-rooms of the great world that Napoleon's conquest of Egypt (which also littered the salons of London and Paris with boat loads of exotic bric a brac) provides the only possible, though inadequate parallel. Before one could say 'Nijinsky' the pale pastel shades which had reigned supreme on the walls of Mayfair for almost two decades were replaced by a riot of barbaric hues – jade, green, purple, every variety of crimson and scarlet, and, above all, orange.[10]

36

The illustration which accompanied A.C. Bossom's comparison between the native architecture of Latin America and the skyscraper in his 1936 book, *Building to the Skies*. Mayan motifs were undeniably a source of exotic decoration, but the stepped form of the skyscraper itself owed as much to the strict 'zoning' laws which regulated the shape of tall buildings in American cities.

Again, there is certainly a direct design lineage from the Ballets Russes to the 1925 Paris Exposition and beyond. Erté, a Russian immigrant who studied under the painter and stage-designer Léon Bakst, began work with the Parisian designer Paul Poiret in 1913 and went on to design costumes and sets for the Paris stage throughout the 1920s. Although, as Lancaster suggests, the Ballets Russes did promote daring new uses of colour, it is important not to attribute stylistic change to any one event. Jean-Paul Bouillon claimed that the ballet 'was the fuel that set Art Deco ablaze';[11] but we must not forget that there was already something burning.

The varied sources of non-European exoticism which fed into the stylistic fusion of 1925 also need careful consideration. The discovery of Tutankhamun's tomb in 1922 by the British archaeologist Howard Carter, often held to be a seminal aesthetic and cultural event of the inter-war period, had a significant stylistic impact. 'Cleopatra' earrings became the vogue in Paris; furniture designers such as Pierre Legrain made chairs like Egyptian thrones, using the quintessentially Egyptian materials of palmwood and parchment; J. J. Garcia's bookbinding from around 1925 is embossed with a majestic sphinx. The Egyptian influence was especially apparent in cinemas, with their elaborate friezes of ochre and gold. The shapes of the pyramid and ziggurat joined that of the Mayan temple as models for aspiring architects. The Mayan influence is less easy to pinpoint than that of ancient Egypt. The influence of Native and Latin America was broadly prominent in the literature and cinema of the 1920s and 1930s, due in part to a series of revolutionary political situations and a tradition of viewing these cultures as sites for projected utopias, but it is hard to isolate a specific design link with European Art Deco. Frank Lloyd Wright's architecture has been considered in these terms, and in 1934, the American architect A. C. Bossom described the temple of Tikal in Guatemala as 'The original American Skyscraper'. It has also been suggested, however, that the visual similarity of the skyscraper to the Aztec temple can be more readily explained by examining the zoning laws of New York, which required skyscrapers to taper towards the top, so as not to block out the city's light.[12]

In many ways, however, these three sets of stylistic influences are superficial. The modern European decorative arts already had a fast developing stylistic and political identity by the early 1920s, so events such as Carter's discovery, or a more general inter-war fascination with the Americas, did not have a fundamental effect on their evolving forms and ideologies. The admittedly strong influence of these themes on the fast changing fads for decorative motifs can help explain specific examples of imagery, while being of limited help in defining the underlying nature of Art Deco. Indeed the whole question of exoticism in design in the inter-war period needs to be put into context. The imagery of empire and the Orient had been present in the picture palaces and amusement halls of late Victorian and Edwardian

Britain, for example, long before Art Deco could be identified. In this respect Art Deco can be seen to be adapting to existing practices. It is the use of these themes in conjunction with the forms and images of modernity which was unique to Art Deco.

It is significant that the aesthetic influences traditionally identified in Art Deco share one crucial characteristic: all three are from outside the decorative arts. The inference of this analysis is that the traditional system of decoration had collapsed. It has been suggested that the decorative arts before Art Deco were facing such a crisis that the only alternative was to look beyond the old canon of European culture for new 'systems'; hence Cubism, the Ballets Russes and Egyptian and Native American influences. Yet this vision of collapse is much more dramatic than the reality of events. Certainly, there had long been a sense of dissatisfaction with the nineteenth century's succession of 'revival' styles and its failure to produce a new stylistic embodiment of the age. However, this did not necessarily mean a wholesale rejection of the decorative arts and all they stood for. This was the radical position adopted by Le Corbusier and other Modernists after World War I, but it was fundamentally rejected by the majority of artists and designers who exhibited at Paris in 1925. Since at least 1900 there had been a growing tradition of modern decoration in the European decorative arts in which Le Corbusier himself had played a part before the war. While disillusionment with historicism had led to the questioning of traditional decoration, there was no reason why the tradition of decoration itself should be jettisoned. In the early twentieth century this tradition was developing a vocabulary of design which provided some of the constituents for the emergence of Art Deco. It would therefore be more accurate to see the three 'influences' discussed earlier as interacting with an already distinct tradition in the decorative arts, going back to the early years of the twentieth century.

So, in order fully to understand the architecture, interiors and objects on display in the 1925 Exposition, and those which it inspired, it is necessary to define Art Deco as a *decorative* response to modernity. This definition recognizes two tendencies within Art Deco: the desire to be modern, and the desire to be decorative. It also encourages us to examine the direct antecedents of the Art Deco on display in Paris in 1925, which in reality represented only the latest in a series of decorative responses to modernity.

The development of modern French decoration from the organic experimentalism of *fin de siècle* Art Nouveau onwards must be seen in the context of the perceived threat of Germany to France's traditional dominance in the decorative arts. Indeed the 1925 Exposition itself was a culmination of these worries: it was planned before World War I, when Germany's threat still had a realistic malevolence, but became a celebration of French triumph from which Germany was excluded (the late decision to invite Germany left insufficient time to prepare a representative national pavilion). Thus the combination of

Germany's industrial strength and system of design education, which provided the initial impetus for an international exhibition before the war, was absent in 1925. Nevertheless, the official American government report had few doubts about the influence of German competition on the French decorative arts:

> Although the particular motives of L'Art Nouveau soon fell into disrepute, the stimulus toward creative design in the modern spirit persisted. This was particularly true in Germany, where the movement was organised to a remarkable degree ... France has taken a leaf out of Germany's book ... Instruction in the modern quality of design is now offered in all the schools of applied art throughout the republic.[13]

It was Le Corbusier himself who had been instrumental in drawing attention to the success of Germany. The young Pierre Jeanneret, as Le Corbusier still called himself, had published his *Étude sur le mouvement d'art décoratif en Allemagne* in 1912 in which he recounted the achievements of the German Werkbund, a successful model of the possibilities of uniting artists and industry. For Jeanneret, Germany was, 'consciously aligned against ugliness, and unified with a view toward the realisation of beautiful Industry. All are working for the Werkbund; the Werkbund is animating them all. Each one strives in its own sphere: Commerce, Industry and Art, and as a result there is fruitful solidarity.'[14] Thus the Deutsche Werkbund was perceived by many in France to be achieving a decorative response to modernity, both stylistically and in terms of industrial production and marketing. The threat of the new German decorative arts had been heightened in 1910, when an exhibition including the work of celebrated Munich designers opened in Paris that autumn.[15] The exhibits of designers such as Bruno Paul, who was later to become prominent in the evolution of American Art Deco, had first been shown at an extensive, albeit local, exhibition in Munich in 1908, intended to establish the city as an artistic and industrial centre within Germany, but also coinciding with the first congress of the new French Union Provinciale des Arts Décoratifs, which was being held in the city.

An official report for the Conseil Générale du Département de la Seine told how the French had expected to see their dominance confirmed by a 'heavy and complicated execution in a pastiche of earlier styles'. In reality the report's author conceded, 'our surprise and stupefaction was immense when [we were] confronted by the enormous progress accomplished by Munich.'[16] The French were not only concerned with the quality of the work, but by the economic success which it was engendering. German imports were rising and during 1912–13 a press campaign against German goods was mounted.[17] An international exhibition in Paris had been suggested as a response to growing competition as early as 1907. By 1911, support was gathering from a range of groups representing French decorative artists. For René Guillere, president of the Société des Artistes Décorateurs, it was 'a duty of the first order for the Republic to help in the realisation of modern styles'. Immediate action was imperative. 'We must make haste in the face of the foreign menace,' urged Guillere.[18] The outbreak

Upholstered chair by André Groult, 1929. Ebony and stained maple, fabric designed by Paul Follot (now upholstered with a modern copy of the original). Groult's designs were executed by a small group of craftsmen at his atelier at 29–31 rue d'Anjou, Paris.

of war provided a set-back, and after a succession of post-war delays, the Exposition finally materialized in 1925.

Despite the popular anti-German reaction, the influence of Munich on the modernization of the French decorative arts was immense. Indeed, the primary medium for Art Deco as luxury decoration, the room ensemble as a vehicle for display, arrived in Paris via Munich. French designers soon 'decided to adopt the method [of the Munich designers] … and [began] to present art objects not in isolation but united and grouped as they are found in real life.'[19] So French designers became *décorateurs*, and the careers of many celebrated *décorateurs* at the Exposition can be traced from this response to the pre-war German challenge. In her book *Modernism and the Decorative Arts in France: Art Nouveau to Le Corbusier*, Nancy Troy highlights the differences within this new profession of the *décorateur*, revealing the tensions developing between modernity and conservatism. Contemporary critics isolated two groups: the more conservative *constructeurs* and the younger *coloristes*. Included in the first were designers such as Léon Jallot and Maurice Dufrène, both of whom trained as craftsmen at the end of the nineteenth century and initially worked in an Art Nouveau style. The *coloristes,* who included designers such as André Groult, Louis Süe and André Mare, were not craftsmen and were more concerned with presentation of objects and with colour, due to their backgrounds in the fine arts. Both groups were represented in 1925, and their contrasting approaches illuminate the dual strands of traditionalism and modernism within French Art Deco. The *constructeurs* still believed in the tradition of fine French furniture, whereas the *coloristes* had a more eclectic approach and more readily embraced new fashions.

By 1925 the work of both groups of *ensembliers* had developed to the extent that it dominated the coverage of the Exposition. The pages of *Art et Décoration* overflowed with lavish interiors from the Salon's French embassy, Ruhlmann's

Maurice Dufrène, five-piece Salon suite of giltwood upholstered with Beauvais tapestry, typical of the furniture exhibited at the 1925 Paris Exposition.

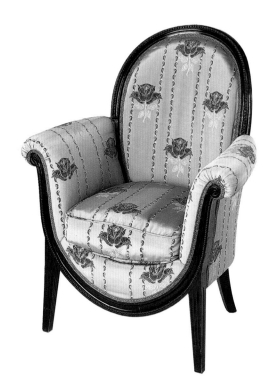

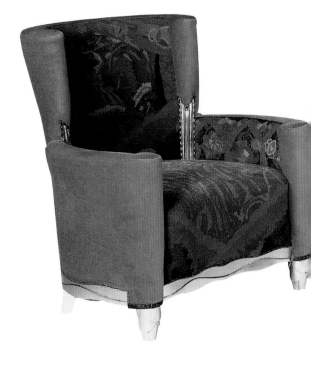

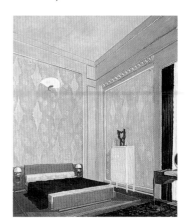

Hôtel du Collectionneur ('the town house of an art lover'), or Süe & Mare's Museum of Contemporary Art. These sumptuous interiors drew heavily on the tradition of French furniture; indeed, both *coloristes* and *constructeurs* appeared conservative when compared to the aesthetic radicalism of Le Corbusier, Robert Mallet-Stevens or Melnikov. For the *ensembliers*, however, modernity meant a contemporary style rather than a revolutionary austerity. Moreover, the charges of unattainable luxury often aimed at this manifestation of Art Deco were to some extent answered by *ensembliers* such as Paul Follot and Maurice Dufrène, who worked for Parisian department stores and displayed in their Exposition pavilions. Significantly, the report of the US Department of Commerce highlights the role of the department stores in the spread of the new aesthetic:

> In the last decade each of the large department stores, Bon Marché, Galeries Lafayette, Printemps and the Louvre, has inaugurated a special department that offers all kinds of material conceived in the modern spirit and has placed at the head of this department an individual of talent and reputation in this field. Each of these directors is furnished with a staff of designers and personally designs and superintends the design in his own studio of much of the material offered by his department.[20]

The commercial collaboration between *décorateurs* and the department stores meant that, for the first time in such displays, luxury items of the kind on show were affordable. The movement had been 'popularised … by bringing its productions within the reach of the ordinary purse whereas the modern creations up to a few years ago were to a large extent *objets de luxe* only available to the wealthy.'[21] The four stores all had their own pavilions at the Exposition which were renowned for their architectural flamboyance. For *Commercial Art*, the pavilion of the Galeries Lafayette was 'impressive and daring and made to appeal to women of all nationalities, whatever one might think of its purely artistic merits.'[22]

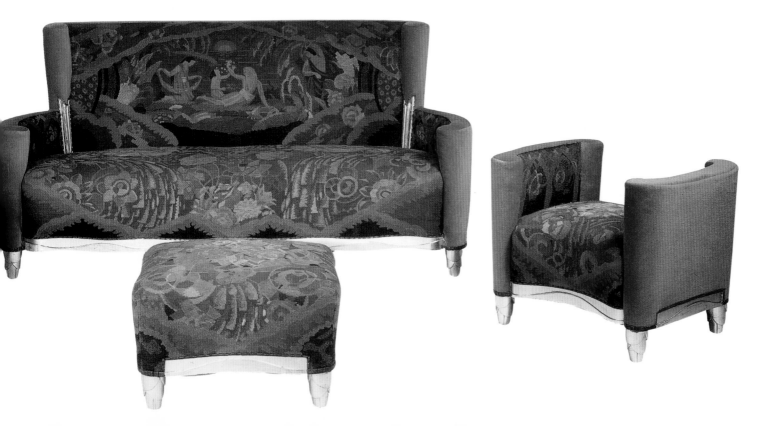

Above: Commode of mahogany, ebony and shagreen with marble top by Paul Iribe, 1912. Iribe rose to fame within the decorative arts after he was commissioned by Paul Poiret to make drawings for his 1908 album of dress designs. In 1912 Iribe was established in business at 104 rue du Faubourg Saint-Honoré, and his work was recognized for its coloriste tendencies.

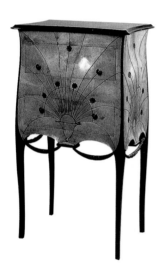

Apart from the French *décorateurs*, and the German designers who provided them with direct competitive stimulation, there were other tendencies within European design contributing to the developing idiom of modern decoration in 1925. These have been recognized in varying degrees as antecedents of Art Deco, and include the work of the Wiener Werkstätte in Austria, the decorative arts of the Czech Cubists, Italian Novecento design and architecture, the Amsterdam School of architects and Swedish neo-classicism. It is these traditions to which we must now turn to understand why any explanation of Art Deco must go beyond Cubism, Exoticism and the Ballets Russes.

If one were to draw an Art Deco axis across Europe, its most significant points would be Paris and Vienna. While the work of the Deutsche Werkbund gave the French decorative arts the impetus of political and economic competition, the designers and architects of the Wiener Werkstätte provided Art Deco with its aesthetic foundations. The Werkstätte (workshop) was founded in 1903, drawing ideologically on the English Arts and Crafts movement, and stylistically, to begin with, on Charles Rennie Mackintosh's interpretation of Art Nouveau. Founded by the architect Josef Hoffmann together with the artist Koloman Moser, and supported by a banker who had just returned from Britain full of enthusiasm for Mackintosh's work, it differed from the ideas the Werkbund was later to promote about marrying art with industry. Instead, it was thought that the best way to improve the quality of design was for the artist to go into business, a workshop approach which many of the French *décorateurs* later adopted. This approach came to embody the first paradigm of Art Deco discussed earlier: modern design, but with the emphasis on the craftsman enhanced by a lingering suspicion concerning the motives of industry. Again, this can be seen as challenging the historical dichotomies between modernity and decoration, technology and craftsmanship. The Wiener Werkstätte had its basis in craftsmanship, yet it embraced both modernity and decoration. The quest for an appropriate style for the new century was unequivocal, as a stark warning in the Werkstätte's 1905 work programme shows:

As long as our cities, our houses, our rooms, our cupboards, our utensils, our clothes and our jewellery, as long as our speech and sentiments fail to express in an elegant, beautiful and simple fashion the spirit

Below: Chaise-longue in bronze by Armand-Albert Rateau, made for the terrace of Jeanne Lanvin's boudoir and displayed in La Maison Callot Soeurs at the 1925 Paris Exposition. Rateau usually limited production of each design to three pieces, an unashamed rejection of the principles of modern manufacturing.

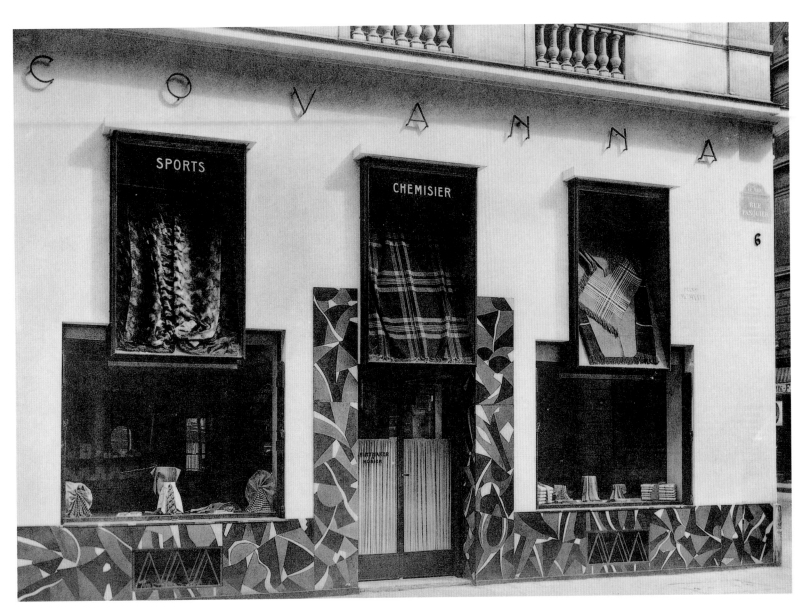

The shop front of Covanna, rue Pasquier, Paris, designed by Pierre Patout, 1927. Patout employs geometry from the vocabulary of Modernism, but decoration is far from being banished, as the continued band of abstract pattern shows.

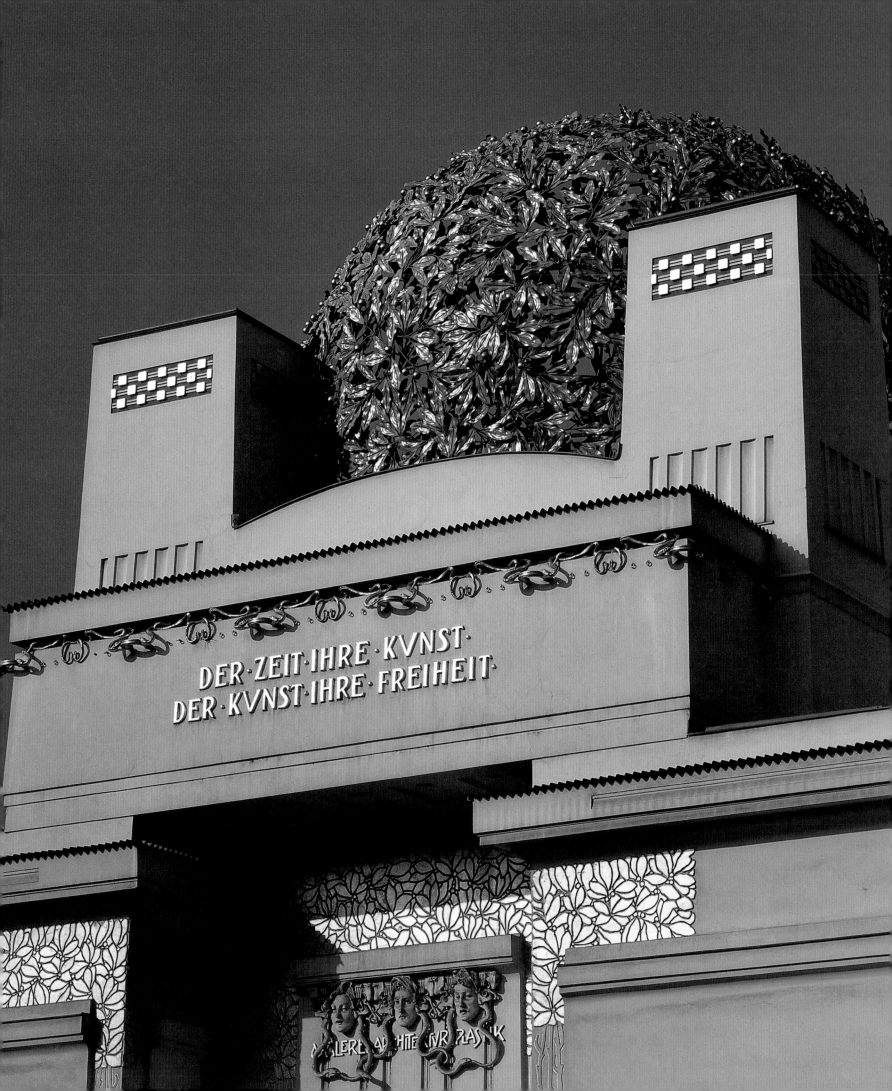

DER · ZEIT · IHRE · KVNST
DER · KVNST · IHRE · FREIHEIT

of our own times, we will continue to be immeasurably behind our forefathers, and no amount of lies can deceive us about all these weaknesses.[23]

The use of geometry was developed during the early years of the Werkstätte, as can be seen in Hoffmann's chair of 1903, as well as in the architectural work of Hoffmann, Moser and Josef Maria Olbrich.[24] Hoffmann's Palais Stoclet, completed in Brussels in 1911, and his Purkersdorf Sanatorium in 1904, continue to illustrate the use of a simplified geometry. This is combined, however, with the use of floral decoration in the interiors to create a vocabulary of modern decoration which helped create an ideological bedrock for Art Deco. Moser's departure from the Wiener Werkstätte in 1907, and the arrival of Carl Otto Czeschka, heralded an increase in decoration and ornament and a decrease in austerity; nevertheless, the theme of a decorative modernity continued in the work of the Werkstätte until its demise in 1930. Moreover, there is ample evidence of the cross-fertilization of these design ideas across Europe, including several direct links between Vienna and Paris. Most famously Paul Poiret, after seeing Hoffmann's pavilion at the 1911 exhibition in Rome, visited Vienna and bought a substantial quantity of Werkstätte fabrics. Several fabrics subsequently designed by Raoul Dufy and Poiret's Atelier Martine bear distinct resemblances to Werkstätte patterns, as well as using similar block-printing techniques.[25] Hoffmann's Palais Stoclet was also enormously influential. The French architect Robert Mallet-Stevens, who designed the distinctive Tourism Tower at the 1925 Paris Exposition, was a nephew of Adolphe Stoclet, the patron, and is thought to have met Hoffmann in Brussels when the house was completed; he later visited

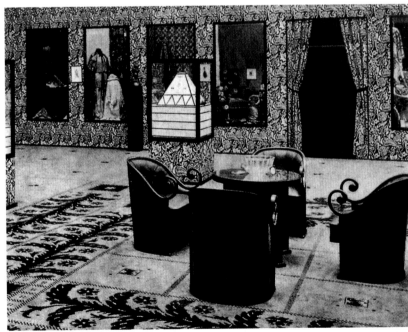

46

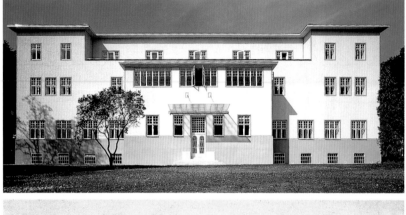

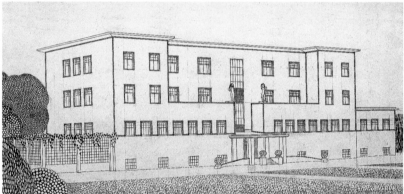

Left: Two views of Josef Hoffmann's
Purkersdorf Sanatorium, 1904. A retreat
for Vienna's wealthy bourgeoisie rather
than a hospital, the Sanatorium epito-
mizes the evolution of Hoffmann's
geometric austerity, which was comple-
mented by fresh flowers which were
delivered daily, their colours dictated by
the Wiener Werkstätte. Below: One of
Hoffmann's chairs designed for the
dining room at Puckersdorf. Of beech
with wide-nailed leather upholstery, the
chairs were made by J. & J. Kohn. The
wooden balls screwed below the seat
were designed to stabilize the chair.

Vienna, confirming the obvious visual similarities between his earlier work and the Palais Stoclet.[26]

The Palais Stoclet facilitated a further link between Vienna and Paris through the influence it had on the early work as a *décorateur* of Louis Süe, who in partnership with André Mare had become one of France's most notable *ensembliers* by 1925. Süe was also in Brussels at the time the Palais Stoclet was opened, and direct parallels have been drawn between the house and Süe's work on the architecture and interiors of the Château de la Foujeraie in Brussels[27] (the interiors in particular draw on the combined use of geometry and patterning). As with many examples of Wiener Werkstätte work, the approach to modern decoration in the Palais Stoclet takes the form of naturally derived ornament enclosed by geometry.

Another movement which can be compared with developments in Vienna, and also displayed themes that were later to recur in inter-war Art Deco, is the brief flowering of Czech Cubism. Unlike the Cubist painting of Picasso and Braque, Czech Cubism was a movement in the decorative arts and architecture. Thus, in a sense, it anticipated the Parisian designers who applied Cubist ideas directly to objects and buildings. It is worth noting that while bold Cubist architectural experiments were taking place in Bohemia, the only architectural

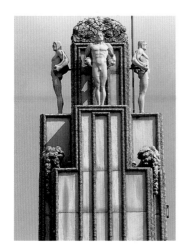

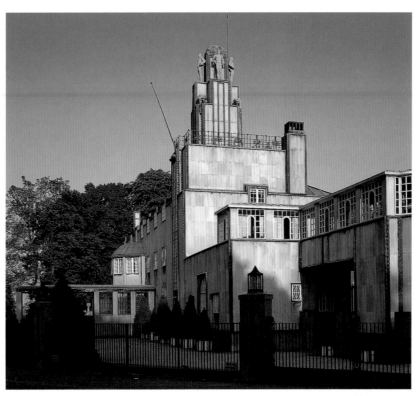

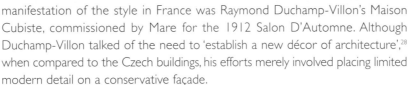

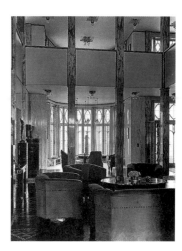

Above: Josef Hoffmann's Palais Stoclet, Brussels, 1905–1911. The outer walls of grey Norwegian marble are framed in bronze. Left: Detail of the central tower. Right: The main hall. An ebony writing desk by Koloman Moser can be seen on the left.

manifestation of the style in France was Raymond Duchamp-Villon's Maison Cubiste, commissioned by Mare for the 1912 Salon D'Automne. Although Duchamp-Villon talked of the need to 'establish a new décor of architecture',[28] when compared to the Czech buildings, his efforts merely involved placing limited modern detail on a conservative façade.

Prague before World War I was still a part of the Austro-Hungarian empire, and it was to a Viennese model of organization that designers, such as Josef Gočár and Vlastislav Hofman, turned when they embraced Cubism. In 1912, the Prazske Umelecke Dilny (PUD – the Prague Artistic Workshops) were founded in collaboration with Pavel Janák, with the Wiener Werkstätte as a role model.[29] All the Czech Cubist furniture which survives from this period was made by PUD, and combined with the adventurous buildings erected in Prague, the Czech Cubist movement represents an important episode in the development of the modern European decorative arts. The Czech Cubists recognized themselves as a movement in the true sense of the word, and they advanced theoretical justifications for their designs. From these manifestos we can begin to trace the interacting themes of modernity and decoration. Writing in 1913, Vlastislav Hofman could be read as a forerunner of Le Corbusier: 'Today the new sensibility is no longer enamoured of simple naturalism, today we want liberated form. In contrast to the vegetal forms of the Secession, today's

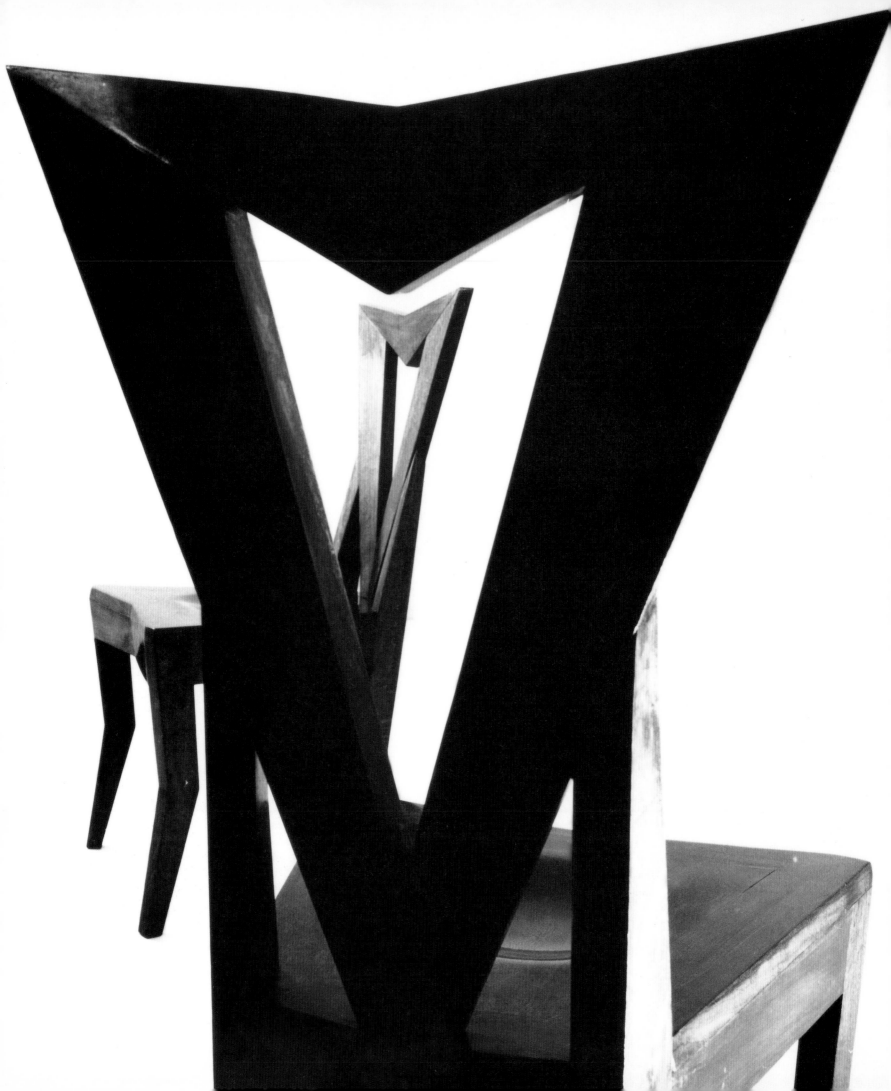

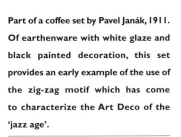

Side chairs by Pavel Janák in stained oak, 1911–12. Janák's designs were among the most literal three-dimensional interpretations of Cubism.

sensibility finds its expression in the appearance of the machine, in the lucid purism of its form.'

Yet this triumphant declaration of modernity must not be taken out of context. In contrast to the machine aesthetic of the pioneer Modern movement in the inter-war years, the appearance of the machine in 1913 did not exclude the notion of decoration. While there was little in the way of superficial ornamentation on the buildings, furniture and ceramics of the Czech Cubists, the forms of the objects were nevertheless decorative in themselves, their outlandish forms and jagged edges making them far from functional. Indeed, it has been argued that one reason why the Czech Cubists took so readily to the decorative arts was because the practicalities of construction were making their buildings increasingly dubious propositions. Pavel Janák encapsulated this view of modern decoration in 1909 when he wrote that,

Progression from simple utility to the design of the whole is certainly sufficient to build well. But architecture requires more – architecture is art. Contemporary architecture is not restricted to pure utility, to the material and construction, but goes beyond it to create abstract forms.

Until a revival of interest in the 1960s, Czech Cubism was a marginalized episode;[30] yet at the time Czech designers were widely known. Two appearances on the international design stage are worthy of note. The Austrian stand at the Deutsche Werkbund exhibition, held in Cologne in 1913 (this exhibition contributed to the provocation to which the French responded with the 1925 Paris Exposition), featured a Bohemian stand designed by Otakar Novotny and a room featuring the furniture of Gočár and František Kysela. In the spirit of the Werkbund, the Cubists promoted their idea of combining modern art with industry through the Artel Co-operative, which manufactured and distributed inexpensive ceramics to a broad range of customers. Janák was emphatic about the 'Usefulness of Applied Arts in Industry' which should manifest itself in the design of an object rather than merely superficial decoration.[31]

After the war and collapse of the Austro-Hungarian Empire, the pavilion of

Part of a coffee set by Pavel Janák, 1911. Of earthenware with white glaze and black painted decoration, this set provides an early example of the use of the zig-zag motif which has come to characterize the Art Deco of the 'jazz age'.

newly formed Czechoslovakia at the 1925 Exposition was praised in much of the coverage. The pavilion building was designed by Gočár and was, according to the *Studio*, 'in no sense regional but unreservedly modern in the most complete significance of the word'. Overall the same correspondent noted that, 'The participation of Czechoslovakia in the exhibition is a matter of no small importance, and has aroused as much interest among the general public as in artistic circles.' As in many other national pavilions, it appears stylistic modernity was toned down by attempts to portray an idealized sense of traditional national identity. Nevertheless, the *Studio* concluded that Czech decorative art should be grouped with that of France, Holland, Austria and Belgium, as 'up to a certain point, having made a clean sweep of all the traditional styles, [and] trying to create a modern style which shall possess as much novelty as possible'.

Significantly, the Italian pavilion was not included in the *Studio*'s list of innovation and novelty, yet the work of a number of Italian designers and architects needs to be considered in any assessment of the decorative response to modernity across Europe. The Futurists, and later the Italian Rationalists, were Italian movements with a place in the history of Modernism. Yet, those architects and designers who have been seen as belonging to the Decorative Novecento movement are closer in spirit to the evolution of Art Deco. An awareness of post-World War I Italian decorative arts is particularly valuable in helping to explain the prominent neo-classical elements in much Art Deco architecture.

The Decorative Novecento was a predominantly Milanese architectural movement of the early 1920s, which combined broadly neo-classical motifs with a degree of unashamedly modern plasticity. Giovanni Muzio's Ca' Brutta in Milan, built in 1922, is generally regarded as the first example of the style, and provoked hostility from *Il Secolo* when it was unveiled; it introduced a 'Berlin syphilis' into the city, abusive bywords for the modern and unfamiliar.[32] By 1936 Vincenzo Cardarelli could write retrospectively that Muzio 'had founded in Milan what is called a school, which indisputably was the first sign of modern architectural taste.'[33]

This classical interpretation of the modern is clearly seen in the ceramics of Gio Ponti who graduated from the Politecnico of Milan in 1921. Between 1923 and 1930, Ponti was the artistic director of the Richard–Gironi ceramics factory, where he was clearly attracted by the modern ideal of industrialized production. In the catalogue of the 1925 Paris Exposition, where his ceramics won the Grand Prix, he proclaimed that 'Industry is the style of the twentieth century, its mode of creation.'[34] This commitment to design in industry was continued in Ponti's 'Domus Nova' range of furniture for the department store La Rinascente. In *Domus*, the magazine Ponti founded in 1928, he wrote, 'The aim of the new system is to provide at modest prices, furniture of simple shape, but excellent taste and studied in detail so that the end product is endowed with all the most modern practical qualities.'[35]

Engraved glass bowl by Simon Gate for the Orrefors glassworks, 1920. Artists in Sweden were combining stylized decoration with simple, often classical, forms, contributing further to the eclecticism of the modern decoration on display in Paris in 1925.

As in the writings of the Czech Cubists, this type of modern rhetoric could easily have come straight from Le Corbusier, yet once more we can see that theories of modern production and design need not lead solely to a purely functionalist machine aesthetic. Ponti spoke of his 'classical inspiration owing to the enormous impression made on me by living, while resting from the front during the war, in buildings by Palladio and seeing as many of them as I could'.[36] This inspiration is played out in his ceramics, yet they are never merely revivalist. Ponti was conscious of this synthesis of the modern and the traditional, as the name of a vase he entitled *La conversazione classica* ('The classical conversation') suggests. The decorative detailing on some pieces features such modern motifs as the aeroplane, while his neo-classicism is tempered with humour, one pot showing an angel carrying a golf bag.

The attention Ponti received at the 1925 Exposition points to the Decorative Novecento as being one source of the strong element of modern classicism which fed into Art Deco. Another is the classicism promoted in the Swedish Pavilion; this was designed by Carl Bergsten, with interiors by Carl Horvik which contained displays from the influential Orrefors glassworks. The Swedes offered a stylized classicism whose influence was to be felt as far afield as the American PWA (Public Works Administration) Art Deco of the 1930s, and suburban English Odeon cinemas. Unlike the totalitarian states of the 1930s, which used large-scale classicism to symbolize 'a return to order',[37] Swedish neo-classicism had developed over the previous twenty years in an environment uninterrupted by the ravages of war. The apparent ease with which an architect such as Gunnar Asplund moved between classicism and rationalism suggests that Swedish neo-classicism was as much a response to challenges of modernity as the Novecento movement.

A more specifically architectural movement from the 1910s and 1920s which promoted a decorative solution was the Expressionist Amsterdam school which

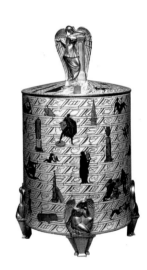

Above: Gio Ponti's porcelain vase entitled 'La Conversazione Classica' ('The Classical Conversation'), manufactured by the Ginori factory, Doccia, 1923–30. A figurative representation of the dialogue between antiquity and modernity in the Italian decorative arts of the 1920s.

grew up around architects such as Michel de Klerk, Piet Kramer and J. M. van der May. The predominantly brick buildings of the Amsterdam school are characterized by an overall organic plasticity, their often sweeping surfaces complemented by stylized sculptural ornament together with meticulous decorative features. Part of a largely northern European trend of architectural Expressionism, the occasionally fantastical forms of the buildings were achieved by modelling the initial designs in clay. The nature of the building material (hand-laid brick) was exploited to its maximum decorative effect, while decorative artists were allowed to run rampant on the interiors and architectural details.[38] On a relatively crude stylistic level, it seems fair to assert that elements of plasticity and the use of curvilinear forms in Art Deco architecture reveal the influence of the Amsterdam school, and indeed, Expressionist architecture as a whole. Within a Dutch context, it is not surprising to discover that the Amsterdam school was vilified in the pages of *De Stijl* in the same terms as Art Deco was condemned by the more zealous rationalists of the Modern movement; it was deemed 'decadent' and too emotional.[39] By the same token, advocates of Expressionism saw its strength in its freedom from the constraints of rationalism – a factor which has also been seen as contributing to the popularity of Art Deco in the inter-war period. Writers for the Amsterdam school's journal, *Wendingen*, were quick to praise the movement in the magazine's first issue in 1918, one contributor proclaiming that, 'fortunately, there has arisen a new generation that has an eye for form and colour, and considers no single material inferior for its purposes. Purified by a correct insight into rationalism, it is trying to recapture lost ground.'[40]

It is possible to trace a particular type of Art Deco architecture through the 1930s which, through its use of brick as opposed to concrete, draws on the balance between tradition and modernity that the Amsterdam school represents, while at the same time taming the wilder elements of Expressionism to achieve a more sober idiom. Charles Holden's London Underground stations are the most notable examples, designed after Holden had toured the Netherlands and Germany with Frank Pick in 1930. Further examples can be found in municipal buildings across the English-speaking world – not surprisingly, given the coverage that the less expressionist exponents of brick-built, Dutch modern architecture, such as J.J.P. Oud and W.M. Dudok, received in the British and American architectural press at the time.

The Amsterdam school was represented at the 1925 Exposition, yet not always in a manner we would now readily label 'Art Deco'. Michel de Klerk's *ensemble* was actually designed in 1916 and shows a significant folk influence which many interiors by members of the school evoke. This was a theme which surfaced in a number of the national pavilions, as an alternative response to a set of problems which the various decorative idioms of Art Deco addressed. At first sight, it might appear doubtful that folk art, or work derived from it, would

Below: The Dutch Pavilion at the Paris Exposition, 1925. The decorative brickwork and rustic appearance of the building create a distinctively Dutch folk-inspired idiom which is at the same time far from being traditional, as the geometry of the lower section suggests.

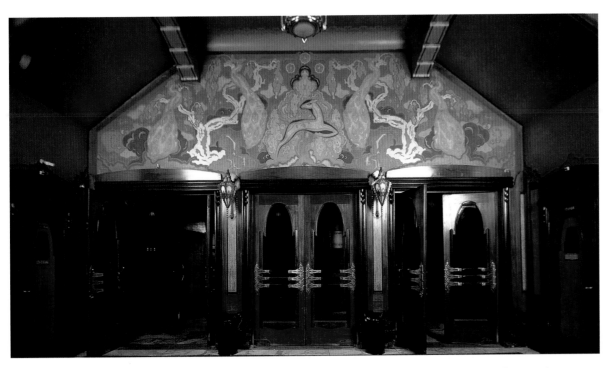

Left: The foyer of the Tuschinski Cinema, designed by H. L. de Jong, Amsterdam, 1918–20. The shape of the arches echoes the traditional forms of Dutch architecture.

Above: The elaborately decorative glass and iron roof of the Scheepvaarthuis, an office block constructed in 1912 in Amsterdam, designed by J. M. Van der May, Piet Kramer and Michel de Klerk. Regarded as the first Amsterdam School building.

Below: Piet Kramer/Michel De Klerk building complex, 'De Dageraad' – section showing housing at the corner of P.L. Takstraat/Burgemeester Telleger-straat, Amsterdam, 1920–23. Public housing was central to the work of the Amsterdam School whose members pursued a radical agenda.

be allowed in Paris. Surely it was not modern, drawing on nineteenth-century traditions of national romanticism? Yet at the same time it was undoubtedly new; examples such as de Klerk's were influenced by, rather than copied from, studies he had made of folk art in Scandinavia in 1910. Indeed, the exploitation of sometimes spurious folk traditions could be seen as another example of a decorative response to modernity. The Wiener Werkstätte certainly incorporated folk influences into its modern idiom, and such influences formed part of the eclecticism which fed into Art Deco. In the case of the pavilions of the newly created Central European nations (Poland, Czechoslovakia, Hungary, Yugoslavia) their Art Deco is impossible to assess without an understanding of the nationalist context of its development.

The objects in the pavilion of the Kingdom of Serbs, Croats and Slovenes (later to become Yugoslavia) represented these apparently contrasting themes. The international element came from Zagreb, '*un véritable foyer d'art décoratif*', and the traditional Croat and Slovenian association with Vienna and Italy. The sculptor Ivo Kerdic had worked at the Wiener Werkstätte, Vladimir Kirin was a draughtsman for the *Studio* and the *Architectural Review* in London, while a further international dimension was given by Ivan Gundrum who worked with pottery and scenography and was soon to emigrate and continue work in America. Their designs were mixed with anonymous folk works, thus creating a new national 'people's tradition' for a country that was barely seven years old, a fact stressed by the displays of urban planning for Belgrade, the new state's capital. It has been argued that this

54

'mythologizing of the people' was fused with the 'reductionist elements of New classicism' to create 'a culture of Art Deco [which] expressed itself as a moment of paradoxical resolution of the tendencies toward reduction and signs of exaltation'.[41]

If Art Deco was evolving from an ideology of modern decoration in Central Europe, there was little sign of similar developments in Britain, if her pavilion at Paris was to be taken as representative. For the editors of the *Studio Yearbook*, the British contribution in 1925 displayed little more than the 'tedious reiteration of traditional formulae'.[42] The British government had a distinctly half-hearted approach to the Exposition, and the fact that no financial encouragement was given to potential exhibitors ensured a chronic shortage of visual experimentation. After the Exposition, the Department of Overseas Trade set up a committee to assess Britain's contribution in Paris. Although keen to play down the success of other countries, particularly France, while defending the traditional nature of the British pavilion, the report posed some interesting questions. In the opening remarks, the chairman of the editorial committee, Sir H. Llewelyn Smith asked, 'How far may the Exhibition be regarded as fairly representative of the present state and trend of the Industrial Arts?'

> *Twenty-two countries exhibited [including] all important European states except Germany and Norway. Other continents were much less fully represented. America was entirely absent and Asia was but half represented, in the absence of India and Persia, while the only African exhibits were from the French possessions or protectorates ... for practical purposes therefore the Exhibition was mainly representative of modern European art. If we confine attention to the countries which actually participated we are at once struck with the overwhelming predominance of France ... the space occupied by the French sections was probably at least two thirds of the entire area of the Exhibition, and perhaps twenty times the area of the British Section.*

This excerpt again highlights the importance of economic nationalism, as well as the imperial role of the Exposition exemplified by the near-exclusive representation of the non-European world by the French colonies. The political and economic agenda of the Exposition was certainly not lost on the British. The Department of Overseas Trade recognized the importance France accorded to art and industry, observing that, 'the result was not attained without the expenditure of much wisely directed energy and a good deal of public money, both by the state, the great Municipalities and the Chambers of Commerce.'[43] The report noted the grants of F900,000 that were given to the national factories at Sèvres, Gobelins and Beauvais, and the ringing endorsement of the supportive role of the French authorities emphasizes the economic concerns which underpinned the Exposition, concerns that are often overlooked in the rush to praise the new style. In fact in the eyes of the US Department of Commerce, who were analysing regretfully the absence of their own country, the impact of the new 'modern movement in industrial arts' was assessed primarily in economic

The Polish Pavilion at the Paris Exposition, 1925, which was praised in *The Studio* for its modernity.

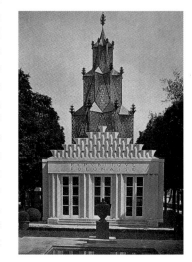

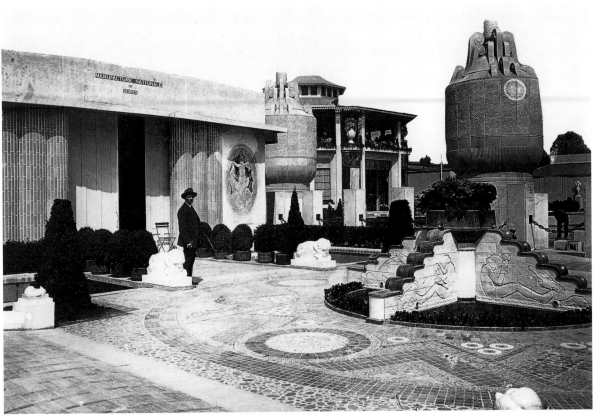

Left: The pavilion of the Sèvres Porcelain Factory at the Paris Exposition, 1925, designed by Pierre Patout and André Ventre. The pavilion was adjacent to a series of colossal concrete urns, a literal representation of the output of the state ceramics factory.

Below: A Sèvres porcelain and plated metal illuminating vase designed by Jacques-Emile Ruhlmann, 1928, as a light fitting for the first-class hall of the liner Île de France.

terms. Unlike the British authorities, who remained somewhat aloof from what they undoubtedly regarded as the vagaries of aesthetic fashion, the Americans argued that embracing the new style was essential because 'the nation which most successfully rationalises the movement and brings its expression into terms acceptable and appropriate to modern living conditions and modern taste will possess a distinct advantage both as to its domestic and its foreign trade.'[44]

So, by the time the Paris Exposition closed its gates in October 1925 and the temporary buildings were dismantled, the stage was set for a clearly perceived new style to assert itself. The eclecticism of the Art Deco of 1925 reflected its diverse roots, in both Cubism and the vogue for exoticism as well as in the modern decorative arts of Austria, Germany, Holland, Italy, Czechoslovakia, Scandinavia and France itself. The new style had evolved a decorative vocabulary that would be developed and distilled across the globe, and would eventually come to symbolize the speed and scale of the modern world. Art Deco was poised as the stylization of modernity which, as the US Department of Commerce perceptively recognized, was 'destined to play a large part in the near future in many important fields of production throughout the western world'.

W e cannot lose sight of the fact that the United States represents the greatest consuming public in the world – one with the highest standards of living and one that is constantly availing itself of novelties in its household and business life. Furthermore, in no other nation are the facilities for transmitting new ideas to the mass of the people so highly developed, and in no other nation is the response so immediate when interest is aroused.

US Department of Commerce, 'Report of the Commission on the 1925 Paris Exposition', 1926

I dined alone and looked always at the gorgeous, unreal skyscrapers.

Greta Garbo on being asked what she did on her first night in New York in 1925[1]

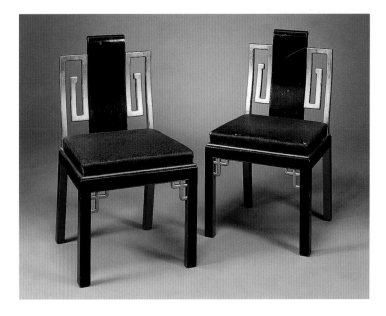

Left: The RCA Building in the Rockefeller Center, designed by Raymond Hood, New York, 1931–40. The floodlighting was designed by Abe Feder.

Right: Lacquered and gilt-wood dining chairs by Paul Frankl.

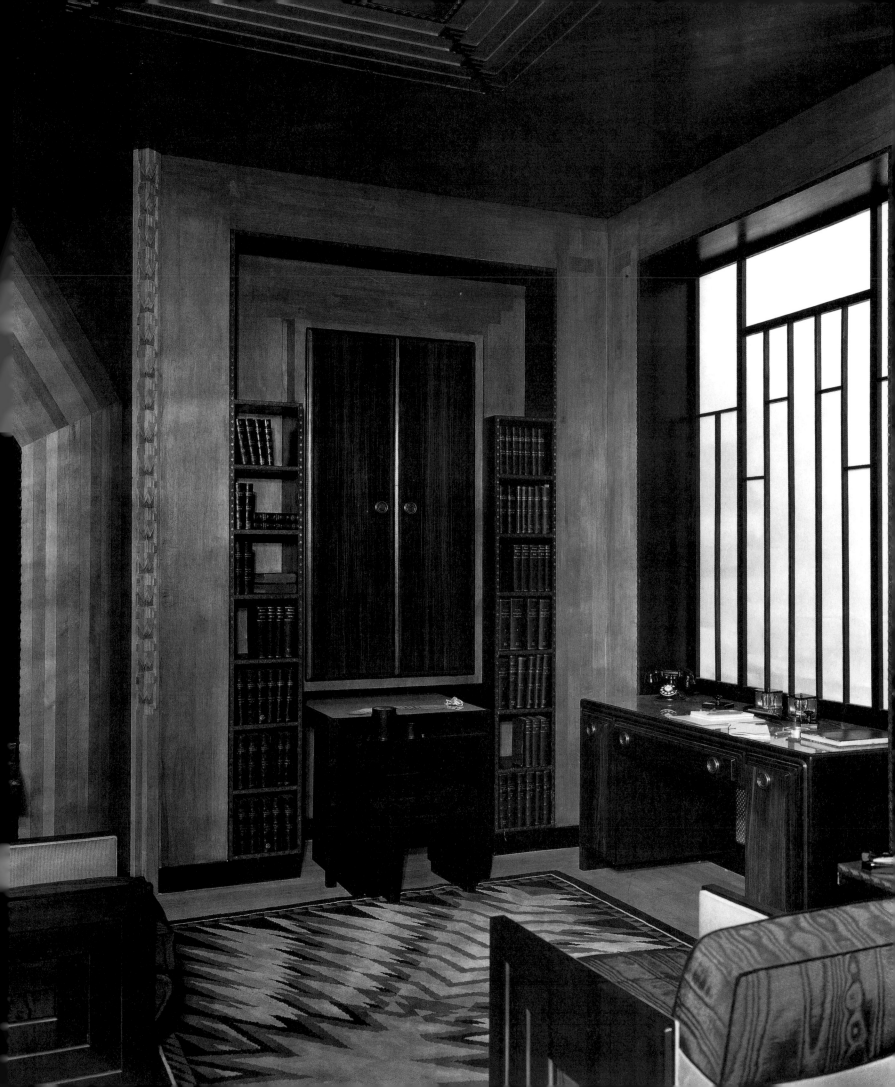

The American government declined the French invitation to exhibit at the *Exposition des Arts Décoratifs* because of a lack of confidence in American design; in the words of the designer Robert Frankl, 'we found that we had no modern decorative art'.[2] Nevertheless, many American buyers, designers and industrialists visited Paris in 1925 to investigate the possibility of exploiting the new European styles for their huge domestic market. While the report of the Official US Commission on the Exposition doubted that ideas could be directly lifted or copied, because they were 'too radical to be generally accepted by the American consumer', it was also emphasized that Art Deco could be 'utilised in modified form in the American market'. There was a clear sense of the potential economic importance of the new European styles, yet it was a sense of excitement and optimism countered by the humble air of pessimism surrounding the reality of indigenous modern American design.

Many contemporary critics were swift to endorse these official sentiments. Emily Genauer adopted this view, and furthermore argued that the first American attempts at new design after the Paris Exposition were little more than examples of clumsy pastiche: 'It was, in truth, the literalness on the part of the American designer and manufacturer that started modern decoration on the wrong foot in America.' For Genauer, the manufacturers had failed to take heed of the warnings of the Official Commission report of 1926. Because of what she saw as an American way of life, influenced by the burgeoning cultures of mass production and mass communication, 'It was more important [for America] to draw on inspiration from the tremendous assortment of things on view, rather than to copy them.'[3] Genauer argued that this did not take place to a sufficient extent, and as a result American designers were 'drawn into a vortex':

> They turned out a succession of wild 'modernistic' pieces, ugly things that revealed no real understanding on the part of their designers of what functionalism and form really are. And the results were unfortunate. The new kind of furniture revelled in 'skyscraper' contour, exotic woods, austere lines, box-like proportions, self-conscious zig-zag 'decoration'. The pieces were massive, bulky, too low to be comfortable.[4]

These personal recollections of American designers 'starting off on the wrong foot' after 1925 suggest that those observers were right who believed that America had no modern design. In fact, the Department of Commerce report can be seen to be more of a misreading of what the French actually meant by 'modern' than a valid assessment of the state of American design. Genauer's criticism is steeped in Modernist attitudes, which could not accept the eclecticism of the Art Deco on display at Paris, examples of which were soon on display in America itself. Her dismissal of early American Art Deco furniture could easily apply to virtually anything in the Paris Exposition. What she regarded as 'modernistic', many European decorative artists would have regarded as contemporary and modern, and we would now regard as Art Deco. If the

American authorities had realized how far the term 'modern' could be stretched, they would surely have felt less sheepish about displaying in Paris. In reality there already existed a tradition of modern decoration in America which, coupled with the intense interest generated in the wake of the Paris Exposition, enabled the rapid spread of the Art Deco aesthetic across America.

Perhaps the most obvious place to begin a search for an American version of modern decoration is the early twentieth-century work of the architect Frank Lloyd Wright. Wright's decorative work of the 1900s and 1910s shared a stylized approach to natural decoration with his employer and mentor Louis Sullivan, making his work at once indigenous yet inexorably intertwined with contemporary Europe, and in particular Vienna. In common with the earlier work of Wiener Werkstätte designers such as Hoffmann, Moser and Olbrich, Wright put geometry at the centre of the decorative process, 'adding to it until the design becomes a growing organism'.[5] Wright regularly read European design periodicals, claiming in his autobiography that 'Vienna had always appealed to my imagination. Paris? Never!'[6] The designers of the Wiener Werkstätte exhibited in America at the World's Fairs, most notably the interiors of Olbrich and Joseph Urban at St Louis in 1904, and examples of Wright's work from the first decade of the century (for example the Dana House, 1902, or the Darwin D. Martin House, 1904) show the repeated use of geometric decoration; the interior of the Unity Temple (1906) in particular invokes the work of Olbrich. Moreover, Wright was not merely working in a European mode. The significance of his work was such that it provided an inspiration for the next generation of German Modernists, architects like Ludwig Mies van der Rohe and Erich Mendelsohn, following the publication of Wright's drawings in Berlin in 1910. Wright's German publisher, Wasmuth, heralded him as the 'American Olbrich', while Kuno Francke, a German academic visiting Harvard, implored Wright to leave for Europe: 'Your people are not ready for you. Your life will be wasted. But my people are ready for you.'[7]

Wright stayed in the USA and his work continued in a personal idiom which produced a specifically American, perhaps even more particularly Midwestern and later Californian, style which contained the seeds of many motifs and techniques later to become commonplace in American Art Deco architecture, furniture and interior design. Proof that American designers were developing their own modern idiom before the frantic post-Paris rhetoric of 1925–6 can be found in the sculptural relief above the hearth at Wright's Barnsdall House, California (1923), in the stylized architectural ornament and modern furniture of Midway Gardens, Chicago, or the ceramics Wright designed for his Imperial Hotel in Tokyo (1916–22).

There was certainly an awareness of the importance of Wright's work in relation to the new design emerging from Europe in the 1920s, yet Wright's very individual interpretation of modernity had a limited immediate impact in his own country. Indeed, the irony of the rush by New York department stores to 'go

Right: The main room at the Barnsdall House, Los Angeles, designed by Frank Lloyd Wright in 1922, the abstract geometric relief above the fireplace showing that there was such a thing as modern decoration in America before 1925.

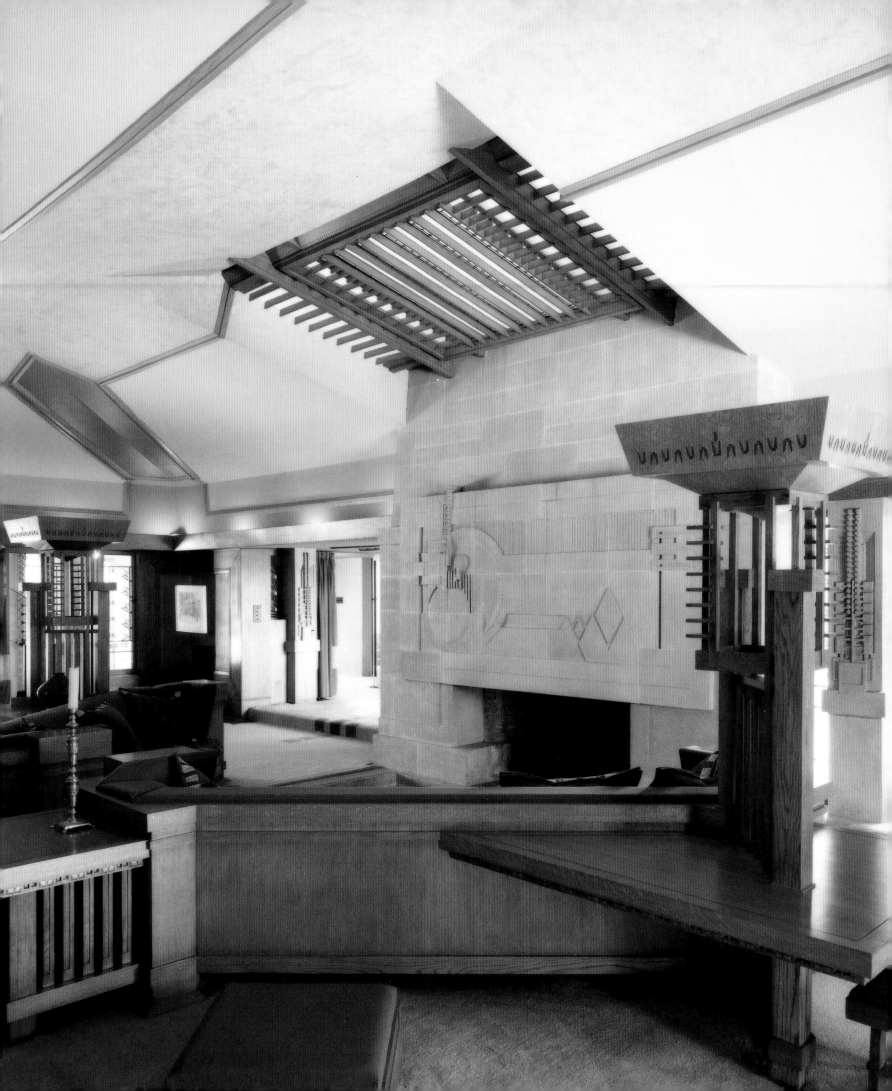

modernistic' in 1928 was not lost on one commentator, who noted in the *Architectural Record* that, 'It is embarrassing that we now turn our attention to Europe to learn the lesson that our own pioneer modernists taught Europe.'[8] Although American buyers and designers flocked to Paris in the summer of 1925, apparently driven by a sense of discovery of the new, this was not the first opportunity they had had to see the decorative seeds of American Art Deco. In addition to Wright, the presence of Joseph Urban, an Austrian by birth, in America since World War I, further questions the notion of the USA as a desert of modern design.

Urban provides an equally fascinating link between the new European design styles, the emerging markets of the USA and the development of American Art Deco. Urban was born in Vienna in 1872. He followed a diverse career and came under the influence of the Wiener Werkstätte in the first years of the twentieth century. His first work in America was as early as 1904, when he designed the Austrian rooms at the St Louis World Fair in 1904. By 1912, he had become artistic adviser to the Boston Opera Company. After its bankruptcy in 1914, he pursued an eclectic career encompassing interior design, architecture and set design for the theatre and cinema.[9]

Urban's popularization of Art Deco designs through the cinema has been rightly emphasized,[10] yet his role in directly introducing new European decorative arts, in particular the work of Josef Hoffmann and the Wiener Werkstätte, to America in the early 1920s has been underplayed. In 1922, Urban designed an exhibit room for the Wiener Werkstätte at the Art Institute of Chicago. Even more significantly, Urban opened the Wiener Werkstätte of America in 1922 with its exhibition space/shop on Fifth Avenue.[11] The high profile that Hoffmann and the other Austrian designers had in New York reached its zenith in 1925 when the Austrian pavilion was mimicked in an apartment building on 72nd Street. As a result of Urban's activities and the exposure the Wiener Werkstätte had received in New York, it is very likely that this particular strand of new European design had a more significant influence on the emerging American Art Deco styles than its relatively small presence at the Paris Exposition might suggest. Indeed, on Urban's death in 1933, the *Studio* noted that 'America owes much to the late Joseph Urban, architect, theatre designer and latterly, industrial designer, who, more than any other man helped to revolutionise the American sense of design'.[12] Urban has been described as a stylistic chameleon, nevertheless the apparent ease with which he could move between Wiener Werkstätte-influenced work – for example, the Man's Den exhibited in 'The Architect and the Industrial Arts' exhibition at the Metropolitan Museum, New York in 1929, with its symmetrical patterning, heavy woods and uncompromising angular Modernism – and the more Moderne streamlined interior of the New School in New York, serves to illustrate the influence of Viennese design on the evolution of Art Deco.

Alongside Urban's endeavours to introduce the Wiener Werkstätte to New York, the activities of other relatively small galleries and shops should be considered here. Paul Frankl's Gallery on West 48th Street was credited with thankless 'long years of trying to show the public that modern art was less dangerous than beautiful, courageous years of scant success'. Frankl imported 'Poiret papers and objects in pottery and porcelain from Vienna', as well as his own furniture. According to the critic Edwin Avery Park, 'He has designed and made his own ateliers, skyscraper bookcases, strange slender chests of drawers with almost delicious metallic finish, odd chairs and tables, sometimes of metal, all kept very flat and treated in rich all-over colours with different coloured edges.'[13]

Commenting on Rena Rosenthal's shop at 520 Madison Avenue, the same critic observed that, 'It is the influence of Dagobert Peche one feels here, of the Wiener Werkstätte, of the Austrian love of colour and whimsical form.' Rosenthal, who was Ely Kahn's sister, argued that 'modern art objects chosen with discretion will fit any American interior. I believe in using the creations of living artists of America and Europe.'

The Metropolitan Museum of Art, where Urban exhibited his Man's Den, served as another arena for the display and dissemination of the new style, both before and after 1925. The first opportunity that large numbers of the American public had to see the new style was a flamboyant selection of exhibits from the Paris Exposition, provided by the American Museums Association, which made up a touring exhibition covering eight cities, culminating in a show at the

Frank Lloyd Wright's Unity Temple, Oak Park, Illinois, 1906. Widely celebrated as one of Wright's greatest achievements, the building, with its innovative use of geometry, reflects his fascination with Vienna at that time.

Right: Watercolour of Joseph Urban's Reinhardt Theatre, between 50th and 51st Streets, New York, 1928. The importance of light in the design is interesting, as is Urban's obvious quotations from the modern Viennese tradition.

Metropolitan entitled the 'International Exhibition of Modern and Decorative Art.' This was not the Metropolitan Museum's first foray into the world of modern decorative arts. In the early years of the century it had been a conservative institution, refusing to stage an exhibition of the German Werkbund in 1912 because it did not wish to be connected with anything commercial;[14] by 1922, however, attitudes towards the contemporary decorative arts were changing. A benefactor, Edward C. Moore, gave the Museum $10,000-a-year for five years with which to buy examples of modern decorative arts. The Curator of Decorative Arts, Joseph Breck, began purchasing ceramics, glass, textiles and metalwork from France, Austria and Denmark, as well as the USA. These included work by leading European decorative artists, including Jean Dunand, Emile Gallé, Raoul Dufy, and a silver bird by Dagobert Peche of the Wiener Werkstätte. Breck's purchases were displayed in 1923, and in the same year he went to France and bought two pieces of furniture, a lady's desk by Ruhlmann, and a commode and mirror by Süe & Mare. After the arrival of the French pieces it became clear that limiting American manufacturers to pieces inspired by the Museum's collections was stifling new design, and this rule was repealed in 1924. Breck brought back further European pieces from Paris in 1925; although 'modern' according to the rules of the Paris Exposition, his choices were nevertheless from the traditional wing of the Art Deco idiom rather than the radical Modernist approach. Yet this exposure to the European decorative arts was crucial: 'With the display of these stunning examples the American public could and did accept the modern French idiom. The Metropolitan had found a palatable modern style.'[15] In 1929, the work of American designers on show in 'The Architect and the Industrial Arts' exhibition included a concentration on the use of new materials such as plastics, aluminium and rayon. The rules for the exhibition were similar to those of Paris in 1925: as well as being American, the displays had to be modern.

There was also an awareness in America before 1925 of the debates over the importance of art and design in industry, which were pivotal in the planning of the Paris Exposition. Even the *Architectural Record*, at this point still very conservative in its approach, could point to at least one American example of an enlightened attitude in practice. In the Crane Company building, designed by architects Rogers and Stout, America had an 'example of the union between art and industry to which special attention might be given'.

It was planned in the summer of 1924. Of this planning it must be said that the tendency of the time has not merely been seen and understood, but the chief lesson of the exhibition at Paris in 1925 has actually been anticipated.[16]

The building, in Atlantic City, New Jersey, was to be a showroom for the company's products. Its façade was made of a white artificial stone, Onondga Litholite, mixed with marble and dolomite chips to enhance its whiteness. Its arched façade, sweeping interiors and brightly coloured décor (the ceilings and

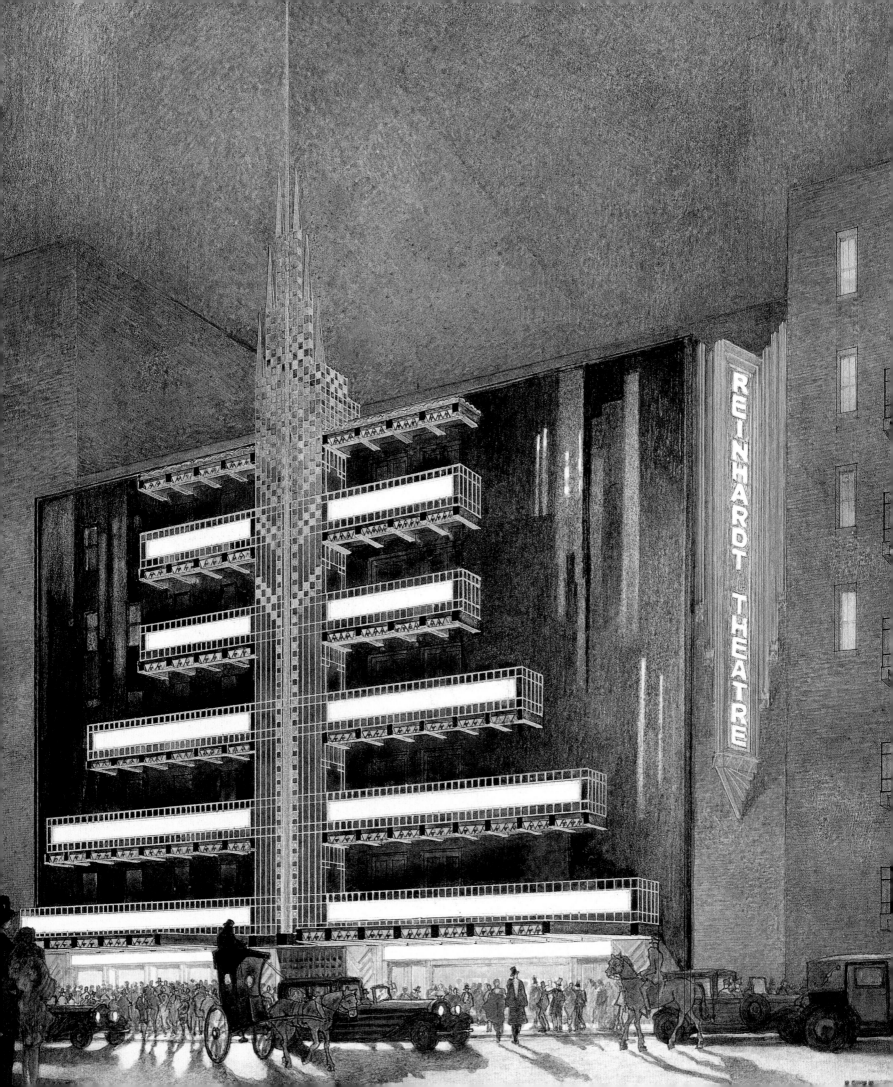

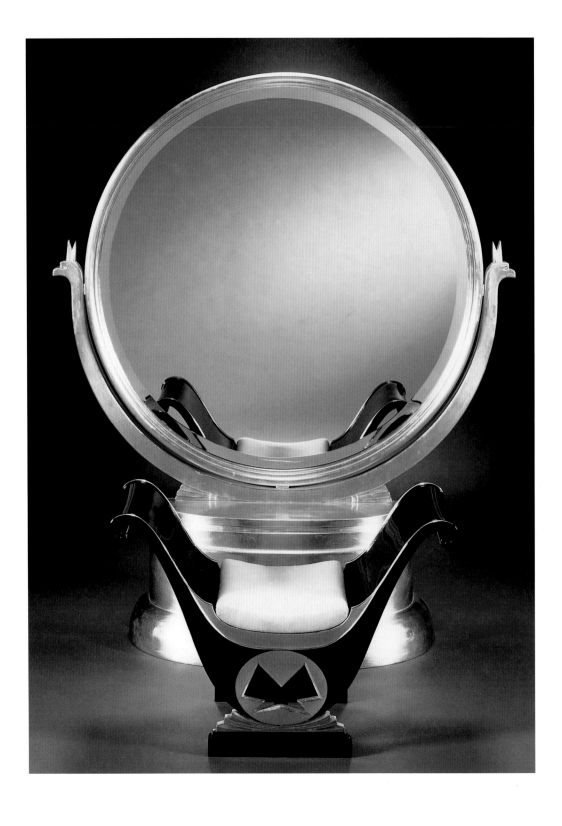

Left: Dressing table and stool of lacquered and silvered wood by Paul Frankl, c.1927.

Right: Folding screen by Donald Deskey, commissioned by Mr and Mrs Glendon Alvine in 1929. During the 1920s Deskey, fresh from his studies in Paris at the time of the 1925 Exposition, also designed screens for Paul Frankl and for Saks Fifth Avenue.

floors were gold) produced a building which would not have looked out of place among the pavilions in Paris. Like many of the more conservative exhibitors in 1925, James Gamble Rogers, the principal architect, was keen to play down the overt modernity of the building: 'No traditional style was quite appropriate, but the element of novelty might be translated, as it were, into a well proportioned old form with extreme propriety to detail.' The *Record* endorsed such sentiments, celebrating the fact that, 'usurping rationalism was not allowed to take the place of aesthetics'.

Although there was a tradition of decorative responses to modernity in America by 1925, no account of the evolution of American Art Deco can ignore the high profile the new style achieved in the wake of the Paris Exposition. The major department stores and museums were crucial agents in the promotion of the style. Throughout the late 1920s and 1930s they staged a succession of exhibitions which sought to explore both 'modernistic' and 'modern' interiors and furniture. These exhibitions adopted the format of rooms and ensembles in the spirit of the Paris Exposition, rejecting the traditional notion of displaying individual pieces as 'art'. In 1928, the American Designers Gallery displayed the work of such designers as Donald Deskey, Joseph Urban, Wolfgang Hoffmann and Raymond Hood in ten fully-decorated rooms, a response to the display methods at the Paris Exposition, as well as to the more directly commercial approaches of the stores.

It is interesting that museums – often viewed as purely historical institutions – played a major role in the promotion of Art Deco as a new style in America in the late 1920s. It has been suggested that an exhibition of 'Contemporary American Industrial Art', staged at the Metropolitan Museum in 1934, contributed more than any other to the opening of numerous small retailers in the city, such as Modernage, Doehler Metal Furniture Co., New Mode Furniture and Joseph Aronson Ltd.[17] Nevertheless, these developments were confined to the sophisticated markets of the East coast, and New York in particular. The Metropolitan Museum of Art may have 'found a palatable modern style', the grand claim that, as a result of this development, 'the American public could and did accept the modern French idiom' may be overstated. Mirroring the role of the French department stores at the Paris Exposition, it was their American equivalents which promoted Art Deco in the USA to a far broader, non-metropolitan American public. If American museums were embracing commercial concerns, the department stores were reciprocating by serving as arenas for new French furniture, which was often put on display for a curious public in the manner one would expect of a museum.

There was already a modern presence in the great New York department stores by 1925. Lord and Taylor displayed an American-made ensemble in the autumn accompanied by a range of imported objects, while there was a modern element to Wanamaker's tercentennial pictorial pageant of New York at the

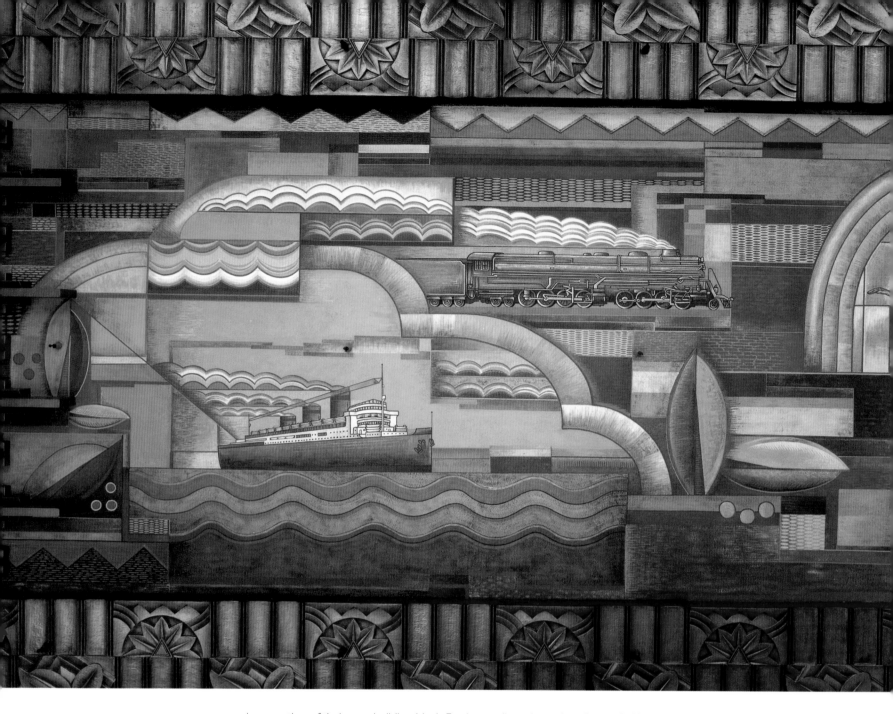

inauguration of their new building. Hugh Ferris contributed a series of remarkable panels depicting Harvey Corbett's conception of the future of New York City. These panels, called *The Titans*, showed a vision of the city to come, 'piling mountain on mountain to reach to the sky'. Two years later, with the style beginning to thrive in the stores, Wanamaker's advertising adviser confidently predicted its continued growth, claiming that 'John Wanamaker believes in the future of the new style and is making a policy to let the public have as much of it as they will absorb.'[18] The influence of the style soon spread beyond the shop floor and into the architectural appearance of the stores. Modernization at Macy's and Bloomingdale's included the façade, but such developments were not confined to New York. The stylized decoration of Art Deco adorned the rapidly expanding chain of Sears retail stores in the late 1920s, and the architect Edward

Herman Sachs's ceiling fresco, *Speed of Transportation*, at the Bullocks Wilshire department store in Los Angeles, 1929. By incorporating the aggressive icons of speed and technology into the interior decoration of a shop, he celebrated and at the same time tamed them. Machines were no longer dangerous, dirty or threatening in this colourful environment.

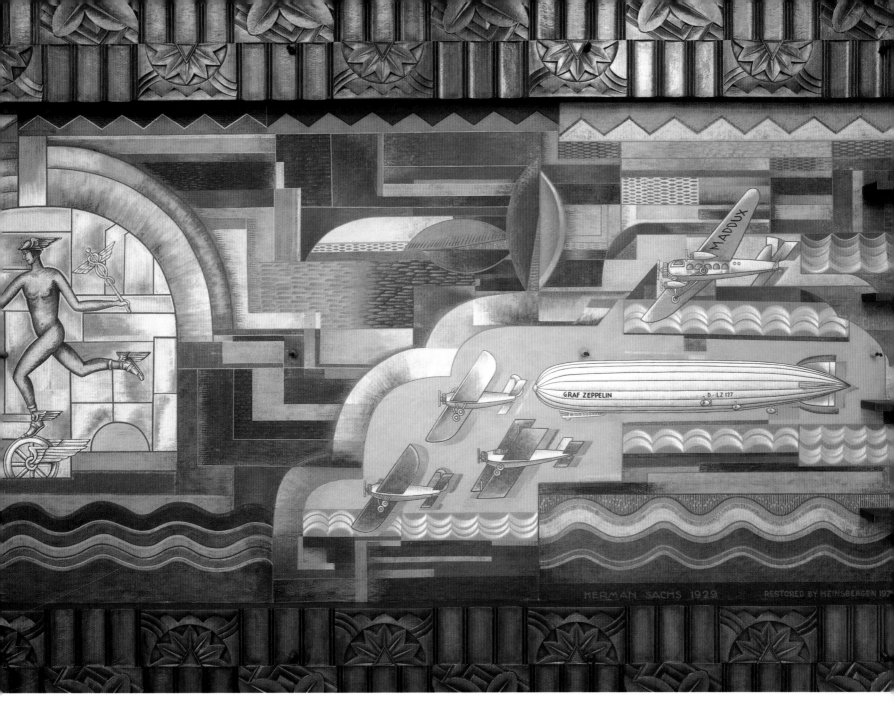

F. Sibbert transformed the S. H. Kress chain from Beaux Arts to Art Deco from 1929 onwards.

But perhaps the most celebrated of the first wave of purpose-built Art Deco department stores is the Bullocks Wilshire store in Los Angeles. Designed in 1928 by the architects John and Donald Parkinson, its terracotta and copper tower embodies the 1920s American Deco idiom: ziggurats, fluting, stylized decorative fretwork, and faceted, almost plastic surfaces. It comes as little surprise to learn that P. G. Winnett, the store's vice president, visited Paris in 1925 since the building is a towering quotation of the French department store pavilions at the 1925 Exposition. However, while its decoration may draw on European sources, its stepped, vertical form proudly proclaimed the American nature of its modernity.

By 1928, many stores were going beyond special displays of French furniture.

Right: The Bullocks Wilshire department store, Los Angeles, 1928, designed by John and Donald Parkinson, bringing vertical modern architecture to the horizontal suburbs of Los Angeles.

Again New York set the trend, but stores across the country were quick to follow. In February 1928, Lord and Taylor of New York staged an influential 'Exposition of French Decorative Art', which featured the store's own designs alongside French pieces. The cross-over between the high decorative arts and the potentially massive American market was alluded to by Macy's in their 'Art in Trade Exposition', which featured the work of Bruno Paul, Kem Weber and Gio Ponti.[19] In aesthetic terms, American furniture designers such as Frankl, Weber, Eugene Schoen and Donald Deskey were defining an American Art Deco idiom of the 1920s which has been termed 'zig-zag'. Desks, chairs, cabinets and screens all received angular decorative treatments, while the stepped shape of the skyscraper, the archetypal Art Deco architectural form, found its way into the designs of Frankl, Weber and J.B. Peters. The upholstery on chairs by Weber and Wolfgang Hoffmann dating from 1928–9 mixes triangular and curvilinear patterning to achieve a pseudo-Cubist effect, and it was this very approach that provoked the Modern movement propagandist Philip Johnson to lament that:

> Styles in interior decoration follow one another like women's clothes. The 'Modernistic' with its zig-zags, setbacks and tortured angles merely redesigns the surfaces of furniture and rooms. The same cornices and moldings, the same sideboards and mantels are given a new surface treatment. A modernistic chair, for example is only an old style chair attempting to look modern. Its curves are replaced by freakish angles; geometric or cubistic designs are used in its upholstery patterns. In principle, however, it is nothing but the same old chair carrying a new burden of ornament.[20]

It has been estimated that by 1928 there were over fifty different exhibitions of modern rooms across the country in department stores such as L. Bamberger's, Hahnes (both in Newark), Marshall Field (Chicago), Wanamakers (Philadelphia as well as New York) and City of Paris (San Francisco), as well as in museums.[21] One commentator, Herbert Lipmann, was emphatic:

> All of a sudden it is all around. New York's department store area, bounded on the north by Sak's, on the south by Wanamaker's, on the east by Altman's and on the west by Macy's has gone contemporaneous. Shop windows in this region are gesturing emphatically with their modernity, stores have exhibition rooms completely furnished and decorated in the new manner ... More and more novelty shops are replacing 'antique' emporiums ... the works of Italian potters, Wiener Werkstätte, Rodier, Süe et Mare and Lalique are authentic.[22]

Public taste was stimulated by the adoption of display methods directly influenced by the International Expositions, with American stores and museums clearly attempting to make up for their lack of participation in 1925. By January 1928, the Architectural Record could proclaim that 'in some of the finest shops and department stores of American cities rises a new art – the art of commercial display.' Its importance was clearly recognized: 'May we not ask whether the new art of commercial display is not the most important role of art in industry?

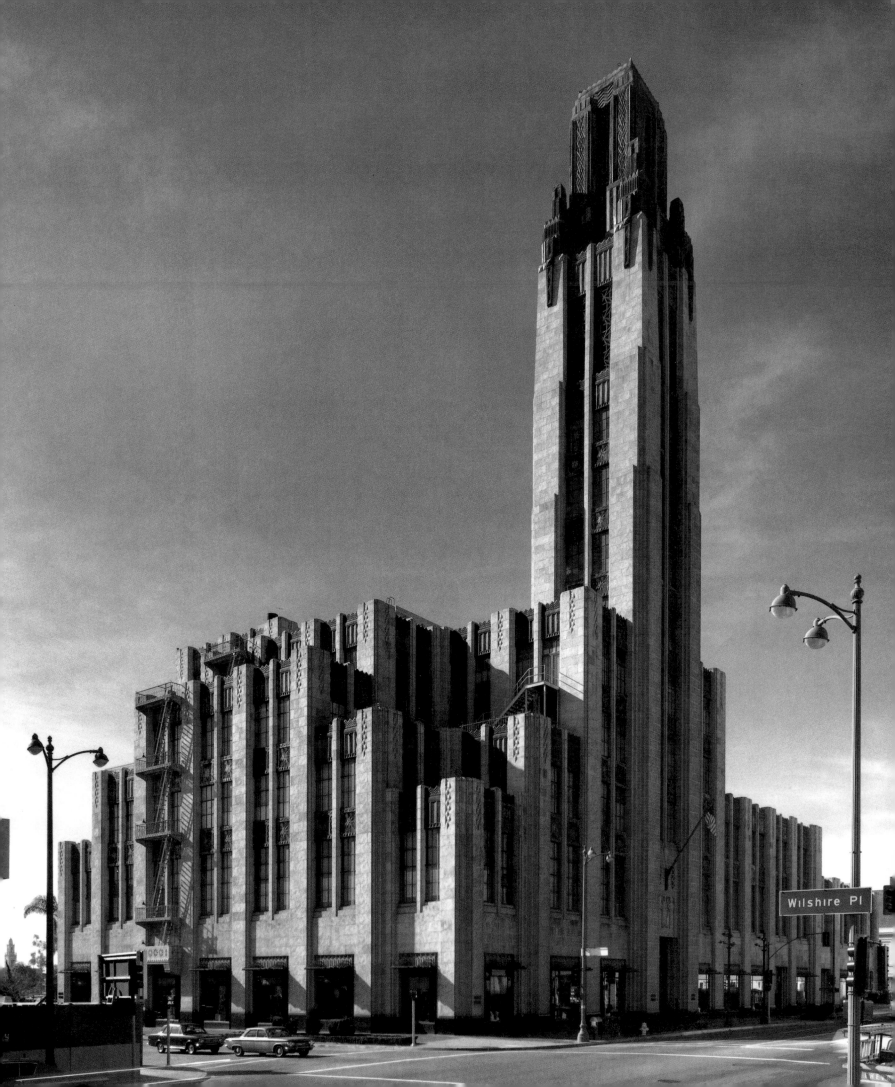

72

In any case if it continues to progress, it brings into modern life a most powerful new influence on modern taste.' In fact the *Record* could foresee the shop window as a major agent of stylistic change, with popular style becoming homogeneous 'as in the great art periods' such as that of Louis XVI:

> As a definite style varied by the seasons' changes becomes more understood by the public, the public will be schooled in that style through daily use, in the intimate contact with the furniture, clothing, furnishings, motors, and the types of design, colouring and taste which they impress, both on the conscious and unconscious perceptions. Popular taste, thus molded, will inevitably react upon the 'higher arts'. Now if such a popular reaction provokes the effort of architects, painters, sculptors and decorators to a more vital, direct and more modern ideal, no better accident could happen.[23]

The new medium of film also played a crucial role in the promotion of Art Deco in the 1920s. Although modernistic set designs and architecture had featured in avant-garde European films throughout the 1920s, it was not until towards the end of the decade that Art Deco began to enter the stylistic vocabulary of American film-makers. The Art Deco idiom in film, however, tended to carry negative associations, as in the use of Modernist or modernistic surroundings as a sign for the sinister (this was an inheritance from European cinema, from such films as Marcel L'Herbier's *L'Inhumaine* and Fritz Lang's *Metropolis*). Robert Mallet-Stevens was one of the keenest European Modernists to promote visual modernity in the cinema, but in his 1928 book *Le Décor moderne au cinéma*, he lamented that the style was used 'exclusively for places of debauchery: night-clubs or boudoirs of the demi-monde, which would allow one to suppose that the admirable efforts and researches of painters, decorators, and architects are good to surround drunkards or those of ill-repute.'[24]

In American cinema, Art Deco kept its disturbing edge. It was used to display the decadence of independent women (Greta Garbo in *The Single Standard*, Jean Harlow in *Dinner at Eight*) or exotic bathrooms (*Dynamite*, 1929) and bedrooms (*The Easiest Way*, 1931), while Paul Fejos used stylized sunbursts and a giant skyscraper mural to create a zig-zag Art Deco interior to the night-club in his 1929 film *Broadway*. In addition to suggesting hedonistic luxury, the style was used in industrial or big-business settings to symbolize financial power, the male world of work, and often the perceived unsuitability of women in such an environment (*Big Business Girl*, 1931 and *Female*, 1933).[25] Nevertheless, the use of the style as a material expression of luxury, even though a decadent one, would have helped establish Art Deco in the hearts and minds of the vast movie-going American public. Women's magazines regularly provided patterns enabling readers to copy the fashionable dress of their favourite film stars, suggesting that cinema was an important taste-maker, providing inspirational role models for its audience. But it was the environment in which these movies were shown which, as much as the films themselves, enhanced the exotic allure of the luxury

Still from Marcel L'Herbier's film *L'Inhumaine*, 1924. *L'Inhumaine* was the earliest film to use modern design and architecture. It represented the collaborative work of Chareau, Lalique, Puiforcat, Templier, Poiret and Mallet-Stevens. This set, the machine-age laboratory, is by Fernand Léger.

and decadence of Art Deco. It was inside these buildings that architects of the period could indulge themselves and their public in an orgy of decorative excess. In many theatres, the audience were required to suspend their sense of reality and belief for the building as well as for the film.

The auditorium of the Wiltern Theatre in Los Angeles (1929–31) saw the architect S. Charles Lee confirm that Art Deco could reduce classicism to frivolous decoration by making the fluted columns flanking the screen gold and pink, while leaving no available surface of the room untouched by colour. But at least Lee retained some degree of formality by echoing the columns along the walls with repeated strips of patterning; Marcus Priteca appeared to abandon all known architectural theory in the auditorium of the Pantages Theatre, also in Los Angeles

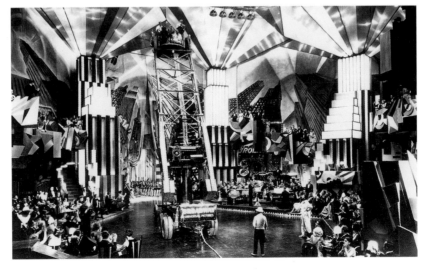

Set designs of the Paradise Club for the 1929 film Broadway, directed by Paul Fejos. Above: Greta Garbo poses behind a model of the club.

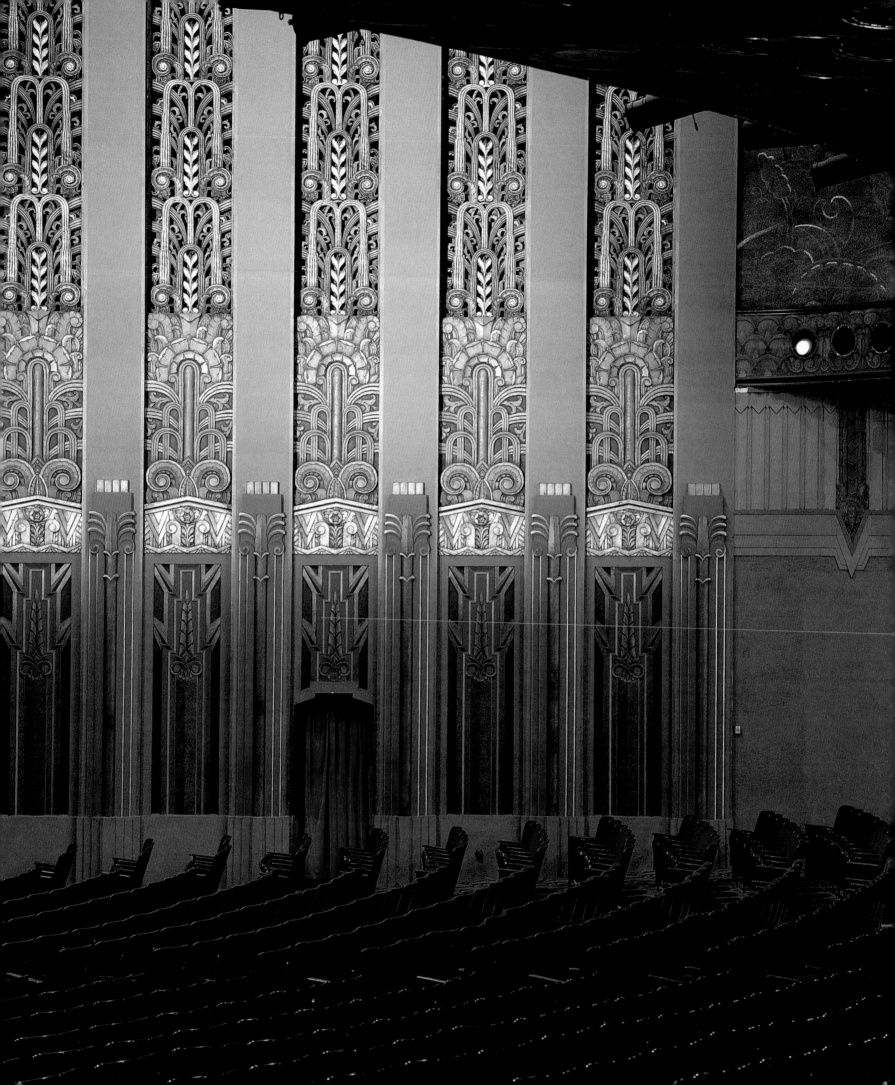

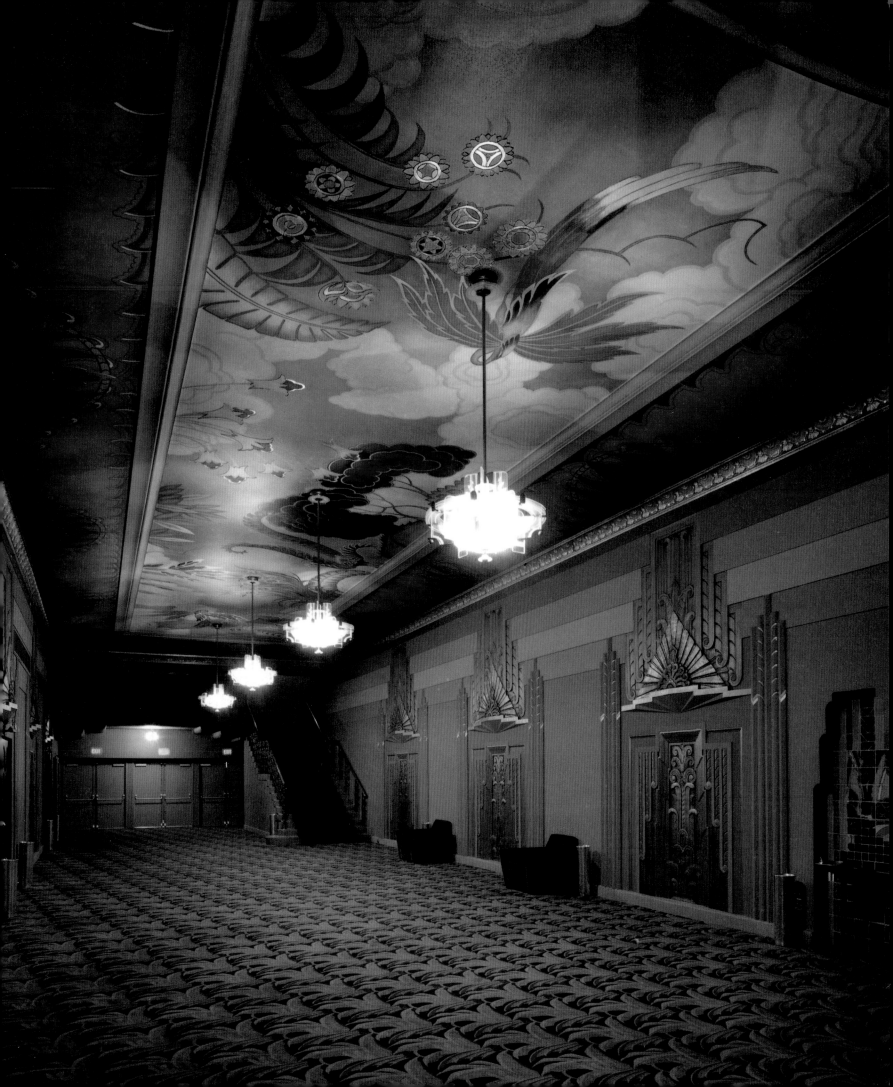

The auditorium and foyer of the Wiltern Theatre, Los Angeles, 1930, embodying the decorative excess of escapism which flourished in cinemas across America. Architect: G. Albert Lansburgh. The ceiling murals were by Anthony B. Heinsbergen, Los Angeles's most prolific muralist of the time. Latterly the theatre was saved from demolition, thanks to the efforts of the Los Angeles Conservancy.

(1929–30). The ceiling contains a violent discord of zig-zags and the decoration is unhindered by any convention, even those developed by Art Deco itself in its short history.

Cinema architecture had to match the modernity of the new talking pictures, but it also had to reflect the escapism of much of the content of the movies. Art Deco was the ideal style and it prospered in a type of building that rapidly permeated the whole country. Cinemas were both a barometer for the increasing popularity of the style as well as being agents for its promotion. As the dynamic of Art Deco shifted away from applied decoration towards modern yet still decorative forms of streamlining, cinema architecture also underwent a gradual transformation.

Magazines and advertising were also important agents of stylistic change. It was noted that 'half a dozen furniture, decorating and architectural magazines started the new year [1928] by presenting changes in format, covers, editorials or contents in the January editions, all obviously intended as a genuflection towards the modern.' It is no surprise that the driving force behind the new style in America was seen to be unrestrained capitalism. One commentator in the *Architectural Record* suggested that 'The characteristic American version of any movement is emphatically the commercial … That, for the moment, is the kernel of the Modernistic nut. Modernism gives a new slant, livens up the stock, shows that the dealer is no dead one, and may just prove a selling wow.' It is this very commercialism which was sneered at by the more politically radical Modernists, who objected to their design solutions being bastardized by overtly commercial artists and designers. In the eyes of the more puritan adherents of Modernism, this commercialism reduced the serious business of 'design' to little more than a whimsical fashion by adding flamboyant and unnecessary decoration.

Even those at the forefront of the commercialization of Art Deco, however, could acknowledge 'a new beauty', despite the doubts which accompanied the new style. 'There are many who honestly doubt the efficiency of the more exotic and fantastic of these exhibits as far as the selling of things is concerned,' claimed the chairman of the Art Directors Club of New York in his introduction to the Sixth Annual Exhibition of Advertising Art in 1927. 'They recall,' he continued, 'that there are large stratas of the public to whom modern art or any sophistication towards distortion or fantasy brings confusion.'[26] Abstract advertisements by European artists in the 1927 exhibition included those for Macy's by Leo Rackow, and for Steinway & Sons Pianos by Vladimir Bobritsky, and as the inter-war period progressed Art Deco advertisements continued in the USA, although they never matched the sophistication of Art Deco graphics in France, Holland and Italy. More common were literal representations of images of modernity, such as skyscrapers, aeroplanes and streamlined trains, which were used in American trademarks for products as diverse as coffee,

needles and shoes. Images of modernity were juxtaposed with anything that would fit, as the 1929 advertisement for GEC refrigerators shows;[27] the fridge is placed next to a futuristic cityscape reminiscent of the fantasies of Antonio Sant'Elia or Hugh Ferris.

The Paris Exposition had been an ephemeral event, at the close of which 'the proud national pavilions presenting a panorama of the arts, crafts and techniques of almost the entire civilised world [were] razed to the ground',[28] but the American stores, museums, magazines, movies and theatres continued in the spirit of the Exposition and helped incorporate its spectacle into a more permanent reality. Most aggressively permanent of all were the skyscrapers which multiplied rapidly in the downtown areas of cities across America. As well as inexorably transforming the skylines, they provided constant reminders of what the new style represented: power, prestige, luxury and glamour. Manhattan in the late 1920s was the venue of the ultimate sport for the nation's super-rich – the race was on to erect the world's tallest building. Walter Chrysler and his architect William Van Alen watched H. Craig Severance construct his 927 ft skyscraper at 40 Wall Street. Severance took the title temporarily before the opposition raised the 27-ton steel spire they had hidden within the Chrysler building and topped him at 1,048 ft.

In the cities of the Midwest and the West coast too, these buildings with their stylized façades and opulent interiors saw businessmen and their architects consistently ignore the distant voices of European Modernism, which advocated decorative restraint. Banks in particular were great patrons of Art Deco. The Second National Bank in Boston, Union Trust in Detroit and Title Guarantee and Trust in Los Angeles all erected skyscrapers with lavishly ornamented interiors. For these companies, which were the powerhouses of American modernity, ornament was functional. It signified success and confidence, not frivolity and whimsy, as Art Deco's critics in Europe had insisted.

In 1930, the same year as the Empire State Building was completed, Paul Frankl cast his mind back to 1925 and America's non-appearance at the Paris Exposition and saw that his adopted country had come a long way since her non-appearance at the Exposition. 'Five years have passed,' he wrote, '[and] today we find ourselves in the midst of a movement more active and significant than that ever experienced by any other nation.'[29]

In the American development of Art Deco, there was an important stylistic shift away from a French-inspired 'jazz age' or 'zig-zag' Art Deco characteristic of the skyscrapers of the late 1920s towards the streamlined 'Moderne' Art Deco of the 1930s. Skyscrapers were still built, but there is a world of difference between the Chrysler building and the obvious restraint of the PSFS (Philadelphia Savings Fund Society) building in Philadelphia, erected just one year later. In contrast to Chrysler, the directors of the Society were reluctant to go ahead with such an expensive project in times of economic uncertainty and so

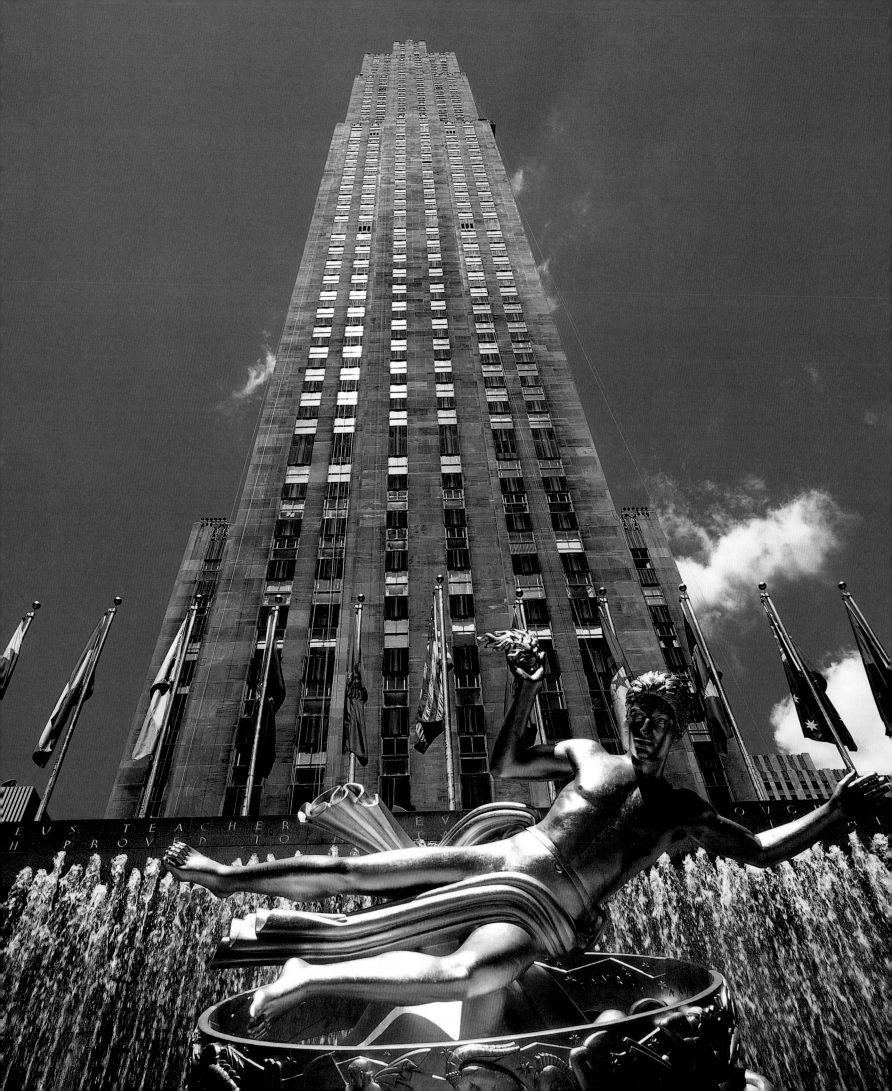

Above: Two perspectives by John Wenrich of the RCA Building in the Rockefeller Centre, New York, c.1931. By this date the ornate decoration of the preceding decade was deemed inappropriate, but the skyscrapers it had adorned continued to be built. American architects now needed to place greater emphasis on form as a decorative tool in their quest to represent modernity. Left: The statue of Prometheus at the foot of the RCA Building was executed by Paul Manship, c.1930.

decided to tone down its original design specifications. This stylistic change has often been associated with broader cultural change. The contrast between zig-zag and Moderne can be seen as one between opulence and austerity, luxury and utility, the decorative arts and industrial design, craftsmanship and mass production, or European influence and a quintessentially American interpretation of modernity.

In aesthetic terms, the evolution into the American Moderne centred around a gradual move away from applied ornament and patterning, a process which is clearly visible in both design and architecture. A glance at the work of interior designers, such as Kem Weber and Donald Deskey, shows that the change involved a rejection of the angularity of zig-zag patterning in favour of curved surfaces and uninterrupted smooth lines. While Weber's illustration of furniture for Barker Brothers of 1926–7 shows a repeated use of the angular skyscraper motif, by the early 1930s his furniture owed more to new streamlined forms of industrial design than the skyscraper. Most famously utilized by Frankl, the skyscraper motif had by 1932 been rejected by him as a 'passing fad': 'the tallest of them, the Empire State, is but the tombstone on the grave of an era that built it … Skyscrapers are monuments to the greedy.' At the same time, Deskey abandoned his wealthy private clients for large-scale manufacturers as the Depression continued. As the 1930s progressed, it was the steamship rather than the skyscraper that became the favoured symbol of modernity. The 1930s were the halcyon days of the great transatlantic ocean liners. *The Normandie*, *The France* and *L'Atlantique* of the French line and the *Queen Mary* from Cunard echoed the skyward competition of New York architects in the 1920s with the quest for the Blue Riband, the unofficial title held by the ship capable of the fastest Atlantic crossing. While the combination of speed, and on-board luxury offered a seamless continuation of the Art Deco ethic, the liner had other more austere connotations. Le Corbusier had looked to the liner in 1923 and found 'freedom from an age-long but contemptible enslavement to the past',[30] despite the fact that the aesthetics employed within were about as far away from Corbusian Modernism as it was possible to get. Nevertheless, the American industrial designer, Norman Bel Geddes, again chose to overlook the gaudy interiors of the steamships in favour of the horizontal simplicity of the exterior. In his book *Horizons* he insisted, 'aboard a ship, if you are observing, you have seen better modern architecture than you have ashore.'[31] It was clear that while luxury persisted at sea, designers and architects at home were aware of an economic upheaval in America which demanded a rethinking of modern decoration.

The relationship between the stock market crash in 1929, the following years of economic depression and the development of the Moderne style of Art Deco is regularly cited. Not only was the overt luxury of Art Deco deemed vulgar and inappropriate, as Frankl suggests, but economic reality hit the luxury decorative arts as much as any other field, forcing designers to address the needs of a

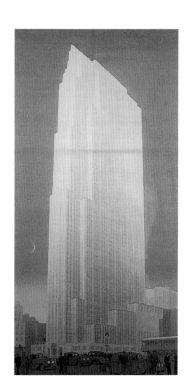

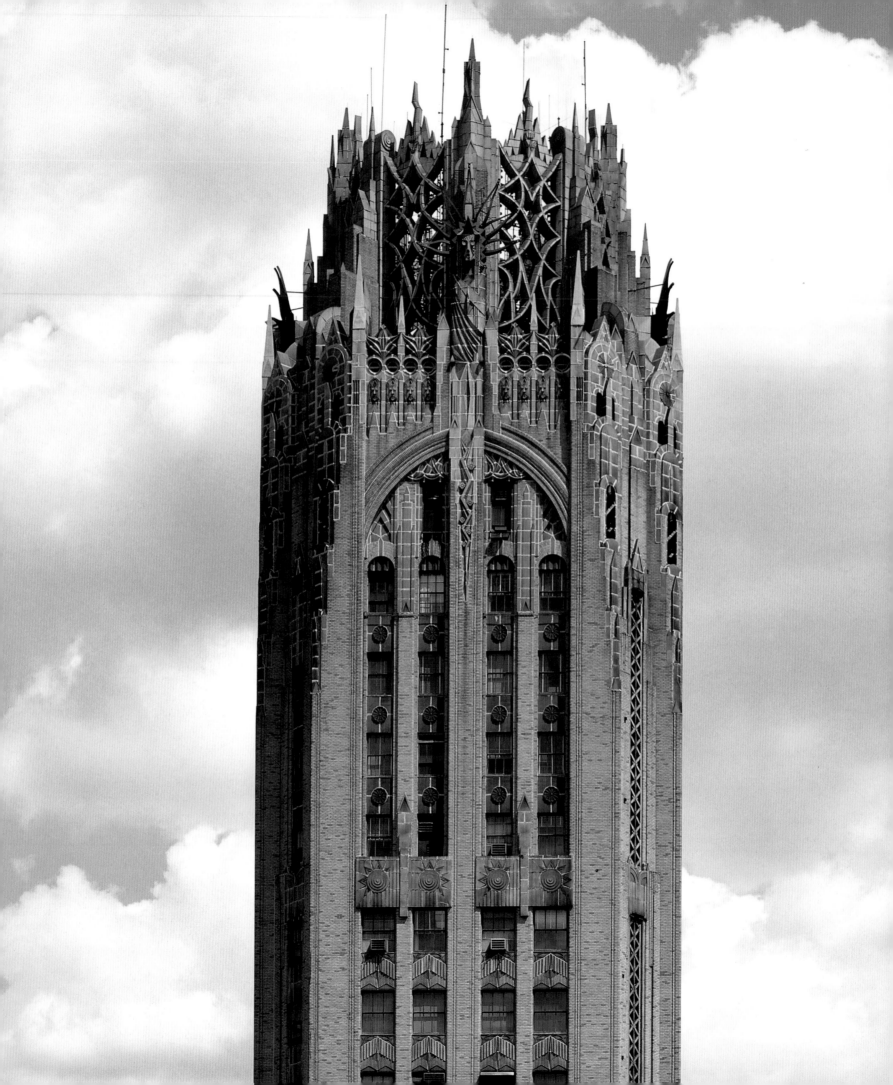

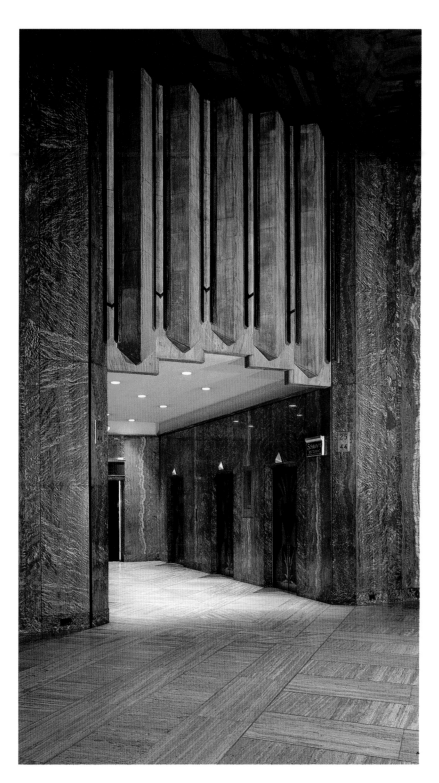

The original headquarters of RCA, 570 Lexington Avenue, New York, 1931. Architects: Cross & Cross. The building's neo-Gothic crown symbolized the radio waves and electric power of RCA.

The elevator lobby of the Chrysler Building, New York, 1929, its luxurious onyx-lined walls reminding users of the building that they were entering a latter-day temple of industrial wealth and power.

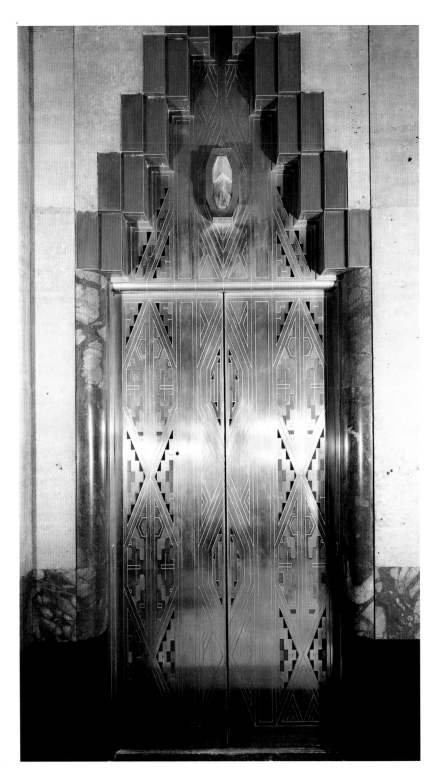

The elevator doors and surround in monel, Tiffany glass and Numidian red marble of the Union Trust Co. Building, Detroit, 1929, designed by Wirt Rowland in collaboration with Smith, Hinchman & Grylls Associates. Polychromatic schemes were integral to both the interior and exterior of many Art Deco buildings of the late 1920s.

The Empire State Building, New York, 1929–31, designed by Shreve, Lamb & Harmon. With its restrained ornament the Empire State Building represents a moment of transition in American Art Deco. It was rentable space rather than a shrine to a particular industrialist or company, so the overt expression of power and prestige through decoration was not required. Its height and bulk certainly caused such meanings, but the simplicity of its lines represented a distinct departure, as designers increasingly looked to the modern movement for aesthetic inspiration if not moral guidance.

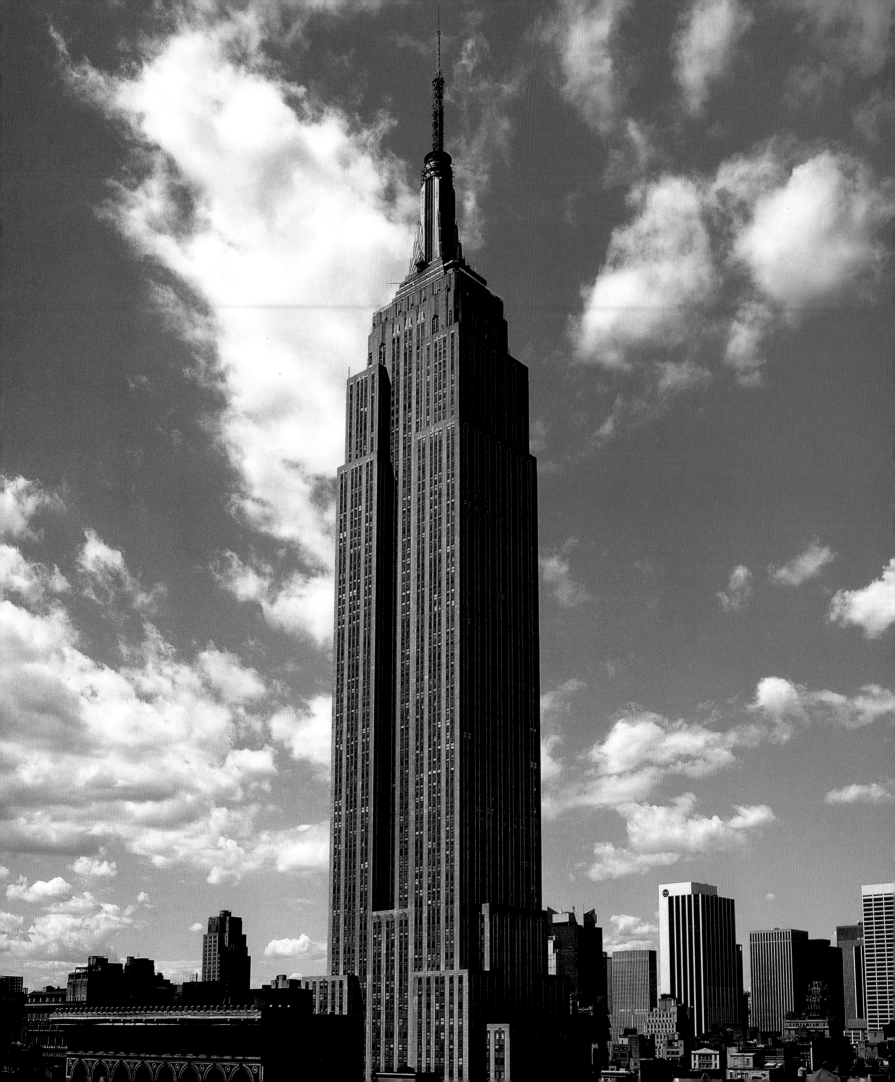

84

A Cunard publicity poster from the late
1930s showing the *Queen Mary* together
with the *Berengaria* and *Aquitania*.

broader population. Bel Geddes, described by David Gebhard as a 'Buck Rogers futurist', recognized the stylistic impact of the economic crisis, even if he couched it in more fundamental rhetoric. In 1932 he foresaw that:

> In the perspective of fifty years hence, the historian will detect in the decade of 1930–40 a period of tremendous significance. He will see it as a period of criticism, unrest and dissatisfaction to the point of delusion … Doubtless he will ponder that in the midst of a world-wide melancholy owing to an economic depression, a new age dawned with invigorating conceptions and the horizon lifted.[32]

According to such contemporary readings, it would seem that the futuristic treatments given to household appliances and vehicles by designers, such as Bel Geddes, Raymond Loewy and Walter Dorwin Teague, were the symbols of a new post-Depression age that aspired to an almost science fiction aesthetic. At the same time, a slightly less revolutionary stylistic evolution can be followed, which puts the importance of the Depression in its commercial and political context.

The early history of the industrial design profession, which collectively contributed so much to establish streamlined Moderne as the popular style for 1930s America, is well documented.[33] Bel Geddes and Walter Dorwin Teague both established their offices as early as 1926, with Raymond Loewy and Henry Dreyfuss following in 1929. These designers, together with many others, were employed by industry to redesign products for the post-Fordist American mass market. Certain designers had long relationships with corporations (notably Teague's with Kodak and Loewy's with Sears Roebuck), and they are often celebrated for their 'ability to resolve technical problems in terms of aesthetic form'. However, unlike the radical Modernists of the Bauhaus in 1920s Germany, whose ideas about art and industry these American industrial designers might at first appear to have been putting into practice, many of the new designers came from the commercial background of the advertising world and were well aware that their work was an important part of the marketing process. Loewy and Teague had been commercial illustrators before moving into three-dimensional design, and the designers' awareness of commercial pressures, and the tensions and compromises which accompany them, suggests the reasons for the spread of streamlining. In this respect the Depression did have direct aesthetic consequences. An instantly reduced market-place intensified competition and increased the attention paid by manufacturers to the appearance of a product. The designer Harold Van Doren went further. 'The truth is,' he argued:

> … much so-called streamlining is imposed on the designer by the necessity of obtaining low cost through high-speed production. What may thus appear to be a captious preference for voluptuous curves and bulging forms… proves to be one result of the evolution of fabricating methods and assembly-line techniques.[34]

Even Bel Geddes, who as more of an idealist than many of his fellow designers continued to lament the lack of visual awareness in industry, saw signs

Reverse painted Vitrolite panels
depicting Generation, Illumination,
Gas and Transmission on the Niagara
Mohawk Power Corporation Building,
West Syracuse, New York, c.1930–2, by
Bley & Lyman. The 'Illumination' panel
depicts the 'city of the future', a popular
image in advertising and decorative
painting during the inter-war years.

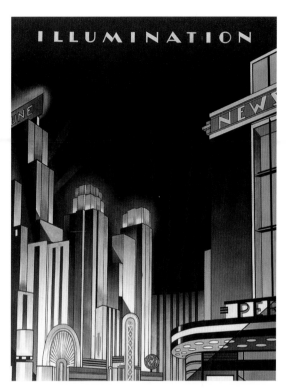

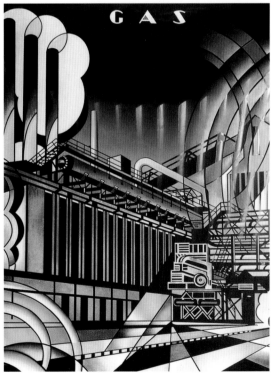

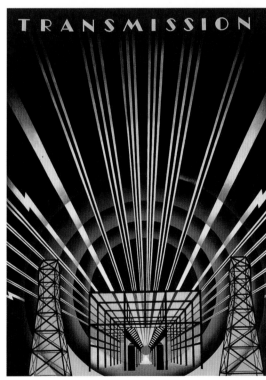

Bakelite bookends, c. 1930. Designer unknown. The new and often gaudy plastics produced in the 1930s were used in the manufacture of a never-ending range of domestic objects.

of progress. He was convinced that the consumer's cry of 'durable and cheap but look at it!' was having an effect on manufacturers. As *Fortune Magazine* observed in 1934, 'Furniture and textiles had long sold on their design. Now it was the turn of washing machines, furnaces, switchboards and locomotives.'[35]

It was because streamlining could be applied to cheap durables, and indeed cheap disposable products, that the Art Deco of 1930s America can lay claim to being a 'total style'. The aesthetic spread beyond the direct involvement of 'name' designers working for corporate giants and created a modern demotic idiom, which has been affectionately nicknamed 'Dime Store Deco',[36] including anything from cheap plastic jewellery upwards. Important factors enabling the spread of the Moderne style at all levels were advances in material technology and the economic availability of certain materials. Following the development of Bakelite in 1909, an increasing variety of brand-named plastics appeared on the market during the 1930s, such as Durez, Plaskon, Resinox and Catalin, 'the gaudy brother of Bakelite', creating new possibilities for cheap goods. Catalin's colourful durability made it a favoured material for jewellery, 'baby' radios and lamps, and the sculptural possibilities gave designers and manufacturers alike new freedoms. Now even the smallest detail could be 'designed', as a 1939 advertisement proclaiming the 'sculptural beauty' of a thermostat by Henry Dreyfuss suggests.

The vogue for chrome and tubular steel furnishing, central to the archetypal Moderne interior, was given an important impetus when, in the early 1930s, the price of steel dropped below that of wood.[37] Although many consumers were reluctant to embrace the novelty, and many established manufacturers were unwilling to embark on the expensive changes which metal production would entail, metal furniture was mass-produced for the popular market by such companies as the Royal Metal Manufacturing Co., who had showrooms in several cities, and whose 'Royalchrome' line was available by mail order in the Sears Roebuck catalogue. Indeed, the significance of the Sears Roebuck catalogue in bringing modernity to even the most remote parts of America should be noted. In his autobiography, *A Childhood*, describing life in rural Georgia in the 1930s, the novelist Harry Crews recounts how:

> The Sears Roebuck catalogue was much better used as a Wish Book, which it was called by the people out in the country, who would never be able to afford anything out of it, but could at their leisure spend hours dreaming over … The Federal Government ought to strike a medal out to the Sears Roebuck company for sending out all those catalogues to farming families, for bringing all that colour and all that mystery and all that beauty into the lives of country people.[38]

Along with steel, the other characteristic material of the Moderne style, in interiors and architecture, was glass. Vitrolite was a new form of colourful structural glass which was widely used in modern kitchens and bathrooms and was sold with its 'glistening, reflective [and] sanitary' qualities in mind. 'Build with glass today!'[39] proclaimed the advertisements.

Advertisement for Vitrolite and Vitrolux. New materials played an important role in the development of the 'Moderne' aesthetic in the early 1930s.

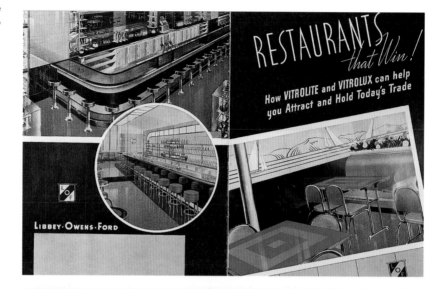

Chrome and tubular steel furnishing in Harry's New York Bar, Chicago, 1935. Even by the mid-1930s the Moderne look still retained a popular association with the sophisticated metropolis.

Although the motives of the companies employing industrial designers might not have met with the approval of the utopian Modernist pioneers of Europe, the question of European influence remains an important one. The rhetoric of industrial designers emphasized a belief in 'good design' and functionality shared with the European Modernists. Bel Geddes was even likened to Le Corbusier: 'His book *Horizons*, lies on many an important desk in Detroit and in Wall Street. The book pictures the Parthenon cheek by jowl with grain elevators. In 1921 Corbusier, the architect, did the same in his book, but not many industrialists have read Corbusier.'[40] In aesthetic terms there are also similarities suggesting direct influence. For instance, the countless models of Moderne tubular steel chairs on the market in America in the 1930s owe much to the Bauhaus furniture designer Marcel Breuer's prototype, and there is often only a hazy line to be drawn between Moderne Art Deco domestic architecture and some of the more flamboyant buildings by professed Modernist architects.

Butler Mansion in Des Moines, Iowa, designed by George Kraetsch (1936) was presented as the archetypal functionalist house (see page 103). It was the General Electric House of the future; constructed of reinforced concrete it claimed to be fire-proof, earthquake-proof, termite-proof and tornado-proof. Inside it bristled with mod. cons. But despite drawing on the aesthetic of the European Modern movement, its very form remains decorative. Its cylindrical tower with 'nautical deck railing', the 'speed lines' running around its upper edges all contribute to an evocation of the modern spirit which goes beyond the requirements of functionalism and into the realms of representation, which is after all a hallmark of Art Deco as a decorative response to modernity.

However, it is the commercialization of the Moderne style, and its departure from pure Modernist theory, which set it apart in the minds of many critics. 'The Bauhaus was closed about the same time the streamline mania began,' wrote John McArthur, a Modernist sympathizer at the Museum of Modern Art, 'and it would have rejected the streamlined typeform for objects such as cocktail shakers and fountain pens where its use is nonsense.' To blame a designer like Bel Geddes for all of these 'evils' is perhaps unfair, considering he was 'often embarrassed by being called the father of streamlining, especially when such bastards as streamlined stoves are laid at his door by trade-paper editors.'[41] Nevertheless, McArthur was unrepentant in his condemnation of the whole episode, adding that, 'Typical Bauhaus designs, whether for chairs, lighting fixtures, or ash trays, are free from both modernistic and streamlined aberrations; sound Bauhaus training would not permit them.'[42] What McArthur chose not to see was that often Bauhaus designs were as much representations of modernity as Moderne Art Deco. The historian John Heskett has cited Gropius's Adler automobile which was advertised as the model of functionalism, 'harmonizing the form of its external appearance with the logic of its technical function.' According to Heskett:

Thermos bottle and tray by Henry Dreyfuss, c. 1930, in enamelled and chromium-plated glass. Many objects were streamlined for purely aesthetic reasons. This functionalist 'look' had more to do with a visual association with modernity than ergonomics.

… the choice of geometric form as most suitable for automobiles stemmed from Gropius's particular artistic theory of the form suitable to technology, not from the technology itself. In fact it directly contradicted contemporary technical concepts of form such as streamlining. Gropius's design for the body-work of the Adler, a hand built luxury automobile, was therefore symbolic of function … rather than its direct expression.

To understand Moderne as a parallel representation of the machine age, we must return to the commercial roots of the industrial designer. Bel Geddes proclaimed that the new designers 'perceive that the person who uses the machine must be imbued with the spirit of the machine and comprehend the machine.' Yet most of the appliances and machines which commanded the attention of the industrial designers were actually invented and on the market before 1925, and the designer's role was thus 'the conservative one of modernising appearance without deeply changing function'. If the Art Deco of the 1920s was a decorative response to the pressures and opportunities of modernity, then its evolution into American Moderne can be seen as a development of this pragmatic approach. The curved, almost organic aesthetic of the 'machine age' was in fact a stylistic device to minimize fear and suspicion of the machine as much as a revolutionary expression of speed. Bel Geddes justified streamlining his vehicles by likening them to the natural form of a falling drop of liquid; streamlining 'eliminates disturbances in the media through which [the vehicles] pass'. There was no aerodynamic need for streamlined food mixers or scales, but perhaps the shapes eliminated other 'disturbances'; certainly, many of the streamlined designs of the 1930s are exercises in concealment. Thus Raymond Loewy's famed 'Coldspot' refrigerator, designed in 1935, encased previously exposed mechanisms in a smooth, plain, white enamel case; 'the disturbing implications of a new machined Nature were pacified by the suggestion of familiar shapes and surfaces; its changes would be benign, conflict free … neatly self contained.'[43]

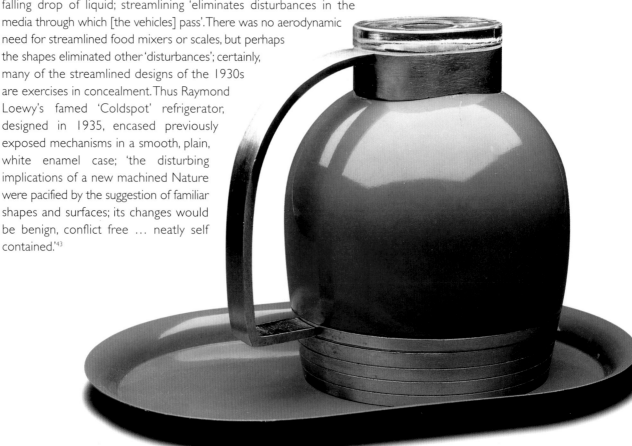

So despite the aesthetic changes from zig-zag to Moderne, parallels in meaning can be seen to continue. When the issues of economic nationalism and national identity are considered, American Moderne and French Art Deco can be seen as two manifestations of popular modernism. The backdrop of French economic nervousness and the search for the expression of French modern identity through the decorative arts have been emphasized, and similar arguments could be applied to the evolution in the USA of zig-zag Art Deco into Moderne in the 1930s. While French worries, dating from before World War I, were based in the perception of the burgeoning industrial and artistic capacity of Germany as a major threat to France's political and economic position in Europe, America's problems were those of a new nation. Indeed, it has been suggested that a primary need was to establish a cohesive sense of national identity in a nation of multi-racial and multi-cultural immigrants: 'They could identify themselves as Americans only if they had an idea what American-ness was ... Great efforts were therefore made to establish an American ideal with which all races and creeds could identify.'[44] In 1933, Hazel Kyrk attempted to encapsulate what it meant to be American when she wrote:

> 'Americanisation', it is quite frankly said at times, means inculcation of our passion for hot water, large and numerous towels, soaps, baths and other cleansing agents. The physical comfort motive shows itself in the widespread systems of central heating, electric fans, refrigeration and easy chairs.

Although it is presumptuous to suggest that America was struggling for an identity before Moderne Art Deco evolved, one of the explanations for the advent of streamlining and the dominance of an increasingly pure, white aesthetic, can nevertheless be traced to notions of hygiene and modernity which were increasingly identified as quintessentially American. In an article about the American house, the contemporary critic and historian Lewis Mumford claimed that the model for designers to aspire to 'is to be found in the modern hospital',[45] while Henry Dreyfuss preferred the word 'cleanlining' to describe his designs.[46]

The political and social function of Moderne Art Deco came to the fore in the succession of World's Fairs held in America during the 1930s. These grandiose events were part of the same tradition as the 1925 Paris Exposition, with even less well-disguised aims of social propaganda. The 1933 Century of Progress Fair held in Chicago had as its mottos the almost Orwellian 'Advancement through Technology' and 'The Growth of Science and Industry' – slogans which government and industry alike hoped would be the rallying cries to lead America out of the Depression. Walter Dorwin Teague, Chairman of the Committee which organized the New York World's Fair of 1939–40, was surprisingly frank when describing the themes of the Fair. According to Teague, competition between exhibiting firms was largely absent, leaving 'the great new industries of America [to] state the case for the democratic system of individual enterprise'.[47] Indeed, it seems appropriate that, in an age of ideologies, 'the major emphasis is on the

system under which our present standard of living has been made possible.'[48] Teague was proud to proclaim that, 'For the first time in the history of expositions we shall see great companies banding together to tell a common story, proudly marking the milestones of industrial progress, asserting present triumphs, and projecting future plans possible under democracy.'[49]

America had been holding international trade fairs since the nineteenth century; until the 1930s the most notable had been the 1904 Fair held in St Louis, which had seen Olbrich's display introduce the Wiener Werkstätte to America. The first major fair in the Art Deco era was held in Philadelphia to celebrate the 150th anniversary of Independence in 1926. As well as providing a platform for European modern decorative arts (the Wiener Werkstätte was once more among the exhibitors), it also celebrated the progress of modernity with an experimental 'all electric house'. Although the fair was not a great commercial success, it is memorable architecturally for its 200-ft tall 'Tower of Light', with its curvilinear supports, set-back structure and sun-rise motif bas-reliefs providing an Art Deco shell for its revolving colour lights and silver light beams which lit the fairground every evening.

In the decade before the great New York and San Francisco World's Fairs of 1939, there were numerous expositions across America, including San Diego (1935) and Cleveland and Texas (both 1936); however, the largest and most significant before 1939 was Chicago's 'A Century of Progress', held in 1933–4. Architecturally, the pavilions reveal the development of Art Deco from the zig-zag to the Moderne. The angular protrusions of the Travel and Transport Building exhibit little of the streamlined modernity which was to prevail in the 1930s, while the Court of the Hall of Science appears somewhat transitional; its geometric ornament recalls the work of Mallet-Stevens, even Hoffmann, yet its form, largely horizontal with a single vertical tower, points to future trends. The building has on its tower the three speedlines characteristic of the Moderne style, but they are still angular rather than curved. The three pavilions of the GEC group suggest a more austere yet curvilinear version of Modernism, while Raymond Hood's Electrical Building combines increasingly curved horizontal forms with stylized relief murals.

The futuristic nature of the streamlined aesthetic was suggested more overtly in some of the exhibits. The major 'amusement attraction', a skyride 600 ft over a lagoon in mock 'Rocket Cars', had strong science fiction overtones, and there was even a Buck Rogers exhibit. According to Clarence W. Farmer, an assistant director of the exposition, 'the design of the buildings and grounds … necessitated the development of an entirely new grammar of architectural expression.' The increasing simplicity and declining use of decoration in the Art Deco style were alluded to when Farmer observed that 'the departure from classical architectural forms and decoration in the buildings permitted the use of simple structural forms without ornamentation.'[50] Promoting the technological

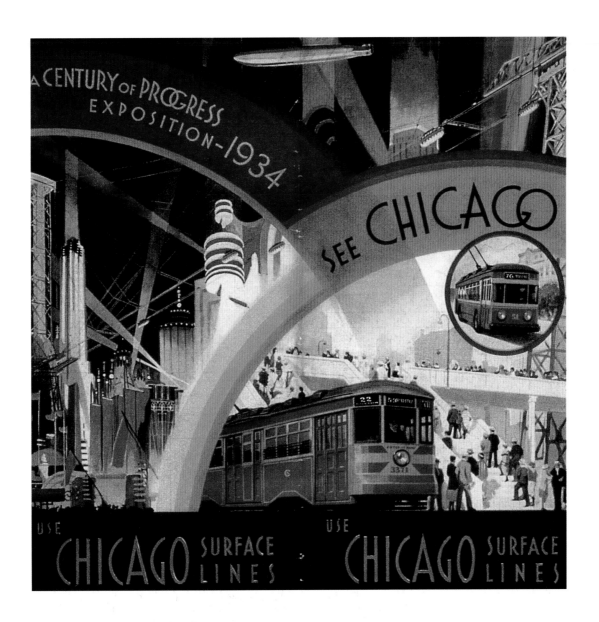

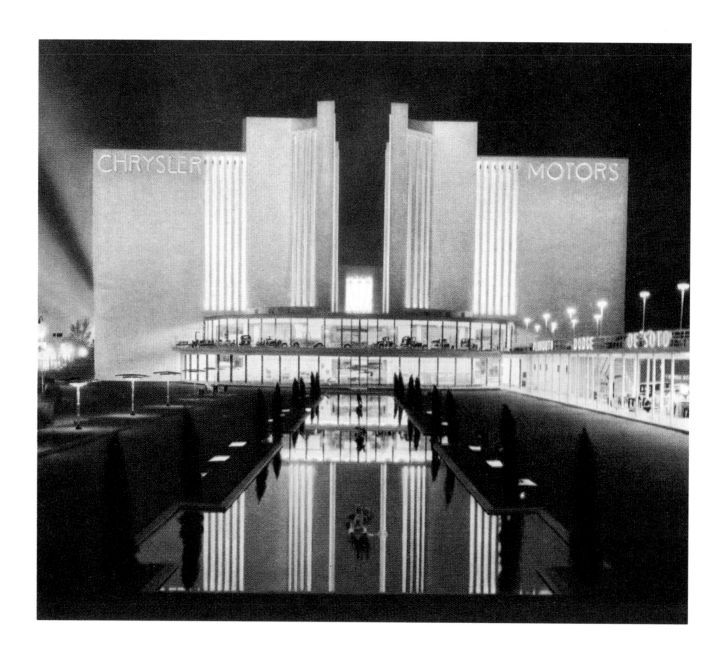

The Chrysler Corporation Pavilion at the Century of Progress Exposition, Chicago, 1933–4, designed by the Chicago architects John A. Holabird and John Wellborn Root, Jr. The recesses in the façade were in shadow by day and provided bright lines of light by night. Each recess was lit by two 1000-watt lamps.

revolution as an antidote to the Depression was a tactic eagerly pursued by firms competing in the Depression-era market, and 'A Century of Progress' saw manufacturers emphasizing the potential for new building materials for the home. There was a house of sheet metal on display, while the Owens Illinois Glass Co. promoted translucent glass bricks, a material later to be widely used in 1930s Moderne architecture, in its own model home.

Despite the futuristic references the title suggests, the exposition was essentially a celebration of past achievement. By contrast, the New York World's Fair of 1939–40 was 'The World's Greatest Show-case' for 'The World of Tomorrow'. Ostensibly held to celebrate the 150th anniversary of the inauguration of George Washington as President, the $155 million Fair was held on a 1,216-acre site in Flushing Meadows, Queens. Attracting 45 million visitors over a nine-month period, it was the extravagant culmination of the Art Deco era in America. Its size and international significance rivalled that of the Paris Exposition of 1925, and a comparison of the two exhibitions reveals the transatlantic shift in the development of Art Deco during the intervening period, as well as the stylistic change which had taken place over those fourteen years. In many ways, the New York World's Fair was as eclectic as Paris, with giant cash registers and typewriters resplendent on top of the buildings of two of the commercial pavilions, and its 'countless experimentalism in new forms, some successful, some merely bizarre, but all liberating in their final effect'. Yet the dominant aesthetic in 1939 was a curvilinear, streamlined Art Deco, typified in monumental form by the Trylon and Perisphere; this 699-ft tall tower was connected by a walkway to a sphere 180 ft in diameter, dubbed 'the neatest trick in steel history' by Teague.[51] The World's Fair phenomenon reached beyond the millions who visited the site through a whole range of mass-produced memorabilia which turned the Trylon and Perisphere into the final hallmark of inter-war Art Deco. The President's wife set the tone at the opening ceremony, with her dress covered with tiny Trylons and Perispheres, and by 1940 around 900 companies across the world had been licensed to sell World's Fair memorabilia, ranging from Japanese Genies' lamps to Trylon and Perisphere dining furniture.

Given the importance afforded to transport in the Fair, it is significant that the three automobile giants, Ford, Chrysler and General Motors, all built Moderne buildings designed respectively by Teague, Loewy and Bel Geddes, with characteristic curved planes and sans serif lettering. In his display of transportation of the future, Raymond Loewy gave futuristic streamlining treatment to taxis, liners, trucks and cars, as well as his vision of a New York–London rocket service. Meanwhile, Albert Kahn and Norman Bel Geddes' 'Futurama' for General Motors involved a fifteen-minute journey to 1960 and a world of cities linked by seven-lane arterial highways. This futuristic theme was captured in George Gershwin's World Fair song 'Dawn of a new Day', and Henry Dreyfuss's 'Democracity'

The New York World's Fair, 1939, is celebrated on the cover of British Vogue. The Statue of Liberty is receiving a new crown made of a series of trilons and perispheres.

96

Official guidebook to the Golden Gate International Exposition, San Francisco, 1939.

Diorama inside the Perisphere; visitors to the 'Futurama' emerged wearing a badge proclaiming 'I've seen the future!'

The architecture of the 1939–40 World's Fair typifies the *laissez-faire* attitude to Modernism which was especially characteristic of American versions of Art Deco, and because of this complex diversity it is worth reflecting on the specifically architectural evolution of the style. As we have seen earlier, American architecture of the inter-war period presents an incredibly rich and varied set of responses to the challenges of modernity, largely free from the ideological dogma that accompanied European Modernism. The architectural historian David Gebhard has isolated three broad trends within American Art Deco architecture: zig-zag and Moderne we have already encountered, and to these Gebhard adds 'PWA [Public Works Administration] Art Deco'. This was stylized classicism used in the public architecture of Roosevelt's New Deal in the 1930s, which was reminiscent of the Swedish and Italian pavilions at the 1925 Paris Exposition and partly related to the 'monumental' trend in contemporary European, particularly totalitarian, architecture.

These three broad Art Deco idioms accounted for most of what was considered 'modern' architecture in America in the inter-war period. It is thus hardly surprising that the American architectural press placed less emphasis on the distinction between Modernism and the 'modernistic' than was in evidence in many European architectural journals. Indeed, it at first seems ironic that the country whose architectural and industrial forms had so enchanted Le Corbusier should have produced forms of visual modernity which were the embodiment of what many European Modernists rejected in 'modernistic' design. The idea of a European Modern movement united by its credo of austere functionality is, however, a myth that is often betrayed by the inevitably luxurious nature of the commissions many of the European pioneers received. When the Modern movement strayed – as it frequently did – from its apparently firmly established ideological path, the conflict between Modernism and Art Deco, and correspondingly between design and the decorative arts, seems less clear-cut. Can functionalism be purely functional if it is unashamedly élitist? In *The Heroic Period of Modern Architecture*, Peter and Alison Smithson complained that:

> No one has properly observed a quite definite special sub-category of modern architecture. An architecture of the enjoyment of luxury materials, of the well made, of the high finish. It is special to Mies and occasional to Le Corbusier and Gropius. It has a shameless banker's luxuriousness about materials and a passion for perfection in detail which is obvious in the Barcelona Pavilion.

Judged purely in aesthetic terms, Mies's German pavilion at the 1929 Barcelona Exhibition, briefly erected before being prematurely dismantled, can be seen to be ultra-modern, yet ideologically it shares much with the more flamboyant contemporary French and American decorative arts. Moreover, if one considers Le Corbusier's use of Ralph T. Walker's Barclay-Vesey building

Face-powder compact commemorating the New York World's Fair, 1939, in blue and orange enamelled metal, the official colours of the fair.

98

(1923) on the cover of the first English-language edition of *Towards a New Architecture*, it suggests that Walker's vocabulary of geometric sculpture, reliefs and murals, combined with an austerity of scale in the elevation, at least shares a spirit of modernity with Le Corbusier.

While, from the American perspective, the development of radical European Modernism remained a relatively distant phenomenon, the evolution of a style of decoration suitable for modern architecture was a major feature of American debates about architectural aesthetics. It was this continuation of the tradition of modern decoration which characterized zig-zag Art Deco architecture. In an address to the Producer's Council at the end of 1927, Walker, by now a partner in the firm Voorhees, Gmelin & Walker, set out a vision of modern architectural decoration to accompany the new technologies of building:

Graybar Building, New York, 1927, by Sloan & Robertson.

> We will not use a material with infinite and unknown possibilities in a mentally lazy imitation of another material with known limitations, as is the case today with new methods, each striving strenuously to slavishly imitate one already known. Our walls then will not be decorated to look like something else, but will have their own pattern and colour which will furnish comfort, repose and beauty to man's needs.[52]

The key to the new decoration was to be the extensive use of pattern and colour. Walker argued that 'Simplicity cannot help but breed monotony, because it sustains no mental interest.' This was hardly surprising given that 'thought and art and civilization had been bred in the study and the making of patterns'. As early as 1926, the colourist Léon V. Solon, who collaborated with Ely Kahn on 2 Park Avenue, and with Lee Lawrie on the sculptures at the entrance of the RCA building,[53] had recognized the need for a 'new decoration'. It was obvious to Solon that neither of the 'two main directions' in architectural decoration – the classical mode, whose purpose was 'to accentuate structural articulation and to beautify features which are not providing vital supporting functions', and the Gothic mode in which 'embellishments of the surface and elaboration of silhouette are the designer's fundamental considerations' – were suitable for modern architecture with its 'fascination of apparently monolithic mass':

> In the Modernist manner we detect a tendency to regard a major structural area as the unit of space to be decorated. This will necessitate a revision of ornamental technique … With towering masses demanding an ornamental scale adjusted to large areas and long range effectiveness … It will be necessary to devise a technique in ornament which has the capacity for a new decorative emphasis and for long range visibility … There seems little doubt that polychromy will provide the logical solution of the decorative problem, and the uncompromising premises which must necessarily control the manner of its application will produce a technique without precedent.

The coverage of the new Graybar Building in New York in the American architectural press in 1927 presents a case study in the blurring of definitions. The thirty-four-storey skyscraper designed by architects Sloan & Robertson was built on a plot of over 1.5 acres; rising 400 ft above the street and descending 89 ft underground, it held the temporary honour of being the world's largest skyscraper. Moreover, the building featured street-level façades and entrance hallways which would today be labelled Art Deco without hesitation. The main entrance façade provides an eclectic clash of features, from the decorative hanging lamps and Art Nouveau-inspired lettering to stylized low-relief figures. Above three geometrically-patterned limestone grilles is the flagstaff, ornamented in bronze and coloured terracotta. The exotic nature of these features was praised: 'The terracotta extends on either side forming a broad band between the piers. This band together with stone grilles below and the bronze grilles at either side are executed in an excellent Moorish pattern.'[54] The sculpted low-relief figures to either side, executed by John Donnelly, represent *Transport* and *Electricity*, 'symbols of the twin forces responsible for the creation of the building'. Similar figures over the north and south entrances represent the four elements, *Earth*, *Air*, *Fire* and *Water*.

Despite such apparent decorative excess, it was argued that Sloan & Robertson belonged to a group of architects who 'recognise the futility of draping exteriors with old shop-worn forms'. Indeed, the fact that the decoration stopped after four floors impressed the *Architectural Record*'s correspondent: 'The building above these features towers its 30 storeys unadorned. The restraining hand of the designer has mercifully spared us the order, the pediment, the cornice and the cartouche, without which a decade or two ago, no building was complete.' The contrast was intended to highlight the perceived absurdity of the Gothic skyscraper:

> Although we have discarded the stagecoach as a means of locomotion [and] men have laid aside powdered wigs and lace sleeves … many well known architects who eagerly accept modern equipment still cling to an architectural style which has long prevailed, serving its purpose well enough before the dawning of the day of the skyscraper.

The inappropriateness which 'the purist' might ascribe to classic, Romanesque and Moorish decoration in one elevation of the building was acknowledged, but this was considered no reason why the building should not be considered modern: *The evidence of freedom in the mind of the designer … is of greater significance … An open mind and a fearless attitude towards the God of Convention is perhaps the designer's best asset when he attacks the problem of supplying proper architectural clothing for the tall office building.*

Joseph Urban's Ziegfeld Theatre in New York, which opened in the same year as the Graybar Building (but was demolished in 1966), further showed how decoration could be deemed to be 'appropriate' in a modern context. At the same time, a less successful attempt could be vilified. Ely Kahn described how another, un-named, theatre in New York opened around the same time as Urban's, in which:

The upper mezzanine of the Music Hall in the Kansas City Municipal Auditorium, Joseph Murphy for Gentry, Voskamp & Neville, with Hoit, Price & Balker. This was Public Works Administration project 954, begun in 1934. The murals were painted in 1936 by Walter Alexander Bailey.

… full expression is given to the assumed evil taste of the New York public. The building is loaded with meaningless ornament produced quite obviously to startle the audience with a display of cardboard magnificence. The Ziegfeld Theory apparently, is that the kind of architecture that theatre owners have produced for some years past is not necessarily the final word in design. The pathetic Adamesque creations, the Italian palaces in the latest interior decorator manner, need not be a steady diet. The Ziegfeld building cannot be labelled historically so it will be fitting to say that it is modern in conception.

Perhaps the most fascinating example of Solon's ideas about polychromy in architecture can be found in Ely Kahn's building at 2 Park Avenue (1927) in New York City. Solon himself gave Kahn's highly decorative polychrome treatment of the façade, in red, black, ochre and blue-green, the ultimate modernist accolade; unlike the architects of past periods, who 'absorbed dominant influences in a state of passive receptivity', giving the critic 'little reason to believe that systematic analytical activity was incidental to the assimilative process', Kahn's approach was logical. Kahn styled even the smallest detail from the light fittings to the US Mail box in an outer wall of the building. Solon celebrated 'the Modernistic feeling [which] has actuated the creation of every detail', as well as 'the ornamental principle [which] has controlled practically all composition of plastic features.'[55] It was this use of decoration, ziggurats, stylized sculptural detail, reliefs, polychromy and murals which characterized zig-zag Art Deco. However, as we have seen, the style evolved into a less overtly decorative yet equally flamboyant idiom throughout the 1930s.

The dividing line between zig-zag and Moderne was by no means clear, as is demonstrated by the buildings at 'A Century of Progress' in 1933. However, it is broadly true to say that the stylistic shift also represents a geographical one away from the urban to the suburban, and in particular from the big cities of the north-east. If a brief survey of zig-zag Art Deco inevitably leads to New York, then the same process applied to Moderne takes us to Los Angeles and its environs. Moderne was closer to the aesthetic of pioneer European Modernism and further from the angular decorative excess of 1925. Architecturally, the style was applied on a much smaller scale than zig-zag and PWA Art Deco. Moderne was applied to houses, motels, cinemas, service stations and small stores, rather than gargantuan office developments and apartment blocks, and its form tended to be horizontal and curvilinear rather than vertical and angular.

The importance of industrial design, even in Moderne architecture, cannot be understated; after all, it was Norman Bel Geddes who provided an American manifesto for the modern home in his book *Horizons* of 1932. Bel Geddes reiterates the litany of space, health and light, characteristic of Le Corbusier, Gropius and their disciples:

The beauty of the modern dwelling is the logical result of emphasis upon its functional values. Open walls let in an abundance of sunshine and light which are

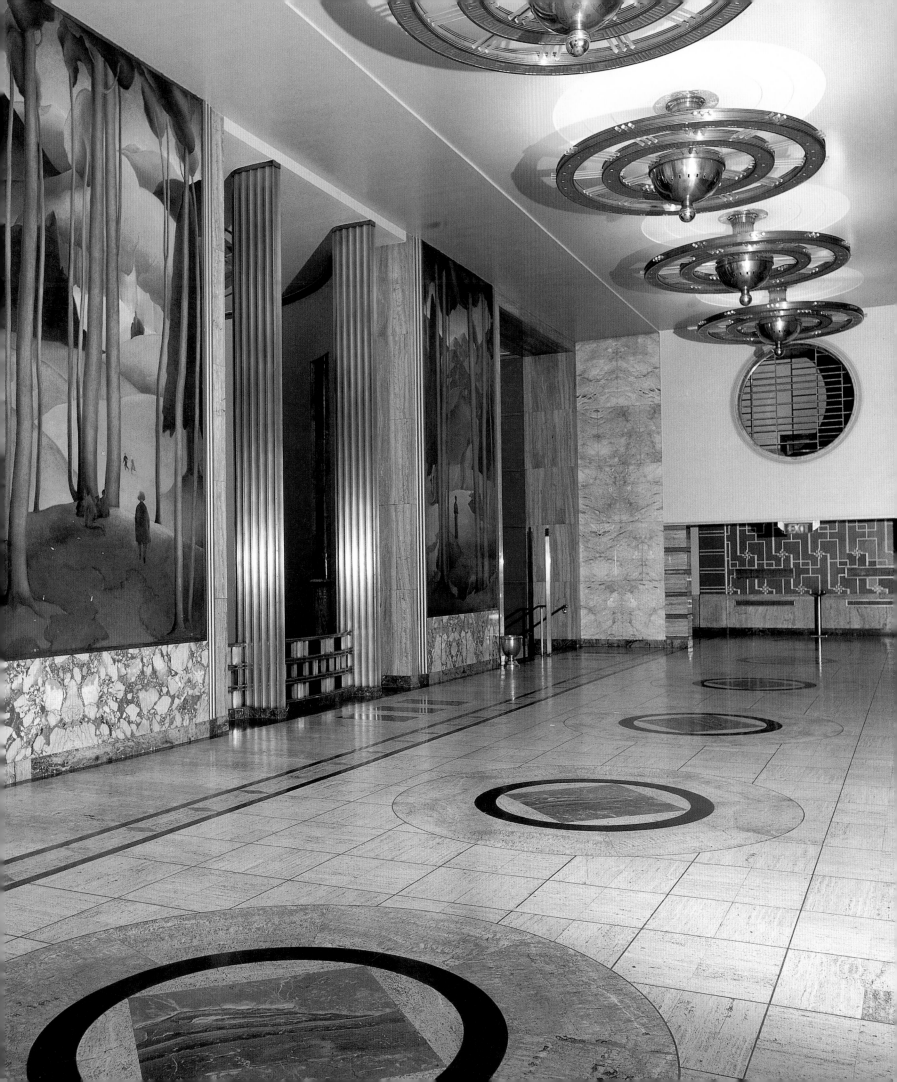

The Paramount Theatre, Aurora, Illinois, 1929–31, by George and C. W. Rapp. Built on the banks of the Fox River, the building was updated in 1977–8 and continues to be used as a cinema.

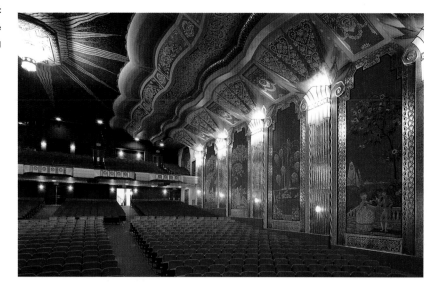

both physical and spiritual assets. The successful structure typifies the buoyancy of life. It's clearly defined, simple forms are devoid of imitation and false show, and there is a harmony of proportion between all the parts.[56]

In reality, few Modern movement buildings were built in America in the inter-war period; those that were, by architects such as Richard Neutra and Rudolph Schindler, were to be found in California. Even those architects who embraced the International style were also attracted to streamlining; Schindler in particular has been characterized as a 'maverick' who worked in a number of styles.[57] Most Moderne buildings were constructed of stucco, steel and glass, and were suited to the favourable climates of the south and west; subsequently both Florida and California were the most fertile states for architects working in this style.

Los Angeles in the 1930s was portrayed as representing the innovative heart of the American spirit, a new city which was growing despite the Depression. The city's growth was largely suburban and thus centred around the automobile, and the use of Moderne as the new architecture of the highways was deemed appropriate to represent the ideal of speed central to the iconography of the modern age. In 1928, Paul Frankl had stated that 'the conquest of space will be symbolized in aesthetics through the horizontal line, the expression of speed and our time', and the accuracy of this prediction meant that the suburban or roadside skyscraper remained a rarity.[58] His prophecy began to be realized in 1934, when Walter Dorwin Teague won the contract to redesign all America's Texaco service stations. Teague designed five standard buildings, which were reproduced 10,000 times across the country. Their sleek stucco overhangs, red speed lines and luxury tiled rest-rooms created for Texaco an unrivalled corporate identity, while giving streamlined Art Deco an unprecedented presence in small towns all over America. The Greyhound Bus Company also adopted streamlining, for both their

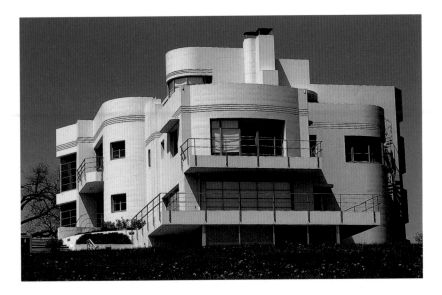

Built as the General Electric House of the Future, this house at 2633 Fleur Drive, Des Moines, Iowa, was designed in 1936 by George Kraetsch. It is the embodiment of the American Moderne Art Deco idiom which evolved in the 1930s. Designers used the functionalist 'look' to create forms which remained decorative.

buses and terminals. Many were designed by the Louisville architect W.S. Arrasmith and their use of vitrolite tiling, glass bricks and neon signing helped to establish Moderne as an integral part of downtown America.

In the popular imagination, streamlining was the architecture of luxurious leisure: the ocean liner, the hotel and the night-club. Hollywood played an important role in promoting this perception of the Moderne, arguably at the expense of portraying it as a viable domestic style for the majority of the population. A succession of films starring Fred Astaire and Ginger Rogers used streamlining in a luxury entertainment context. A Moderne hotel provided the setting for *The Gay Divorcee* (1934), *Swing Time* (1936) was set in a night-club, while *Shall We Dance* (1937) utilized the black and white streamlining of an ocean liner. Hollywood confirmed the élitist credentials of Moderne, distancing it still further from the utopian ideal of Bel Geddes and his European mentors. As with the initial explosion of zig-zag Art Deco in the 1920s, the transition towards the Moderne is also reflected in the architecture of the cinemas in which these films were screened. The most celebrated are those by the architects Liebenerg and Kaplan who designed over 200 cinemas across the Midwest during the 1930s. The sweeping horizontal curves of Jack Liebenerg's designs were often punctured with an appropriately sleek tower (reminiscent of Mallet-Stevens' 1925 Tourism Tower) which brought the glamour of the steamship style to even the most landlocked states of America.

Robert Vincent Derah's 1936 Coca Cola Bottling Plant in Los Angeles and the Aquatic Park Casino in San Francisco (now the National Maritime Museum) are two of the most literal interpretations of the ocean liner theme, with their port-hole windows and ship's railing detail, while the now famous Art Deco district of Miami Beach was home to a number of distinctive streamlined hotels,

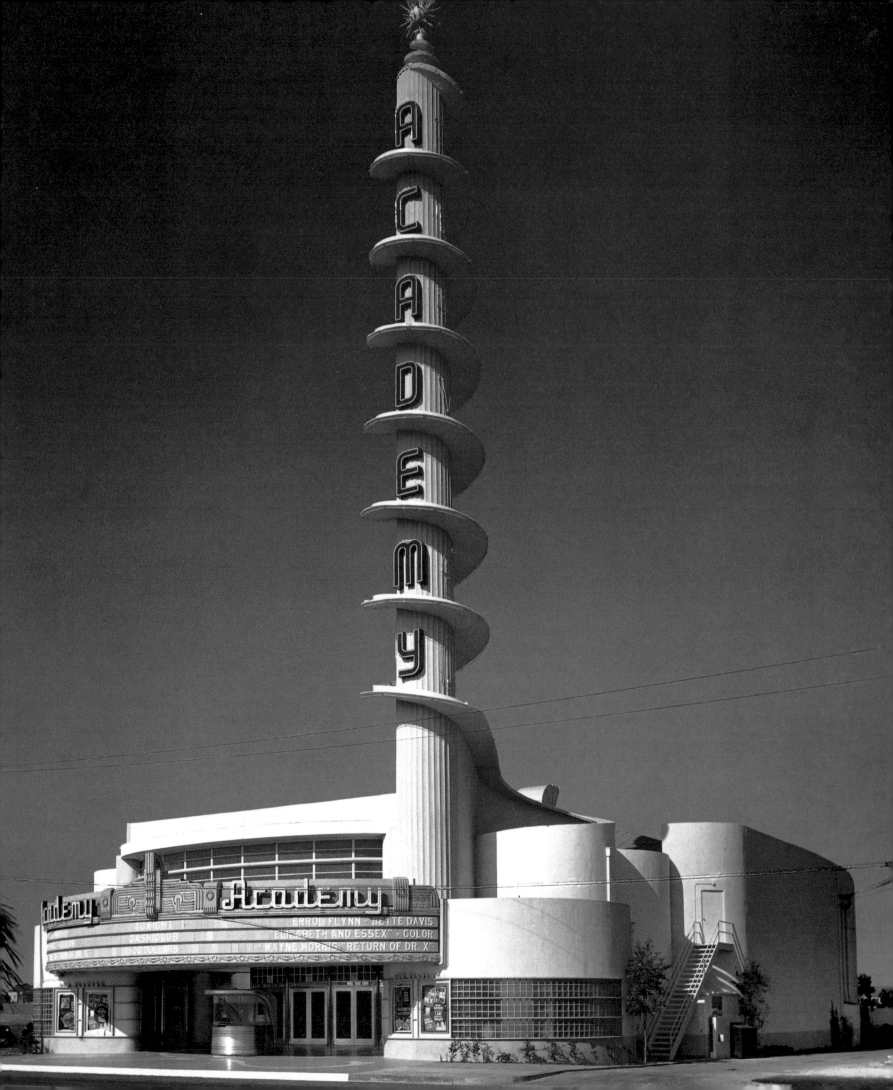

The Academy Theatre, Inglewood, Los Angeles, 1939, by S. Charles Lee. After his death in 1990, the S. Charles Lee archives, containing records of the hundreds of theatres he designed, were left to the Research Library at the University of California, Los Angeles.

such as Hotel Cardozo, the Marlin Hotel and the Senator (all 1939, the latter demolished in 1979). The Moderne style remained relatively exceptional in suburban and domestic architecture, with the dominant styles continuing to be Colonial, Spanish Mission, Queen Anne or other hybrid creations. It is difficult to assess how important films were in fostering ideas of stylistic appropriateness, although the fact that by 1939 America's cinemas could boast a weekly attendance of 85 million suggests that film was the principal medium through which many people encountered the Moderne style. Whether the themes of entertainment and industry which accompanied Moderne settings in the movies were confirming or creating the attitudes of the American public, it seems clear that film-makers did at least have a conscious idea of what the style was suitable for. In a 1938 article, Paramount's Hans Reine recognized that modern architecture had:

> … its place in the world of today, particularly today, particularly in America. For skyscrapers, broadcasting stations, steamships, factories, warehouses and other structures of an impersonal nature having few ties with the past, contemporary design and materials are indicated. The more functional the better. But in the home, the emotions as well as intelligence have their place. As an institution it is ageless, and its design should express the many ties and facets of its essentially intimate role in our lives.[59]

Despite its presence in Hollywood and its ubiquitous role as highway architecture for the dawning age of the automobile, Moderne was not the only direction in which Art Deco evolved in the 1930s. Another significant development involved an increased emphasis on the neo-classical element present in the eclectic aftermath of 1925, and the creation of an austere, stylized classicism. Examples of this style built in America during the 1930s, such as the Veterans Hospital in San Francisco, the Municipal Building in Hamilton, Ohio and the string of courthouses across the country, have been labelled Public Works Administration (PWA) Art Deco, because the style became almost ubiquitous with the radical programme of public building which the Roosevelt administration embarked on in 1933 in an attempt to bring the country out of recession. As with Moderne, the ideological rationale of the style is crucial and even more evident due to the political nature of the buildings themselves. An official survey of the six years of building which made up the PWA architectural portfolio was unambiguous:

> Men build temples to the things they love. During the ten years of post-war boom the finest buildings in this country were being constructed to serve business and commercial interests. Today, on the other hand, we are watching structures being erected everywhere to fit the needs of humanity in general.[60]

'The needs of humanity in general' encompassed town halls, high schools, prisons, post offices, roads, tunnels, bridges and even sewage treatment plants. Although a multiplicity of styles was employed by PWA architects, small town halls continued to be built in the Colonial style, especially in the East. The use of stylized classicism for big municipal buildings made the style synonymous with the

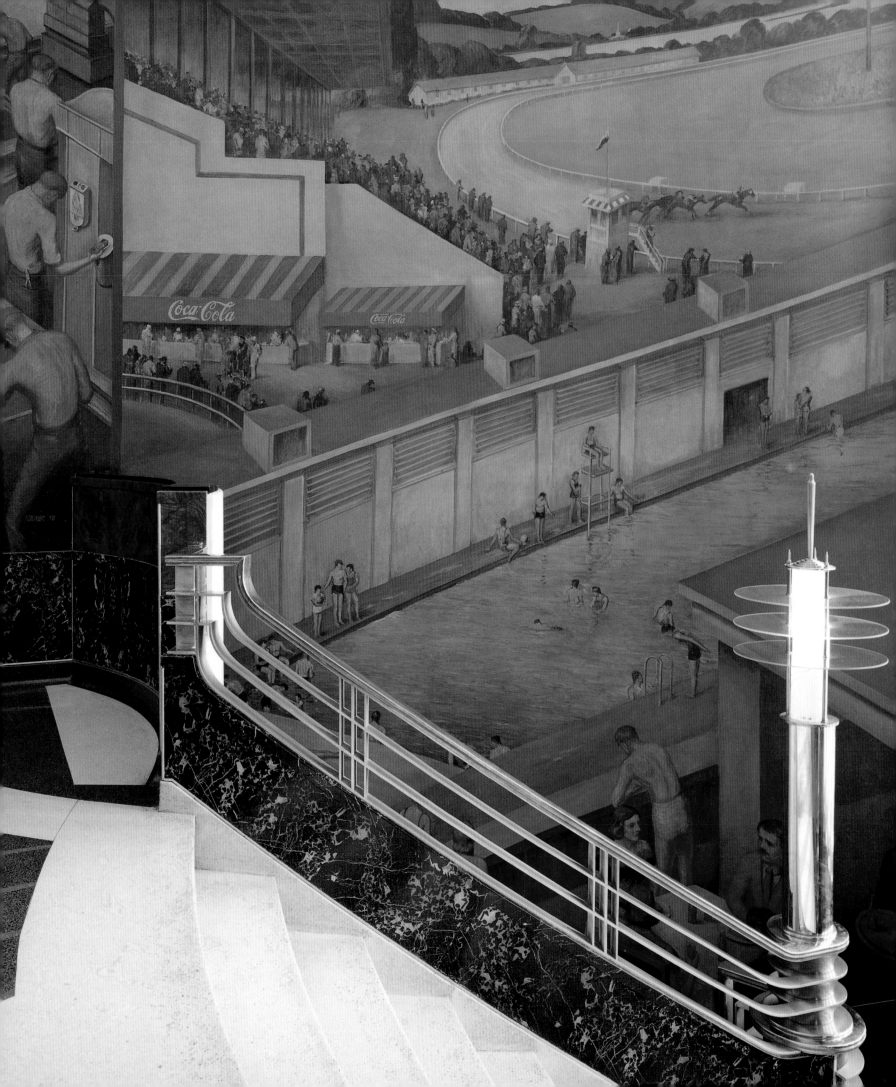

Mural by John F. Holmer in the main lobby stairwell of the Coca Cola Bottling Company plant, Cincinnati, Ohio, 1938. It depicts River Downs and Coney Island, popular Cincinnati recreation areas. The swimming pool scene in particular represents the broader themes of health, fitness and cleanliness, which became increasingly popular concerns in the inter-war period.

Federal government programme, but the continued use of Art Deco sculptural reliefs and murals in many buildings reaffirms PWA classicism's place within the broad Art Deco idiom. The fusion of classical motifs with a modern approach to design can be traced back to Gio Ponti and the Italian Novecento movement, as well as the classicism of Swedish architects such as Asplund in the 1920s. In 1930 Paul Frankl had already recognized that, 'The new movement has already produced its realists and its romantics. It has developed a right wing, a centre, a left wing,'[61] but a comparison of the neo-classical and Moderne versions of Art Deco reveal how difficult and contradictory the politics of Art Deco could be. Roosevelt's New Deal was the radical, almost Keynesian response of a government which recognized the Depression as the greatest threat to liberal democracy America faced; in this respect the buildings constructed under the PWA scheme were symbols of progressive social and economic thinking. Yet the use of a monumental idiom rather than a streamlined one in many public buildings emphasizes the essentially conservative rationale behind the veneer of radicalism. Roosevelt wanted to promote stability and so an apparently revolutionary style of architecture was not appropriate.

Yet at the same time American Moderne architecture contained none of the ideological baggage of its distant cousin, European Modernism. It was more often than not an architecture of futuristic escapism rather than social reform. Together, the austere classically-inspired courthouses of the South, and the streamlined cinemas of the Midwest, tell us a great deal about the underlying conservatism of Art Deco, as well as representing the schizophrenic reality of a country which experienced the extremes of Depression and futuristic hope within the same decade. This stylistic dichotomy draws attention to the division between public and private, government and commerce, austerity and luxury, solemnity and frivolity, realism and idealism.

Needless to say there were exceptions. There were Moderne schools, such as the Hollywood and Thomas Jefferson High Schools in Los Angeles, and even sewage works. Moreover, it was not only public buildings which were constructed in the stylized classical PWA style; in Los Angeles both the LA Times and the Sunkist drinks company adopted a monumental approach. The continuities between commercial zig-zag and the PWA styles are also significant. It is the bas-reliefs on many of the neo-classical PWA buildings which provide the most visible link. Kansas City Hall (1936) takes a skyscraper form and combines sculptural reliefs with classical fluting, while the interiors of the Municipal Auditorium (1933) in the same city show little sign of austerity, with their murals and luxurious fittings, allegedly the result of imaginative financing by the notorious local Democratic Party boss.[62] Indeed, the notion of 'public art' was integral to the New Deal programmes, as the range of Art Deco murals within many public buildings, particularly post office buildings, testifies. The Works Progress Administration (WPA) was a separate programme from the PWA, yet it also resulted in the production of state-funded

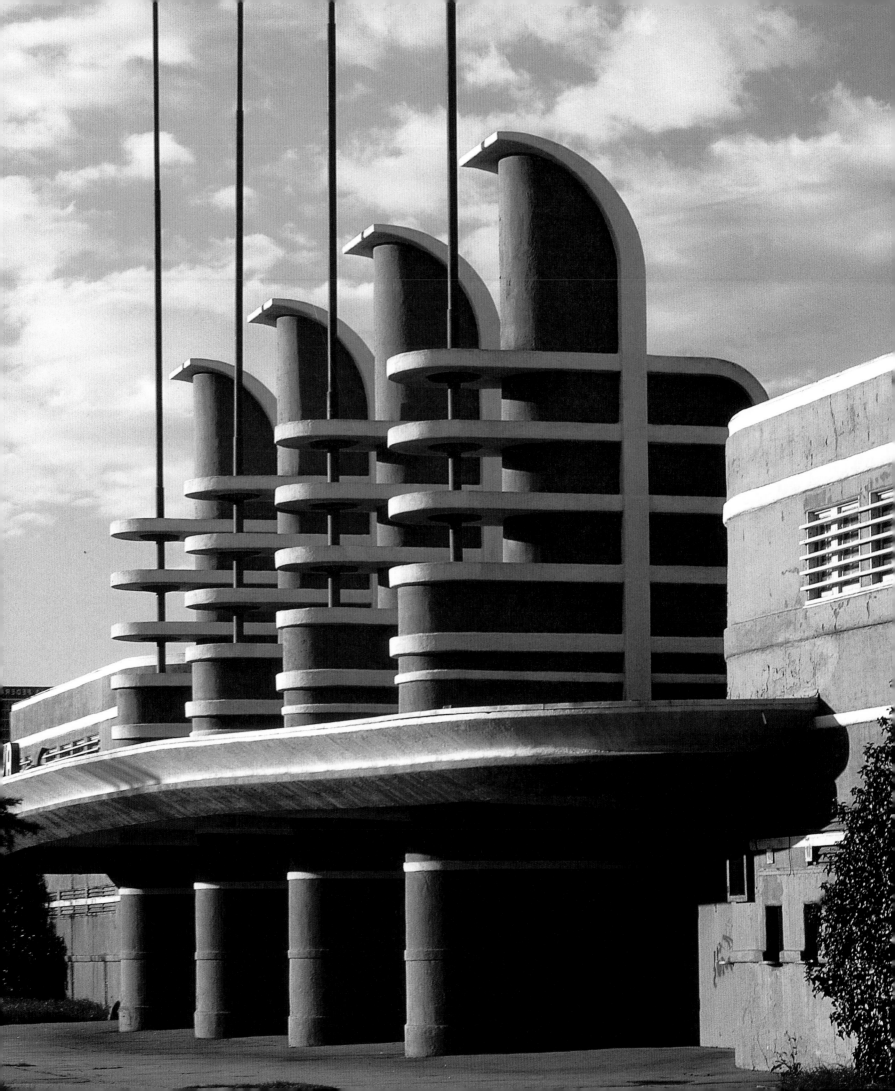

The Cincinnati Union Terminal, 1936, designed by Roland A. Wank for Felheimer & Wagner.

Left: The Pan Pacific Auditorium, 7600 Beverly Boulevard, Los Angeles, 1935. Architects: Walter Wurdeman and Welton Becket. The auditorium was later demolished, leaving only this façade, which in turn was destroyed by fire. A replica of the portals now forms the entrance to the Disney/MGM Studios theme park in Florida.

Right: Detail of the mural in the auditorium of the Avalon Theatre, Santa Catalina Island, Los Angeles, 1928. The blend of exoticism and modernism which was so prevalent in Paris during the period is here given a specifically American reading with the stylization of a group of Indian warriors. The muralist was John Gabriel Beckman.

Art Deco, this time primarily murals and public sculpture. Five thousand jobs for artists were created, the only guidelines being that the work had to be 'American'. The results, such as Robert Hallowell's 'Scenes from American Life', submitted for use in an Interior Department Building in 1935, and Frank Shapiro's entry for the Washington N. J. Post Office Mural competition in the same year, gave stylized and idealized portrayals of families at rest and men at work. Hymns to the industriousness of the world's most powerful nation, works such as these have been compared by the historian Bernard F. Reilly to the triumphalist art being produced in Fascist Italy and Nazi Germany. For Reilly it was no coincidence that, 'All three countries sought to instil in their citizens a new sense of belonging to an integrated society wherein the individual contributed to large-scale national projects ... the mural programs and art projects of the 1930s had introduced the American people to the societal ideas of a collective identity and a strong and pervasive government.'

However, not everyone was satisfied with the endeavours of the government; Frederick A. Gutheim surveyed 'the entire building programme' in 1940 and concluded that it had 'not produced one architectural masterpiece'.[63] But the significance of Art Deco in design and architectural history lies as much in its use in ordinary contexts as in its 'classic' architectural statements. Celebrating the eclecticism of American architecture in 1928, in the face of an increasingly doctrinaire Europe, Henry Russell Hitchcock Jr expressed a hope 'that in America the modern style will not be rigidly exclusive ... as the foreign modernists have demanded'.[64] In many ways it was this, occasionally anarchic, lack of 'rules' which contributed to the popularity of Art Deco. An exploration of the evolution and influence of American Art Deco in the inter-war period reveals many variations of the style, representing contrasting ideals at different moments in history; taken as a whole, this variety serves only to reinforce the constantly eclectic nature of the American decorative response to modernity.

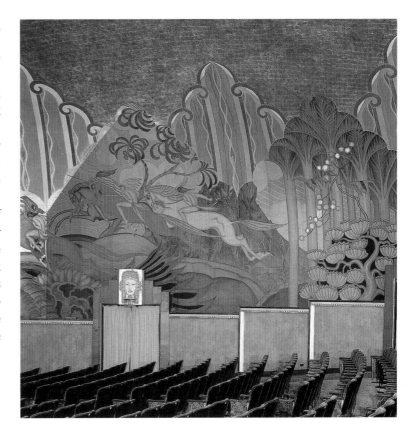

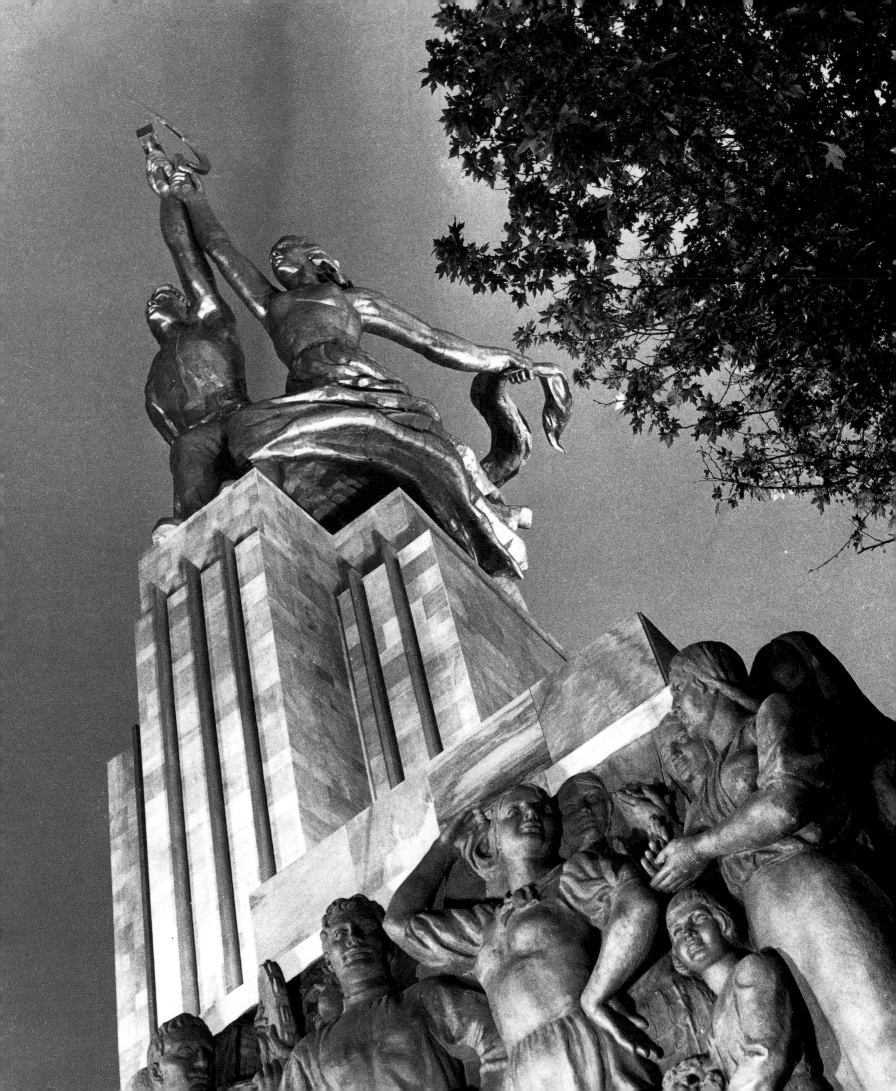

he blind triumph of the machine ends in a tragic disaster for all of humanity ... Under the threat of famine or revolt, we must return to the hand the tools which it has abandoned and which it no longer knows how to use.

Paul Iribe, 'Profits and Losses', 1931[1]

The current repertory of ornaments consists of a set of once useful things which have become useless, remnants of forms that died years ago.

The manifesto of the Union des Artistes Modernes, 1934[2]

Left: The Pavilion of the USSR at the International Exhibition, Paris, 1937. The sculpture, by Vera Mukhina, which surmounted the monumental façade was entitled Industrial Worker and Collective Farm Girl. The art of the USSR and the fascist states of Europe shared the glorification of the worker with many of the PWA murals in American public buildings of the 1930s.

Right: Cover of the guide to the Exposition Coloniale Internationale held in Paris in 1931. This, the first great French fair of the 1930s, saw Art Deco being associated with overtly imperialist meanings.

The period between 1925 and 1939 in Europe was above all an ideological age, dominated to different degrees in different countries by the politics of progress, industrialization, race and national identity, the ideology of politics itself. In France, the rhetoric of industrial production provoked a stylistic split in the decorative arts; that this followed political as well as artistic fracture-lines was clearly expressed by Anatole de Monze, the spokesman for the Société des Artistes Décorateurs, in 1937:

> Totalitarian regimes inspire a totalitarian art, symmetrical, geometrical, uniform, an obedient art submissive to the disciplines of economy and the rules of commerce, if not to tradition. Decorative art presupposes the expression of needs, of desires, emanating from divergent personalities. Its fate and its growth depend on the yearning of individuals.[3]

In other countries too, the varieties of Art Deco that evolved during these years reflected the importance of politics and ideology in the decorative arts. The commercial Moderne style that served industry in France was adopted by Italian totalitarianism, while the luxury Art Deco idiom simultaneously incorporated the neo-classicism so close to Mussolini's heart and reflected the stylistic pluralism of Italian fascism. In Central Europe the discourse between Art Deco and the folk tradition signified either a retreat from modernity, as in Vienna, or the emergence of newly defined national identities, as in Prague and Warsaw. In the Netherlands, the Moderne style provided a populist version of the increasing orthodoxy of Modernism. This web of different associations explains how Art Deco could be condemned for being both luxurious and austere, archaic and modern, bourgeois and populist, reactionary and radical. As an essentially eclectic style, it mirrored very diverse aspects of the social, economic, political and aesthetic discourse of inter-war Europe.

The ideological and aesthetic tensions within the French decorative arts after 1925 were part of a broader politicization of art and aesthetics identified by the German-Jewish philosopher Walter Benjamin during the period. In a Europe experiencing economic slump, mass unemployment, the threat of Communist revolution on the one hand and the rise of nationalist totalitarianism on the other, Benjamin saw art as having significance on an unprecedented scale. Central to his concerns was the inexorable rise of Fascism and its harnessing of the technologies of mass production – the creation of a mass culture for a new mass politics. Although Benjamin did not identify the role of style in his warnings about the dark side of modernity, style unavoidably played a major role in these freshly politicized aesthetic battles, and it is clear that contemporary designers had conscious political motives for particular forms of stylistic expression. Benjamin noted that, while totalitarian regimes relied on both the theory and practice of mass production, the theoretical advocates of mass production such as Gropius and his Bauhaus colleagues, were primarily on the left. Their insistence on an austere, functionalist style led defenders of decoration and the more traditional

The German Pavilion at the International Exhibition, Paris, 1937. Osbert Lancaster noted that, 'Napoleon too had his creative whims and as an architectural expression of "sacro egoismo", the First Empire style ... makes the masterpieces of our latter day dictators look empty, bombastic and ridiculous. It was indeed unfortunate for Herr Hitler that the German Pavilion at the Paris Exhibition should have been within a hundred miles of the Arc de Triomphe.'

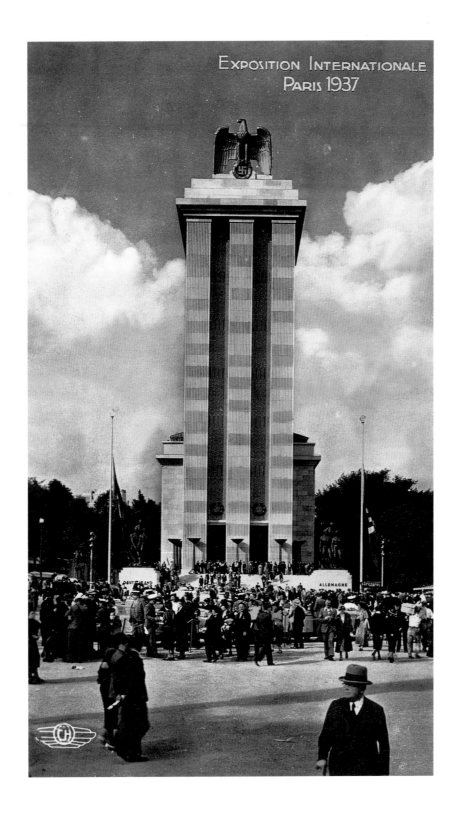

EXPOSITION INTERNATIONALE
PARIS 1937

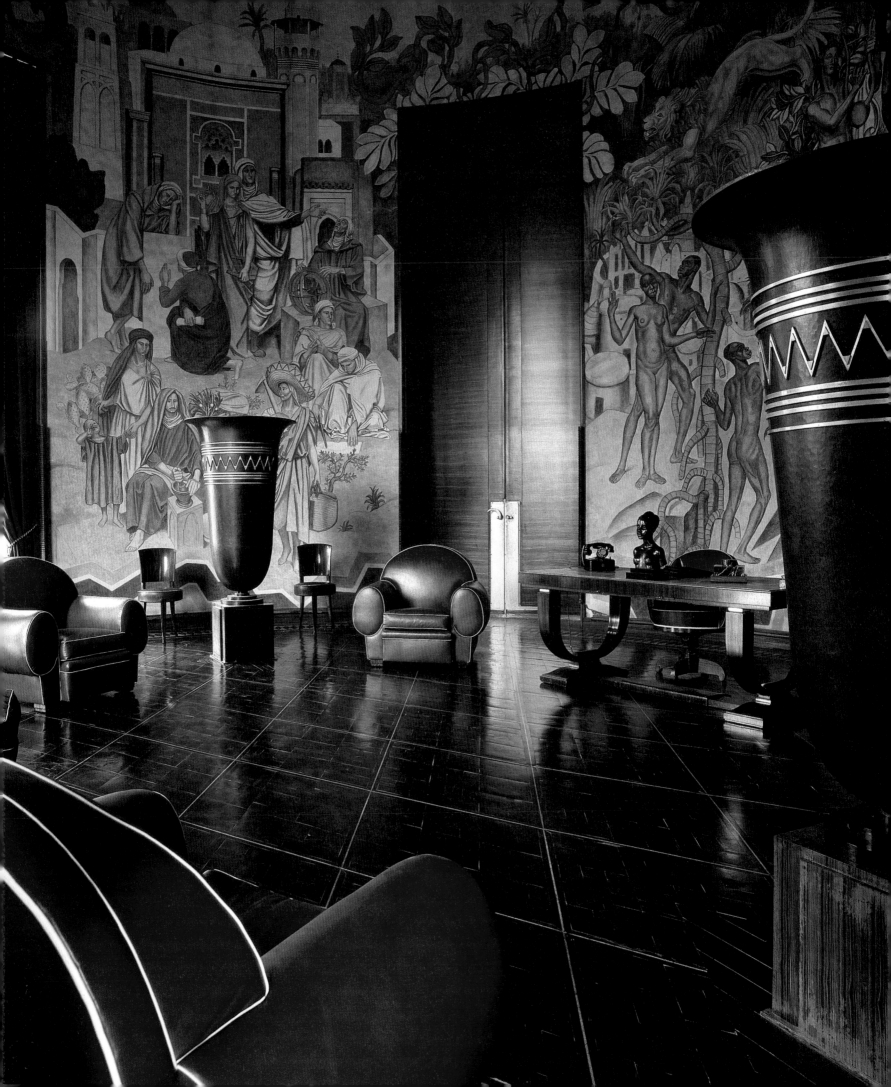

NORMANDIE
C.ᴵᵉ Gᴵᵉ TRANSATLANTIQUE
French Line
60 VOYAGES
400.000 MILLES-115.000 PASSAGERS
AU 1ᵉʳ JANVIER 1939

designer/artisan/client mode of production to couch their defence in aggressively political terms. Thus it is unavoidable that currents within art and design, even in non-totalitarian states such as France, must be considered in terms of political ideology. In an age when traditional bourgeois notions of the individual seemed to be under serious threat, Anatole de Monze's assertion that, 'Decorative art presupposes the expression of needs, of desires … Its fate and its growth depend on the yearning of individuals' provided a rallying cry for conservatives. Yet, it was the very plurality of Art Deco's associations, springing from the variety of themes that had been in evidence at the 1925 Exposition, which ensured the pan-European spread of Art Deco styles in the 1930s.

In France, the luxury and decorative arts continued to thrive in the wake of the 1925 Exposition. As late as 1929, the country was still enjoying the benefits of long-term economic growth, which had begun in the 1890s and continued without serious interruption. France's influential position was retained throughout the 1930s, despite the increasing prominence of American design and, after 1931, prolonged economic depression which hit the arts particularly hard. Historical analyses of the aesthetics of the 1930s have tended variously to emphasize three developments: the evolution of the Modern movement throughout the decade; the ideological battle between left and right epitomized by the Soviet and German pavilions at the 1937 Paris Exposition; and the rise of industrial design in the USA, culminating in the 1939 New York World's Fair. To follow the development of Art Deco in Europe after the 1925 Exposition, however, it is necessary to view the 1937 Exposition from a different perspective and to consider two more defining events of the intervening years. The first is the Exposition Coloniale staged in Paris during 1931; the second, the interior decoration of the new French transatlantic liner the *Normandie*, which entered service in 1935.

The political and economic themes of the 1925 Exposition have been stressed, yet the 1931 Exposition Coloniale was an even bolder example of French imperial posturing. Although there were some foreign pavilions, the majority of the Exposition Coloniale was devoted to France's overseas colonies, and more specifically to the benefits for all concerned: colonized and colonizer. Unlike the 1925 Exposition, the Exposition Coloniale was not primarily concerned with the decorative or industrial arts: the pavilions were built in an array of vernacular styles (albeit by French architects), ranging from Indo-Chinese temples to African huts populated by resident 'natives'. The result was a spectacle of racial and cultural otherness, reminding the French public that, despite recession and depression, France had continuing international political and economic strength.

Despite this display of ethnographic variety, the French decorative artists of the Société des Artistes Décorateurs had a role to play in the service of empire, allowing the traditional wing of Art Deco to confirm its conservative credentials – in J.P. Bouillon's words, 'its civilizing and colonizing vocation'. The Palais Permanent des Colonies included two rooms, 'L'Asie' and 'L'Afrique', furnished by Printz and

Above: Roger Henri Expert's Fountain of Light was the crowning glory of the nightly Spectacle de Théâtre d'Eau at the Exposition Coloniale Internationale, Paris, 1931. Left: The murals in Ruhlmann's office (now the Musée des Arts Africains et Oceaniens) exhibited at the 1931 Exposition reflect the imperialist overtones of French Art Deco. The chairs are the 'Eléphant' model first exhibited at the Société des Artistes Décorateurs in 1926. According to G. Janneau, 'the proportions of these enormous fatherly monsters are so fine, and the colours so well chosen, that they look light despite their weight.'

Above, right: Cassandre's poster for the *Normandie*. When it entered service in 1935, the liner was at once the crowning glory of the French merchant fleet and a showcase of the luxury French decorative arts. The simplicity of this poster belies the decorative excess which could be found on board.

Page 116: These views of various suites on board the *Normandie* demonstrate the broad range of aesthetic approaches taken by the designers concerned. Dominique's 'Rouen' employs almost Americanized stream-lining while Louis Süe's 'Deauville' echoes the designer's decorative work of the 1920s.

Page 117: The guests gather in the Grand Dining Room of the *Normandie* (*L'Illustration*, 1935).

Salle à manger " Trouville ".
(Leleu, décor.)

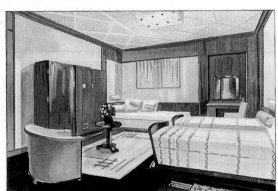

Une chambre à deux lits sur le sundeck tribord, " Trouville ".
(Leleu, décor.)

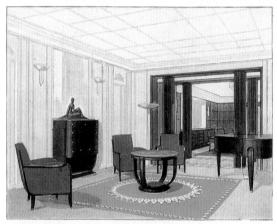

Salon et salle à manger d'un appartement du pont A bâbord, " Caen ".
(Montagnac, archit. décor.)

*Un coin du salon donnant sur le pont-terrasse,
sundeck bâbord, " Deauville ".*
(Süe, archit.)

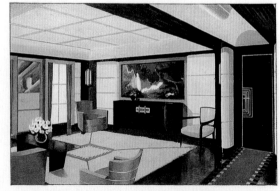

Salon d'un appartement du pont A tribord, " Rouen ".
(Dominique, décor.)

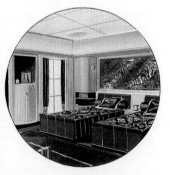

Chambre à coucher " Rouen ".
(Dominique, décor.)

APPARTEMENTS DE GRAND LUXE PORTANT CHACUN LE NOM D'UNE VILLE DE NORMANDIE

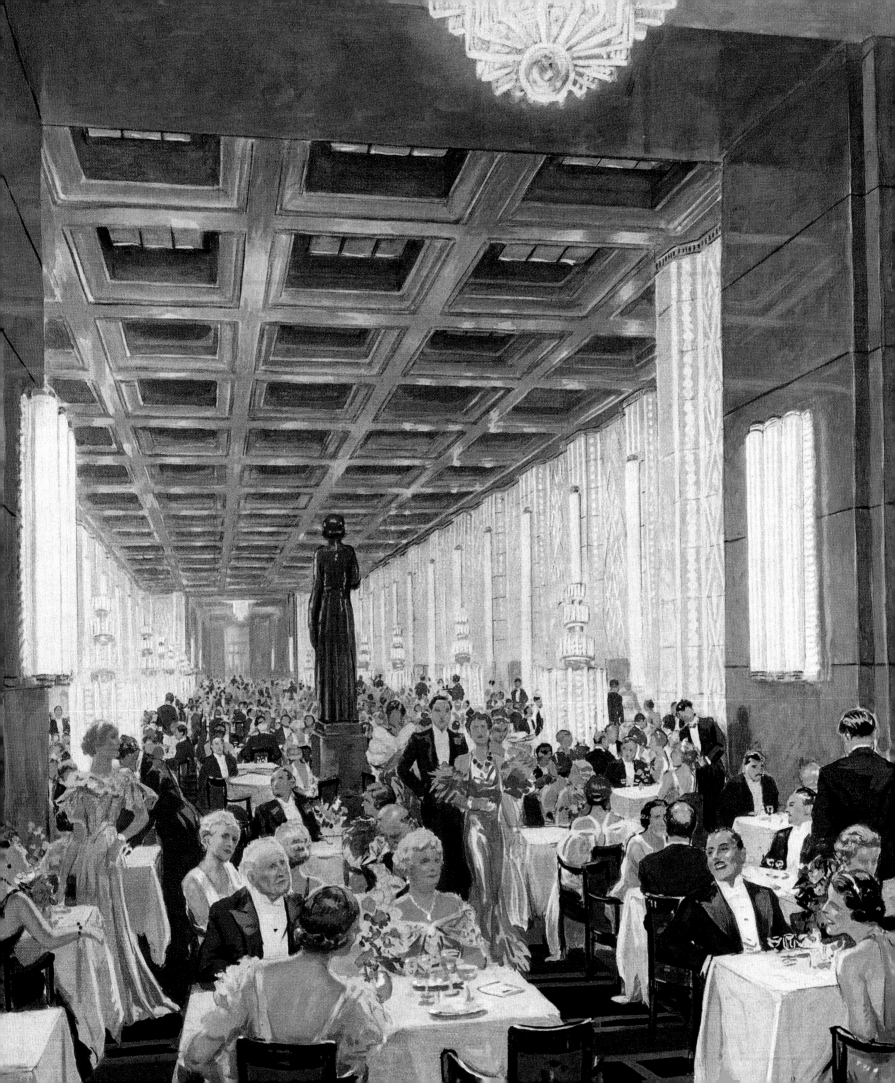

The cover of *L'Illustration*'s 1935 celebration of the *Normandie*. L'Illustration heralded the liner as a floating exhibition of French decorative arts.

Ruhlmann respectively, as well as lacquerwork by Dunand. Printz's treatment of the room 'L'Asie' reflects his continuing commitment to the status of the *décorateur*. Envisaged as a drawing room for Marshal Lyautey, the Commissaire Générale of the Exposition, the space was luxurious and statesmanlike. The veneered wooden floor with its ziggurat decorative theme, coupled with the fountain-like standard lamps, provided the most obvious echo of the Art Deco idiom of 1925, while the exotic wall-paintings by André Hubert and Ivanna Lemaître provided a constant reminder of the room's ideological affinities. In the furnishing of the adjacent 'L'Afrique' room, Ruhlmann too confirmed his association with luxury and power. Similarly planned as a drawing room, this space had a ministerial theme. Once more the exotic murals reinforced the ideological identity of the work, although neither room matched the scale of the allegorical mural by Pierre Ducos in the festival hall of the Colonial Museum. The furnishing of 'L'Afrique' consisted of the kind of pieces which, two years before his death, confirmed Ruhlmann as the very personification of traditional, monumental French Art Deco.

With its stepped, angular and curved forms, the Cité des Informations (designed by Bourgon and Chevalier) provided an architectural image of French modernity in a colonial setting, exemplified by the surrounding palms. However, in terms of the exhibition as spectacle it was in the creation of 'La Nuit Merveilleuse' that the frivolity of Art Deco asserted itself in the face of increasing global economic turmoil. The collaboration of the architects Roger Henri Expert and A. Granet produced a series of fountains to rival Lalique's 1925 work. La Fontaine des Totems and La Fontaine du Cactus emphasized the continuing strength of Native American motifs; combined with the frivolity of 'La Belle Fleur', they confirmed Art Deco's ability to reinvent itself in spite of the restrictions of reality. For the ordinary Parisian visitor, Expert's luminous fountains, crowned with the nightly *spectacle de théâtre d'eau*, were the last word in exotic escapism. In broader terms, Art Deco was no longer solely exploring the relationship between tradition and modernity within the European decorative arts: the 1931 Exposition mediated between the electrically-powered conservative modernity of metropolitan France and the 'primitive' art traditions of the colonies. Expert's Palais de la Métropole was 'dedicated to a greater France', and if French culture was to become a world culture through empire, this was to be its style.

If French Art Deco presented an overtly imperial aspect in 1931, its luxuriousness was once more emphasized in 1935 with the maiden voyage of the *Normandie*. The *Normandie* was the largest and most powerful ship yet built for transatlantic travel; the pride of the French line, it held the Atlantic speed record, the 'Blue Riband', until it was taken by the British liner, the *Queen Mary*, in August 1938. Like the 1931 Exposition, the ship was heralded as a symbol of national and colonial achievement, '*une synthèse des activités nationales*'. *L'Illustration* billed it as a '*Chef d'œuvre de la technique et de l'art français*',[4] and it is little surprise

that the designers of the Société, by now the traditional French decorative arts establishment, were chosen to carry out the commission for this floating showcase for French art. The result was predictably far from Le Corbusier's modernist ideal of the steamship, or even the American Moderne style of Bel Geddes, another advocate of the ocean-going aesthetic.

The interior architects were Expert and Bouwens de Boijen, and so many different designers worked on the ship that it was referred to as, '*une exposition flottable de tous les arts décoratifs français*.' The dominant impression given by pictures of the interior is one of lavish decorative luxury, with notions of modernity given a flamboyant setting designed for conspicuous consumption. The lighting and furniture represented the development of a conservative Art Deco idiom, but although simple shapes remained, the decoration often reverted to natural forms. Thus, while the extravagant lighting of *la grande salle à manger* emphasized symmetry, furniture such as Aubusson's, which could be found in many of the communal rooms, was emblazoned with figurative floral designs. Some of Dunand's 133 feet of gold lacquer and 92 square feet of coloured incensed lacquer decoration were moderately stylized, but both Dunand and Dupas consistently rejected images of modernity in favour of those of tradition. Gone were suggestions of speed, mechanization and abstraction; they were replaced by exotic but traditional maritime scenes: native African fishermen or Tudor galleons in anachronistic battles with classical sea monsters. The themes for Dunand's smoking room, 'Man's Games and Pleasures', further enhanced the sense of isolation from the challenges of modernity – his panels represented 'sports', 'fishing', 'taming the horse', 'dancing' and 'harvesting the grape'. Such artistic statements possessed a self-conscious agenda: 'These panels are expressly intended to seem abundant and high flown,' Dunand admitted; 'I felt the need to protest against the poverty and bareness of the decorative conceptions which arose in Northern Europe after the war and entered France at the time of the 1925 exhibition.'[5]

Nevertheless, the subtle influence of the Moderne style can be discerned in the *Normandie*. Significantly, it was the dining room of the tourist class which displayed a marked simplicity and paucity of decoration, again suggesting the equation between ornamental Art Deco and social class. Some of the more luxurious cabins suggested American influence: Dominique's 'Rouen' suite of rooms appeared to owe a debt to Weber and Frankl as well as Chareau's more overtly decorative furniture from the late 1920s. Perhaps more typical, however, was Montagnac's classically inspired, Ruhlmannesque 'Caen' suite, or Louis Süe's breezy, floral 'Deauville'. Despite press adulation, the *Normandie* had its critics. 'I must acknowledge,' said Fernand Léger, comparing the interiors to the Radio City music hall in New York, 'that the French work, the decoration of this ship, is backward looking and in bad taste. It is Art Nouveau at its worst.' This was harsh criticism indeed, made as it was in the knowledge that the Société had originally

ROBOT

ISOKON

METAL
SURGERY

NESTLÉ

ATLAS ALUMINIUM

ARMCHAIR
COMFORT

IN
VICTOR
SHOES

Art Deco style pervaded all aspects of decorative and graphic design, including trademarks. The designs shown opposite date from the 1920s and 30s. Most of these companies either disappeared or their logos have not survived; the only one in use today is the MG logo.

been formed as a bulwark against both the internationalism and the excess of Art Nouveau. For those of more radical aesthetic persuasions, it seemed that the Société was betraying its original aims.

Indeed, the eclecticism that had characterized the work of the Société's members at the 1925 Exposition was far from comfortable. Art Deco in 1925 was united by the desire to decorate and the requirement to be modern, yet these two criteria carried as much divisive potential as unifying principle. The steady divergence of tradition and avant-garde, craftsmanship and mass production, is customarily viewed in terms of the opposition of ornament and austerity. These are the battle lines across which the Modernist 'pioneers' and the Art Deco *décorateurs* faced each other. Yet the fifteen years following the 1925 Exposition exposed a still wider fragmentation within the French decorative arts. While elements of the eclecticism evident in 1925 were absorbed by American designers, with Frankl and Weber, for example, gradually moving from the 1920s zig-zag style and the accompanying luxury modes of production to a more streamlined Moderne style more appropriate to the economic realities of the 1930s, France saw a much more diverse development of the themes of modern decoration which were in place by 1925.

If we are to understand the dynamics of the development and spread of Art Deco as a truly popular and populist style across Europe in the 1930s, it is crucial to recognize the gulf between the increasingly luxurious work of the Société's members and the style as manifested in posters, packaging and other more demotic arts. Since France remained an important stylistic centre, these tensions within the French decorative arts are also reflected in developments in other countries such as Italy and, especially, Austria. Both the Exposition Coloniale and the *Normandie* had been arenas for the *décorateurs* of the Société, but by 1929 it was no longer the sole representative organization for French decorative artists. The Union des Artistes Modernes (UAM) was formed as a splinter group of the Société after the 1929 Salon, and it is the work of two influential UAM members, Jean Carlu and A.M. Cassandre, which embodies the alternative idiom of Art Deco. As Bouillon pointed out, it is ironical that the most enduring historical image of the *Normandie* is Cassandre's famous poster for the Le Havre–Southampton–New York route. Its stylized, monolithic, thoroughly modernist image of the ship's hull reveals Cassandre's affinity with the UAM. This is a vision of the ship that echoes Le Corbusier's praise for the functional modernity of the ocean liner as typeform; it was unambiguously restated in the only UAM manifesto, published in 1934: 'three cheers for the steamship style if it teaches us to furnish our homes, clearly brightly and simply'. However, the luxurious eclecticism of the *Normandie*'s decoration and furnishing put paid to any Modernist fantasies.

In contrast to the privileged world of the Société's traditional clientele, the UAM stood for the search for a democratization of Art Deco in 1930s France. The Corbusian rhetoric of mass production demanded a marriage between art

122

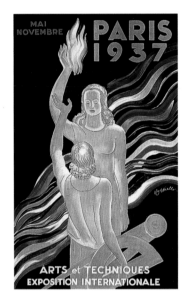

Loretto Cappiello's poster for the 1937 International Exhibition in Paris. The imagery of international harmony and progress was a far cry from the turbulent reality of European politics.

and commerce, and it is to graphics and commercial illustration – rather than furniture, architecture and the other decorative arts – that we must now look.

Cassandre and Carlu are the two designers most widely credited with replacing pictorial realism with stylized imagery and geometric symbolism in French graphic design. According to Bouillon, Cassandre's 1929 Bifur typeface symbolizes the union between art and industry, and his powerful images have typified Art Deco in the popular imagination of subsequent generations. Yet Cassandre is unusual in the context of inter-war French decorative arts in that he actually practised what he preached. A painter by training, he made a conscious decision to switch to poster design, which he perceived as the mass art for the mass age. While the philosopher Walter Benjamin warned against the dangers of mass production in the hands of Fascism, Cassandre embraced the same technology in the service of commerce. 'Cassandre's initial instinct was the right one,' recalled his friend, the sculptor Raymond Mason in 1966: 'He went out into the street … Look at his designs of 35 years ago … they were conceived to take their place in the thick of life, in the joyous tumult of the street – where they spoke to the people.'

Cassandre's first published text, in *La Revue de l'Union de l'Affiche Française* in 1926, has much in common with the ideals of the Bauhaus. There is a healthy disdain for the bourgeois art market and an enthusiasm for modernity; yet, significantly, this is coupled with a lack of any dogmatic suspicion of commerce:

> *Painting is evolving increasingly toward individual lyricism, toward purely poetic works rather than pictorial ones … the poster on the other hand is moving towards a collective and utilitarian art. It strives to do away with the artist's personal characteristics, his idiosyncrasies and any trace of his personal manner.*
>
> *A poster unlike a painting is not, and is not meant to be, a work easily distinguished by its 'manner' – a unique specimen concerned to satisfy the demanding tastes of a single more or less enlightened art lover. It is meant to be a mass produced object existing in thousands of copies – like a fountain pen or automobile. Like them, it is designed to answer certain strictly material needs. It must have a commercial function.*[6]

Indeed, it has also been suggested that the Bifur typeface represents Cassandre's unorthodox interpretation of Modernism. Unlike the typographical experimentation taking place concurrently at the Bauhaus, Bifur is an upper-case typeface making use of lines and blocks to suggest a monumentalism that contrasts with the Modernist emphasis on simplicity and purity achieved through the use of lower-case type.

In the wake of innovators like Cassandre and Carlu, a version of Art Deco found its way into the ordinary homes of France via the work of countless obscure graphic artists who created myriad stylized, modernistic trademarks and packaging designs. Many of these *publicité* designers had received a training in

Bracelet by Raymond Templier. Templier belonged to a dynasty of Parisian jewellers and exhibited at the Société des Artistes Décorateurs as early as 1911 when he was just 20 years old.

The actress Brigitte Helm wears Raymond Templier's famous *parure* in the 1928 film *L'Argent*.

the decorative arts, some even having formal fine art training in such fields as illustration or bookbinding, which had become available by 1925.[7] Designers of advertisements such as Léon Dupin and Leonetto Cappiello also began to create trademarks. Their sparse modernistic style was enhanced by a technique called *pochoir*, which involved applying gouache with a sponge to produce monochrome designs which were easily recognizable and could be mass-produced conveniently; this technique was used in advertisements, theatre programmes and label designs.

This type of work represented the most unproblematic union between commerce and modernity. Serving both a decorative and functional purpose, the commercial logos were stylized and simple, a far cry from the increasingly figurative decorative schemes so much in evidence in the work of the Société members. This version of Art Deco, of modern decoration, was not concerned with communicating luxury and status (although its frequent use of stylized blacks reminds us of the imperial framework of art, politics and economics during the period). Instead, it provided a stylistic vehicle for a modern consumer society's discourse between manufacturer and consumer. Cassandre epitomized the simultaneously pragmatic and aggressive approach of the commercial graphic designer: 'Success does not come to the artist who tries to cajole the onlooker with soft words,' he concluded in his 1926 article, 'It comes to the artist who sweeps down on the public like a hussar or rather (if I am allowed the term) who rapes it.'

So how does the commercially orientated approach of Cassandre, Carlu and others compare to that of the decorative artists who also belonged to the UAM? Of its thirty members in the early 1930s, many came either from the ranks of the *décorateurs* (Sonia and Robert Delaunay, Eileen Gray, Frantz Jourdain, Pierre Legrain), or were silversmiths and jewellers (Jean Fouquet, Gérard Sandoz, Raymond Templier, Jean Puiforcat) – hardly groups from which one might expect great radicalism. The bourgeois credentials of two other founding members, Robert Mallet-Stevens and Pierre Chareau, were also formidable. Chareau, who had received his training with Waring and Gillow, shunned the commercial approach, preferring to operate only a modest *atelier* and shop. His biographer Brian Brace Taylor tells how he was a perfectionist who 'would have the plans for a project redone many times over, at considerable expense, before he was satisfied … it is not surprising that he preferred to work within a relatively closed network of clients and craftsmen whose mutual confidence prevailed.'[8] His work before 1928 encapsulated the bourgeois luxury of Art Deco. Likewise, despite his outward radicalism, Mallet-Stevens' heart seemed to remain firmly in bourgeois individualism. He was staunchly middle class and enviably well-connected; his maternal grandfather, Albert Stevens, had discovered Millet and Corot and Paul Leon, director of the Beaux Arts,

Assistant General Commissioner for the 1925 Paris Exposition and General Commissioner for the 1937 Exposition, was his cousin.

In the thinking of many of these *décorateurs*, however, the spectre of Le Corbusier's egalitarian Modernist ideas had already been gaining ground. In January 1926, following the closure of the 1925 Exposition, a number of Société members contributed to an exhibition of 'Furniture for the Average French Family' held at the Musée Galleria. According to the *Bulletin de la Vie Artistique*, this was 'an indirect critique of the initiators of the International Exhibition of Decorative Arts who did not have preoccupations of a practical nature.' Three months later a group of fifteen members, including Mallet-Stevens and Jourdain, abstained from the Sixteenth Salon. Those who did exhibit, with the occasional exception such as Djo Bourgois, continued in the vein of decorative eclecticism which had characterized the 1925 Exposition. Gabriel Englinger's '*Salle à Manger en Palissandre*' continued the angular motif in the forms of the furniture and fittings themselves, while cabinet-makers such as Boudiet, Rapin and Montagnac persisted in using traditional heavy wooden forms, maintaining that modernity could be achieved with angular or straight lines in the veneer. Ruhlmann's writing desk in ebony at once embraced simplicity and tradition, its delicate fluted legs were a far cry from Mallet-Stevens' increasingly industrial version of Art Deco. Moreover, it is significant that Maurice Dufrène's furniture for 'the ordinary Frenchman' was in fact extraordinarily expensive, typically retailing at some FF 100,000. Commenting in *La Revue de l'Art Ancien et Moderne*, Yvanhoe Rambosson highlighted the increasing sense of paradox between modernity and luxury:

> Admiration is not enough for those who have been won over by the new aspect of this art. There are more and more people of taste who wish to surround themselves with a decor that corresponds to the evolution of their vision. They will be satisfied only through mass-produced fabrications, which have been studied equally closely from the economic and the artistic point of view.[9]

It seemed that the terms of the debate were becoming economic. But had Mallet-Stevens and the other Société members abstained for political or artistic reasons? Stylistically at least, Mallet-Stevens seemed to have a marked affinity with Le Corbusier – his Alfa Romeo garage/showroom in Paris, built in 1925, at first appears an exercise in pure functionalism, with an austere symmetrical façade framing two large showroom windows. Yet the details reveal the emphasis he still placed on decorative ingredients. The 'speed line' eaves above the two side doors echoed his Tourism Tower at the 1925 Exposition as well as providing perhaps the archetypal Art Deco lighting effect. Inside, the showroom was decorated with geometric motifs; the floor was covered in coloured ceramics, and the lighting continued the scheme begun with the external eaves. Nevertheless, if Mallet-Stevens was far from renouncing decoration, he was clearly promoting an austerity of design which appeared to have a potential for mass production eschewed by many of the *décorateurs*.

Mallet-Stevens' attempt to combine decorative modern architecture with an acknowledgement of the wider social concerns shared by Le Corbusier and the emerging Bauhaus designers can most clearly be seen in the Rue Mallet-Stevens, constructed in 1926–7. This was conceived as an ideal modern urban street – by implication a contribution to the debate on the ideal modern city. Yet, while the outward aesthetic suggested sympathy with Le Corbusier, the interiors, which included work by various Société members, suggested an unwillingness to depart from Art Deco's traditional luxury mode of production, despite an attempt to achieve a less ostentatious decorative expression than that displayed at the Sixteenth Salon. The interiors were co-ordinated by Pierre Chareau, with whom Mallet-Stevens had collaborated on the set designs for L'Herbier's films. They included angular sculptural decoration by Jan Martel, furniture by Jourdain, stained glass by Barillet and carpets by Lurçat. Stylistically, the interiors drew criticism from the Modernists; for the Dutch Modernist Theo van Doesburg, Mallet-Stevens was 'a temperament still in thrall to the Viennese'.

By the late 1920s, the stylistic differences between the aesthetically less traditional Société members and its establishment were becoming more noticeable. At the 1928 Salon, the work of Djo Bourgois was notable for its austerity, while Herbst and Charlotte Perriand were also praised by radicals as 'daring young spirits always forging ahead'. Even Dufrène, sensing that styles were changing, embraced metal furniture in his interior for a country house. But the Société would only go so far to accommodate the younger generation.

At the root of the ensuing permanent split was the conflict between the dissidents who, while still often embracing the principles of decoration, were beginning to recognize the importance of the Werkbund ideal of partnership with industry, and the rest of the Société who remained faithful to the notion of furniture and interiors as fine art, which should be made by craftsmen individually and sold as unique pieces. Since its formation, the Société had sought influence among politicians rather than industrialists, and this conservative position became further entrenched following the foundation of the UAM. Changes to the statute of the Société's annual Salon

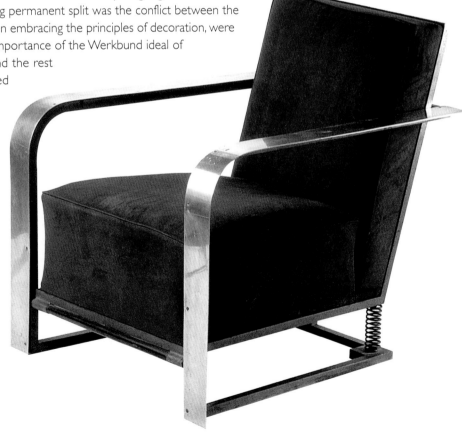

126

in 1929 institutionalized this thinly disguised contempt for industry. The Salon was now 'open to all its creators, whether members of the Société or not, on the condition that they do not also participate in exhibitions reserved for industrialists.'[10] This not only effectively excluded the dissidents, but precluded designers following a progressive approach towards mass production. The Société was making a clear delineation between the work of its members, which it considered art, and the work of the progressive designers, whom they considered to be slaves to the vulgarities of industry. In 1930, the Société announced that it would participate only in the 'fine arts' section of international exhibitions, rather than showing its work as examples of the 'industrial arts'.

The inevitable outcome of this split was the rejection of the increasing functionalism which went hand in hand with the rhetoric of design for mass production. This rejection was in many ways a predictable one; underlying the suspicion of moves towards a more overtly Modernist aesthetic was the continuing influence of economic nationalism, the powerful driving force behind the quintessential 'Art Deco approach' of the more conservative designers. As in 1925, the ideology of French Art Deco was first and foremost anti-German, and in 1929 French fears about the potential impact of Modernism were articulated by André François Porcet, the Under-Secretary of State for Fine Arts. The consequences of Modernism, which was by now equated with German industrial power, would be, 'the development of a standard style that eliminates technical difficulties without resolving them, leaving our finest faculties unused, and condemning a large number of our artisans to unemployment … let us remain attached to our national qualities, to tradition, to the virtues which until now have constituted our security.'

It is significant that, even by 1930, it was still German Modernism rather than world economic crisis which was perceived as the main threat to the security of the decorative arts. The 1929 economic crash was slow to impact on France, in part because of the relatively archaic nature of French industry, typified by the decorative arts which were often funded by private capital rather than institutional credit. A mood of optimism remained throughout 1930 and, after the stabilization of the franc by Poincaré, France was temporarily considered a haven for capital.[11] The delayed impact of the crisis until 1931 might help explain

Left to right: Fruit bowl, flask and tazza by Jean Puiforcat c.1925. During the 1930s, when Puiforcat was a member of the Union des Artistes Modernes, his work represented the continuing paradox within the French decorative arts. He actively embraced geometry and logic, studying Pythagoras and Plato, and he subscribed to the necessity of functionalism, but his medium, silver, was never going to be democratic.

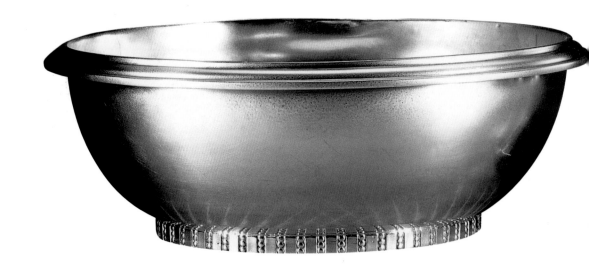

the continuation of the traditional anti-German mindset in the decorative arts (it was the financial implications of the crash which, at this time, pointed many American designers to gravitate towards industry).

So, if the work of Dunand, Expert, Ruhlmann, Süe and other Société traditionalists in the 1930s was still imbued with luxurious and imperial meaning, should the UAM artists be seen as moving towards a harsher Modernism, or as formulating an alternative, yet still essentially decorative idiom? Did they pursue a more radical political agenda, embracing mass production and democratizing Art Deco? Was Mallet-Stevens consciously steering his version of Art Deco to the left, embracing mass production and the social question?

Despite the stylistic rhetoric of functionalism, economic realism remained distant. While economic crisis forced innovation and the commercial development of design in the USA, Mallet-Stevens lamented in 1935 that 'the depression is artistic as well as social'. Indeed, the depression finally engulfed the French economy in 1931, and it persisted until 1938, despite a recovery in the world economy which began in 1935. The crisis had two major consequences for France: the decline of overseas trade, and the onset of a balance of payments deficit. French goods, especially luxury goods, were over-priced in the world market, and exports fell by fifty per cent between 1929 and 1938.[12] Instead of responding with an increased partnership with industry, the UAM continued to survive on funds provided by its wealthier members and the patronage of an evaporating pool of moneyed clients. Mallet-Stevens' connections have been emphasized, and Templier and Puiforcat also provided money, or rather their parents did. Like Mallet-Stevens, Puiforcat displayed avant-garde aesthetic qualities in his work, which appealed to those who were politically avant-garde, but he himself belonged to the *haute bourgeoisie*. Not only was Puiforcat well provided for by his rich parents, he took as his second wife Marta Estevez, the heiress to a Cuban sugar factory. Despite a radical aesthetic, his major patron from 1934 onwards was the Catholic Church, for whom he made chalices, ciboriums, monstrances, candlesticks, fonts and crosses.

On such evidence, one might suggest that the much-heralded ideological split in the Société was merely stylistic. While Mallet-Stevens, Chareau, Puiforcat and others were attracted to the aesthetic of functionalism, they were reluctant to embrace the attendant changes in production. Nevertheless, when viewed side by

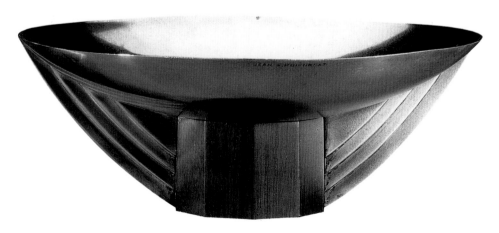

Pierre Chareau's project drawing for the library of a French Embassy, 1925, exhibited at the Paris Exposition of 1925. The palmwood panelling embodied the luxury of 1925, but the almost metamorphic desk suggested an appreciation of the technology and functionalism which was to lead Chareau towards the Union des Artistes Modernes. By 1929 his furniture had acquired a distinctly modernist sense of lightness and angularity.

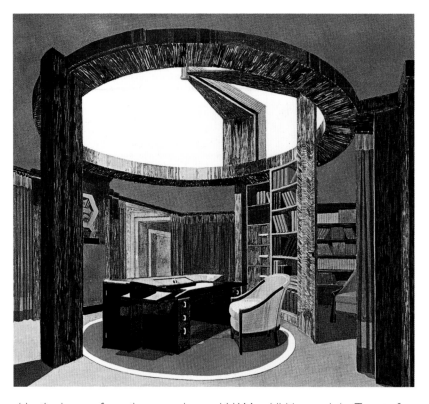

André Arbus's dining room for a residence in the Île-de-France, exhibited in the pavilion of the Société des Artistes Décorateurs at the Paris International Exhibition, 1937. The cabinet was veneered with tortoiseshell and gilt bronze. The glass panel behind is by Paule Ingrand. In 1948 the critic Waldemar George asked of Arbus's interior: 'Are these masterpieces of craftsmanship the leftovers of a bygone era? Not at all. They vouch for man's resistance to the machine. They escape the downward pull of mass production, and the resulting poor quality'.

side, the images from the second annual UAM exhibition and the Twenty-first Salon in the 1931 volume of *Art et Décoration* vividly exemplify the stylistic differences, confirming at least the visual rhetoric of functionalism among members of the UAM. Mallet-Stevens' *Maquette pour un Groupe des Maisons Ouvrières* is austere and rectangular, the jewellery of Fouquet and Templier lacks pretentious elaboration, Chareau's furniture appears compact and unassuming compared to his work of just four years earlier, while the furniture of Barbe and Ginsburger embraces the dreaded Teutonic menace: tubular steel. Even so, in its reluctance to embrace the supposed rigidity of the Modern movement, their work, especially that of the jewellers, silversmiths and *ensembliers* such as Louis Sognot, can be seen as a more austere version of the luxury Art Deco idiom – an essentially decorative response to modernity.

This argument is complicated by the fact that the UAM's political affiliation was decidedly left-wing. The UAM forged close links with the new Popular Front, a governing coalition of three left-wing parties. This can be seen as much in terms of pragmatism as ideology – the UAM wanted influence, and more importantly commissions, and if their rhetoric pleased a sympathetic government, so much the better. Certainly by the time of the 1937 Exposition, there was a public perception of the style of decorative arts that was now in official favour. After visiting the 1937 Exposition, Amedée Ozenfant recorded a sense that:

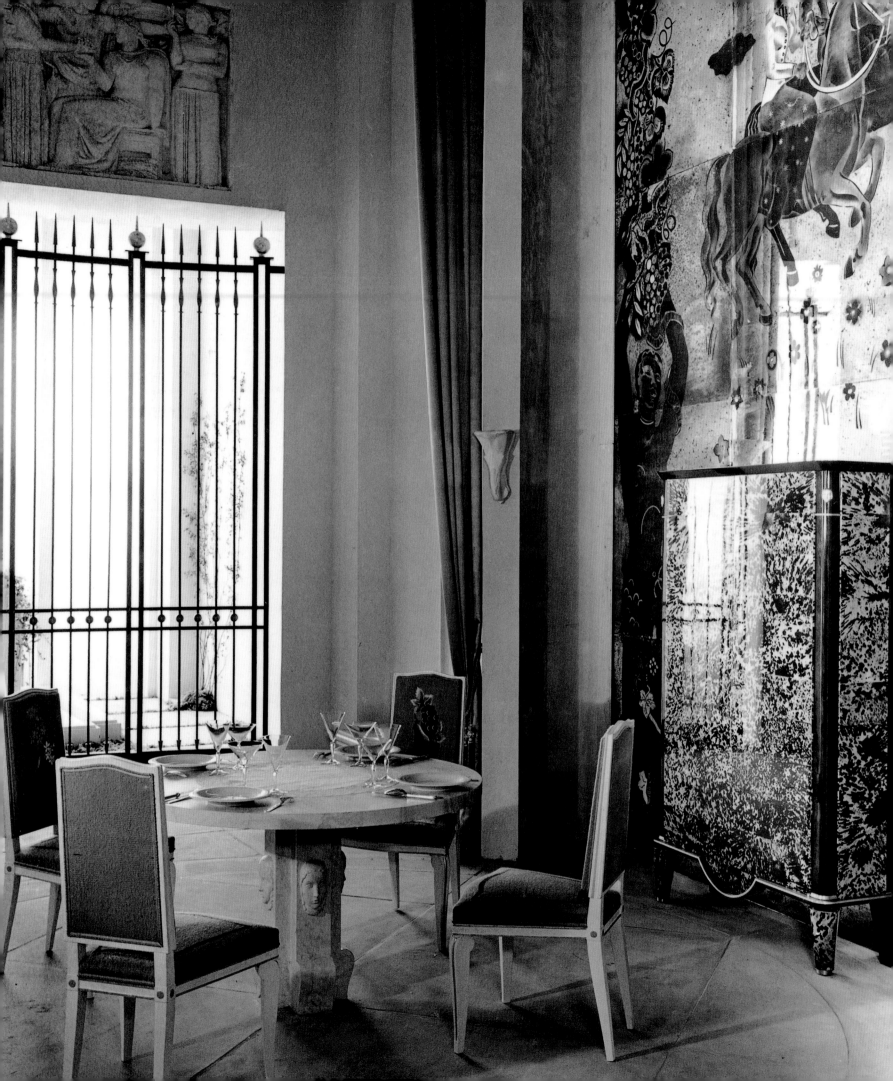

130

Given the state of our tame democracy and its habit of shielding the second rate, the public authorities have gone as far as they could towards the negation or burial of the worst pillars of artistic reaction (though without being able to eliminate those who consider themselves to be among 'the moderns' [i.e. the Société]). Indeed the 'left wing' of the arts, for better or for worse, has never been so firmly and officially supported as now.[13]

With the 1937 Exposition, the UAM and the Société had their showdown on the international stage. As Ozenfant suggested, the UAM had the upper hand in terms of influence. In the early 1930s it was Société members who had been chosen for the 'national project' of the Normandie, but by 1937 the UAM were being given the bulk of the commissions for the Exposition. Robert and Sonia Delaunay provided both the façade and interior murals for the railway pavilion, while Mallet-Stevens was responsible for five pavilions, including the electricity pavilion or 'palace of light', as well as smaller stands for the Brazilian coffee industry and the state-owned French tobacco company.

Although the design of the Société's pavilion in 1937 was austere, its heavy concrete façade was still a world away from the UAM's seemingly flimsy steel-framed Modernism, its lightness emphasized by the steel stilts which held it above the bank of the Seine. The UAM pavilion consisted of a series of light, breezy interiors dominated by the tubular steel furniture of Burkhalter and the sparse style of Herbst and Jourdain, while a display of Modernist graphics suggested the union of disciplines under the banner of Modernism. By this time, however, splits were beginning to occur in the ranks of the UAM. Puiforcat had his own pavilion, which took the form of a chapel, and although he contributed to the UAM exhibition, he was far from satisfied. He lamented to Herbst, 'I have seen the UAM exhibition. Alas the UAM is extinct.'[14] In contrast, the Société's three-storey pavilion struck a predictable note of luxury: 185 artists had contributed to the furnishing and decoration of the 'home of an artist', the 'home of a doctor' and a series of luxury apartments. Dufrène's bedroom appeared to be gravitating towards a kind of surrealist baroque, while Louis Süe's Ambassador's Salon combined overtly baroque fenestration and light fittings with a neo-classical carpet and fireplace. To some extent, the 1937 Exposition can be seen as the end of Art Deco as a recognizable élite style in France: both the Société and the UAM were becoming further removed from their common ground throughout the 1930s of a decorative response to modernity. While Société designers such as Süe and Arbus became more overtly historicist, members of the UAM moved progressively further away from any notion of decoration. The ideological split which had characterized the French decorative arts over the previous decade had finally succeeded in undermining the eclectic Art Deco style which had once served as a bridge between both factions.

This split into two equally extreme positions, coupled with a pragmatic negotiation between commerce, modernity and decoration, also defined the

Poster by Roger Broders for the Vichy Festival Committee, France, c.1930.

Holiday poster for Lake Garda, Italy, 1935.

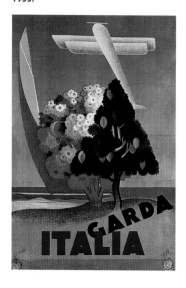

'Groot-Hertogdom', the Grand Duchy of Luxembourg, c.1930. This poster by Rabinger shows how the bridges of Luxembourg enhance the city.

course Art Deco took in other parts of Europe. Even under the apparent cultural monopolism of totalitarian regimes, the style survived in varying degrees – perhaps most successfully in mass-produced commercial ephemera, ensuring Art Deco's popular continuation.

It is to the totalitarianism of Germany, Italy and the Soviet Union that historians usually turn to see art and architecture at their most ideologically loaded. Eric Hobsbawm has isolated 'three primary demands which power usually makes of art': the demonstration and glorification of power itself; the production of politicized public drama; and the provision of 'educational' material or propaganda. Art which does not appear to serve any of these functions is deemed unnecessary, probably subversive, and usually persecuted until suppressed, silenced or exiled.

The apparent paradoxes at the heart of fascism are well documented.[15] It was aggressively revolutionary, yet culturally conservative. It was concerned with the creation of a new order, but employed the bastardized visual language of an ancient one. It desired the fundamentally modern goal of total industrial mobilization, yet its rhetoric was founded on the mythical idyll of a pre-industrial golden age. Albert Speer's monumental German pavilion at the 1937 Paris Exposition combined the imagined grandeur of the Holy Roman Empire with the classicism of Greece, the cradle of the Aryan race. The Italian pavilion looked with hollow pomposity to Ancient Rome, equating *Il Duce's* recent conquest of Abyssinia with an empire that had spanned Europe over a thousand years earlier. Here, in architectural terms, was the conjunction of fascism, decoration and the aesthetic of modernity. Recalling the Swedish pavilion at the 1925 Exposition, it is clear that neo-classicism was accepted by the Exposition committee as being modern, and although it purported to follow quite austere rules, it was undeniably decorative. Similarly, Speer's version of classicism was a form of decorative modernism, albeit sober and forbidding. Hitler had an ambiguous relationship with modernism: as an architectural style it was seen as part of the Bolshevist menace, a view that had been current in some sections of the press before the Nazis came to power. Hans Poelzig, whose early expressionism was so influential on British Art Deco cinema design in the early 1930s, was denounced in 1932 as an 'exponent of an artistically, culturally and ideological left tendency'. Moreover, his work 'declared sympathy for Bolshevism'.[16] The Bauhaus was closed in 1933, and architects such as Walter Gropius and Mies van der Rohe fled to Britain and America. Yet in broader terms, Hitler embraced the technology and the scale of modernity. The *Autobahns* and the mass-production of the Volkswagen car were thoroughly modern projects, and there was still work for a number of Gropius's former associates in the industrial building sector under the Nazis. But although, generally speaking, any aesthetic which was at odds with the officially sanctioned styles of classicism and the rural vernacular was excluded from Nazi Germany, it is important to bear Speer's work in mind when considering the wider impact of classicism on certain versions of Art Deco. The PWA style in the USA and the

Poster by Roger Broders advertising Marseilles as the gateway to North Africa, c.1930.

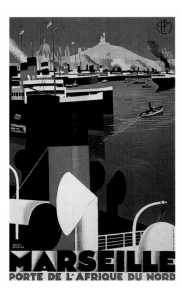

Poster by C. V. Testi advertising an Assembly of the Foreign Avant-garde at the Campo Mussolini, Rome, 28 August-3 September 1932. By the mid-1930s many Italian designers were adopting a more overtly classical style, a trend the state sought to encourage with clients such as the Mostra della Rivoluzione Fascista in 1932, an exhibition celebrating the tenth anniversary of Mussolini's march on Rome.

eclectic version of modernism found in many suburban cinemas until the early 1930s show that classicism could be an expression of modernity, and the monumentalism central to much 1930s architecture also suggests that it would be wrong to consider Art Deco in isolation from Nazi art styles.

Indeed, it is this sense of monumentality which provides further parallels between fascism and international Art Deco. The response of American commerce to the perceived challenge of the twentieth century was the Art Deco skyscraper, which shares with Speer not only scale, but also purpose. It too is an expression of power, albeit commercial. Moreover, the adoption of a stripped neo-classicism as the stylistic language for the municipal building of Roosevelt's New Deal, and the employment of artists to paint ideologically loaded murals depicting the industrial might of democratic America, provides echoes of Speer across the Atlantic (as well as seeming to correspond with Hobsbawm's criteria for totalitarian art). One only needs to look at Ruhlmann's later works and his apparent debt to Carl Horvik's furniture in the 1925 Swedish pavilion, to see that by the 1930s any explanation of Art Deco – particularly its conservative French idiom – must take account of classical influence.

However, while Speer's decorative modernity is relevant to Art Deco, it is too far removed to be included. Classicism was part of Art Deco's eclecticism, but neo-classicism itself is not Art Deco. Italy, on the other hand, had by 1925 already developed the beginnings of an Art Deco idiom which incorporated classicism among other influences. By the time Gio Ponti had won a Grand Prix at the 1925 Paris Exposition, Benito Mussolini had already been in power for three years. Although the rhetoric and imagery of ancient Rome played an important role in his regime, Mussolini never had a clearly defined and dictatorial notion of 'official style'. Simonette Fraquelli has emphasized the role of Giuseppe Bottai, an 'enlightened fascist' who became Minister of National Education, in the survival of pluralism in Italian design under Mussolini. His review, *Critica Fascista*, instigated a debate on the possibility of a fascist art in 1927, and concluded that the fostering of 'Italianness' relied on individual creativity which the state should not undermine by decreeing stylistic preferences. Nevertheless, the existence of an evolving Art Deco style in Italy was a product of the official sanction afforded to the artists and designers of two movements in particular: Futurism and the Novecento.

Marinetti had connections with Mussolini dating from before World War I, and during the 1930s Futurist 'aeropainters' sought official sanction for their mural art. Although Mussolini never officially identified with the Futurists, his tacit acceptance of them is perhaps most evident in the development of Italian graphics during the period. Like Cassandre, Marinetti saw the potential of mass-produced art. On one level he was an aesthetic radical, proclaiming 'I am beginning a new typographic revolution.' Yet, at the same time, he endorsed the totality of public involvement which fascism demanded, and saw advertising

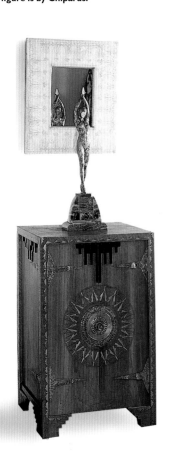

Mirror and cabinet by Carlo Bugatti. The figure is by Chiparus.

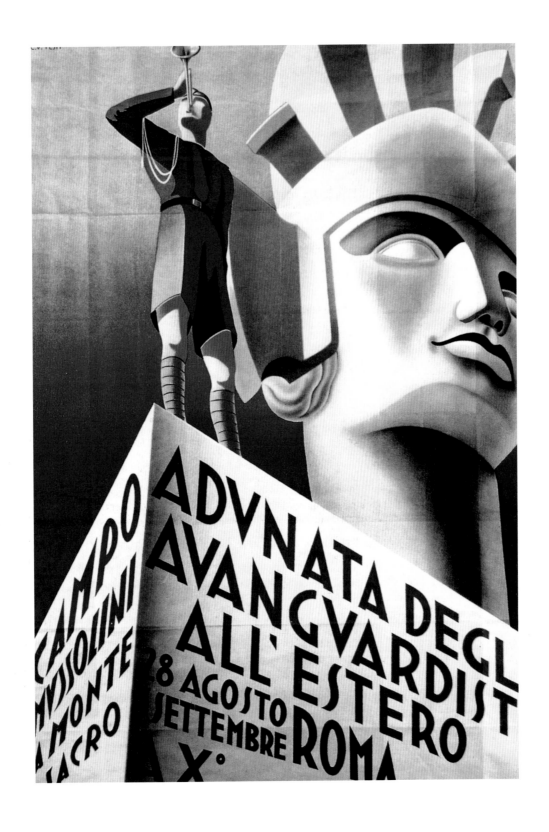

as a way to achieve this. As Steven Heller has argued, 'Marinetti understood the power of advertising, which must reach people at every depth and height, excluding nobody from the cultural landscape.' He quotes a Futurist designer who argued that: 'It is necessary to understand that a good poster and good concept [must] generate … from the very modern brains of new men – every one of them full of the dynamic and fast mechanism of our time, and capable of the most daring experiment of colour and design.'[17]

Thus, by importing Modernist ideas derived from the Bauhaus and combining these with images of youth and speed in the service of both commerce and fascism, an Art Deco graphic style developed in Italy. Fascist magazines, youth handbooks and posters combined abstraction, stylization and simplicity, using sans serif slogans to create modern yet populist totalitarian propaganda. The importance of the image was certainly not lost on the leader of a country where thirty per cent of the population was illiterate in 1921. But fascism was not the only commodity which used Art Deco to sell itself. Countless posters, logos and packaging designs for everything from cigarettes to perfume and clothes were designed in a style which was derived from the Modernist avant-garde, yet was essentially commercial. Moreover, Italian posters were not entirely parochial; they occasionally gained an international audience, as when in 1932 posters by Beremy, Irsai, Richter and others received English coverage in *Commercial Art*.

If the association of Futurism with fascism contributed to an Italian graphic Art Deco idiom, the same can be said of the Novecento and Art Deco furniture. Irene de Guttry and Maria Marino's survey of inter-war Italian furniture reveals the kind of wide-ranging decorative experimentation and luxury also found in French decorative arts of the 1930s, again confirming the aesthetic eclecticism that flourished under Mussolini until the late 1930s. 'Luxury,' wrote Gio Ponti, 'puts the designer's skills no less to the test than economy.' Ponti and other Novecento designers pioneered an approach to decoration that produced two distinct styles: a traditional idiom which would not have looked out of place in the Société's Salon (for example the work of Tomaso Bruzzi); and a more Moderne streamlined, almost American aesthetic (as purveyed by Goetano and Osvaldo Borsani for the *Atelier di Varedo*). The inherent contradictions of Art Deco were played out in Ponti's approach to

Jewellery cabinet on a stand, designed by Gustavo Pulitzer, 1927, of walnut, zebra wood and rosewood inlaid with maple. The inlay is a stylized reference to Botticelli's *Birth of Venus*, a combination of old and new which came to characterize the work of the Novecento designers.

furniture. His daughter recalls how, 'at the fourth Triennial in Monza in 1930 it was the "Palladian" Gio Ponti who promoted the "Electric House" designed by the young Rationalists Figini and Pollini, while he himself was represented by the neo-classical Vacation House. That was the way Gio Ponti worked.'[18]

Like the Futurists, the artists and designers of the Novecento had courted fascism and found favour because of their modern interpretations of 'traditional' Italian themes. Together with Ponti and the designers Emile Lancia, Venini and Chensia, Buzzi formed 'Il Labinnto' in 1927. The group aimed to promote the spread of domestic modern decorative arts, and they exhibited collectively at the third Triennial in Monza in 1927. Yet their modernity was expressed firmly in neo-classicism, and their pieces were characterized by an elegant, delicate simplicity of line with piping and pseudo-classical decorative motifs.

While Buzzo and Ponti continued in this vein of Art Deco into the early 1930s, by the fourth Triennial in 1930, again held in Monza, an alternative Italian version of Art Deco can be seen to be evolving. It is one which loosely equates with the aesthetic of the UAM in Paris, as well as increasingly Moderne American style. The furniture of such designers as Alfio Fallicia employed a much heavier, curvilinear style, while the Altier di Varedo stand at Monza in 1930 contained furniture united by an emphasis on horizontal lines; the Moderne eaves of the entrance itself echoed the curved arms of the chairs. By 1931, Ponti was designing a series of pieces of 'exceptional furniture' – topped with mirrors or made entirely of glass – for Fontana, a company for whom he later designed a wide range of objects including paperweights and light fittings.

That Paris had remained a source of inspiration for Italian designers was borne out in 1938 when its influence came under vitriolic attack because of its 'Jewishness'. This 'problem' had been identified in the new Racial Laws of that year which heralded a closer relationship with Germany, but it was a perception that had a longer history. In his 'Defence of Modern Art' in *Critica Fascista*, Bottai admitted that 'the tendency of Italian artists to seek intellectual refreshment in Paris has long been polemically called the "Parisian disease",' but he remained unsure as to whether 'the Parisian experience [had] been a mere motive for artistic exercises, or so strong an impression as to alter the Italian nature of their character for good.'[19] Bottai's apparent unwillingness to reject charges of the 'Parisian disease' confirms both the perceived internationalism of Art Deco, and the radical modernism of Italian Rationalism and its prevalence in 1930s Italy.

The existence of a vibrant Italian Art Deco tradition under Mussolini can be contrasted with the rise of rationalist Modernism which, in architectural terms at least, triumphed in northern Europe in the 1930s. In the Netherlands, this was at the expense of the plasticity and expressionism of the Amsterdam School, while in Scandinavia its ascendancy can be seen as a natural progression from the ordered serenity of 1920s neo-classicism. Similarly, the ascendancy of avant-garde tendencies in graphics, especially in Holland, has often been emphasized.

Poster advertising Bugatti automobiles.

The incredibly rich tradition of the Dutch avant-garde – of De Stijl, Wendigen and the Constructivists – has captured the attention of scholars at the expense of a more pictorial, less radical, but nevertheless more typical commercial Art Deco idiom which evolved in the 1930s. According to Alston W. Purvis, 'poster design in the Netherlands … for the most part remained outside the mainstream, often constituting a style within itself.'[20] Examples of publicity for left-wing political parties and avant-garde cultural events are rightly cited here. But Holland was certainly not immune from what Modernist historical narratives describe as the 'bland commercial internationalism' of Art Deco. The reality, as Steven Heller reminds us, was that, 'as elsewhere in Europe, Art Moderne in Holland was exuberant'. Following Cassandre's forays into the Low Countries, many Dutch artists looked towards France, when it came to commercial work. Cassandre designed posters for Phillips, Van Nelle and Broste, commanding fees of around 1,000 gilders, between five and ten times the usual Dutch fee, and Dutch artists such as Wijia, Jac Jongert, Wim ten Broet and Adrian Joh. Van't Hoff embraced a similar style – more representational and unequivocally decorative than the avant-garde. Again, as in Italy, Art Deco evolved into a brand of popular decorative modernism, achieving widespread use and visibility through posters and commercial packaging.

In order to focus on the overtly decorative elements in Dutch architecture following the 1925 Exposition, it is necessary to begin where we left off in Chapter 1 – with the Amsterdam School. Although the decorative excitement of the School began to wane towards the end of the 1920s, such architects as J. F. Staal moved closer to Mallet-Stevens than Corbusier. Despite a move towards Modernism, the continuing preference for brick tempered any austerity of line. The obvious influence of Frank Lloyd Wright on architects such as W. M. Dudok moderated this brand of Dutch modernism, placing it somewhere on the periphery of Art Deco in the French sense, closer to the restrained modernism of suburban Britain. Architects such as J. Wils progressed from a pseudo-prairie style in the 1920s to an austere brick Moderne style typified by his Citroën garage in Amsterdam (1929–31). This building, like the British Odeon cinemas of the later 1930s, straddles the blurred divide between Moderne Art Deco and the strict rhetoric of Modernism. The garage is austere and unadorned by applied ornament; yet its 'functional' status is ambiguous: is its shape purely functional, or does its curvilinear element serve to make its form inherently decorative? While pure Art Deco is concerned with applied decoration, its Moderne idiom utilizes the decorative nature of form to create an illusion of functionalism, which like Puiforcat's silver is more concerned with aesthetics than rationality.

Two other Dutch decorative architects who dabbled on the fringes of Art Deco were Sybold Van Ravesteyn and F. P. J. Peutz. Peutz seems to have been the Dutch equivalent to Oliver Hill, 'turning out buildings in any style the client required from neo-classical to Queen Anne'.[21] Despite, or perhaps because,

'The Papermill'. Catalogue cover for a Dutch paper manufacturer, 1933.

The Café l'Aubette in Van Doesburg's Strasbourg entertainment complex, designed together with Jean Arp and Sophie Täuber-Arp, 1926–9.

of this, some of his houses in the early 1930s such as 'Casa Blanca' (1929–32) in Houthern and the house on De Linde in Heerlem (1931) echo Mallet-Stevens and André Lurçat. Peutz and Van Ravesteyn, whose style approximated a neo-baroque idiom, were seen to advocate an alternative to the De Stijl-inspired Dutch modernism heralded by Van Doesburg, Rietveld, Oud and others from the mid-1920s onwards. In this context, it is worth drawing attention to one example of Van Doesburg's work in the later 1920s which relates quite closely to Mallet-Stevens' sets for L'Herbier's films. The interiors of his entertainment complex, L'Aubette, Strasbourg (with Hans Arp and Sophie Täuber Arp) followed the colour-painting of building surfaces – 'une chambre de fleurs' – in the villa which Mallet-Stevens had just built for the Vicomte de Neuilles.[22] Van Doesburg's Strasbourg complex has been described by the architectural historian Joseph Buch as 'one of the most eloquent architectural expressions of the "jazz age" … the Midway Gardens of its era.'[23] The walls, floors and ceilings were coloured in a Cubist manner and the designs were echoed in the coloured glass and stairway railings.

If the transition from tradition to Modernism was both ambiguous and varied in the Netherlands, the same can be said for Sweden's move away from the classicism of the 1910s and 1920s to the functionalism of the 1930s. While the Stockholm International Exhibition of 1930 demonstrated the architectural triumph of Modernism in Sweden, the decorative arts displayed there, and the glassware in particular, show the continuation of a distinct Art Deco idiom. The glass manufacturers, led by the firm of Orrefors and including Kosta, Eda and Gullaskruf, continued to produce ornamental glass with stylized Art Deco motifs. Some of the glass manufacturers had direct links with Paris; one of Kosta's artists,

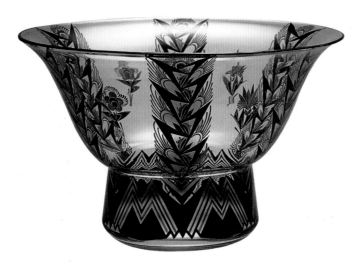

Josef Eiselt, glass bowl painted with enamel, Czechoslovakia, 1925.

Sven Erixson, lived there and sent his designs back to Sweden regularly, and such artists as Simon Gate and Edward Hald were still producing modern yet classical geometric forms decorated with figures and stylized buildings.

The economic problems that beset Swedish glass manufacturers at this time are exemplified by the experience of Limmared, who produced an adventurous range of perfume bottles designed by Edvin Ollers in 1930. Their geometric form and decoration in the Moderne style were aimed at the international consumer, but they found themselves hopelessly over-priced in a market which had been revolutionized by cheaper bottles with Bakelite screw-tops. Nevertheless, the Swedish decorative arts were well received abroad. Sweden was the first foreign country to display its industrial design at the Metropolitan Museum of Art in New York, and one English critic dubbed its increasingly modern style of industrial design 'Swedish grace'.

At the 1925 Paris Exposition the Dutch, and to a lesser degree the Swedes, had displayed modern interpretations of traditional folk art, a theme which they shared with the Polish, Czechoslovak and Austrian pavilions. In the light of the apparent dual triumph of the Moderne and the rational styles in the Netherlands and Scandinavia in the 1930s, it is interesting to look at the development of Art Deco in Central Europe, an area which was still dominated by the political upheaval following the collapse of the Austro-Hungarian Empire in 1918. Central to the story is the painfully drawn-out demise of the Wiener Werkstätte in the years following the 1925 Exposition. Since the Werkstätte is widely accepted as having stylistically anticipated Art Deco, why did it lose momentum, first to Paris and then to America? And what can the circumstances of its demise tell us about the wider ideological context of Art Deco in the late 1920s? Finally, what can the nature of the work produced in these final years reveal about the state of modern decoration in Central and Eastern Europe after its appearance at Paris in 1925?

Josef Eisèlt, glass jar with lid, painted with enamel, Czechoslovakia, 1924.

The answers to the first two questions form part of the same story, and reveal a number of parallels with the ideological battle between the Société and the UAM in France during the later 1920s and 1930s. Like the Société in the aftermath of the 1925 Exposition, the Werkstätte had also experienced ideological and aesthetic tensions between decoration and austerity, art and industry. But the outcome had been determined as far back as 1907 with the departure of Koloman Moser, the standard-bearer of the austere tendency. From then on Hoffmann's position had prevailed, and the Werkstätte followed the same ideological route which the Société members were to tread nearly twenty-five years later. In the same way that the Société was to defend luxury, Hoffmann pronounced that 'it is no longer possible to convert the masses … But then it is all the more our duty to make happy those few who turn to us.'[24] Of course, the members of the UAM would have been more honest and realistic had they admitted the same thing but, unlike the UAM, Hoffmann's economic defeatism led to a stylistic regression which entailed first an increasing emphasis on decoration and finally, by the late 1920s, a largely craft-inspired idiom.

The Werkstätte made no attempt to embrace industry, instead concentrating on 'promoting good-quality, beautiful work'. 'We sought only the best materials,' boasted Hoffmann. However, this approach required money, and an unwillingness to cut prices at the expense of craftsmanship resulted in high prices and the need for the backing of sympathetic financiers who did not expect returns on their 'investment'. Such backers were initially found in the Primaseri family but later, after their unflagging support led to bankruptcy, Philip Häusler induced the Werkstätte to struggle on long past the point where it was viable, leading to its final collapse in 1932. Although the Werkstätte had exhibited in the Austrian pavilion in 1925, the general reception was lukewarm, and increasing financial woe only hastened the recourse to the craft aesthetic. Faced with defeat, many artists fell back on the folk idiom; as Jan Kallir suggests, 'as the flow of silver and gems ebbed, so the artists used wood, beads and ceramics.' The closest Hoffmann ever came to industrialization was a toy factory he produced in 1920 – things were becoming increasingly 'petty and pretty'.[25]

Yet the folk-inspired idiom had been accepted as modern by the organizers of the 1925 Paris Exposition. It was a decorative response to modernity through an attempt to synthesize the modern and traditional. Furthermore, it was a forward-looking aesthetic, embodying the hopes and uncertainties of what were essentially new nations. The case of the Werkstätte was different, because hindsight told contemporaries that its aesthetic was one of retreat. Vienna had been the fount of modernity in the early years of the twentieth century but had failed to rise to the never-ending challenge of modernity, the challenge to change. This was not entirely the fault of Hoffmann, Peche and his successor Zimpel – circumstances conspired against them. Austria was not only defeated in 1918, her European empire was decimated and much of the Werkstätte's glass and ceramics

140

capacity found itself behind the borders of the newly formed Czechoslovakia and Hungary. Moreover, rampant inflation curbed the spending power of the bourgeoisie, the Werkstätte's traditional constituency, and illness and emigration took its toll on the artists and designers: Peche and Zimpel both died young, Hoffmann was periodically ill throughout the 1920s, and the ceramicist Vally Wieseltrier left for America in 1929.

Given the economic and aesthetic collapse of the once-influential Viennese, what did the post-1925 period hold in store in terms of Art Deco for Austria's neighbours? Both Poland and Czechoslovakia had provided examples of folk-based Art Deco in 1925, and this idiom persisted, although there were also signs of infiltration by a more international Moderne aesthetic. In Czechoslovakia, designers such as Frantisek Novak, who had been associated with an ornate folk-baroque Art Deco hybrid in 1925, began to adopt a simpler, Moderne style for their interiors by the late 1920s. Novak had earlier used stout, almost functional, stools in a room with wallpaper which drew on abstract folk tapestry designs of the time, but by 1936 his furniture had attained a much lighter, unambiguously modern style using plywood to attain a more streamlined aesthetic. In the field of mass-produced ceramics, the UDM company was producing thoroughly modern tablewares, although they had lost much of the angularity which characterized ceramics during the brief Czech Cubist episode. However, it was glass manufacture for which Czechoslovakia, drawing on its Bohemian heritage, had been traditionally celebrated. In this field, although designers such as Josef Dranhonovsky were working in a more identifiably international Art Deco style by 1928, the majority of Czech Art Deco glass remained closer to a folk tradition than to contemporary French, Swedish or American work. Decoration was abstract yet heavy, and forms were largely traditional, compared with the delicacy and stylization of the Orrefors glass manufactory.

In Poland, a similar story emerges, although, on the admittedly limited evidence available, it seems that there was a burgeoning Art Deco culture among the bourgeois political élite in Warsaw. Nevertheless, the overall aesthetic contradictions between the modern and the traditional mirrored the socio-political situation in Poland's Second Republic. 'Inter-war Warsaw', wrote Norman Davies in God's Playground, 'possessed an unmistakable bitter-sweet quality. It was characterised on one hand by the sad realisation that the appalling problems of poverty, politics and prejudice could not be alleviated with existing resources ... [but] the Polish bourgeoisie relished the city's profitable metropolitan role.'[26]

The aesthetic split is exemplified by the competing idioms in Polish poster design. In the mid 1920s, posters for the 1925 Paris Exposition and for the Domestic Exhibitions in Poznan in 1927 and 1929 used geometric forms derived from the folk tradition, while posters for sport, tourism and travel by Warsaw architects and graphic artists, such as Pictrowski and Osiecki, embraced the French style. Indeed, Tadeus Gronawski, the most prolific Polish Art Deco graphic

Stefan Osieki and Jerzy Skolimowski, poster for Zakopane Ski Festival, 1929. Graphic abstraction is here being used to advertise an event in the town which is still recognized as a centre for Polish folk art. Although the typeface is a modern sans serif one, it retains a hint of the folk styles which Polish Art Deco continued to draw upon.

artist, whose work included countless magazine and book covers, owed a direct debt to Dupas and Cassandre. However, in broader terms the folk tradition was enshrined in the Polish decorative arts; in 1926, the Co-operative of Artists and Artisans was founded and thrived throughout the 1930s, aiming to 'design and execute objects in wood, fibre, metal, clay and glass … all possible handicraft objects.' The predominance of kilims and Jaquard loom products exemplified the use of modernistic angular motifs within a modified folk idiom. Yet the obvious problems of an over-emphasis on a tradition peculiar to Poland came to the fore when catering for export markets. Ceramic factories such as Cmielow moved away from traditional decoration and embraced more angular designs in the 1930s, and the increasingly pan-European nature of Art Deco is emphasized anecdotally by the success of one Polish glassmaker abroad as recalled by a friend: 'One day Bronislaw Stolle, while paying one of his numerous visits to Paris saw his glassware in the *Galeries Lafayette* stand; he was surprised by the improbably high price and so asked for an explanation. The shop assistant, pointing to the firm label, said, "*Cela n'a rien d'etonnant Monsieur, donc c'est Stolle.*"[27]

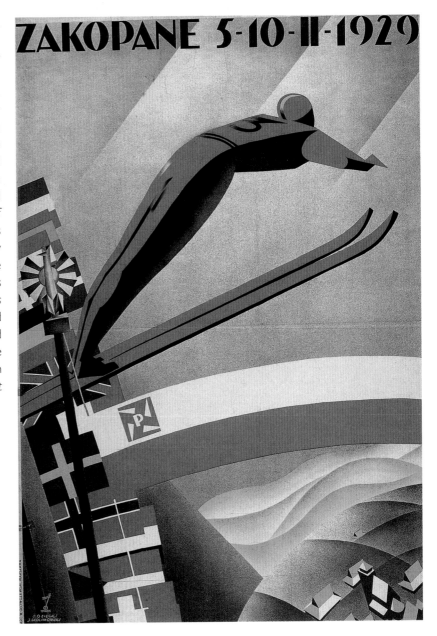

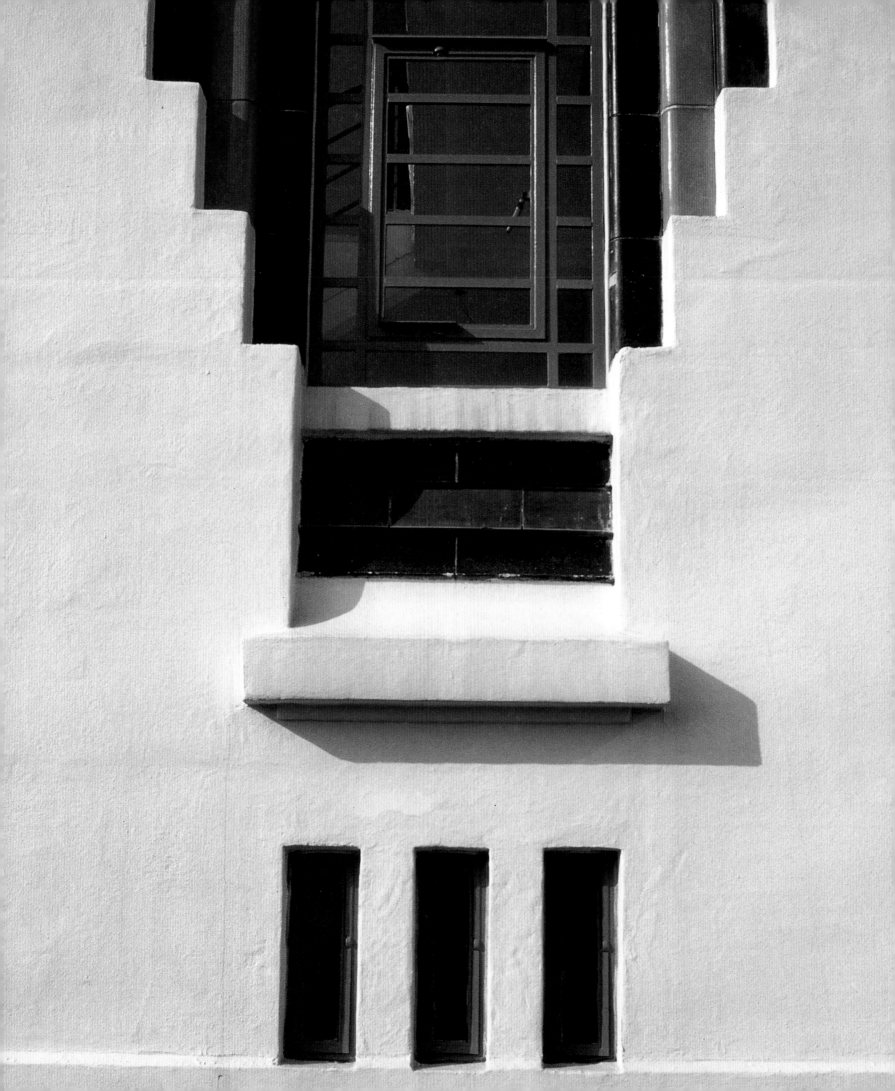

DILUTED DECO: THE BRITISH AFFAIR WITH THE MODERNISTIC

ubism, Constructivism and Futurism are hard, but Art Deco is supremely easy. Its subject matter is often technological, and its rounded forms hum like vague generators, or reproduce exactly cars, ships and planes. But Art Deco turns machines into comfortable jokes, presents them pot bellied and lazy-looking. Airplanes with clocks or radios in them, racing-car teapots and parachute lampshades make all noise toy size. When it is more serious, the style turns bland and the imagery recessive, causing even sunbursts of energy to feel cool and reptilian carried out in stainless steel and onyx, a myth of machine men not heroic machines, which echoes technological innovation fawningly.

Robert Harbison, *Eccentric Spaces*, (1977)[1]

Left: detail of the Hoover Building, Perivale, London, 1932–5, designed by Wallis, Gilbert & Partners.

Right: English wallpaper design from the 1930s, artist unknown.

Although many English commentators appeared sympathetic to the aims of the 1925 Paris Exposition, they were by no means all enthusiastic. 'The general impression gained of the Exhibition,' claimed the Paris correspondent of *Drawing and Design*, 'is that it is really a gallant effort that has been made to find a novel style of architecture and decoration and that this effort has greatly failed.'[2] The conservative nature of the British pavilion pleased those who balked at the frivolity of French decorative experimentation, yet those concerned with design reform and the competitiveness of British industry were less impressed by this failure to present good modern design in Paris. The impasse in the British decorative arts was variously blamed on the education system, the government and the tastes of the British public. Given the hesitancy of the government in embracing the French rules for the Exposition, the final appearance of the pavilion is hardly surprising:

> It is laid down in the French authorities' regulations that the exhibition is confined to articles of modern inspiration and real originality. These words do not mean that exhibits will only be admissible if they are entirely novel in design. Originality, it is clear, may be displayed as much in the development of existing art-forms as in the invention of the entirely new. The term (originality) should, therefore, be interpreted in a liberal sense, as indicated above.[3]

The apparent nervousness with which the British rushed to clarify radical concepts such as 'modern' and 'originality' is reflected in the interiors, designs and objects which went to make up the British pavilion. The pavilion building was designed by architects Easton & Robertson and the interiors decorated by Henry Wilson. The rooms were dominated by displays of heavy furniture, calligraphy and tapestry resulting in an aesthetic more reminiscent of a heraldic festival than an exhibition of modern industrial arts. Many British observers faithfully praised the stout conservatism and stunted adventurism of the British pavilion. *Drawing and Design* told its readers that 'the designers have caught the exhibition spirit and produced a work that strikes a note of gaiety, modern yet suggesting a traditional influence.'[4] But yet another observer noted how, 'the British Pavilion stands out for its dour heaviness and its uneasy hybrid of gothic and colonial influences.' Frank Scarlett and Marjorie Townley were both on the staff of the British section, and their memoirs recall the pavilion with a sense of disappointment:

> Entering under a fanciful parabolic arch into a vestibule flanked with Mycenahaeon ceramic columns one was confronted with a perspective seemingly of nave and aisle, of which the focal point was a Pieta by Reid Dick … This was the Kitchener memorial now in St Pauls Cathedral, and although imposing it was surely neither industrial nor decorative … it was hardly 'modern' in the sense intended. It is hard to understand why such emphasis should have been given to the ecclesiastical arts, particularly as the exhibits chosen were not on the whole very original. The most probable reason is that they were thought to represent the most significant art and craft work of the time, and, although this may well

The British Pavilion designed by Easton & Robertson at the Exposition des Arts Decoratifs, Paris, 1925. The exterior was a bizarre concoction of Gothic and colonial styles, while the interior, designed by Henry Wilson, has an almost ecclesiastical feel. The building can hardly have compared favourably with the French pavilions as a showcase for new national design.

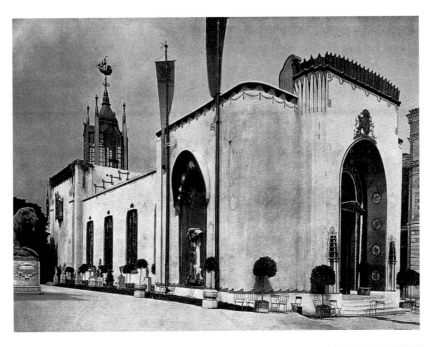

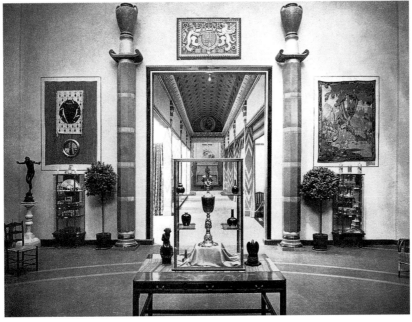

have been true, one cannot avoid the dispiriting conclusion that the arts, particularly the industrial arts, were in a pretty bad way in Britain at this time.[5]

In a sense, the struggle between the aesthetics of modernity and traditionalism which continued in Britain throughout the 1920s and 1930s found its first expression in Paris in 1925. However, to assess the extent of the spread of a popular modern, or Art Deco, style in Britain it is necessary to understand the background to this struggle. We have already seen the many varied responses to the pressures and inspirations of modernity in the European decorative arts, which were developing at the same time as the Modernist functional aesthetic. Some of these movements were stylistically novel as well as decorative, while others – notably the classically inspired tendencies in Italian and Swedish design – harked back to historical styles. It is perhaps in England, however, that the greatest surge in modern historicism can be located.

The cartoons and writings of Osbert Lancaster satirize a trend which frustrated design reformers and proponents of all forms of modern design equally. It was the expansion of suburbia, particularly in the South East of England, which provided the 'moderns' with an unending supply of ammunition with which to attack the taste of the relatively affluent lower middle-class English public. The speculative building which took place between the wars has been labelled 'the great final period of unplanned suburban expansion',[6] and it produced what Orwell saw as 'the huge peaceful wilderness of outer London ... sleeping the

'By-pass Variegated', cartoon by Osbert Lancaster, 1938. 'Notice the skill with which the houses are disposed, that ensures the largest possible area of countryside is ruined with the minimum of expense.'

'Stockbroker Tudor', cartoon by Osbert Lancaster, 1938. 'All over the country the latest and most scientific methods of mass production are being utilized to turn out a stream of old oak beams, leaded window panes and small discs of bottle glass.'

deep, deep sleep of England'. From 1923, the number of new, private-sector homes built in the London area rose to an average of 6,000-a-year. Growth continued in the 1930s as the South East escaped the worst of the Depression. Between 1933 and 1934, 73,000 homes were built in a twelve-month period. The new suburbs, ranging from Croydon, Morden and Wandsworth to the south of London, and Harrow, Finchley and Edgware to the north, saw the growth of a sea of detached and semi-detached homes in an amalgam of styles characterized by Lancaster as 'By-Pass Variegated':

> If an architect of enormous energy … had the assistance of a corps of research workers ransacking architectural history for the least attractive materials and building types known in the past, it is just possible, although highly unlikely, that he might have evolved a style as crazy as that with which the speculative builder, at no expenditure of energy at all, has enriched the landscape on either side of our great arterial roads.[7]

The more up-market, middle-class, rural suburbia of Surrey and Sussex had an even more distinctive historical vocabulary. The vogue to recreate a pseudo-Elizabethan suburban façade was branded by Lancaster 'Stockbroker Tudor', while he attributed an anonymous song to the estate agents of Sussex:

> Four postes round my bed,
> Oake beames overhead,
> Olde rugs on ye floor,
> No stockbroker could ask for more.[8]

The paradox was obvious. In an attempt to provide the ideal modern, comfortable family home, the builders and the house-buying public were turning to a seemingly bizarre blend of historicism and modernity. The Modernist ideal

of industrially produced architecture and design was being transposed on to the manufacture of reproduction period furniture and fittings. The irony was not lost on Lancaster:

Not even the First World War and its aftermath could sensibly diminish the antiquarian enthusiasm which had gripped the English public in Victoria's reign … the experience gained in aircraft and munition factories was soon being utilised in the manufacture of old oak beams, bottle glass window panes and wrought iron light fittings.[9]

The result was 'a glorified version of Ann Hathaway's cottage' where 'electrically produced heat warmed the hands of those who clustered enthusiastically round the yule logs blazing so prettily in the vast hearth', and 'from the depths of some old iron bound chest came the dulcet tones of Mr Bing Crosby or the old world strains of Mr Duke Ellington.'[10] Yet as this caricature suggests, the embracing of pseudo-historicist architecture and design did not mean a rejection of the increasingly widely available benefits of 'the machine age'. So although the 'conservative modernity' which produced 'Stockbroker Tudor' was a powerful force in marginalizing modern styles when it came to domestic architecture, it did not follow that Art Deco, and later Moderne, design was totally rejected in Britain. What it did mean was that in locating the development of the style in England, it is necessary to look in two places: first, the domestic interior; and second, high-street architecture, advertising and commercial and retail interiors.

Despite the enduring success of historically-derived style throughout the period, there was – as in Europe and America – a small yet important tradition of modern decoration in Britain which contributed to the alternative form of Modernism which Art Deco was to become. Two unique and contrasting examples will serve to illustrate this tradition: the decorative work of Charles Rennie Mackintosh and the proponents of the 'Glasgow Style'; and the furniture and interiors of the short-lived Omega Workshop in Bloomsbury. Both had an admittedly limited initial impact, but both approached the challenge of modernity with a decorative solution.

Roger Fry's Omega Workshop was a firm of 'Artist Decorators' whose activity spanned the years 1913–20, and whose varied output was famously typified by Fry's gaudily painted furniture. The painting is often representational and derivative of a Post-Impressionist style, while the rhetoric of modernity in the firm's literature has its roots in the nineteenth-century Arts and Crafts movement's suspicion of mechanization and its belief in art for all. In a Workshop catalogue, Fry proudly announced of his artists:

They refuse to spoil the expressive quality of their work by sandpapering it down to a shop finish, in the belief that the public has seen through the humbug of machine made imitation works of art … They try to keep a spontaneous freshness of primitive or peasant work while satisfying the needs and expressing the feelings of the modern cultivated man.[11]

The significance of Omega's approach in the decade prior to the flowering of Art Deco is twofold. Although the forms used are largely traditional (much of the painted furniture was actually second-hand), the fact that such conspicuous and unfamiliar decoration was deemed necessary to cater for 'the needs and the feelings of the modern cultivated man' presents us with a clear alternative to notions of functionalism and 'inappropriate' decoration, as well as providing an early example of an attempt to apply, albeit crudely, the ideas of modern art to domestic objects. Moreover, although on the whole the decoration is far from being Cubist or geometric, there are at least two pieces of Omega furniture employing an embryonic Art Deco decorative vocabulary. The first is a painted wood and upholstered chair made by A.H. Lee & Sons of Birkenhead in 1913; its 'Cracow' pattern upholstery features a compact abstract repeat, while the painting on the chair consists of angular lines and small dots, reminiscent of an Olbrich architectural drawing. The second, a dressing table of 1919 made by L. Kallenbourne Ltd, is clothed in geometric patterning made up of veneers of ebony, walnut and sycamore, perhaps the archetypal decorative technique in Art Deco furniture.

To illustrate Charles Rennie Mackintosh's decorative work within the context of the 'Glasgow style', two examples will suffice. For Nikolaus Pevsner, Mackintosh was a pioneer of Modernist austerity, but David Brett's psychoanalytic study of Mackintosh's decorative style places it instead at the culmination of the nineteenth-century challenge to find a contemporary idiom.[12] According to Brett, Mackintosh's modern decorative style grew out of his artistic training, rather than any theoretical architectural quest. Thus the stepped decoration above the entrance to the 1907–9 library wing of the Glasgow School of Art (Mackintosh had designed the main building in 1896) is not part of the rejection of ornament. It is part of a new decorative idiom with a traditional lineage exemplified by Mackintosh's stylized thistle; an idiom which informed the work of later decorative Modernists.

A further example of Mackintosh's decorative modernity can be found in his remodelling of W.J. Bassett-Lowke's house, 'Derngate', in Northampton in 1917. The decorative and colourful interiors of 'Derngate' have often been seen as a progression in Mackintosh's aesthetic, partly due to the close involvement of the client in the design, but more significantly because of the designer's move from Glasgow to London. Basset-Lowke specified a 'severe and plain' design; however, rather than promoting a rejection of decoration, this resulted in modern, geometric decorative techniques. The walls above the fireplace were far from plain, and the decorative detail on the wooden sofas shows the use of symmetrical pattern, including tiny stepped motifs reminiscent of the Glasgow School of Art doorway.

While Fry, Mackintosh and the other 'Glasgow style' designers illustrate vastly differing approaches to design, they share a role in the development of a decorative response to modernity in Britain which – if in a much less glamorous

150

Below: Dressing table of holly veneered in walnut, sycamore and ebony, designed by the Omega Workshops and made by J. J. Kallenborn Ltd, *c.* **1919. The combination of geometric forms and a purely decorative veneer show the existence of an Art Deco idiom in Britain before the 1920s.**

Right: The distinctive stepped shape above the west door of Charles Rennie Mackintosh's Glasgow School of Art, 1907–9.

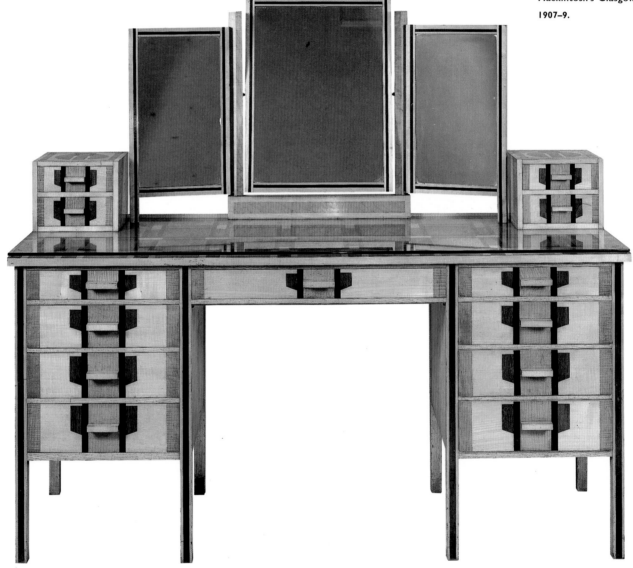

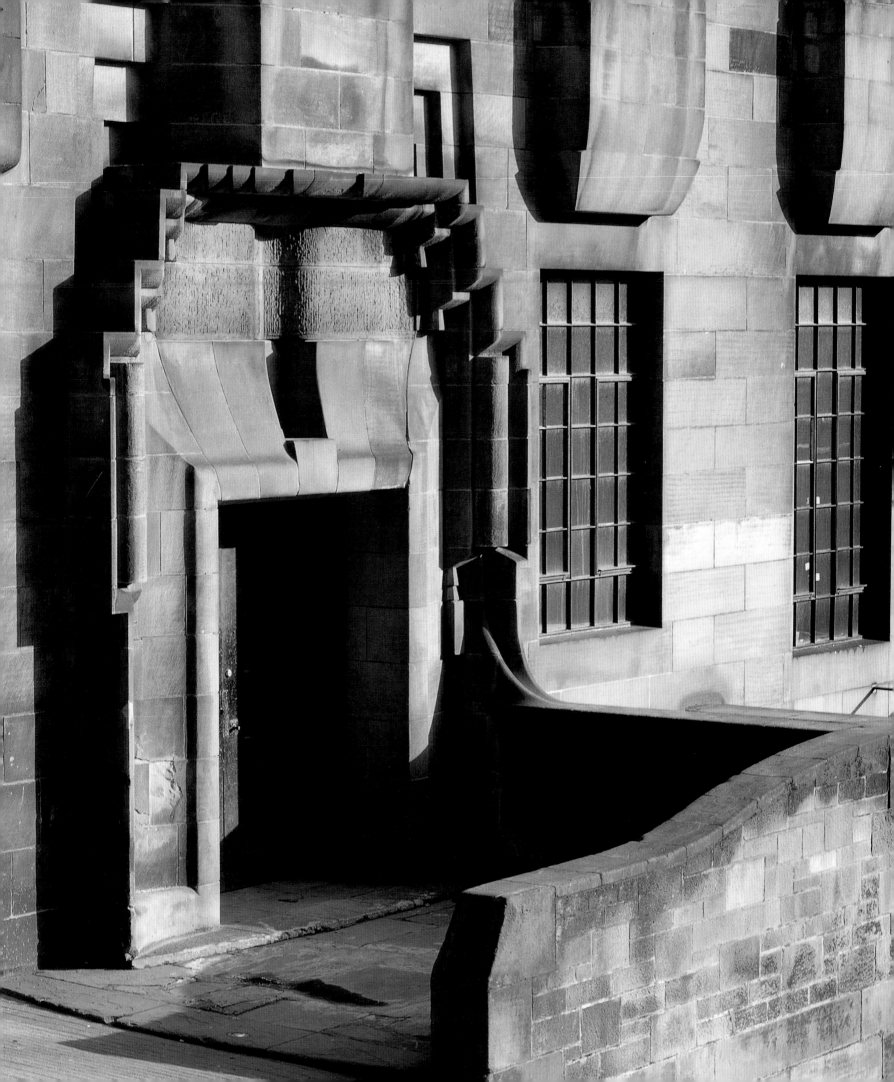

152

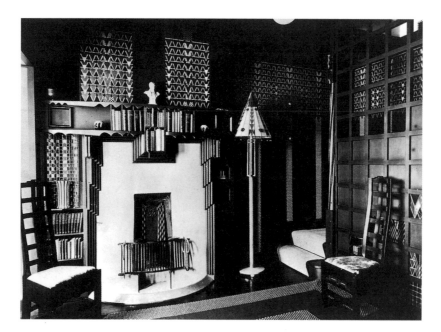

The hall of 78 Derngate, Northampton, which Mackintosh remodelled in 1916–17. The stepped wooden fireplace echoes the door of the Glasgow School of Art; the triangular motifs of the wall stencils are repeated on the lampshade.

fashion than either France or America – continued through the inter-war period. This is not to say that either were as directly influential as the 1925 Paris Exposition, yet they serve to illustrate the existence of a tradition of British designers addressing the challenges of modernity and the quest for appropriate decoration.

Bassett-Lowke was also the patron for whom what is considered to be the first Modern movement house in Britain was built. He had lost contact with Mackintosh, who had moved to France, and later recalled that he 'could not find any other architect with modern ideas in England, and when looking through a German publication called *Werkbund Jahrbuch* of 1913, I saw some work by Professor Peter Behrens which I thought was very simple, straightforward and modern in its atmosphere.'[13] Bassett-Lowke subsequently commissioned Behrens to design a house for him, and 'New Ways' was built, again in Northampton, in 1926. Like Mackintosh, Behrens has been seen as a Modernist pioneer; however, the interiors of 'New Ways' show a distinctive approach to decoration, rather than a Modernist hostility to ornament which the exterior of the house might seem to betray. The fireplace, ceiling, lighting and stained glass of the lounge are the kind of geometric, angular yet unquestionably decorative features that were to become frowned-on as the attitudes of the Modern movement hardened. Yet the fact that Behrens retained his 'pioneer' status, while at the same time appearing to work within the Art Deco tradition of decorative modernity, may suggest that the dichotomy between the two traditions has been over-emphasized by art historians. There is no doubt that the Modern movement, especially in Britain, did have its aesthetic hard-liners, whose radicalism was abhorred by the architectural establishment. 'It has spread like a plague to this

Black lacquered settee by Charles Rennie Mackintosh, for 78 Derngate, Northampton, 1916–17. The settee was designed to be en suite with the hall chairs.

country,' thundered the architect Sir Reginald Blomfield, perhaps the most reactionary personification of the British ambiguity towards aesthetic change. 'Whether it is communism or not,' Blomfield continued, '*modernismus* is a vicious movement which threatens the literature and art which is our last refuge from a world that is becoming more and more mechanised every day.'[14] It is against such attitudes that Modernism struggled in Britain; yet Art Deco, Modernism's more flexible cousin, managed to negotiate a compromise. Because of the reluctance of both the architectural establishment and of most corporate and public clients, the Modern movement was largely confined to private domestic commissions for wealthy 'progressive' clients. Nevertheless, it is worth briefly discussing the Modernist experience in inter-war Britain in an attempt to understand more fully the form Art Deco took and its relative popularity in the domestic setting. Oliver Hill offers a concise account of the Modernist aesthetic and its logic, while remaining aloof from the radical politics which were regularly espoused but less often practised:

> The new materials, the product of the engineer, chemist and machine – concrete, steel, glass, rubber, cork, asbestos, plyboard, plastics and the metallic alloys having cleanable and durable surfaces – each with its own intrinsic beauty of colour and texture, needing no embellishment, provide the forms we use. The requirements of today and the profound influence of the machine made article which makes for precision, have been utilised by sensitive designers and compound the new aesthetic. Clarification of purpose, the elimination of the essential and

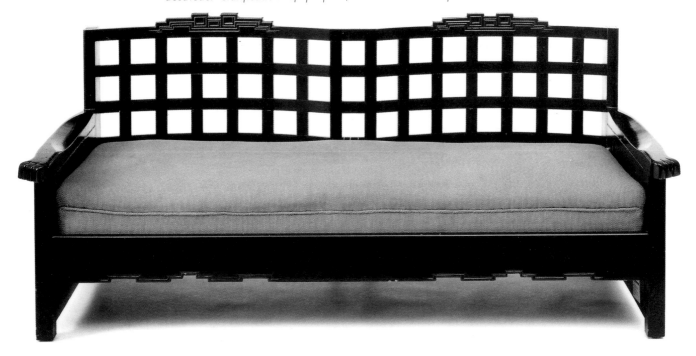

154

'New Ways', the house designed by Peter Behrens for W.J. Basset-Lowke, Wellingborough Road, Northampton, 1925–6. The austere exterior gave way inside to the decorative use of geometry in the lighting, stained glass and fire-surrounds.

disencumbrance from the pomposities of the past are keynotes of the contemporary house.[15]

'Many new ideas have broken up the hard and fast arrangement of living room and parlour, of drawing room, dining room and study,' remarked Patrick Abercrombie, emphasizing the sense of change. 'The whole position is much more fluid: rooms open out of one another.' Yet Modernism faced a difficult struggle in terms of domestic architecture, an inherent conservatism being supported by suggestions of its unsuitability to the British climate. Mrs Greene, one of Oliver Hill's clients, complained of her new house, 'Jolwynds, is the coldest and draughtiest house we have ever lived in.' A succession of practical problems with the new materials that had been used led her to lament the apparent divergence of attitude between architect and client. In a letter to the architect, Mrs Greene reminded Hill, 'Unfortunately, Jolwynds was meant as a house to live in, not a lovely film set.'[16] The perception of Modernism as a luxury aesthetic was confirmed by the fact that nearly all such houses were commissions from wealthy intellectuals carried out by 'name' architects who have subsequently been celebrated by historians; architects such as Erich Mendelsohn and Serge Chermayeff, Maxwell Fry and Walter Gropius, Wells Coates, Connell, Ward & Lucas and Berthold Lubetkin's Tecton group. Despite the social radicalism which underpinned the new architecture, most houses were designed to accommodate upper middle-class families with their quota of servants, and with the exception

Interior of Gayfere House, London, 1932, designed by Oliver Hill for Lady Mount Temple. His often lavish interiors gained Hill a reputation as a maverick of the Modern movement.

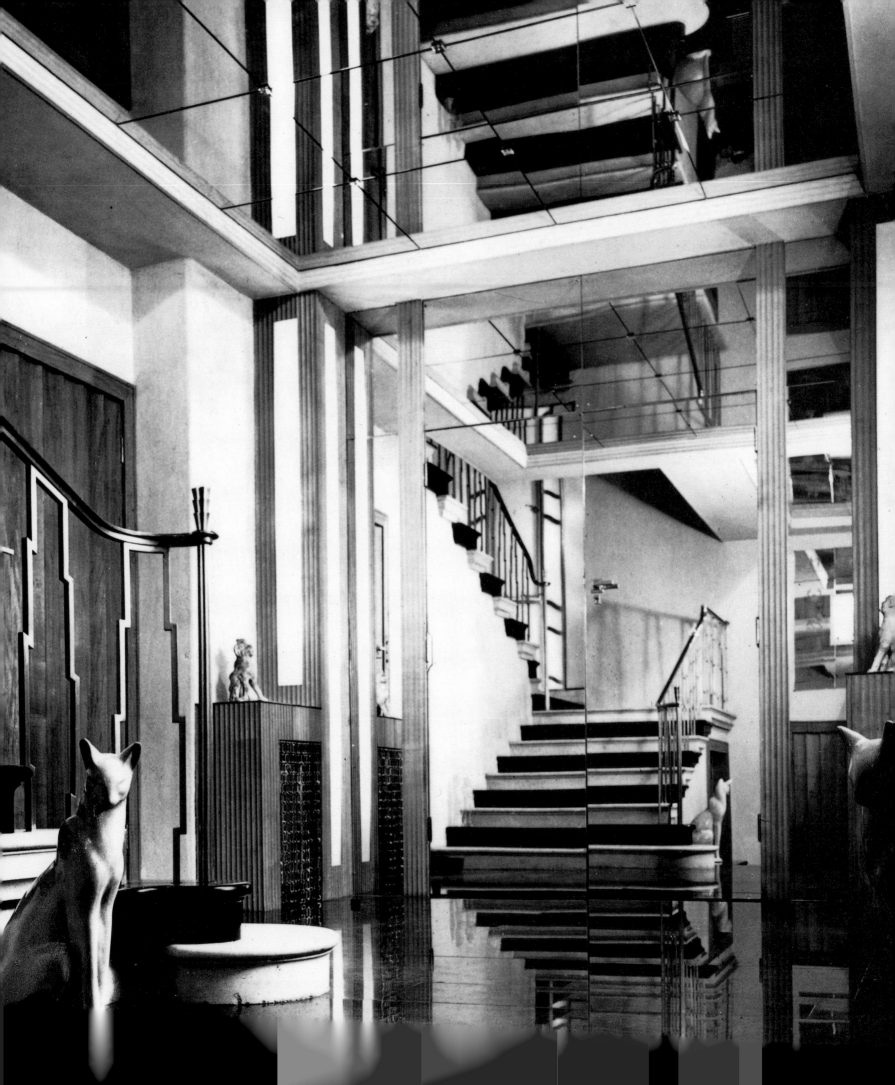

156

of a few notable examples, the young radicals were rarely entrusted with projects such as social housing, which would have fulfilled their idealism. Osbert Lancaster ironically suggested that the human race had yet to scale the heights which the Modern movement required of it: 'the [Corbusian] conception of a house as "une machine à habiter" presupposes a barrenness of spirit to which, despite every indication of its ultimate achievement, we have not yet quite attained.'[17] As the spread of the 'Stockbroker Tudor' and 'By-pass Variegated' styles suggests, the popular vision of the future in 1920s Britain was a materialist but not necessarily a stylistic one. An article in *Tit Bits* in February 1926, about foreseen developments in the home by 1940, stressed the potential health, comfort and convenience of modernity rather than its aesthetic:

> *Today perhaps one home in 20 is lighted by electricity. In 1940 the electric light will be universal, with all that means in cleanliness and health. Homes, too, will be electrically warmed, chimneys will be out of date, and the smoke of the domestic hearth a thing of the past.*
>
> *Moreover the long, toilsome day of the 'busy housewife' will be past … washing drying, ironing and cooking will lose their horrors. The mangle and the sewing machine will be electrically driven. Even stairs may become obsolete for the electric lift will be a commonplace even in small houses and a necessity in large ones.*
>
> *Even the domestic broom will give place everywhere to the vacuum cleaner and dust will disappear like magic, to the greater advantage of health and the suppression of infection.*[18]

Many of these developments did take place, although they were largely limited to the suburban homes of the South East, as well as the more affluent urban provincial homes. Stylistic developments, however, were not as functional

Strand Palace Hotel, London, 1929–30,
by Oliver Bernard. Main entrance by
night.

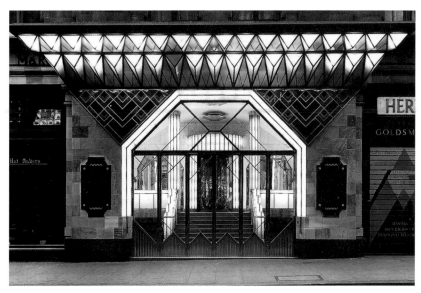

Strand Palace Hotel, London, 1929–30,
by Oliver Bernard. Main entrance by
night.

as the technological rhetoric. In looking at the domestic interiors of suburban England, we can discover a compromise between modernity and tradition; the decorative interpretation of modernity that resulted is now labelled Art Deco by collectors, dealers and enthusiasts increasingly eager to seek out the design trend in more demotic and ephemeral objects.

The plurality of British domestic taste in between the wars is most effectively illustrated in the literature of the furniture trade. Catalogues and journals contain a vast array of suites and ensembles, with only the most committed Modernist firms displaying any degree of stylistic unity. A noticeable trend was to adopt Modernist typography and abstract design on the cover of publications which then contained both 'modern' and traditional furniture designs. Alongside its 'modern' ranges, P.E. Gane Ltd featured period furniture in their 1935 catalogue containing 'Simple Cromwellian' or 'Restrained 17th Century' detail, and even 'Elizabethan Grape Vine Carvings'. Such historicism in domestic furniture had its roots in the tastes of the mid-nineteenth-century middle classes,[19] a trend which showed little sign of abating as the twentieth century progressed. In 1916, the *Cabinetmaker* expressed concern that, 'it is somewhat difficult to find in any of the Wycombe showrooms, furniture which the historian of the future will assign without hesitation to the twentieth century';[20] similarly, by 1927 the Parliamentary Committee on Trade and Industry expressed concerns in its report 'Factors in Commercial Efficiency'. The report lamented that, 'All the higher class furniture manufacturers employ designers trained in all the historical styles of furniture. The training is, however, seldom used as the foundation of modern design.' There was a perceived conservatism among consumers as well as manufacturers. 'Hundreds of rooms in the West End of London, and the larger country houses,' observed the *Cabinetmaker*, 'testify to the complete subjection to period of one class of people.'[21]

The 'Electra' fire from the 1935 Creda catalogue: 'An attractive model which combines excellent heat distribution with the pleasing effect of burning coal'. The sunburst motif and angular top were combined with fake coal to ensure that a home embellished with the modernity of an electric heater was not robbed of the look of a traditional coal-fire.

158

Nevertheless, modern furniture did have a foot in the luxury market by 1928. It was in this year that the firm Waring & Gillow held an exhibition of French and English decoration and furniture at its London gallery, a British example of the cross-over between shop, museum and manufacturer which was so evident in the United States. The exhibition made great claims. It was 'conceived on a scale that is altogether exceptional and represents the most liberally planned display of modern art in home decoration and furniture yet attempted, either in Europe or America'. The display contained a series of ten rooms designed by the French *ensemblier* Paul Follot, who was then Director of the 'Modern Art Department' at Waring & Gillow's Champs Elysées branch. This was matched by 'an English rendering' of ten similar rooms by Follot's London counterparts. In the catalogue Lord Waring proudly acknowledged that Follot was on the conservative wing of modernity, but the tension within the firm with regard to 'Modern Art', and particularly its perceived French tendencies, is clearly apparent in the rest of Waring's introduction, in which he singles out the English 'specimens' from Follot's and notes that, 'it is a pleasure to me to be able to recognise the direct influence which the classic styles so long associated with the house of Waring & Gillow have had in the formulation of this style, distinctly new as it is, and essentially of our age.'[22] The *Cabinetmaker* certainly saw the exhibition as an important moment in the progress of modern furniture in England, a country whose public 'accepted and affectionately cherished … the hard and fast rules of furniture'. Old certainties were being questioned; 'Along comes the Frenchman,' the magazine wryly noted, 'upsetting all these comfortable ideas of ours, and it seems we shall have to think again.'[23]

There were signs that, by 1928, many less up-market firms were beginning to take notice, but in a largely piecemeal manner. In their catalogue of 'distinctive furniture', the Port of London Cabinet Works claimed that, 'Once fine furniture was in the luxury class … Today every home may have furniture not only fine but also strong, durable, artistic, moderately priced and attractive.' Among the designers employed by Shoolbread's were the architects Thomas Tait and Joseph Emberton. Their window display in June 1928 included, 'dining room furniture in French walnut, inlaid with mauve and Hollywood lines, and a bedroom suite in amboyna, designed on severe but refined architectural principles.'[24] Moreover, it was reported that, 'Every new retailer in the provinces is showing the new style, and the exhibition held by Allen & Appleyard [of Liverpool] is a significant indication of the confidence which the trade has in the modern movement.' P.E. Gane's modern ranges were

A **metamorphic settee from the 'Modern' range by the Times Furnishing Company Limited, mid-1930s. Flexibility was the key concept in this catalogue. Another model had a curvacious oak frame which provided built-in 'table space, bookshelves and cupboards at either end'.**

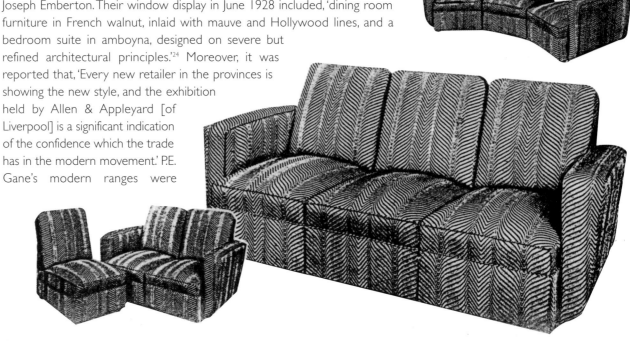

distinctive, if obviously derivative and pedestrian. Sofas and easy chairs had heavy, rounded upholstered arms and sides, clearly borrowing forms from the French. Indeed most of the manufacturers adopted and reworked the forms of the conservative wing of the French furniture industry, typified by Follot. This limited acceptance, however, always seemed to be clouded by a suspicion of the continent, and France in particular, which never entirely evaporated.

Betty Joel, whose firm produced furniture as close to the French Art Deco idiom of the late 1920s and 1930s as any British manufacturer, felt it necessary to qualify the modernity of her furniture which, 'though modern is based upon tradition'. In 1929, she argued that her work, 'learns but little from the Continental movement, and the best of it is pre-eminently British in feeling',[25] while one of her former draughtsmen later recalled, 'You can tell the purity of the design from the photos; there is nothing Art Deco. We all thought it was dreadful. Only in the choice of fabric does the Art Deco element creep in'.[26] The *Cabinetmaker* politely encapsulated the English attitude in its response to Maurice Dufrène's lyrical waxings on, 'joys, sorrows, sounds and colours' published in the *Studio Yearbook* of 1930, remarking that, 'we cannot help but feel that all this is a little obscure, some would say a little high-brow'.[27]

Despite this, the debate over modern furniture continued to share with economic concerns a dominant position in the trade press, and as the 1930s progressed the spectre of metal furniture loomed larger. Two of the most prominent firms involved in its manufacture in the early part of the decade were Cox & Co. and the Bath Cabinet Makers Co. Even in – perhaps especially in – such perceived ultra-Modernism, commentators continued to search for the compromise which would ensure acceptability. It was noted, almost with a sense of relief, that Cox & Co.'s 'Stronglite' range obtained 'a warm and pleasing effect … by the use of modern fabrics and colourful glasses, thus exploding the idea still held by some that metal furniture must necessarily be cold and bare'.[28] In reality metal furniture had a limited domestic popularity. The *Cabinetmaker* would illustrate avant-garde living rooms in Hampstead furnished by Cox & Co. as an indication of increasing popularity, while the work of the Midlands firm PEL (Practical Engineering Ltd) has received much historical attention for its pre-emptive Modernist work. Yet the limited appeal of such furniture ensured small product runs and high prices, which meant that modern furniture retained its luxury status. Most people were more likely to encounter this English realization of the Moderne style in restaurants, hotels and offices, where metal furniture was more enthusiastically embraced. Cox's 1935 catalogue showed the interiors of tea rooms as far apart as Hull and Southend, as well as the interiors of one of the icons of 1930s metropolitan Modernism, the *Daily Express* building. The Express Building, designed by Joseph Emberton in 1932, was furnished by Cox & Co. and Betty Joel Ltd using a gleaming combination of ebony, glass and stainless steel, and it was in this kind of corporate environment

160

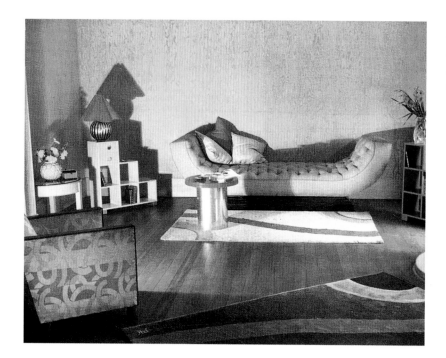

Interior by Betty Joel c.1935. Despite obvious parallels with the French decorative arts, one of the firm's draughtsmen maintained, 'there is nothing Art Deco about it. We all thought it was dreadful.'

that the unashamed celebration of 'the luxurious efficiency of the new age' was most likely to be found.

When modernistic furniture was occasionally presented in domestic trade catalogues, it was often done so in the context of an illustrated domestic interior liberally spiced with carpets carrying pseudo-modern designs, and objects such as lamps, ornaments, clocks, fireplaces and windows which often adopted an Art Deco style. If the suburban dweller chose to 'go modern', it was these objects which could be used to express modernity. The 1935 *Carpet Annual* accepted the transformation of taste which had happened: 'No manufacturer,' argued one commentator, 'can afford himself the luxury of refusing to recognise the modern carpet design as he could twenty years ago.'[29] 'Enormous sales' were being achieved by abstract designs juxtaposing interlinking coloured shapes with dissecting lines and curves – 'Kandinsky several times removed', as one critic has quipped.[30] Companies, such as the Yorkshire firm Firth, marketed cheap modernistic carpets for the lower end of the market, a trend which drew the scorn of trade commentators. Indeed, 'horrible ultra-modern designs which do not possess the slightest artistic significance' were held as synonymous with cheap Boucle carpets, 'truly the carpet of the people'. It was this combination of bastardized modern art and low-quality mass production which was isolated by the *Carpet Annual* as being 'one of the ills of the times'.[31]

By the late 1930s, it appeared to be the lower suburban end of the market which was responsible for the continuing popularity of the 'modernistic'. 'People

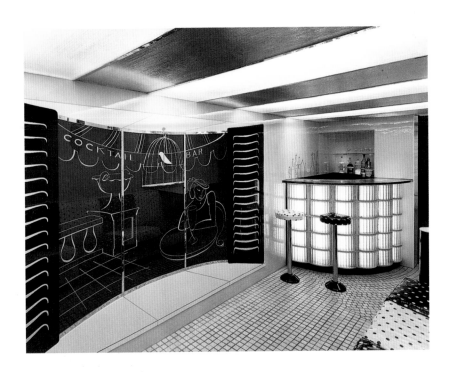

Above: Cocktail bar by Pilkington Brothers, 1937, for the 'Glass Age Exhibition Train'. Designer: probably Kenneth Cheeseman. Below: Advertisement for Heal & Son, London, c.1930–5, featuring examples of tubular steel and chrome chairs, desks, tables and a cocktail bar. By the 1930s manufacturers were beginning to embrace the new materials and a more modernist aesthetic.

162

with money and taste,' pronounced the 1937 *Carpet Annual*, 'prefer the "waltz" lines of the period style to the "jazz" of the modern. It would not be consistent with their tastes if they used Modern carpets.'[32] There was a sense among the big manufacturers that while 'modern tendencies have come and gone, the oriental carpet has remained in its fundamental beauty'. Nevertheless the carpet was an important signifier of modernity to the suburban dweller. People were relying on a popular decorative idiom, rather than Modernist theories of functionality and space, to express their own experiences of modernity and attach meanings to it.

Domestic ceramics were another affordable vehicle for this decorative idiom. 'There remains the necessity of a certain relief,' suggested an article published as early as 1925 in *Our Homes & Gardens*, 'a note of colour, the mitigation of too great an austerity in the outlines of table and cabinet. The decorative qualities of china which is a household necessity for meals or toilet may be made to give that note of gaiety and brilliance.'[33] Recent interest in the work of Clarice Cliff and Susie Cooper has led to an exaggeration of the significance of the most radical ceramics and, as Judy Spours has argued, many of the more extreme modernistic ranges were short-lived and unsuccessful. Shelleys produced two radical ranges in the early 1930s. Their names, 'Vogue' and 'Mode', promoted associations with Parisian Haute Couture, while their forms (the tea-cups were inverted cones with solid triangular handles), exemplified 'a daring spirit' in the words of the *Pottery Gazette*. Nevertheless, both ranges lasted only two or three years before they were superseded by more conservative shapes, such as the 1933 'Regent'. However, it is significant that 'Regent' was available with modernistic block designs dissected by speed lines, a further example of Art Deco as a decorative style combining tradition and modernity. While the radicalism of the early 1930s was confined to such firms as Shelleys, most manufacturers responded to the modern trend, although once again through pattern rather than form. Large established firms such as Wedgwood and Minton had capitalized on the appropriateness of the stackable 'cube' teapot for the

Robert Atkinson's entrance hall, with bas-relief by Eric Aumonier, Daily Express Building, The Strand, London, 1929–31. The building was designed by Sir Owen Williams.

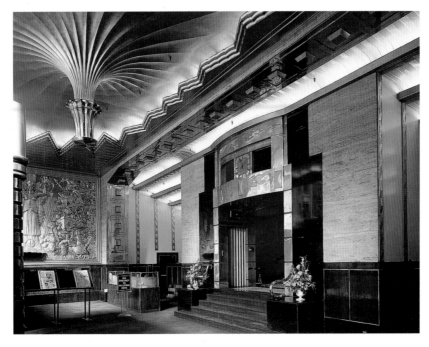

ocean liner market in the late 1920s. The teapot designed for the *Queen Mary* was a good example of the English tendency to confine radical designs to genuinely functional contexts. Wedgwood's trade literature from the late 1930s centred around the slogan 'a living tradition', and patterns such as 'Green Lattice' use an angular yet curving ziggurat pattern on a simple traditional form, juxtaposed with a name evoking feminine, domestic and above all English themes, rather than the adventurism of Paris.

A further location for the ziggurat motif in the home was the fireplace. Fireplaces have traditionally been sites for interior decorators to adapt, satirize or reproduce architectural forms, and many inter-war fireplaces adopted the setback, stepped motif of the skyscraper, while at the same time suggesting the exoticism of the pre-Columbian Americas. Firms like Lamb and Abbey were typical, producing catalogues which might contain more than twenty variations. Despite its traditional name, Lamb's 'Carlton' fireplace centred around a ziggurat motif inspired by the American West (emphasized by an Indian statuette on the catalogue illustration), a design which it was claimed would 'enhance the artistic value of the fireside'.[34] Towards the end of the 1930s, electric 'inset' fires were becoming more commonplace, further modernizing the home. Yet even such an obvious subject for severely functional design was toned down for the suburban home through decoration, whether in metal with a clouded marble-effect finish or as part of a hearth combination.

Apart from the living room, the bathroom was the other likely venue for suburban Art Deco. Following the precedent of decadence set by Oliver Hill's

Overleaf: A selection of teapots by Clarice Cliff. The forms range from the traditional to the revolutionary, the decoration from naturalist to geometric. The combination of old and new approaches typified English Art Deco.

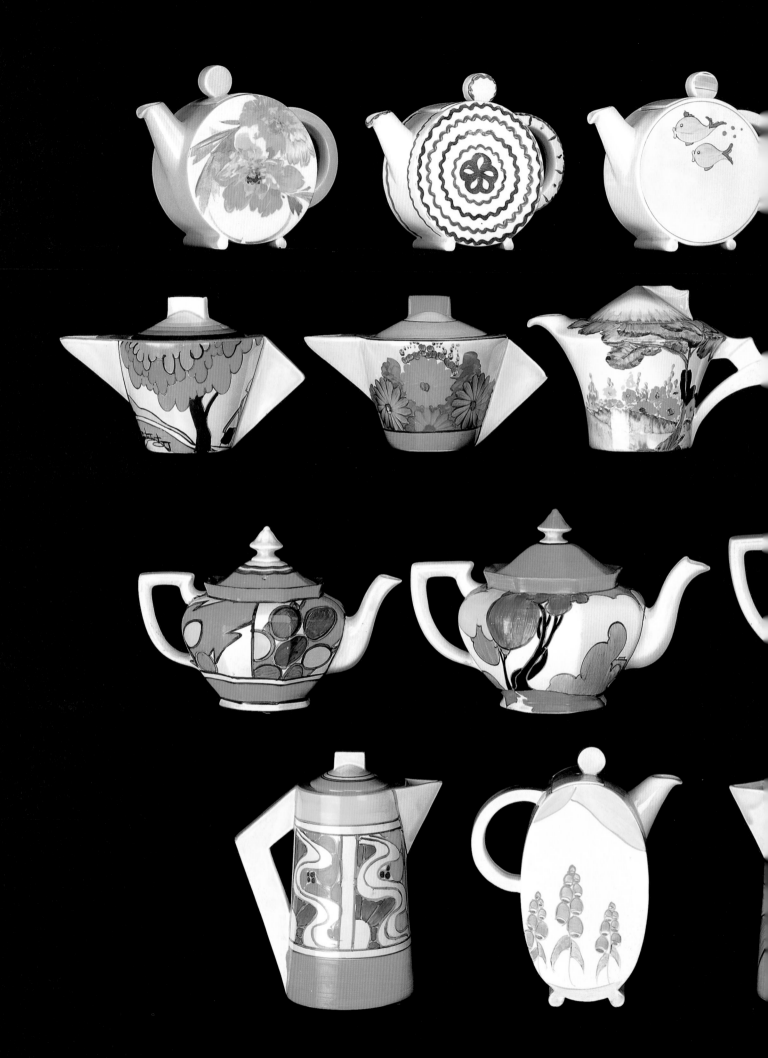

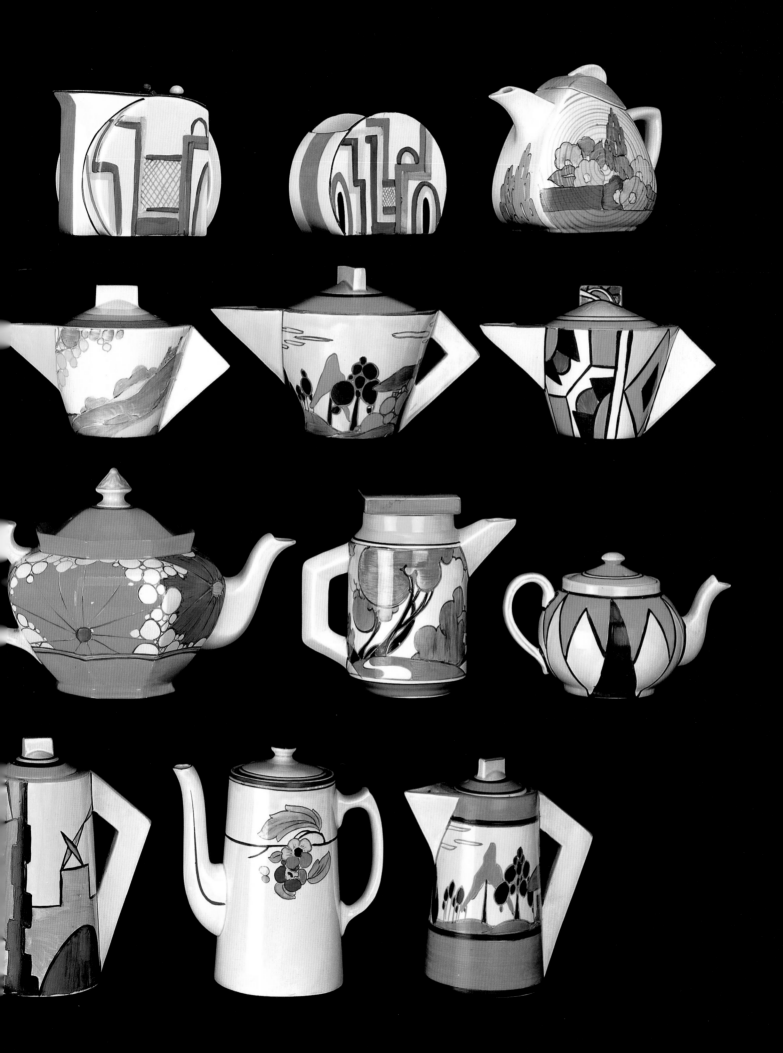

A bathroom at Claridge's Hotel, London, from the early 1930s. Even in suburban homes the bathroom was considered an appropriate setting for ultra-modern metal fittings.

1929 plate-glass bathroom for Gayfere House, Westminster ('Lady Mount Temple's "Crystal Palace'"), and the more influential use of the modernistic bathroom in film sets, bathrooms were deemed valid arenas for an overtly modern aesthetic – hardly surprising, given the relative novelty of a bathroom and indoor lavatory in the homes of the new suburban dwellers. The bathroom was the domestic embodiment of hygiene and health rather than comfort, and even the most resolute traditionalist could accept that, if a modern aesthetic had its place, the bathroom was it. Mirrors were given angular rather than curved forms, often sharing the same 'skyscraper' motif as the fireplace, while the bath became the latest unlikely recipient of 'speed-lines'. Bath rugs might carry a geometric pattern, while the bathroom was perhaps the only room in the suburban interior where tubular steel furniture would be deemed appropriate.

From this brief survey of the domestic impact of Art Deco in Britain, we can attempt to explain its meaning as a means of negotiation; a negotiation between tradition and modernity. Osbert Lancaster satirizes the strength of tradition, yet unlike high Modernism, popular Art Deco was never attempting to challenge this traditionalism. The lukewarm reaction given by consumers to the more radically angular ceramics, which in turn provoked a reversion to accepted forms and a softening of aggressive decoration, exemplifies what the English middle classes wanted from domestic Art Deco. As Robert Harbison lamented, British domestic Art Deco was 'supremely easy'; but, while it may have 'turned machines into comfortable jokes' which 'echo[ed] technological innovation fawningly', it was this very 'weakness' that ensured its place in the popular material culture of the time.

In comparison with the USA, Art Deco architecture in Britain at first appears relatively scarce. As far as the 1920s are concerned, British cities did not witness the kind of high-rise expansion seen in America, and consequently they were deprived of Art Deco's architectural archetype – the skyscraper. As with the domestic interior, the central theme in English Art Deco continued to be one of compromise – a sober approach to the challenge of new building. There was a suspicion equally of the radical rhetoric of European Modernism and of the gaudy flamboyance of America, so the resultant Art Deco idiom in Britain was largely subtle and often understated. Unlike its American counterpart, British Art Deco was not aggressive; it was restrained, and on the rare occasions it abandoned restraint it was noticed. Perhaps the most celebrated, and thus atypical, examples were the series of modernistic factory facades erected in the new suburban areas of west London in the late 1920s. 'After the familiar muddle of West London,' wrote J.B. Priestley in 1933, 'the Great West Road looked odd.'

> Being new it did not look English. We might have suddenly rolled into California. Or for that matter into one of the main avenues of the old exhibitions … It was the new factories on each side that suggested the exhibition … These decorative little buildings, all glass and concrete and chromium plate, seem to my barbaric mind to be merely playing at being factories. You could go up to any one of the charming little fellows, I feel, and safely order an ice-cream or select a few picture post-cards … at night they look as exciting as Blackpool.[35]

George Melly was less charitable when he recalled passing 'the Hoover factory, that great 1930 essay in the mock Egyptian style.''All that,'' I said, ''to suck up shit!''[36]

The years 1932–7 saw the number of factories employing twenty-five or more workers in the Greater London Area increase by 532,[37] and inevitably many of the less extravagant modernistic examples, such as the Hooper Coachworks in Park Royal (1935) or the Young Accumulator Works on the Kingston by-pass at New Malden (1937), are fading from memory. Wallis, Gilbert & Partners were the architects of many of the more celebrated Art Deco factories of the late 1920s and 1930s,[38] and the attitude of the firm to its buildings confirms the decorative humour suggested by Melly and Priestley. 'A little money spent on something to focus the attention of the public,' Wallis told the RIBA in 1933, 'is not wasted money but is good advertisement.' Their colourful façades were far from 'functional' in the Modernist sense, but were arguably highly functional commercially. After hearing Wallis's address, H.S. Goodhart-Rendel commented that, 'the fronts were much better than what came behind', before adding that, 'as an architectural veneer they were by far the best of their kind in the country.'

Priestley's curiosity only serves to confirm the gaudy and outstanding nature of buildings such as the Firestone Rubber and Hoover factories. After the completion of the Firestone Factory in 1929, the *Architect and Building News* coupled its compliments with a thinly disguised warning on architectural

168

The staircase of the De La Warr Seaside Pavilion, Bexhill, Sussex, 1933–5, by Erich Mendelsohn and Serge Chermayeff.

appropriateness when it noted that, 'In an old village it would be blatant; on so modern a thing as an arterial road it is supremely in its place.'[39] It was the architects' 'strong, almost dramatic sense of design' which 'is always interesting to the profession'. This restrained registration of interest, however, falls far short of an unbridled enthusiasm for such drama, a sobering reflection of the conservatism of much of the architectural profession in Britain at this time. It is this suspicion of ostentation which lies at the heart of yet another redefinition of the idiom of Art Deco, a more austere and traditional idiom specific to urban Britain in the inter-war period.

Two buildings of the late 1920s which exemplify the restrained austerity of much of London's corporate Art Deco are London Underground Headquarters (architects Adam, Holden & Pearson) and Broadcasting House (architect Lieutenant-Colonel Val Myers). Holden has been described by Sir John Summerson as, 'the last of the Edwardians and the first of the English Moderns', and the London Underground Headquarters building at 55 Broadway combines a plain Portland stone façade with an adventurous use of modern sculpture. Indeed, it was in its use of modern architectural sculpture and relief carvings that British Art Deco architecture found its distinctive decorative idiom, rather than in the sobriety of the building itself. 'The architects have generally turned to the younger men of the chisel,' observed the *Architect and Building News* in its appraisal of 55 Broadway; 'It may be remembered that they gave [Jacob] Epstein one of his first commissions in this country for figures on the building in The Strand, until recently occupied by the BMA; and at the new Underground Railways offices the moderns have once more had their say.'[40] The figures by Eric Gill, Allan Wyon, A.H. Gerard, Eric Aumonier, F. Rabinovitch and Henry Moore on the upper part of the building represent the winds, yet it was Jacob Epstein's figures representing *Night* and *Day* which provoked the most outrage. In his autobiography, Epstein remembers the 'atmosphere of mystery' in which he worked:

> When I went down with the architect for the first time to examine the site, I was introduced to the Clerk of works as 'the sculptor', which seemed to me strange; but outside his hut Mr Holden explained that it would not do for me to be better known as yet, at any rate not until I had actually set to work. 'Dark forces might upset things'. I had to be smuggled in.[41]

Press interest was intense. 'Peeping journalists bribed the watchmen to let them in,' recalled Epstein, 'and my actions were followed in the press the following day.' The unveiling of the prestigious new building and its sculpture provoked a predictable consternation among traditionalists. Sir Reginald Blomfield decried 'the cult of ugliness', which seemed 'to have taken the place of beauty'. Such was the radical nature of Epstein's work that *Day* was considered enough of a risk to warrant the approval of the Committee of Transport. *Night* fared little better when 'a party of hooligans in a car' attempted to disfigure it by throwing glass containers filled with liquid tar at the sculpture. The reaction illustrated the depth

Façade detail of Broadcasting House, Portland Place, London, 1931, by Val Myers & Watson.

of feeling against Modernism in the arts, especially when associated with public projects, perhaps explaining the restraint generally adopted. The furore was a confused conservative tirade which allied European Modernism with Epstein's Jewishness and the decline of old political and economic certainties. Holden had been brave in employing Epstein for a second time, especially when one considers the uproar his stylized relief *Rima* provoked when it was unveiled in Hyde Park in 1925. 'Take This Horror Out of The Park!', cried the *Daily Mail*, while one observer often told of seeing 'a shiver [run] down the spine' of the Prime Minister, Stanley Baldwin, at the opening ceremony. In Parliament, the sculpture was described as, 'the terrible female with paralysis of the hands', and a 'bad dream of Bolshevist art'.[42] In contrast to the embrace of Art Deco sculpture by corporate capitalism in America, Epstein's work was defaced repeatedly with swastikas by the Independent Fascist League, a potent reminder of the aesthetic politics of Europe.

A less hostile, yet never more than ambivalent, response was awarded the BBC's Broadcasting House the year after 55 Broadway was completed. According to the *Architect and Building News*, it was still the case that, 'Hardly any of the large buildings of London have as yet been designed by architects who can be labelled 'modern.' 'In England,' pondered the magazine's critic, 'where public appreciation of architecture is about on par with the South Sea Islanders' knowledge of gunpowder, the importance of a building is judged almost entirely by the size and number of its columns and the extent and "fitness" of its applied carvings.' Eric Gill's sculptures of Ariel and Prospero were not considered as outrageous as Epstein's, but nevertheless little hope was extended for public applause: 'Will the general public like it? Probably not. It will suffer the fate of all pioneers of being ignored or actively disliked according to importance.'[43]

Eric Gill's ambiguous relationship to modernity may be seen as representative of the general ambivalence of the English towards modern design and the resultant paucity of the kind of frivolous and wildly confident Art Deco architecture built in America during the same period. There was little doubting Gill's status as a 'modern'. His stylized sculpture had been compared to the Post-Impressionist painters, especially Gauguin, as early as 1911, the plasticity of the imagery being praised by Roger Fry.[44] Yet mirroring his unconventional combination of sexuality and Christianity, he never embraced the pace and industrial nature of modernity, and retained a naturalistic rather than mechanized aesthetic. On the one hand he believed that, 'the modern architect is right – let sculpture go. Let him concern himself with the scale and proportion of the building'; yet at the same time he proclaimed industrialism and its inevitable consequences 'an unnatural condition'.[45] Thus any study of Art Deco in England is faced with the symbolic paradox of the man who designed the archetypal modern typeface, Gill Sans, rejecting the changing world which the new style supposedly embraced.

Holden's work for the University of London, and his continued partnership with London Underground in the 1930s, are further examples of this negotiation. In addition to 55 Broadway, Holden's practice was responsible for the design of a number of underground stations throughout the period. He began with the Portland stone façade of Westminster Station in 1924, and designed the façades for the new Northern Line stations from Nightingale Lane (now Clapham South) and Morden before winning the Broadway commission. Holden had known Frank Pick, head of the London Underground, ever since their first encounter at an exhibition of German and Austrian design in 1915, and Pick's continued involvement in the Design in Industry Association confirmed his commitment to the importance of aesthetics. Their partnership came to fruition when Holden was employed for the full design (as opposed to merely the façade) for several of the new suburban stations on the Piccadilly Line. Pick and Holden visited Sweden, Germany, Denmark and Holland together in 1930, and it has been suggested that the brick-built Modernism of the Netherlands informed Holden's Piccadilly Line work, although the visit may equally merely have 'confirmed Holden's belief in a quintessentially English material'.[46] Among Holden's stations were Sudbury Town (1931), the 'circular drum' at Arnos Grove (1932), and Boston Manor and Osterley with their distinctive towers (1933 and 1934 respectively). Whatever the precedent, Holden's interpretation of Modernism was in the spirit of negotiation which typified English Art Deco.

Two further architects whose work has recently received a deserved re-evaluation, and who both exemplify the ambiguous nature of British Art Deco are Oliver Hill and H.S. Goodhart-Rendel. Both men were from a generation whose careers began before the arrival of the Modern movement in England, and both made contributions to British architecture in a modern idiom without ever

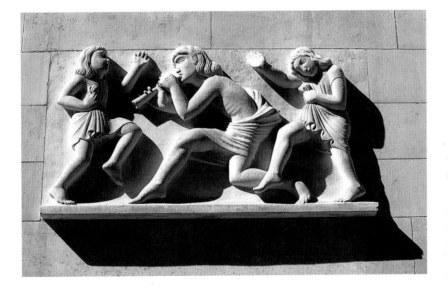

One of Eric Gill's architectural sculptures on Broadcasting House, London, 1931. Famed for his combination of craft and Catholicism, Gill's idiosyncrasies were underpinned by a suspicion of modernity. In this respect he personifies British Art Deco.

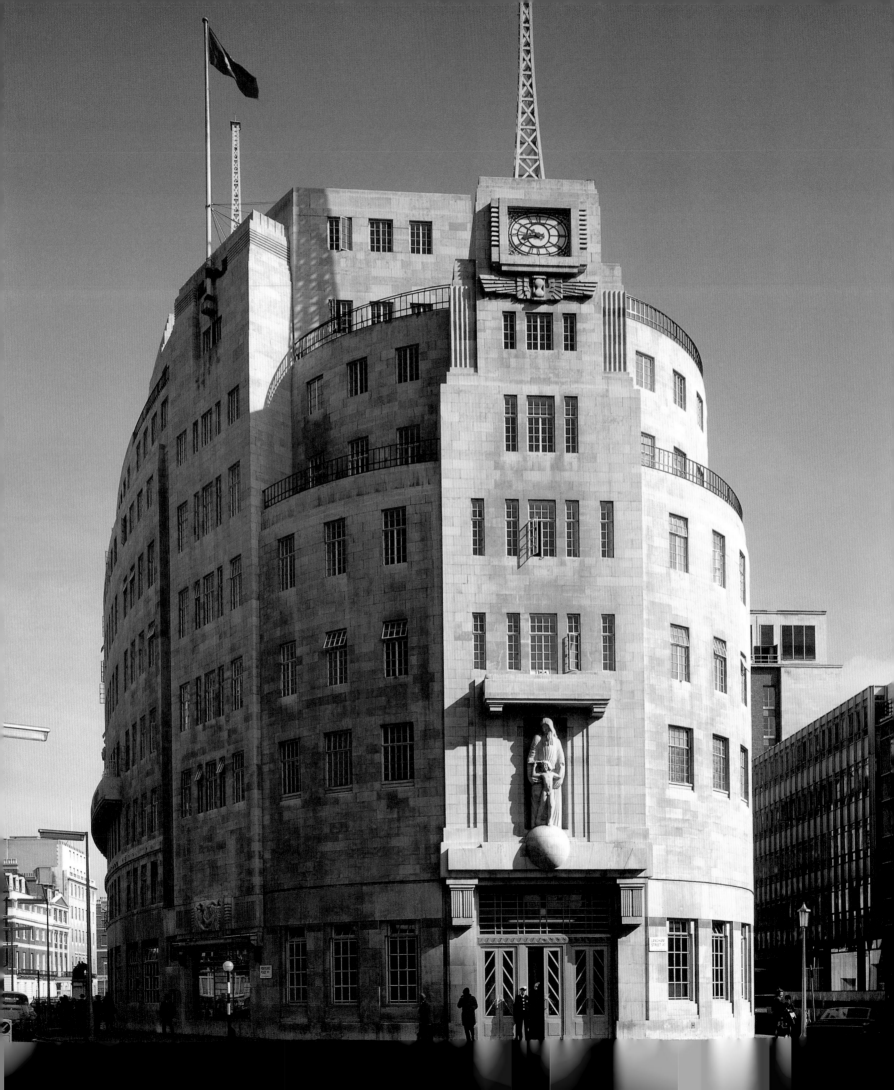

subscribing to Modernism, a point which for Alan Powers, the biographer of both architects, explodes 'the myth of an undivided Modern Movement'.[47] Rendel's most overtly Art Deco building was Hay's Wharf on the south bank of the Thames, and Powers sums up the combination of decoration and modern ideas that make it a textbook example of the principles of decorative modernity: 'the whole concept of the design was based on Goodhart-Rendel's desire to articulate the steel frame and the decoration only serves to emphasize it.'[48]

Rendel had a strong sense that pure functionalism and the complete eradication of ornament was not the inevitable course of Modernism, and recognized the irony of irrational aesthetic preferences being justified by rationality. In response to a Royal Institute of British Architects lecture by Serge Chermayeff he warned:

> ... we scorn the emotionalism of picturesque architecture before the war, but we must avoid the other emotionalism which makes people come over all dithery when they see a good machine and say 'that's lovely' when it is nothing of the kind, but just a thing that will work.[49]

Hays Wharf was the embodiment of a belief that an architect can be honest about function without renouncing decoration.

Oliver Hill was another nonconformist of English Modernism, and thus interesting in terms of the relationship between Art Deco and the Modern movement. Although ostensibly more sympathetic than Rendel, Hill was never dogmatic and used Modernism for stylistic reasons (or perhaps, in reality, when a client asked him to). Houses like 'Landfall' in Dorset are flat-roofed, white buildings, but not necessarily constructed from the new materials of the Modern movement: 'Landfall' is rendered brick rather than steel and concrete. His use of colour and, in the Midland Hotel, Morecambe, decorative mural painting by Eric Gill and Eric Ravilious, emphasize his individual approach. Hill had worked in a multiplicity of styles, and continued to do so after the 1930s. His interiors of Devonshire House, Piccadilly, and Gayfere House, Westminster, both suggest the influence of the more conservative Parisian ensembliers, while his design of the British pavilion for the Paris Exposition of 1937 represents a far more credible attempt to represent Britain in terms of modernity than Eastman's 1925 pavilion.

A consideration of Holden, Rendel, Hill, and Wallis, Gilbert & Partners might lead one to ask whether British Art Deco was a purely metropolitan phenomenon, or at least one confined to the South East of England. The traditional focus on London and the South East partly reflects the fact that this region provided the largest concentration of buildings in the style. In his 1977 survey Modern Houses in Britain 1919–1939, Jerry Gould found 900 flat-roofed houses, only 100 of which were north of Cambridge. This was a social and economic divide which W.H. Auden perceived in his 1937 Letter to Lord Byron, when he wittily observed:

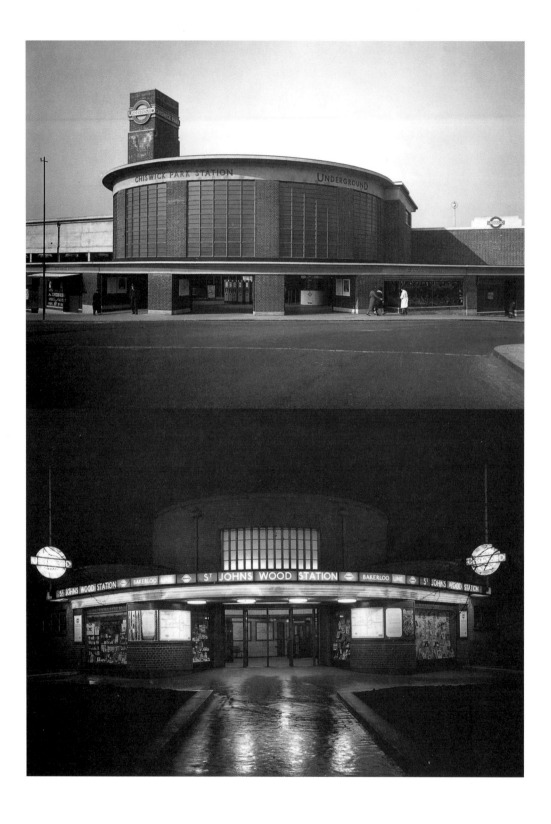

London Underground stations at Chiswick Park, c.1932 by Charles Holden and St John's Wood, 1939 by Stanley Heaps.

Above: Watercolour of Hay's Wharf, London, designed by H.S. Goodhart-Rendel, 1929–31.

Below: The staircase, St Olaf's House, Hay's Wharf.

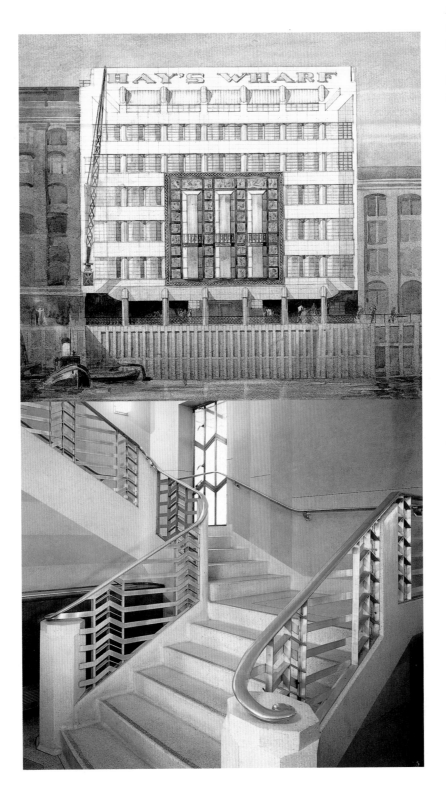

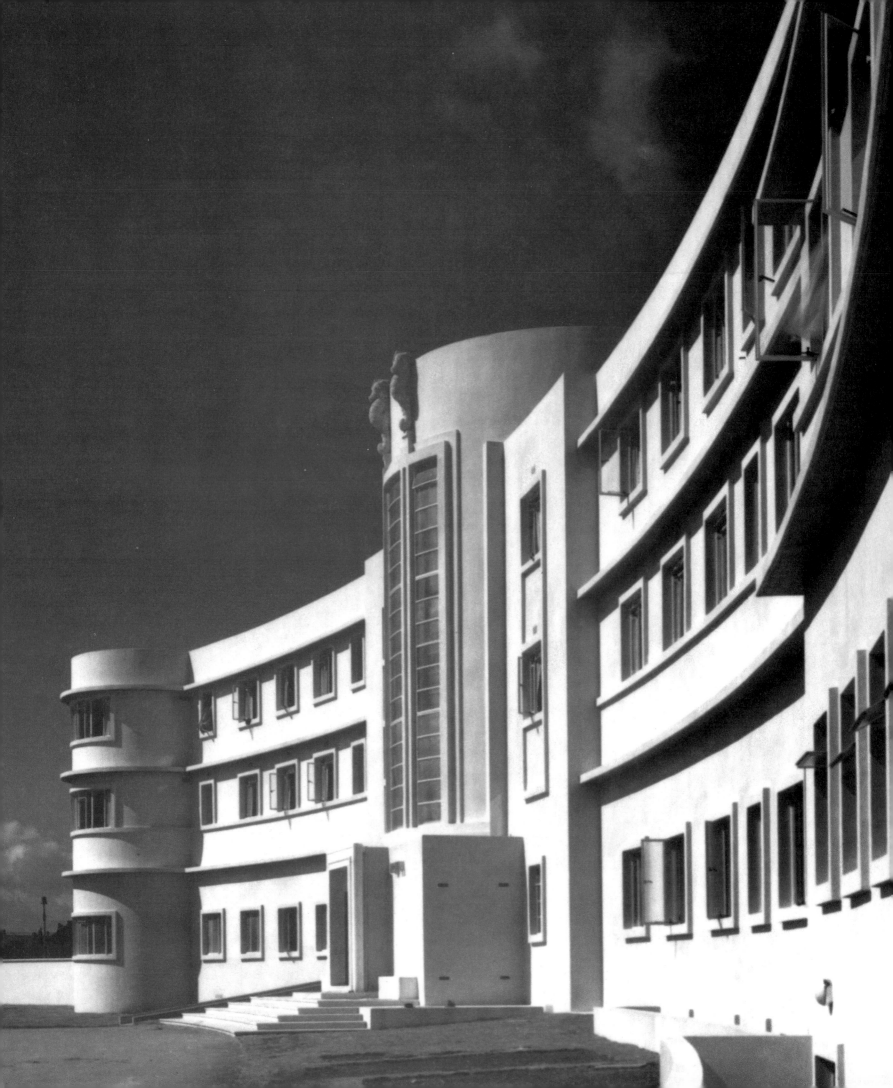

We're entering now the Eotechnic phase
Thanks to the Grid and all those new alloys;
That is, at least, what Lewis Mumford says.
A world of Aertex underwear for boys,
Huge plate glass windows, walls absorbing noise,
Where the smoke nuisance is utterly abated
And the furniture is chromium plated.

Well you might think so if you went to Surrey
And stayed for weekends with the well-to-do,
Your car too fast, too personal your worry
To look too closely at the wheeling view,
But in the north it simply isn't true.
To those who live in Warrington or Wigan,
Its not a white lie, its a whopping big 'un.[50]

While the Modern movement may have had a limited impact in the provinces, however, it certainly reached beyond London and the South East. The social and economic geography of inter-war Britain was a complex one, and this is confirmed by a scattering of modernistic building across the country. Unsurprisingly, it was the building types common to all towns which were most likely to employ the

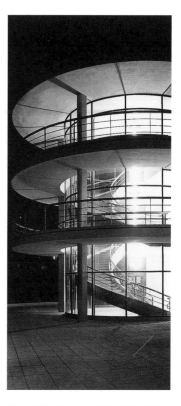

Above: The staircase of the De La Warr Seaside Pavilion, Bexhill, Sussex, 1933–5, designed by Erich Mendelsohn and Serge Chermayeff.

Left: Relief by Eric Gill on the ceiling of the stairwell, Midland Hotel, Morecambe, 1933. A mural by Eric Ravilious in the café was painted over in 1935 because of soaked walls and peeling paint.

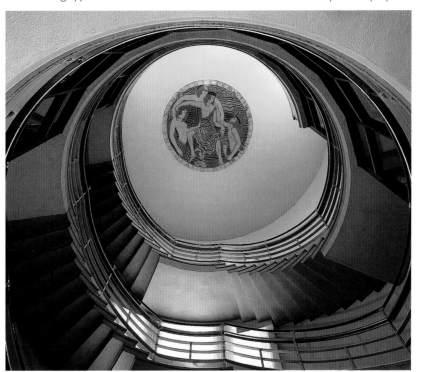

178

style: cinemas, factories and shops. Wallis, Gilbert & Partners built factories in Lancashire and Scotland, while countless other provincial industrial architects of the 1930s used versions of the primarily brick-built 'traditional modernism', loosely echoing Holden in London and Willem Dudok in Holland. More overt, and more noticeable to the public, was the architecture of the movies. Osbert Lancaster observed that, 'Numerous examples of the Modernistic are to be found in all our principal cities', and cinemas in particular were singled out: 'such of our great luxury cinemas as are not built in Metro-Goldwyn Renaissance are almost without exception conspicuous masterpieces of this style.'[51] Oscar Deutsch, the entrepreneur behind the Odeon chain of cinemas, admitted in 1937 that:

> It was always my ambition to have buildings which were individual and striking, but which were objects of architectural beauty … we endeavour to make our buildings express the fact that they are specially erected as the houses of the latest, most progressive enlightenment in the world today.[52]

But despite the modernity of the cinema, as Lancaster suggested, the modernistic style was not the automatic architectural choice to house it in. Taking their lead from the architecture of the Edwardian theatres from which cinemas grew, as well as American treatments of the movie theatre, British cinema architecture had by the 1920s evolved into two basic types. Cinemas that drew on classical inspiration, such as those designed by Frank Verity and Robert

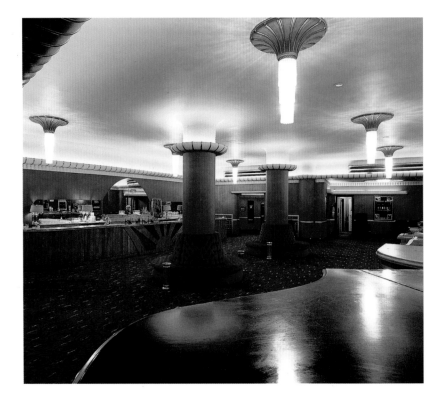

The foyer of Camden Parkway cinema, London, originally opened as the Gaumont Palace in 1937, and designed by Trent, Trent and Mackay. After several changes of name and closures the building was reopened as the Camden Parkway in 1983. The cinema is now closed and threatened with demolition.

The Odeon cinema, Harrogate, North Yorkshire, 1936, by Harry Weedon. Oscar Deutsch's rapidly expanding chain brought a brick-built version of the Moderne to provincial Britain.

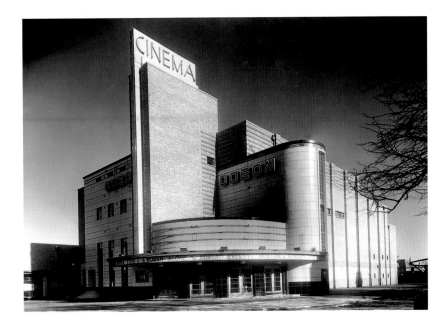

Atkinson, invoked guarded praise from architectural critics such as Morton P. Shand, if only for being the best of a bad bunch, while the unbridled fantasy of the 'atmospherics' was dismissed as crass and ridiculous. The interiors of the atmospherics drew their inspiration from the open-air screens of 1920s America, their eclectic themes leading to the construction of pseudo stage-sets in a Moorish or Spanish style, and internal architectural façades often resembling a fantasy Babylon. The archetypal Art Deco cinema of the 1930s grew out of both traditions. The rise of the cinema chain led to the distillation of design themes and the early chains, such as London's four Astoria cinemas built in 1929, began to use more recognizably modernistic façades to clothe atmospheric interiors. The relatively austere but ungainly buildings, with their suggestions of exoticism were clad in cream faience tiles and were among the first belated efforts to bring the architecture of the 1925 Paris Exposition to the cities of Britain.

From 1929, the old theatres began to give way to the 'supers', larger-scale cinemas whose advent coincided with the 'talkies'. One of the first of the new generation, E. Walmsley Lewis's New Victoria Cinema (Victoria, London 1930), was also one of the first completely Art Deco cinemas (its novelty was underlined by an article in *The Times* which was headed 'Revolt in Architecture'). Its horizontal form was emphasized by Moderne lines around the façade, while its blue-and-green interiors with their stalactite lights have been likened to 'a mermaid's palace' by the architectural historian David Atwell;[53] they displayed a clear debt to the Expressionist interior of Hans Poelzig's Grosses Schauspielhaus (1919) in Berlin. The 1930s saw a spectacular explosion in the building of 'supers' across Britain, exemplified by Deutsch's Odeon chain. Deutsch, the son of Central European

Carved decoration on the façade of Barkers Department Store, Kensington High Street, London, designed by Bernard George, 1933–5.

Jewish immigrants, acquired the Midlands Amusement Co. and control of the Globe and Crown cinemas in Coventry. In 1930, the first Odeon was opened in a Moorish-style building in Perry Bar in the west Midlands, and the name became a chain in 1933 with the opening of five more Odeons around London and on the south coast. A massive expansion, with its accompanying building programme, then took place and, by 1937, a further 100 new Odeons had been built around the country.

Deutsch employed a number of architects, most notably George Coles and those in Harry W. Weedon's firm, and by 1935 a 'house style' had evolved. The first such Odeon, with its characteristic advertising tower contrasting with the streamlined brick of the rest of the building, appeared at Kingstanding in Birmingham. While true standardization of the sort utilized by Teague in his work for Texaco in the US was never achieved, Weedon did develop a nationally recognizable style, again reminiscent of Holden's Piccadilly line work. George Coles designed more flamboyant Art Deco cinemas for Odeon in Muswell Hill, Balham and Woolwich, while the most idiosyncratic, almost Expressionist, cinemas of the period were designed by F.E. Bromige for Grosvenor at Rayners Lane and Harrow in north-west London.

The popular simplification of history gives an image of 1930s Britain exemplified by the Jarrow Hunger March and Orwell's bleak depiction of the industrial north in *The Road to Wigan Pier*. A slightly more accommodating interpretation could point to contemporary developments in the affluent suburban South East. Orwell himself noted, that 'in a decade of unparalleled depression, the consumption of all cheap luxuries has increased', and it is important to remember that commerce and entertainment continued and the frivolities of fashion and the superficiality of style were not things which could be blunted by the Depression. 'The two things that have probably made the greatest difference of all', Orwell continued, 'are the movies and the mass production of cheap smart clothes since the war':

> You may have three halfpence in your pocket and not a prospect in the world, and only a leaky bedroom to go home to; but in your new clothes you can stand on the street corner, indulging in a private daydream of yourself as Clark Gable or Greta Garbo, which compensates for a great deal.[54]

Stylistically, the great achievement of the cinema as a typeform in the 1930s was the propagation of a decorative Art Deco idiom across the provinces, a role which it shared with the modernizing forces within retailing, display and advertising. Together these helped popularize an image of modernity free from the political and aesthetic constraints of the less tolerant elements within the Modern movement.

Despite the apparent dichotomy between commerce and Modernism, two of the metropolitan standard-bearers of the modernization of retailing, Simpsons of Piccadilly and Peter Jones in Sloane Square, were housed in buildings which

Peter Jones Department Store, Sloane Square, London, 1936, designed by W Crabtree with Slater, Moberly and Reilly as consultants. Detail of curvilinear roof. Designed to fit an awkwardly-shaped site, the glass and steel façade was a radical departure form the previous practice of making large stores appear from the outside as a succession of small rooms.

conformed to many of the Modern movement's functionalist criteria. Peter Jones in particular, with its multi-storey curving wall of curtain glass, was favourably compared to Selfridges in the *Architectural Review* because it dispensed with small windows, creating the architectural fallacy that a modern department store is a network of small rooms, and embraced the new technology which enabled the architect to express the truth of large, sweeping, open-plan floors. In Corbusian terms a shop needed to be, according to Austin Reed's display chief, 'a machine to sell in', yet the realities of commercialism did not always sit easily with the more puritanical notions of rationalism. 'Hats off to Mr Alec Simpson for, whatever may be said about his new store, it is a brave adventure,' noted one commentator on Simpson's new sleek vitrolite and glass-fronted building, designed by Joseph Emberton. There was a reluctance, however, to ascribe it to architectural radicalism: 'in design the store is of no architectural "order", it fulfils its function floor by floor and borrows nothing from M. Corbusier. In fact … on the whole, the store ceases to be architectural in conception and becomes spectacular display. This is merchandising at its best.'[55] The fact that the display department was under the direction of Lazslo Moholy-Nagy, the prominent Hungarian Modernist who had just arrived in Britain from the disbanded Bauhaus where he was a teacher, again suggests that many in the Modern movement were able to work in a more pragmatic way than has been admitted by a heroic history of Modernism. Indeed, it was shop-window display which necessitated a combination of simplicity, decoration and even humour, as in Austin Reed's 1933 window display of ready-to-wear clothes against the imagery of the ocean liner: two ship ventilators were cut out of beaver board and the display was surrounded by chromium metal rails. It was this popular version of Modernism which often took a decorative form in the commercial world, mirroring the role of the Art Deco object in the suburban domestic interior.

Simpson's Department Store, Piccadilly, London, 1936, designed by Joseph Emberton.

Periodicals, such as *Commercial Art*, helped to introduce contemporary European and American trends in shop design and window display, and in a brief survey of 'Modern English Shop Fronts', the myth that functionality was incompatible with decoration was again dismissed. 'If it is possible to isolate two points which seem to stand out more than others when "modernity" in Architecture is the topic,' claimed the journal, 'these points would surely be on the one hand, clear expression of function, and on the other, decorative qualities which are directly associated with modern life, rather than the use of worn out motifs.' *Commercial Art* also noted, 'The strong appeal of attractive patterns in decorative metals' in shops such as the Lotus shoe shop in Manchester. It was features such as these which could be superficially added to old buildings to stylistically update them. Commercial Modernism could be an artificially-applied aesthetic, as was the case in a nineteenth-century shop in Bloomsbury Street, London, in which there was not 'a suspicion of Victorianism allowed to peep through – an example to all those with Victorian shops.'[56] This particular

'camouflaging' involved the walls being covered with a plywood veneer, the remodelling of the shelves and counters in sycamore veneer, the chromium plating of the ironwork, and new chromium handles on the entrance doors.

Moreover, retail modernization was not confined to London: '[People are] acquiring new ideas of form and design,' the Northern Display Association was told in 1930:

> … and if shop-window displays are to attract them, they must be in tune with these ideas. The principles of modernist display … simplicity, repetition, rhythm, unity, and colourful appeal. Modernist display is neither difficult or costly; it is worth the earnest consideration of outfitters and tailors.[57]

High-street architecture underwent concurrent modernization with the growth of national chains such as Woolworths, Burtons and Marks & Spencer, all of which built new stores in a restrained Art Deco style. Often the buildings were in a stylized classicism, similar to the PWA style evolving in Roosevelt's America, combined with a subtle use of Egyptian or Mayan motifs, particularly stepped pyramid forms. Advances in lighting technology also helped transform the aesthetic of the high street. *Commercial Art* in 1933 claimed that, 'immense progress has been made in the last three years in the technique of Neon',[58] since more colours were available and lighting was becoming more reliable. In 1929, Gordon Selfridge had told the Architectural Association, 'Light is as necessary to architectural production today as was colour to the painter'; while A.B. Read informed the 1931 International Illumination Congress, 'There is now an Architecture of light.'[59] Indeed, Selfridge was one of the leading advocates of architectural lighting, signalled by the addition of an Art Deco illuminated canopy to the elaborate Edwardian classical fantasy of his Oxford Street store. By the 1930s, the architectural press were lauding praise on the architect

Joseph Emberton for his imaginative use of lighting. His short-lived façade for HMV's Oxford Street store was, 'an example where the Neon lighting is a fundamental part of the design and not merely applied as an afterthought',[60] while for historian John Compton, Emberton's 1929 Olympia Extension, 'exploits its dramatic possibilities by the use of unadorned areas of concrete with deep window recesses and giant block letters which stand out in bold relief, lit by steeply raked floodlights positioned on top of the canopy above street level.'[61]

Another aspect of commerce and trade which embraced the Art Deco aesthetic was the industrial exhibition. The 'North East Coast Exhibition', held near Newcastle in 1929, was representative of the fortunes of the Art Deco aesthetic in Britain between the wars. Designed by architects W. & T.R. Milburn of Sunderland, all buildings and layout cost just £160,000, but there was still a concerted effort to emulate the great European expositions. *Architect and Building News* recognized the traditional nature of the exhibition's modernity: 'In design the buildings are modern in outlook, but pay a suitable tribute to the classical tradition of the city [Newcastle] ... the portico of the Festival Hall, also, is a charming essay in that archaic ionic which we associate with modern Swedish architecture.' Austerity certainly took its toll as far as any desire to indulge in decorative eclecticism was concerned. 'In many places there existed the temptation to spend that little extra on colour, relief or illumination which would have added so much to the gaiety or emphasis,' admitted the *Architect and Building News* correspondent, but, 'That temptation had to be resisted.' He then humbly added that the exhibition 'cannot be compared by our reader, surfeited with a glut of dazzling continental exhibitions, with the Paris Exposition of Decorative Arts.'[62]

During the 1930s, one form which readily embraced American notions of streamlining in Britain was the industrial exhibition stand. The work of Misha Black shown at the British Industries Fairs and other trade fairs illustrates, as well as that of Emberton, the trend towards curvilinear forms across a range of fields. However, it also draws attention to the narrowing of the gap between Modernism and the streamlining of Moderne in the 1930s. Black's exhibition stands were relatively minor projects, but received coverage in the trade press and, like the architecture of Hill, seem to have shared more common ground with the type of commercial Modernism espoused by the American industrial designers than that of the British Modern movement.

Like window display and exhibition design, advertising was also subject to modernizing influences, this time more directly from the Continent rather than America. Again the trade press gave coverage to the European avant-garde, *Commercial Art* featuring a monthly advertising art 'personality', usually from Europe, as well as numerous examples of successful and striking campaigns from France, Holland, Spain, Italy, Austria, Germany and Hungary. In Britain the railway companies were among the first to embrace modern techniques of poster design,

the new style with its associations of speed and health providing them with an appropriate aesthetic. In 1932, the celebrated French artist A.M. Cassandre designed a poster for Southern Railways featuring a stylized lighthouse to advertise the cross-channel service. This prompted *Commercial Art* to remind its readers of the need to embrace new technology in order to achieve such results. 'Modern design very often calls for the use of the airbrush,'[63] the magazine advised, conscious of the reluctance of British artists to embrace new techniques. Along with the airbrush finish, the use of colourful, stylized and simple imagery characterized the Art Deco poster. Posters such as Greaseman's 'Hike for Health' design, again for Southern Railways, illustrate the new importance attached to 'sensibility and legibility' and the concentration on a single idea. A 1933 article on the posters of the London North Eastern Railway emphasized the vogue for sans serif lettering, 'for this is, to a great extent, a sans serif world.' LNER used Gill's sans serif typeface, yet there was one school of thought that attributed 'the continuing popularity of sans … to the legibility and clean printing surface of a serifless face than to any psychological dicta about the "spirit of the age".'[64] Nevertheless, the fact that a company such as LNER, whose record-breaking streamlined Mallard engine exemplified the potential speed of modern life, used a typeface designed by Eric Gill was an irony that was not lost on *Commercial Art*'s commentator, who wryly noted that, 'not one of the real believers in that world, the profits of the age of steel, has been able to draw the really impersonal, purely functional letter.'[65]

This fundamental paradox brings us to the root of Art Deco, and in particular its British manifestation. Unlike the vision of a modern design held by those ideologues within the Modern movement, which not only reflected but also embraced technology and mechanization, Art Deco remained largely reflective. It was this reflective quality that led to such varied outcomes as façade architecture, Cubist designs on traditional teacups and the popularity of a brick-built modern aesthetic in the towns and suburbs of Britain. There was a desire to acknowledge modernity through image and decoration, yet a concurrent suspicion of complete capitulation in the face of rapid technological change. It was as a negotiation between tradition and modernity that British Art Deco developed, and the strength and sobriety of the style's traditional element ensured that it would never attain the flamboyance of American Art Deco.

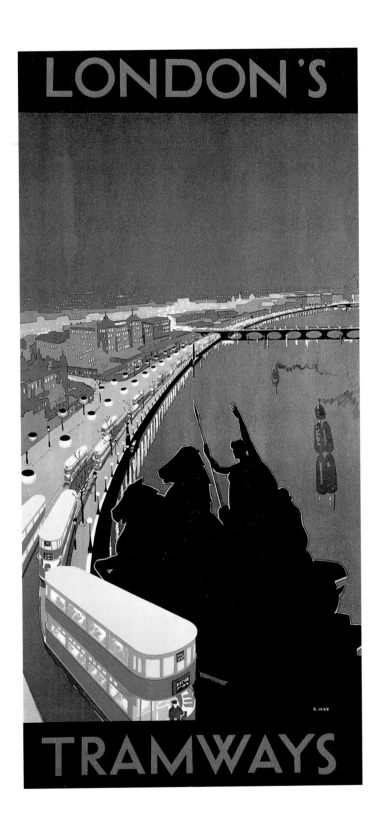

'London's Tramways', 1929. Poster for
London Transport, artist unknown.

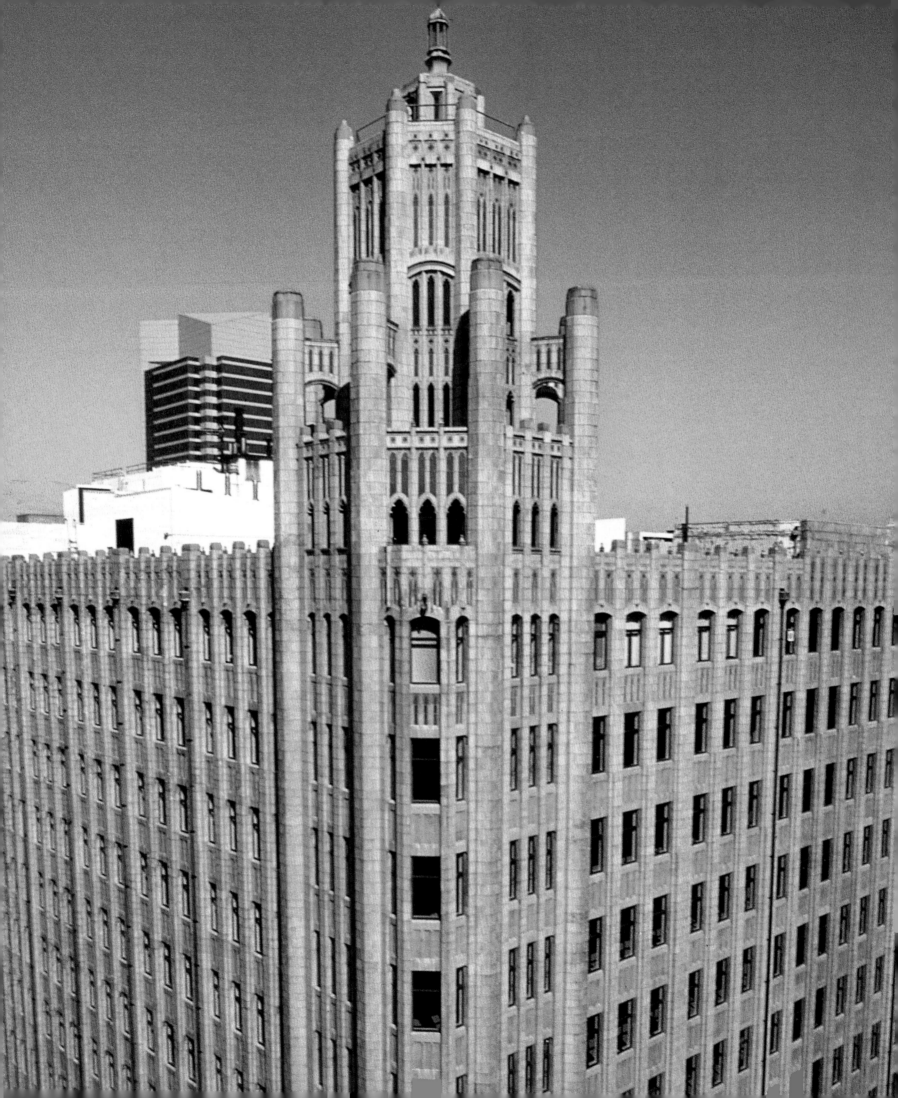

T he ever-present pictures of natural history, founding fathers, national geography, customs of life and work in the different regions, religion ... can greatly encourage the creation of a spirit of national unity.

Alfredo Guido, 'La Decoración en la Arquitectura', *Revue de Arquitectura*, Buenos Aires, October 1941

Left: The Grace Building, Sydney, 1930. Architects: Morrow & Gordon. Influenced by Raymond Hood's Chicago Tribune Building, this glazed terracotta structure is in the commercial Gothic style that preceded the full-blown Art Deco.

Right: The cover of the Australian magazine *Home*, July 1927, designed by Thea Proctor. Thea Proctor was an Australian artist who worked in London from 1903 to 1921. On her return she was much in demand as a designer.

188

The idea of an 'international style' in design may seem to belong to the twentieth century, but the tradition is in reality a much longer one. The rules of Classicism spread across Europe during the Renaissance, and both Rococo and the Baroque later achieved some degree of pan-European influence. It is within this international tradition that Art Deco is located. For a style which took its name from an international exhibition, and which evolved within a varied set of national circumstances, international status might seem easy to confer upon Art Deco. Nevertheless, it was advocates of Modernism who claimed, for a version of Modernist architecture, the title 'The International Style'. When he first used the phrase in 1932, Henry Russell Hitchcock was actually questioning the dogmatic assumption that Modernism was going to put an end to the concept of 'style'; but his use of the definite article helped ensure that modernism laid claim to being the only international idiom of the period. Moreover, the title helped conceal the social, political, economic and national roots of different approaches to Modernism and further enhanced its supposedly 'scientific', rationalist basis. Although a form of the modernist International Style triumphed in business districts and public buildings world-wide in the post-war period, the alternative international style of the twentieth century was undeniably the 'modernistic' or Art Deco one.

For Art Deco was truly international. It was more than pan-European, and its influence spread much further from France than New York. By considering the appearance of the style in countries as geographically distant as Australia, Argentina and South Africa, it is clear that Art Deco was a world-wide phenomenon. To discover which versions of Art Deco spread across the continents, the channels through which the style spread, and the reasons it was embraced in so many different places, it is necessary to explore the relationship

The staircase of Mahratta, a luxury mansion in the northern suburbs of Sydney, built in 1940–41. Architect: Roy Agnew.

between Art Deco and nationalism, colonialism and capitalism, as well as the broader cultural relations between Europe, the USA and the rest of the world. Although by no means comprehensive, with a series of stylistic snapshots it will be possible to compare the influences and manifestations of the style across the world, and discover whether Art Deco really was a unifying, and unified, international design language.

During the late 1920s and 1930s, Australia and New Zealand emerged from a post-war cultural conservatism. Foreign influences had been deemed pernicious evils from which Australians should be protected, and jazz, film, contemporary art and literature were all seen as potentially corrupting. Indeed, according to the director of the National Gallery of Victoria, modern art was, 'the work of perverts'.[2] The only influences which were deemed appropriate were those that were both British and conservative. In New Zealand during the 1910s and 1920s, the predominant architectural solution was an essentially traditional, Beaux Arts one; and in Australia reactionary nationalism was embodied in the Australian landscape genre of painting.[3]

Yet in this conservatism lay the seeds of a small but significant avant-garde movement in architecture and the decorative arts. Reactionary nationalism forced the younger generation to look to Europe and America: 'To go abroad,' remembered Alan Morehead, 'that was the thing. That was the way to make your name. To stay at home was to condemn yourself to nonentity.'[4] Facing this ominous choice, many Australian artists and designers headed for Europe. Olive Nock, who worked in both ceramics and textiles, visited Paris in 1925, studied needlework in London and designed fabrics for Liberty's; while the textile painter Kathleen O' Conner was living in Paris in 1925, where she worked both as an interior decorator and as a painter of silks and velvets for Poiret.[5] Such European contacts provided the channels through which Art Deco spread to Australia and New Zealand. The conventional received wisdom, by contrast, tells us the style spread on celluloid from America. For the Modernist architectural historian J.M. Freeland, writing in the 1960s, Art Deco 'was a glib formula which could be applied to any situation … a facile architecture … The jazz style,' he continued, 'was a result of the cinema and pure mindlessness.'[6] Freeland saw the Depression as providing a clean stylistic break: 'The new type of architecture which crept onto the scene from 1934, when building was slowly revived, was a world away from that which was being built in 1929.'[7]

This view is undermined by two important inaccuracies. First, while a popular taste for Art Deco may have been fostered by the movies, the modernistic style reached designers from both America and Europe by less glamorous means. Moreover, it had reached Australia by the late 1920s. At a discussion evening held by the Royal Victoria Institute of Architects in May 1929, Mr Cummings, an architect who had visited America, told the meeting that, 'Manhattan Island is an example of the effect that can be produced by a number of ornamental towers

Posters by Gert Sellheim for the Australian National Travel Association, c.1936.

The Anzac Memorial, Hyde Park, Sydney, 1934, designed by Bruce Dellit, sculpture by Rayner Hoff.

in close relation to another.'[8] A year later another architect, L.F. Irwin, lectured to the Society on 'The Trend of Design as shown in Modern Architecture',[9] showing slides of New York Art Deco as well as German Modernism. The fact was that foreign styles were making enough impact in Australia by 1929 to provoke concern among conservatives. In a radio address in 1929, the architect R.J. Hadden asked, 'Our architecture for 1929, what is it to be?' In the address he lamented jerry builders and their 'foreign forms of building ... that have nothing to do with our real cultured mentality – Californian bungalows, Chicago freaks, and now "Spanish missions" and "Jazz".'[10] Such sentiments are especially revealing, given the suggestion that it was not only architect-designed buildings which were adopting the style, but also the creations of commercial builders.

It was not only architecture in which the modernistic could be found in Australia at the end of the 1920s. In 1929, Roy de Mestre organized a charity exhibition at Burdeken House, a Sydney warehouse, which showed 'Good Furnishing, including Old and Modern Furniture and fittings.' The exhibition was dominated by antique styles, but significantly there were six modern rooms by de Mestre, Hera Roberts, Thea Proctor, Leon Gellert and Adrian Feint. Although the rhetoric of Gellert's introduction echoed Bauhaus functionalism, the furniture, manufactured by Beard Watson & Co., did not. The chairs were upholstered with fabrics decorated with chevrons, the wardrobes and tables were stepped, and the curtains and carpets were pseudo-Cubist. A Beard Watson advert described the fabrics and carpets as, 'in keeping with the Continental Art Moderne Decorative Vogue', and Parisian influence was also specifically acknowledged:

The furniture is upholstered in a delightful fabric of Modern French design. The whole of the work has been executed by Beard Watson & Co. Ltd, who interpreting in a practical sense the modern trend in interior decoration and furnishing present this modified example of 'L'art Moderne' as being acceptable to Australian conditions as well as temperament.[11]

This advertisement also gives us a clue as to the twofold meaning of Australian Art Deco. Firstly, as it suggests, there was a perceived need to modify Art Deco for Australia. In aesthetic terms, this involved curbing the excess of eclecticism and the development of an idiom which, in architectural terms, mirrored the American evolution from zig-zag to Moderne in the urban environment, and the British development of a traditional brick-built Modernism in the suburban setting. Yet it is misleading to read Australian Art Deco as derivative of these two secondary versions of the style. Both the Burdeken exhibition and the experiences of individual artists suggest direct contact with Europe, and specifically Paris.

So Australian Art Deco was an Australian interpretation of a European style and can thus be read to some extent in nationalist terms. As we have seen, 'jazz' as a style was seen by some conservatives as an alien influence; however, the fact that it was a Western international style was seen as important by those

192

who believed in the futility of the search for a purely national style. In his response to the conservative critics of the new Victoria State War Memorial, designed in 1929, the architect Alec S. Hall observed that, 'the architecture of this country is constantly being faced with the charge that it is not truly Australian … But a purely Australian style is neither possible nor desirable.' Hall went on to applaud modern developments emanating from Europe:

> It is not feasible that our art should be Australian in the sense that the boomerang is: the boomerang was evolved slowly, and now typifies aboriginal life to us. So also our architecture, painting, sculpture, literature, music, if they are to mean anything at all, must reflect our European origin.[12]

Art Deco in Australia was implicated in the discourse of both racial and national cultural identity, as well as in the discourse of modernity. Indeed, in a country which was asserting its identity against both a colonial power and an indigenous population, Art Deco was a conveniently flexible aesthetic proposition; it provided a modern Western visual language which originated in France, but by the 1930s was popularly associated with America. The predominance of American-style 'Skyscraper Art Deco' in Sydney's business district in the 1930s can be seen as an outward expression of this realignment of identity with the pioneering spirit of America – a move away from Australia's humble colonial heritage of the nineteenth century. As a result, urban Art Deco, especially in Sydney, adopted a monumental idiom. The ANZAC war memorial in Hyde Park, designed by C. Bruce Dellit, exemplified the adoption of a stylized modernism for important public buildings. Dellit, who admired Frank Lloyd Wright, won the competition to build the memorial in 1930,[13] and its opening in 1934 revealed an interior with direct zig-zag quotations, especially in the vestibule and the hall of silences. Dellit went on to design other buildings in Sydney and Victoria, most notably the Bank of New South Wales (now Delfin House) on O'Connell Street, Sydney (1939–40) and the Museum of Castlemaine, Victoria (1932). Other Sydney architects who used this monumental skyscraper idiom included Budden & Mackey, Morrow & Gordon and Robertson & Marks.[14]

Apart from the influence of American cinema, the other, equally significant, method of stylistic dissemination in Australia was the range of magazines covering design and domestic decoration. *Home*, which began publishing in 1920, was the most influential. Its modern covers, designed by such artists as Feint, Proctor and her cousin Hera Roberts (all contributors to Burdeken House),[15] followed the style of such magazines as *Vogue* and *Harpers Bazaar* and demonstrated the development of Australian Art Deco. Moreover, Harold Gaztreaux's society portrait photographs were often shot against abstract decorative backgrounds painted by the cover designer.[16] *Home* and other titles, such as *Women's World* (1921), *Australian Women's Mirror* (1926), *Australian Women's Weekly* (1933) and *Home Beautiful*, helped promote the use of modern European and American decorative styles among ordinary consumers, significantly women. At the same

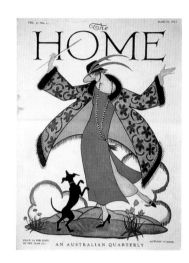

Thea Proctor's 'Flapper', cover design for the Australian magazine *Home*, March 1923.

time, *Art in Australia* and foreign periodicals such as *Studio, Architectural Record* and *Pencil Points* kept designers abreast of contemporary developments abroad.

Indeed, these imported periodicals go some way towards explaining a small yet significant contribution to the tradition of stylized architectural modernity in the years before the blossoming of Art Deco in New Zealand from the late 1920s. In drawing attention to the work of J.A. Louis Hay of Napier, Peter Shaw again highlights the inadequacies of the model of antipodean Art Deco as an imported American style. 'To say that Art Deco in Oceania was a wholesale import from the US and Europe in the late 1920s,' suggests Shaw, 'would be to deny an admittedly small tradition of avant-garde decorative architects.'[17] Basil Ward, a future partner in the London-based Modernist firm, Connell, Ward & Lucas, had served an apprenticeship in his native New Zealand with Hay, whom he described as, 'a far from conventional member of a small town community whose architectural philosophy reflected the turn of the century avant-garde. He was greatly influenced by the Art Nouveau movement, Austrian Secessionists, Frank Lloyd Wright, Louis Sullivan and Charles Rennie Mackintosh.'[18] As well as reading foreign periodicals, Hay also owned a copy of Wright's 1911 Wasmuth Portfolio and designed a series of private houses from 1915 influenced by Wright's work.

During the 1920s, despite the predominance of Beaux Arts architectural ideas in New Zealand, there were attempts to embrace the challenge of modernity through building, resulting in interpretations of the skyscraper architecture of Chicago and New York. Landmark House (1929) in Auckland by Wade & Bartley has only eight full storeys, but has a set-back top and two-storey tower, together with windows divided by stripped classical columns topped with parapets reminiscent of Raymond Hood's 'Skyscraper Gothic' idiom. Additional surface decoration is achieved through the use of moulded concrete panels. By the 1920s most office buildings had a structural steel frame, and buildings such as the Hamilton Nimmo Building (1929) in Wellington by F.D. Stewart used this technology to decorative effect. Green in colour, the steel elements frame the diagonally patterned brickwork, and again emphasize verticality on what is only a four-storey building. Stripped classicism, another antecedent of Art Deco, also had its exponents in New Zealand, most notably W.H. Gummer. His New Zealand Guardian Trust Building (1914) and Dilworth Building (1925), both in Auckland, each offered a severe yet decorative vision of modern architecture which retained powerful traditional connotations.

New Zealand did not escape the consequences of world depression. However, a massive earthquake which ruined the Victorian seaside town of Napier on Tuesday, 3 February 1931, helped stimulate, both intellectually and financially, New Zealand's architectural community. There was much stylistic debate, yet even advocates of Californian Mission styles promoted ideas of stylistic conformity. According to the New Zealand *Telegraph* on 16 February, 'The attractiveness of Santa Barbara, one of the youngest, yet most beautiful cities of California [which

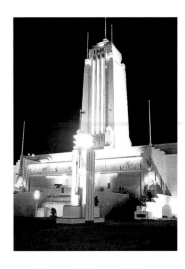

The 169-feet high Centennial Tower was the centrepiece of the 1940 New Zealand Centennial Exhibition. The chief designer had visited the great American fairs of the 1930s.

194

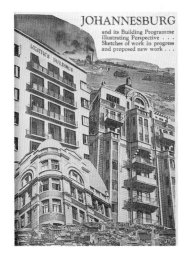

Johannesburg buildings. Composite illustration from *The South African Builder*, April 1934. The three buildings represent the development of architecture in Johannesburg over the preceding decade. The tower building is the Stuttafords Building, 1927, with its brick and rusticated pilasters. On the right is Astor Mansions, 1931, dubbed Johannesburg's Chrysler Building in miniature. The Modernist design is Heath's Building, 1931–2, which uses no obvious decoration.

had also been rebuilt after an earthquake in 1928], is behind the suggestion that all permanent buildings effected in Napier of the future should conform to a uniform style of architecture.'[19] Yet as the town was swiftly rebuilt, it became apparent that it was Art Deco which would dominate the new town (although the Mission style maintained a significant presence). Art Deco fulfilled both a practical and ideological function in Napier. The simplified decoration of reliefs and surface patterns addressed the problem of excessive applied ornament, which had to be avoided due to the considerable amount of death and injury that falling masonry had caused in the earthquake. At the same time, the style expressed the speed and technology of modernity which the struggle to rebuild the town quickly, cleanly, safely and attractively exemplified; Napier was after all a holiday resort. The influx of young draughtsmen from Auckland to work in local offices brought new decorative ideas garnered from the journals *Pencil Points* and *Architectural Record*; many were accepted simply because of the volume of work and the rapidity with which the designs were required.

Although Napier firms monopolized much of the rebuilding, even such a localized building explosion encouraged and stimulated stylistic innovation on a broader scale. Architects elsewhere in New Zealand began experimenting with Art Deco and modernist bungalows and houses, and, as in Australia, many non-architect-designed houses adopted a version of the new style. Local builders appeared quick to appreciate the popular potential of stylized Modernism, as did many New Zealand businesses. The Avon Cinema (1934) in Christchurch by L.E. Williams may be a rare example of an unadulterated streamlined Moderne style; however, towns like Dunedin still boast numerous examples of a version of 'jazz-modern' which continued to be built into the 1940s. Indeed, it was 1940 which saw the staging of New Zealand's answer to the great American World's Fairs of the 1930s. The chief designer of the New Zealand Centennial Exhibition, held in Rongotai, Edmund Anscombe, had visited Chicago in 1933, and both New York and San Francisco in 1939. 'Small wonder then,' remarked Shaw, 'that Art Deco styling dominated his extravagant designs … The 52-metre high Centennial Tower at the centre of the exhibition was a triumph of soaring, streamlined Deco, designed to uplift a nation by that time at war.'[20]

The political and social climate in inter-war South Africa shared broad similarities with that in Oceania. Here was a former British colony striving to assert its commercial and political identity, which needed to be at once international and national, modern and traditional. Art Deco was the style which could resolve these potential paradoxes. As in Australia, an aesthetic identification with America fulfilled some of the requirements of South African capitalism. Indeed, following a trip to New York in 1939, Eric Rosenthal wrote, 'Looking down at the city from a height, I noticed that it was like an immensely magnified version of central Johannesburg … [there was] the same set-back over set-back, but where our buildings reach twelve or fifteen storeys, these were seven and

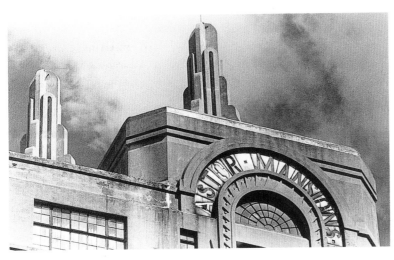

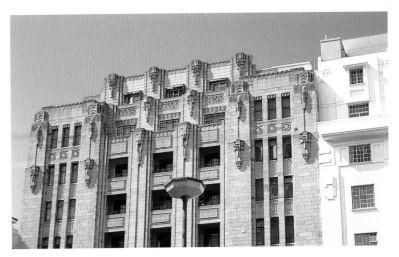

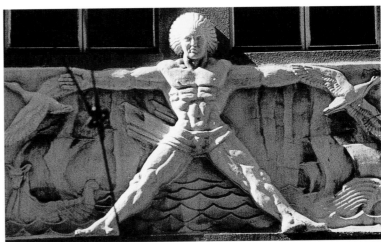

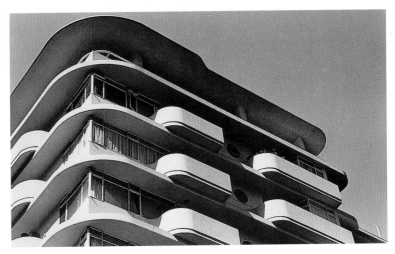

eight times as high.'[21] The relatively austere skyscraper idiom of Art Deco that dominated South African corporate building throughout the 1930s betrayed its antecedents, the 'solid, vaguely classical city buildings'[22] of the later 1920s, with their East coast urban American connotations. Companies, such as McManus Printers in Cape Town, adopted the 'jazz' style foyer for their buildings, and Art Deco once more fulfilled its international role as the idiom of popular modernism favoured by corporate clients.

At the same time, the stylized decorative motifs used in many public and commercial buildings fulfilled a specifically nationalist propaganda function. Federico Freschi has drawn attention to the 'quasi-historical tableaux [plotting] the rationale of nationalised commercial enterprise' in the General Post Offices of Johannesburg (1935) and Cape Town (1941). The mural by W. de S. Hendrikz in Escom House (1937), Johannesburg, entitled *Through Industriousness to Manliness*, bears the legend, 'Dedicated to the ideal of cementing together by common endeavour for achievement all the peoples of South Africa, regardless of race or creed, into a brotherhood of mutual trust and goodwill for the welfare of our country and the glory of almighty God.'[23]

Freschi's work concentrates on the decorative schemes, designed by Ivan Mitford Barber, used on the Old Mutual Building in Cape Town, which depicted a mixture of images of European settlement, South African industry and native motifs. A stylized historical frieze, depicting the European 'civilization' of Africa, runs for 117.65 m around the building just above street level, while higher up are nine native figures, stylized baboons and elephants, and four native masks on the tower. The decorative scheme shares its eclectic subject matter with the exoticism of the Parisian *décorateurs*, particularly as seen in the 1931 Exposition Coloniale; however, in this case it serves commerce rather than empire. For Freschi this fact undermines comparisons which have been made between South African Art Deco decoration and the historicist themes promoted by Mussolini in Italy, as, he argues, corporations had more selfish interests to fulfil than pure nationalism. Nevertheless, he admits that there was an attempt to 'conflate South African history with corporate policy', which resulted in an international style fulfilling a uniquely national role. This combination of indigenous wildlife with representations of corporate industrial might is a recurring theme in commercial Art Deco in 1930s Johannesburg, as Marilyn Martin observes:

> On the façades of Dunvegan Chambers there are representations of [South African] Flora and Fauna, as well as of industrial expansion. The cast concrete panels on the Union Castle Building depict South African industries presided over by personifications of Hope and Nature, while the iconography of some of the panels is directly linked to the corporate identity of the company.[24]

Art Deco also flourished as an architecture of pleasure in South Africa. While a monumental version of the skyscraper idiom dominated downtown Johannesburg and Cape Town, examples of streamlined Moderne were limited

to cinemas, for example the Plaza in Kimberley (1931). There were also over a hundred examples of the 'atmospheric' cinema built after 1922, buildings whose rampant eclecticism often contained Art Deco elements. Martin cites the Colosseum Theatre in Johannesburg (1933) as an example of a cinema which used a variety of themes. Stylized Egyptian and Greek motifs dominated the exterior and foyer, yet at the same time:

> The streamlined crispness and luxurious finishes of the Art Deco movie style were nowhere more evident than the ladies rest room. The walls were covered with sycamore and black velvet panels; the pilasters, which recalled the ceramic figures outside, were silver; while the floor was covered with a silver carpet. An octagonal sofa with a fountain stood in the centre.[25]

The architectural climate in which South African Art Deco flourished presents a familiar story in which the style formed one of three concurrent idioms, together with a conservative Beaux Arts classicism, and a small yet vocal and internationally recognized Modern movement. As in Britain, the proponents of the South African Modern movement, under the leadership of Rex Martinssen, came to dominate the architectural press: 'Art Deco was given scant critical attention,' confirms Martin, 'and its architects, such as Obel & Obel, P. Rogers Cooke, and W.H. Grant, like their New York counterparts Voorhees, Gmelin & Walker and Jaques-Ely Kahn, became missing persons in the history of twentieth-century architecture.'[26]

Art Deco seems to have enjoyed a period of fashionable popularity among the urban bourgeois élite in Latin America during the inter-war period; yet once again the circumstances of the arrival and development of the style remain hazy. In 1931, John A. Benn, an English correspondent visiting Buenos Aires for the *Cabinetmaker*, remarked that, 'Modern furniture in the French style is much in evidence in the newer hotels.'[27] Benn was covering the 'Industria Britannica' exhibition in the city, and in an earlier dispatch had also expressed concern at the increasing dominance of American goods on the Argentinian market. He advanced a range of explanations, but concluded that:

> There is a factor [in American dominance] which deserves the closest study of British interests – American films. Most of the films now shown in Argentina come from Hollywood and their effect in relation to trade is too obvious to require emphasis. Audiences see nothing but American cars and other products, and the films afford most valuable propaganda from the commercial standpoint.[28]

But, as with Oceania, such anecdotal evidence of the role of Hollywood can be balanced by evidence of contact between South America and the European avant-garde. French taste among Brazil's urban élite had a pedigree. The renewal of Rio de Janeiro after the proclamation of the republic in 1889 drew much inspiration from Haussmann's sweeping changes to Paris, and, by the early 1900s a taste for Art Nouveau appeared in graphics and decorative architectural elements such as tiles and railings.[29] By the 1930s, according to Rachel Sisson, Art

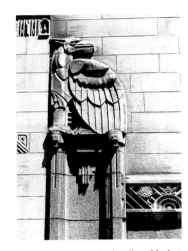

Decorative concrete detail on Market House, Greenmarket Square, Cape Town, 1932, by W. H. Grant. Apparently generic Art Deco styling here included stylized proteas, the South African national flower. Art Deco could be at once national and international.

Deco was being used 'intensively'. The style was a 'notable contribution' to the urban landscape of Rio, 'in the general composition and decoration of new residential buildings, which were also technically innovative for their generalised use of reinforced concrete.'[30]

But for the roots of Brazilian Art Deco it is necessary to look to the early 1920s and the influence of European design. By 1924, there was already modern decorative design in Brazil, as the Cubist fabrics, carpets, wall decoration and lighting of Lasar Segall's Paviaho de Arte Moderna for Dona Olivia Pentado show. Yet it was two expatriot Europeans who proved to be the catalyst for Modernism in Brazil: Gregori Warchavchik, a Russian architect living in Rome who arrived in 1923, was largely responsible for the introduction of a more formal rationalism in Brazilian architecture, while John Graz and his Brazilian associates developed a more decorative modern idiom in the country. Graz was a Swiss artist and decorator who had met Antonia and Regina Gomicide, son and daughter of the Brazilian consul, when they were both students at the Ecole de Beaux Arts in Geneva. Graz moved to Brazil and married Regina in 1920, where the three eventually became known as the 'Graz–Gomicide family'. Collectively they were a pivotal part of the Art Deco scene in São Paulo.

Antonia lived in Paris in 1920–7, where he became familiar with Cubism and developments in the French decorative arts. On his return, together with Graz, Regina, Vicente de Rego Monterio and Theodore Braga, he began transferring art to interior decoration: stained glass, reliefs and painted textiles. Graz had turned to interior decoration as early as 1925 and his work shared both geometry and luxury with the Parisian *décorateurs*. Although Le Corbusier had made a great impact when he visited Rio in 1929, the defining moment of the Brazilian avant-garde, an exhibition in Warchavchick's house in April 1930, demonstrated the ornamental, even figurative nature of Brazilian modernism. The modernity of Graz and his contemporaries was a decorative one, closer to the 'modernistic' Art Deco than to radical Modernist functionalism. Even when a more streamlined aesthetic came to dominate in the 1930s, it was Europe rather than the USA which continued to be the dominant influence. It was Graz, with his awareness of European design trends, who introduced chrome plating and tubular steel to interior design. He incorporated these features into the interiors of the numerous élite São Paulo homes which he decorated throughout the 1930s and 1940s. Graz, like many of the artists of the UAM, was depriving Modernism of its supposed revolutionary intent by adopting its aesthetic to traditional Art Deco modes of production.

So what purpose did Art Deco serve in Brazil? In terms of the urban bourgeoisie, to whom Graz and others catered, the style seemed capable of reconciling two apparently conflicting requirements. Many modernists wanted to develop a characteristically Brazilian art, and indeed Graz's work in the 1920s often uses large stylized murals depicting native Indians or indigenous Brazilian

plants and animals. Yet at the same time, the furniture in these interiors was unashamedly modern, and more importantly European. As in Australia, Brazilian Art Deco was assisting in the construction of a national identity. The evolution of the style in the 1920s and its widespread use in the 1930s coincided with important political developments in Brazil. A huge country with many diverse regions, it was searching for a viable sense of nationhood which began to emerge in the Vargas era (1930–45). President Vargas came to power on a wave of revolutionary left-wing radicalism during the economic turmoil which followed the stock-market crash of 1929, but his dictatorial rule soon seemed closer to the authoritarian right and fostered an increasing sense of Brazilian nationalism.[31] It is within this context that the popularity of Art Deco should be placed.

The extensive use of Art Deco motifs on the façade and interiors of the Banco de São Paulo confirm the style's capitalist connotations. At the same time, the appearance of chevrons and other geometric motifs in decorative ironwork, stained glass and architectural detail on many relatively humble São Paulo residential buildings shows that the style also had popular appeal, with its suggestions of Eurocentric internationalism. Nevertheless, there was also an application of traditional Marajoara decorative motifs to modern architecture; schemes like Fernando Correia Dias's plan for a pool at Guilheme Guinle's residence in Rio de Janeiro recall the work of Frank Lloyd Wright. In 1933, Wright himself addressed the first International Exposition of Tropical Architecture, confirming the potential for decorative modern architecture and design in a country striving for both European modernity and a specific Latin American identity.

The Art Deco art form that most clearly expressed the drive towards a fusion of European modernity and Latin American nationalism was the monumental Art Deco sculpture found in both Brazil and Argentina. This stylized figurative idiom bestowed a monumental sense of power when used either in public sculpture or architectural embellishment; its most celebrated example is the 98-ft-high statue of *Christ the Redeemer* overlooking Rio. The statue, a collaboration between the local architect Hector de Silva Costa and the French sculptor Paul Landinski, was erected at the end of the 1920s and inaugurated in 1931–2.[32] The purpose of the statue illuminates the political context of Brazilian Art Deco. The Christ figure is a monument to the Sacred Heart of Jesus (a devotion proclaimed in Europe and introduced to Brazil with the aim of strengthening Catholicism). Now on the highest point above Rio and proclaiming civilizing piety, it shows Art Deco deprived of its radical connotations and steeped in the conservative power of the Catholic Church: two of Europe's most successful exports united as one.

This version of Art Deco monumentalism can also be found serving conservative nationalism further south, in Argentina. Manuel A. Fresco, the conservative governor of the Buenos Aires Province between 1936 and 1940, commissioned a series of public buildings in the small towns which had grown up between 1880 and 1910, either as forts for protection from the Indians or

Statue of Christ, Corcovado Peak, Rio de Janeiro, 1931. Designed by Heitor da Silva Costa, the sculpture was built under the supervision of Heitor Levy and sculpted by Landowsky.

around frontier railway stations.[33] Governor Fresco wanted to turn each of the towns into a miniature model city with three defining symbolic structures: a town hall, a monumental cemetery gate and a slaughterhouse (the Pampas were renowned for their meat production). Wherever possible he gave these commissions to his friend, the architect Francisco Salomone, an architect trained in Buenos Aires, who is thought to have drawn directly on the work of both Dudok and Mallet-Stevens.

During this brief four-year period, Salomone designed eight town halls (a ninth remained unbuilt), seven slaughterhouses, four cemetery portals, together with lesser decorative features in some towns, and municipal offices in four others. In his book *Mechanisation Takes Command*, Sigfried Gideon considered the historical modernization of the slaughterhouse; but as an exemplary form for the exercise of pure functionalism, the notion of the Art Deco abattoir would have been an anathema. Fresco's programme of urban development smacked of modernist paternalism, yet by using Salomone's heavy sculptural style, he achieved a powerful monumentalism befitting his political ambition. Art Deco can be seen in this context to epitomize political domination over both a population and an entire landscape. The people were reminded of their ruler through the fabric of the three most important structures in their town, and the expansive horizons of the Pampas plains were dominated by the towers of town halls, strangely reminiscent of Parisian exhibition pavilions.

Argentina, not unlike Roosevelt's America, saw an unmistakably Modern idiom being used for the kind of propaganda purposes more often associated with European totalitarianism. The relationship between modern decoration and the newly assertive nation states of South America was unambiguous. Writing in 1941, Alfredo Guido, a nationalist painter, saw no problems for the artist in serving his country:

> By using the artistic decorator, the state allowed him to develop his imagination on a larger scale and exercise his experience as an artisan, channelling it toward a more social and therefore human art, not leaving the beaten path for the strictly individualistic path so common today … The ever present pictures of national history, founding fathers, national geography, customs of life and work in the different regions, religion … can greatly encourage the creation of a spirit of national unity.[34]

Despite this monumentalism in the service of the state, variants of Art Deco were also to be found in the commercial and domestic buildings of cities including Buenos Aires and Rosario. In 1929, Le Corbusier told an audience in Buenos Aires that the city was 'the most inhuman I have ever known'.[35] However, given the difficulties surrounding his favoured solution, which was to build an extension of the city over the sea on a concrete platform, commercial and domestic designers who wanted to embrace the aesthetic of modernity tended to adopt a less radical approach. In the capital, it was garages and cinemas which most readily embraced Art Deco (The Broadway, 1930; The Sipacha, 1930; The Kalnay, 1932; or the

202

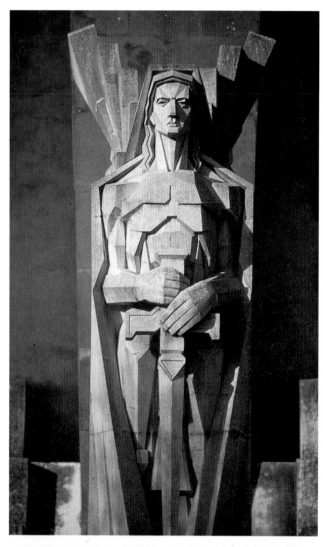

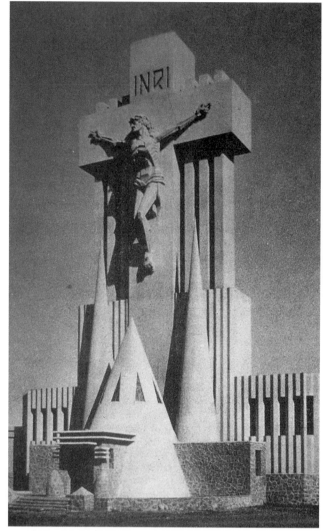

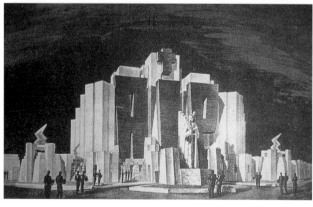

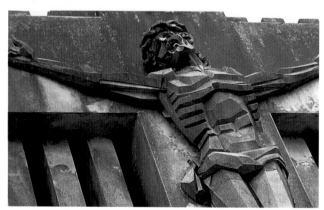

Top Left: Azul Cemetery, 1938, by Francisco Salamone, entrance showing sculpture of angel in reinforced concrete. Bottom Left: Azul Cemetery, portico (the photograph above shows a close up of the figure seen here). Top Right: Laprida Cemetery portico, by Francisco Salamone. Bottom Right: Laprida Cemetery portico, detail relief in concrete.

Capitol, 1932), yet once again it should not be assumed that Hollywood was the main, or indeed only, influence. The architect of the Capitol Cinema, Alejandro Virasoro, had already designed a number of more angular Parisian-inspired Art Deco buildings by the end of the 1920s. Virasoro's own house at Aguero 2038, built in 1925, shows an early awareness of European decorative Modernism; this was followed by the Ganduglia House at Aguero 2024 (1927), the bank Hogar Argentino (1927), and the La Equitativia del Plata Building (1929).[36]

Given the influence of Art Deco in Brazil and Argentina, it is hardly surprising that Uruguay, sandwiched between the two, has a significant Art Deco architectural tradition. According to Jorge Ramos de Dios:

Uruguay was a fertile field for the development of Art Deco. Here was an environment in which an expressionist aesthetic of imprecise origins predominated … closer to the work of Frank Lloyd Wright or Willem Dudok than strong European rationalism. This is the reason for the use of rounded and curved façades in Uruguay, often applied in renovations of older buildings, and found so often in the architecture of the 1920s and 1930s.[37]

Art Deco's predominance can often be measured by the harshness of its critics, and certain Uruguayan Modernists were extremely vocal. After visiting Le Corbusier in 1932, Carlos Gomez Gavazzo returned home to broadcast a tirade against 'pseudo-modernism' on Uruguayan national radio. It is significant that Gavazzo blamed 'the chorus of the Exposition of Decorative Art in Paris', rather than American interpretations of Art Deco, but the origins of the style mattered little as his criticisms reached their sneering climax. 'The broken lintel of your window is no more than a flirting wink,' railed Gavazzo, 'a ridiculous pretension that your designer gave to your house to leave a distinctive mark.'[38] Although Vazquez Berriere y Ruano's 'Expreso Pocitos' apartment building (1936) offers an idiosyncratic example of the streamlined Moderne style being used vertically, there were also a number of architects, such as Tosi and Eloy Tejera, Isola and Armas, Echavaste, and Rocco, working in the more angular, pseudo-Cubist tradition. Again the Parisian influence was evident, exemplified by the praise of the architect Mauricio Cravotto. For Cravotto, the 1925 Exposition was 'a great modern effort … a cooperative effort of artists, industrialists and businessmen in the creation of today's spirit.'[39]

However, by the end of the 1930s, the dominance of a more formal Modernism in South American architecture was becoming increasingly evident. Both the Brazilian and Argentinian pavilions at the San Francisco World's Fair in 1939 were characterized by their light construction – increasingly distant from the heavy monumental character of Latin Art Deco. The Brazilian Modern movement, in particular, was gaining international critical acclaim. It received official endorsement when Le Corbusier was invited to advise the government on their new Ministry of Education building in Rio de Janeiro. Oscar Niemeyer, one of a group of young architects emerging at the forefront of Brazilian Modernism,

204

Above and below: Buildings on Marine Drive, Bombay, c. 1940. These apartments and hotels adorned the seafront bringing Miami-style Westernization to the Bombay cityscape.

combined a uniquely tropical theme with fluid, open Corbusian planning in the Brazilian pavilion at the New York World's Fair. It was already apparent that, in Brazil at least, a more rational Modernism was adapting itself to fill the role that the decorative modernism of Art Deco had previously played: it was both modern and distinctively Brazilian.

Parts of Asia also embraced the new style. In 1935 an Indian architect attacked the 'cleverly forced mannerisms of the decadent style moderne',[40] which was becoming increasingly widespread in the affluent urban areas of the sub-continent. Recycling the mantra of Modernist derision he deplored:

> … the ubiquitous terrace balustrades with streamed bars, the unprotected mid-air projections, the garish colour and decoration are more than indicative of the indiscriminate ransacking of catalogue modes. This naval architecture, if it could be so called, for stationary structures, the projections uncovered to the blazing sun and the monsoon downpour, are illustrative of the grotesque and imitated decadence.[41]

The background to this critique can be compared to the situation in Britain and America – in India too the Modern movement was having a limited impact. On the one hand traditionalism persisted, and on the other, when a Modern idiom was adopted it was not a functional but a decorative one. In the case of India, because most examples of Art Deco architecture were erected well into the 1930s, and tended to be in either domestic or entertainment environments, the version of the style which dominated was a type of streamlined Moderne. Indian Art Deco was also a uniquely urban phenomenon, the richest seam of buildings being located in Bombay, the centre of the country's architectural profession. The city's cinemas, such as the Liberty with its curvilinear decorative motifs and the pink tower of the Eros, provide the most frivolous examples of the style; yet perhaps its most socially interesting application was on new residential buildings for Bombay's urban élite. The spread of the Moderne apartment block in Bombay is outlined by Norma Evenson, in her book *The Indian Metropolis*:

> On Malabar Hill and along the fashionable sea coast, traditional bungalows began to give way to streamlined mansions and apartment houses. One of the most extensive concentrations of the new style was found in the Back Bay Reclamation project. The construction of this new district coincided with the flowering of Art Deco, resulting in an architectural ensemble of remarkable stylistic consistency. By 1940, Marine Drive with its adjacent buildings was almost complete, ornamenting the seafront with a row of apartment houses and hotels not unlike similarly colourful confections in Miami Beach.[42]

Although the architects of such buildings were largely Indian as opposed to British, the fact that they were Western in style reflected the interests of both the architectural profession and the Indian élite. The style of living portrayed in the *Indian Institute of Architects' Journal* was predominantly European, and the profession was geared to catering for the classes who aspired towards Western notions of modernity. In terms of the domestic interior the same situation

Marine Drive, Bombay.

prevailed. Most of the furniture used in India was made locally, including pieces in modern styles. A correspondent for the *Cabinetmaker* reported that, 'Those Indians going in for modern style furniture are thoroughly westernised, and they furnish their rooms in a manner similar to that current in America and Europe.' It was impossible to divorce such trends from seemingly rigid social and economic divisions: 'Parsees in particular,' continued the reporter, 'are very up to date, and very good examples of modern furnishing in Western ways are to be found in the homes of well to do Hindus and Mohammedans.'[43]

So it would appear that Art Deco in India conformed to the international trend of being an élite domestic style; yet it was evolving in a much more volatile political climate, and in terms of building and technology it also faced a number of practical difficulties. Firstly, Art Deco (and indeed Modern movement buildings too) did not bear up well to climatic problems. The introduction of modern building methods into India had been a constant tale of adaptation to meteorological problems.

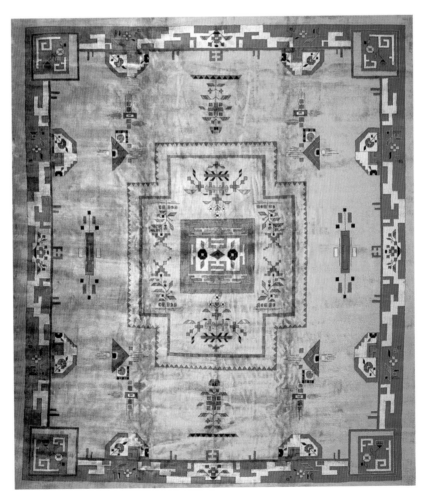

Art Deco style Amritsar rug, India, c. 1920–30.

Multi-storey buildings were only made possible by the invention of the electric ceiling fan in the 1890s, making the lofty ceiling space needed for the operation of hand-powered fans unnecessary. Yet further problems made an international style seem inappropriate to India's specific needs: 'The projections uncovered to the blazing sun and the monsoon downpour', were seen to be major drawbacks, as were stucco surfaces which needed annual renovation. Moreover, the suggestion of modern technology which Art Deco represented only served to emphasize the traditional nature of much of the Indian building industry; according to a study in the 1920s, it was characterized by 'bamboo scaffolding … pulleys worked by manual labour instead of cranes, and the absence of any kind of machinery.'[44] Even if the tastes of the urban élite conspired to overcome or accept these problems, Art Deco's ideological role in India was far from secure. Unlike other outposts (or former outposts) of the British Empire which have been discussed, there was not a significant indigenous population of European descent for whom Art Deco could fulfil its unique role as both symbol of Western modernity and autonomous national identity. In a decade in which the movement for Indian independence was gathering pace, what was seen elsewhere as progress towards the international goal of modernity, was interpreted in India as blatant Western cultural imperialism. In the words of one Indian academic, the country was 'artistically and culturally dominated by Europe, slave to the ideals of modern commercialism, dragged at the chariot wheels of the modern machine age.'[45] A.G. Shoosmith, an English architect who had worked on Sir Edwin Lutyens' New Delhi project in the 1920s, was perceptive in his analysis of popular opinion:

> India is a deeply conservative country, and has experienced as yet no social revolution … [the Nationalist ideal moreover] aims at self-sufficiency and freedom from alien interference, and is therefore in direct opposition to the foreign and commercial interests which share with novelty-seeking potentates responsibility for the importation of Modern European architecture into India.[46]

In many respects, then, Art Deco was caught between two competing visions of the future. The architectural establishment in India was increasingly seduced by the formalism of Modernism and its attendant promises of rational economic modernization. Architects began to apply the utopian vision of Modernism to the perceived opportunities and challenges of independence, while traditionalists saw autonomy as a chance to break free from the shackles of European dominance. Art Deco was left behind as a style associated with Western modernity which had been adopted by those who profited from colonialism and capitalism. It flourished in a brief ten-year period, but it came to represent the worst of both worlds: it was not modern enough to offer a break with the colonial past, but it was too Westernized to represent anything uniquely Indian.

In the light of this survey of the international reach of decorative and stylized modern design, there is little doubt that Art Deco was indeed international. However, its variety of unique, even conflicting, meanings and manifestations

suggests that it cannot be seen as a concerted international 'movement'. Admittedly, the style has certain constant points of reference wherever it appears, the most obvious being its use as an architecture of pleasure. Cinemas from Bombay to Buenos Aires adopted the frivolous 'modernistic' style with its almost universal repertory of decorative motifs: ziggurats, chevrons, stylized figures and curvilinear embellishments. A different embodiment of Art Deco – the more formal yet still highly decorative, 'skyscraper style' – achieved the global patronage of corporate clients. Office blocks from São Paulo to Sydney contrasted classical severity and sculptural monumentality with the humour of ornamental modernistic motifs, ensuring the style's capitalist credentials. Moreover, in the field of furniture and interiors, Art Deco was associated world-wide with luxury; its popularity was concentrated among the urban social élites, spreading further only in countries like Australia where there was more wealth distributed more broadly. Art Deco, it seems, was frivolous, bourgeois and capitalist. It provided an international style for the international activities of movie-going and money-making.

This would, of course, be a chronic over-simplification. It would be more accurate to pinpoint the true force behind the spread of Art Deco as its visual and political flexibility. In a lecture in Rio de Janeiro, delivered in 1929, Le Corbusier told his audience: 'You in South America are in a country both old and young; you are young nations and your race is old.'[47] Although he went on to urge the embracing of his vision of urbanism, Le Corbusier's analysis of the paradox at the heart of South America was an astute one. Indeed, he might have expressed broadly similar sentiments in Oceania and South Africa. Surely this presents us with another unifying role of Art Deco? Its ability simultaneously to represent both modernity and tradition, European heritage and modern independence, nationalism and internationalism. Yet, while the basic stylistic forms and techniques used in these countries were similar enough to be united under the broad Art Deco banner, Art Deco's flexibility – which at once undermines its unity and makes the style itself such a fascinating paradox – is contained not in broad stylistic forms but in its detail. Stylized decoration means that anything can be abstracted – from coal mines, to baboons to religious saviours. All share a style but crucially tell a different story, in a different context, and are loaded with different meanings. Furthermore, a cursory glance at India warns us against generalized meanings. Just as different versions of Art Deco in the same country can represent both pleasure and industry, in different national contexts the style itself can represent modern nationalism or cultural imperialism. The tastes of the urban élites in Bombay had much in common with their counterparts in Brazil, but because the élites represented different dynamics within society, the meanings of their visual cultures were far removed from each other. Art Deco was an international style, but its flexibility and adaptability meant that its use could carry a very wide, even contradictory, range of associations.

DECOMANIA: REVIVALISM, HERITAGE, HISTORY AND POST-MODERNISM

T he blind, unreflecting aversion to ornament and decoration which developed out of a certain reaction to the International style … led to the attribution of a pejorative image to artistic currents such as Art Deco. This needs to be corrected.

Hans Hollein, 1986[1]

They're rushing to buy Art Deco.

Cover headline, *Art and Antiques Weekly*, November 1970

Left: MI6 Headquarters, Vauxhall Cross, Albert Embankment, London, 1990–3, designed by Terry Farrell & Company.

Roy Lichtenstein, *Modern Sculpture with Velvet Rope*, 1968, brass and velvet. In this and other works, Lichtenstein made use of the trappings of Art Deco.

210

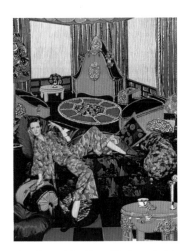

'Art Deco: The First Modern Style',
illustration from a feature celebrating
the Art Deco revival, British *Vogue*,
August 1969.

Although its zenith is often seen as a period of frivolous brevity, the story of Art Deco spans the twentieth century. The evolution of a decorative response to modernity from the beginning of the century has already been charted, but the style's apparent demise in the face of the outbreak of war in 1939 proved to be a premature pronouncement. Art Deco, like the styles it sought to supersede, has become part of the history of architecture and design and thus subject to revival, pastiche and preservation. Indeed, it was the strength of the Art Deco revival in the second half of the 1960s that led to the style acquiring the name by which it has since been known.[2] An account of the varying facets of the Art Deco revival is now as much a part of its history as a study of its original manifestations.

The term 'Art Deco' did not enter the vocabulary of the decorative arts until 1966. It was in this year that the Musée des Arts Décoratifs in Paris staged an exhibition entitled 'Les Années 25'; the subtitle to the two-volume catalogue was *Art Déco*. On 2 November 1966, *The Times* devoted almost a full page to an article by Hilary Gelson headed 'Art Deco'. Exactly a year later, the French magazine *Elle* gave twenty-two pages to 'Les Arts Déco' with articles on Van Dongen, Chanel and André Groult furniture. In 1969, the same year that Bevis Hillier's book *Art Deco* was published in America, Martin Battersby organized an exhibition at the Brighton Museum entitled 'The Jazz Age'. At the same time, 'Moderne' was being employed by David Gebhard and Hariette von Breton in their work on Californian design and architecture of the 1930s. The range of competing terms reflects the style's complexity; nevertheless, it is Art Deco which has passed into the English language through popular usage as a noun and adjective synonymous with the architecture and design of the inter-war period.

The sociology of a stylistic revival is as complex as the evolution of a new style. The opening pages of Hillier's *Art Deco* suggest that the revival had its roots in the fascination of a new generation with the years immediately before their birth. Hillier reiterated this theme in a newspaper interview in 1971:

> To those of us born in the blitzes of 1940, the twenties and thirties were represented by our parents as a golden age ... Not until we grew older did we learn the truth: that the golden age immediately preceding our birth was also a period of slumps, depressions and hunger. We were left with a voyeurish, almost morbid fascination with the period.[3]

In 1969, the fashion correspondent of the *Daily Express* cited 'Laver's Law', the idea proffered by the fashion historian James Laver, that 'at least 30 years must lapse before a style can come back. When that period has passed, it is revived first as an amusing thing, then in a romantic way, and after that in a general way that is taken seriously by art historians.'[4] Yet placed in the broader context of stylistic revivals, the lapse of only one generation after the original style might seem premature. By 1971 America was embracing the inter-war revival, with two major Art Deco exhibitions – at Finch College, New York and Minneapolis.

In the previous year, Chelsea House had sold 50,000 copies of the adventures of Buck Rogers and 27,000 copies of the famous cases of Dick Tracey. The magazine *Liberty*, which had folded in 1950, was revived by Twenty First Century Communications as 'the nostalgia magazine', and a *Time* magazine essay lamented that, 'Sometimes it seems as if half the country would like to be dancing cheek to cheek with Fred Astaire and Ginger Rogers in a great ballroom of the '30s.' By the summer of 1971, it was clear that, 'the most popular pass-time of the year is looking back.' Yet, in the same essay, Gerald Clarke expressed alarm at the new pace of nostalgia:

> Without too much exaggeration, a historian could sum up 2,000 years of Western Culture as A History Of Nostalgia. The Romans regarded the Greeks as paradigms, the Renaissance looked back on the grandeur of Rome, the Pre-Raphaelites discovered their ideal in the Middle Ages. Like everything else, however, the cycle of revivals has quickened in the twentieth century. The '40s seem far away and romantic to people growing up in the '70s, while the '20s and '30s are already shrouded in the mists of legend.[5]

Yet it is not enough to equate the speeding up of the 'revival cycle' with the quickening pace of twentieth-century life. In fact, Art Deco's was the first revival in a century which was until then obsessed with finding its own, original forms of expression. Both Modernism and Art Deco, in their different ways, were products of this search for appropriateness, and the unchallenged development of Modernism into the post-war International Style during the 1950s reflected a continuing confidence, fuelled by post-war reconstruction, in both design and society. Clarke looked for disillusionment with the present to explain the popularity of the past: 'No one in his right mind would argue that 1971 – with its recession and its exhausting and hateful war – is the best this country has ever seen.' Yet could this justify 'a supposedly radical generation [which] genuinely hungers for the past'? 'It is as if they feel cheated,' suggested Clarke, 'for being given their maturity in the sad and sinister world of the '70s.'[6]

So, did the Art Deco revival represent a return to historicism in design and taste symptomatic of the desire to look for something reassuring, even romantic, apart from the doom and gloom of the early 1970s? Did it epitomize the end of Modernist positivism? It is perhaps misleading to equate the end of Modernism in art and architecture with the end of optimism, as there was undoubtedly a period in the late 1950s and 1960s when there was still a belief in progress, concurrent with the gradual undermining of Modernist primacy. Nevertheless, this more general optimism soon floundered, its decline leading the way into the 'sad and sinister' 1970s. Clarke was obviously talking about a stylistic revival that was gathering popularity in America by 1971; yet its roots were in the 1960s. The Art Deco revival can be explained by examining the cultural climate of the late 1960s in Europe and America; by viewing Pop Art and evolving notions of post-modernism as a context for revival. This in turn can be linked to a disillusionment

studio vista | dutton PICTUREBACK 12s 6d | $2.45

Above: The cover of Bevis Hillier's *Art Deco*, 1968, the first book to attempt to analyse and provide a unified account of the style.

Below: The cover of the catalogue of the Art Deco exhibition held at Minneapolis Institute of Art in 1971, curated by Bevis Hillier and David Ryan. The cover was designed by Bentley, Farrell & Burnett.

with the intellectual stagnation in a Modern movement, which in Britain had become the orthodoxy via the Welfare State and the promotion of 'good design' defined solely in terms of rationalism.

It is significant that in 1966, the same year as the first Art Deco exhibition in Paris, Robert Venturi established his post-modern credentials when he proclaimed, 'I prefer both-and to either-or'. Although Charles Jencks had yet to capture the phrase for the vocabulary of architecture, the seeds of aesthetic post-modernism were being sown as early as the late 1950s in Britain. The resultant eclecticism in art and popular culture which had become characteristic in Britain by the late 1960s thus provided the ideal ground for a revival of the eclectic style that so riled the pioneers of the Modern movement in the 1920s. Indeed, Pop Art was compared with Art Deco by Roy Strong, then director of the National Portrait Gallery, London. Reviewing the 1969 Pop Art exhibition at the Hayward, Strong suggested that:

> It is useful, if difficult to try to put Pop into some sort of historical perspective. In the future I would think that it will be looked back on not only as a coherent style in painting and sculpture but, in the same way as Art Deco or Art Nouveau, as a style which embraced the allied arts of interior decoration, book design, advertising, theatre decor and clothes. It is a pity that the overall impact is not at least demonstrated in this exhibition even though the organisers may have felt reluctant to have included Carnaby Street pop tat.[7]

Strong was implying that Pop Art and its designed manifestations, which would come to be labelled post-modern, were part of the same modern decorative tradition as Art Deco, even if at first there was little direct historical plundering of Art Deco's stylistic vocabulary. Richard Hamilton, who together with the other members of the Independent Group began to challenge the Modernist rationale for art, design and architecture in the late 1950s, commended American pop culture to Peter Smithson in a 1957 letter; for Hamilton it was 'popular, expendable, low cost, mass produced, young, witty, sexy, gimmicky, glamorous and big business', adjectives also suited to Art Deco's various manifestations. So a revival of interest in the most recent major decorative style coincided with a renewed desire for decoration and a tendency towards frivolity, irreverence and irony. It was this very resurgence of decoration that enabled Art Deco's rehabilitation.

Along with a common decorative theme, Strong also suggests that the connotations of 'kitsch' may also be shared by the two trends. Pop's use of images and forms selected on the criteria of popularity, familiarity and availability struck at the heart of a Modernist ideology which centred around distinctions between 'good' and 'bad' design. As these notions began to lose intellectual justification, so the 'bad' design which had so long been banished began to be celebrated. 'Another aspect of Pop which has played a part in the contemporary revolution in taste,' observed Michael Compton, writing on Pop Art in 1970, 'is

the nostalgia for old films and consumer goods of the artists' youth. Some of the most pervasive images in Pop achieved a stabilized style and form in the "thirties" and "forties".' There was a dynamic relationship between the new art and collecting the new antiques. The two thrived together in the late 1960s. 'Victoriana', continued Compton, 'waited nearly 100 years before it became collectable, but now the gap is down to fifteen or twenty. Material so recent is naturally abundant and relatively cheap. Owners are free to buy, discard and try something new.'[8]

Indeed, it was the cheap availability of Art Deco which undoubtedly accelerated the pace and increased the scale of the revival of interest in it. The revival was not solely an élite preoccupation, confined to wealthy art collectors, but one which could involve the young. For the first time, the styles of the past had been as mass-produced as those of the present. Because it effectively made 'collectable' historical artefacts available to all, the revival appeared at the heart of popular culture as well as in the auction houses. For Compton, this explosion in collecting is one aspect of the new 'universalisation of art'.[9] By 1968, even *Country Life* was telling its readers about Art Deco: according to Christopher Neave, it:

> … has slowly evolved from parody and spoof into the influence behind the key style of the '60s … The clothes of the period – and even the cars – have a following among the young, who see themselves as pop art versions of Bonnie and Clyde when dressed in the original rags and as sophisticated modern versions when dressed in the store bought Twenties and Thirties of today.

The fashion market was quick to reinterpret the vogue. 'Teenagers have been wearing bits and pieces from the Art Deco period picked up in junk shops and antique markets,' observed Neave, 'but now it's catching on in a wider sense … Far ahead fashion designers such as Marion Foale and Sally Tuffin, and Barbara Hulanicki of Biba have snapped up the first Art Deco prints for their summer ranges.'[10] Hulanicki had not deliberately chosen Art Deco, but adopted the style to fit in with the architecture of her new shop on Kensington High Street. 'Although Biba began as Art Nouveau, we never wished to ruin the original style of any premises,' she recalled, 'if the mouldings were Deco, they would stay Deco.' The change certainly worked: 'When the shop opened in September 1969 it was an instant success … We had a bigger crowd than Queens Park Rangers … the *Sunday Times* called it "the most beautiful store in the world".'[11]

Yet architectural Modernism refused to capitulate completely; it was suffering a protracted decline, and doing its best to stave off the new expressionism in the arts and metropolitan taste. At first, Art Deco's second coming remained a popular phenomenon, perhaps more a craze than a true stylistic revival. In his recent study of heritage, memory and the concept of the past, the historian Raphael Samuel sought to draw a distinction between the old stylistic revivals and their modern populist manifestations, which he describes as examples of 'retrochic':

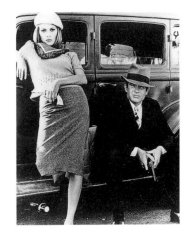

Still from the film *Bonnie and Clyde*, 1967.

The jewellery department of the newly opened Biba shop in the old Derry & Toms building, Kensington High Street, London, 1973. Designers: Steve Thomas and Tim Whitmore. Below: New packaging was designed to fit the Deco aesthetic of the new store.

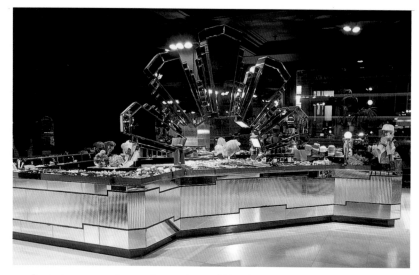

Biba's vast Rainbow Room on the fifth floor of the Derry & Toms building, Kensington High Street. The room retained its original ceiling and room logo of the dancing couple.

Revivals were until recently top-down affairs; the property, to begin with, of small circles of connoisseurs who, aided by wealthy patrons, could indulge eccentric tastes. Neo-classicism was the work of aesthetes and scholars. The Gothic revival famously began as a kind of aristocratic folly. Regency style was a 1920s invention of Mayfair interior decorators ... The taste for Victoriana too, was, in its early days, the 1920s, a kind of upper-middle-class sport ... Retrochic, on the other hand, starting perhaps with the Teddy-boy phenomena of the 1950s, welled up from nowhere. It profited from the boom in, and democratization of, new classes of collectables.[12]

For Samuel, the Art Deco revival was a prime example of retrochic, not only because of its democratic nature, but also because it fulfilled further defining characteristics. Firstly, there was an absence of sentimentality about the past: 'It is deficient in what the Victorians call high seriousness ... it approaches its work in the spirit of the beachcomber.'[13] Moreover, 'retrochic is untroubled by the cult of authenticity ... It blurs the distinction between originals and remakes', something which Biba and the Art Deco-inspired Pop graphics of the late 1960s certainly achieved. Retrochic is not born of academic interest; rather it 'ministers to the appetite for objects of fantasy and desire', yet at the same time it has 'helped to form Britain into a nation of collectors, and in doing so has done some of the spadework not only for the retrieval of the recent past, but also for its interpretation.'[14] Samuel's distinction certainly suits the eclectic nature of the Art Deco revival. There was an interest in authenticity and collecting, yet it was coupled with new design in a historical retro style. Although

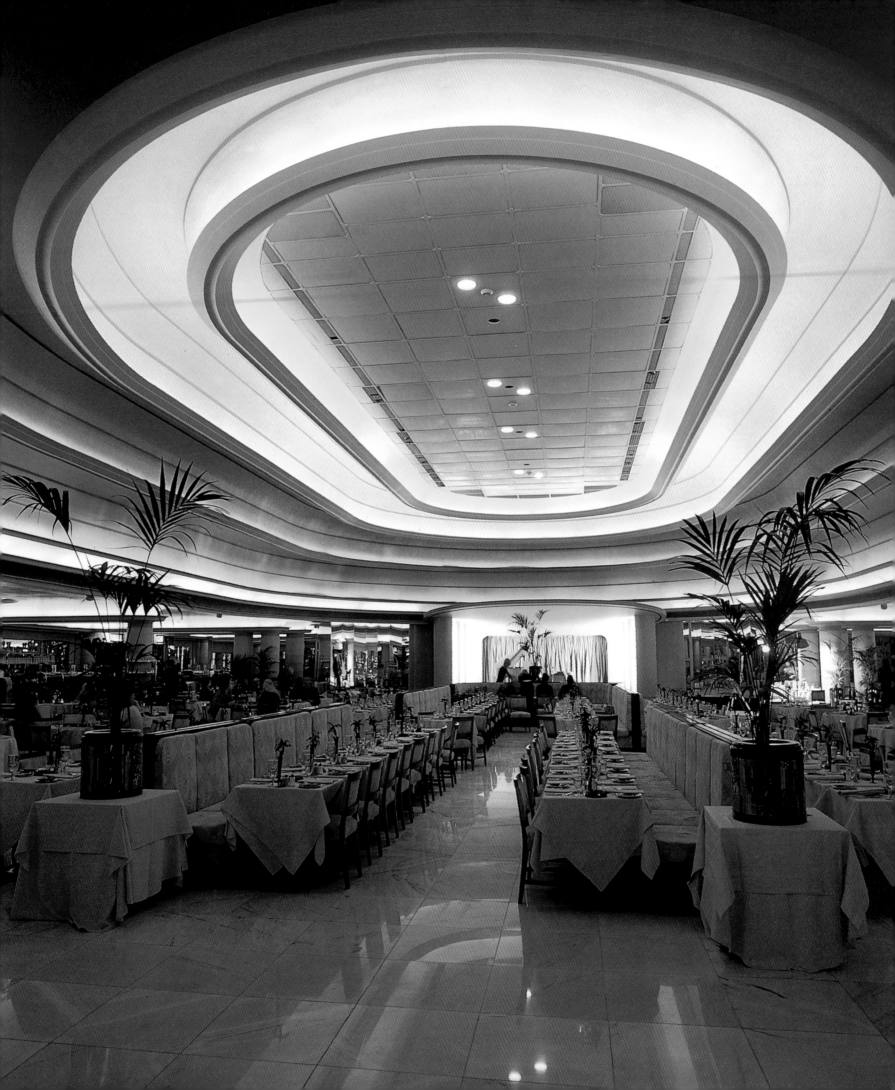

216

such retro design has been interpreted as the pessimistic tail-end of Pop, 'a haven from the uncertainty of high pop', its manifestations were no less frivolous, irreverent and anachronistic. The historian Nigel Whiteley sees its beginnings in David Christiansen's cover for *A Collection of Beatles Oldies*, released in December 1966, featuring the Beatles in scenes from the 1930s, and its continuation in such examples as the promotional material for The Who's rock-opera *Tommy*, or Biba's redesign and relocation in 1969. However, caution is required before suggesting that Art Deco 'welled up from nowhere'. For all its liberating rhetoric, Pop reinforced rather than overturned the cultural importance of a young, urban avant-garde. Although the revival began away from the traditional art and antique buying upper middle-class, it does not necessarily follow that it arrived on a wave of true populism. If anything, the revival signified the shifting nature of Britain's cultural élite, rather than its demise.

The London collectors' and dealers' magazine *Art and Antiques Weekly* recognized a divergence within the new trend; mass-produced Art Deco and Moderne artefacts were not the only commodity, and the revival's commercial potential was recognized early:

> It is clear that there are two classes of Deco. You get your super, expensive things at John Jesse and Sotheby's — one off pieces that are often signed and documented and were originally made for the rich. But 'kitsch' Deco — all those jazzy lightning flashes and fountain sprays on mass-produced goods of the Thirties — are no less important for commemorating the period … These will likely stay with the young flappers of this period and not reach the auction houses for some time.[15]

The cult of authenticity was not dead. Despite the apparent 'democratisation of collecting', the revival of Art Deco was not an entirely democratic phenomenon and became less so as 'junk' metamorphosed into 'antique' and prices were subject to the inevitable inflation. The infiltration of popular culture by Art Deco was only ever one side of the equation. In November 1970, the cover of *Art and Antiques Weekly* proclaimed 'They're rushing to buy Art Deco'. According to the cover story:

> Last week's Sotheby's sale attracted a highly respectable, very large crowd of collectors and dealers who competed keenly for a generally high quality lot … Lalique glass of both Art Nouveau and Art Deco did better than usual, and two very fine Art Deco vases by Henri Navarre drew 'ahs' from the crowd … The competition

Designs for Biba publicity material and packaging, 1973.

Bentley, Farrell & Burnett covers for Evelyn Waugh's *Decline and Fall* and *A Handful of Dust*, from the 1970s.

for the finest Art Deco is going to become very fierce. It is such an international movement that collectors from England, Europe, North America and Scandinavia are going to be struggling for the best craftsmanship of their parents' youth.[16]

Prices continued to rise throughout the 1970s, accompanied by increasingly serious scholarly interest.

In Britain, further legitimacy was given to the period by the 'Thirties' exhibition in the Hayward Gallery, London, in 1979, and the outcry at the destruction of the Firestone Factory on the Great Western Road in 1979 confirmed the popularity of the style as well as the potential strength of the Art Deco lobby in the world of architectural heritage. Meanwhile, the auction houses and dealers were cleaning up. In an article for *The Face*, James Truman charted his rise and fall as a small-time collector in the 1970s:

My own obsession started after someone took me to a flat in Highbury to meet two friends. The girl had been a manageress at Biba until it went bankrupt, he was in advertising. They took horrific amounts of drugs, droned on about decadence, but their living room made me ill with jealousy. It was black and cream, loaded up with chrome and mirrors. It was quite exquisite and it was authentic. Over the next three years I wasted every weekend looking for Art Deco, finally giving up in 1980, by which time all the good stuff was going straight to Sotheby's.[17]

In February 1970, Mr Greenwood, the British Minister for Health and Local Housing, announced that fifty buildings from the period 1914–39 were to be added to the list of 'buildings of special architectural or historical interest'. Included in the list were four of Holden's London Underground stations (Sudbury Town, Arnos Grove, Southgate and Oakwood), the *Daily Express* building on Fleet Street, and the Boots factory in Beeston, Nottingham (both designed by Owen Willliams), together with the Finsbury Health Centre, London and Dudley Zoos, the Peter Jones department store on Sloane Square and Simpsons of Piccadilly.[18] While his announcement was the beginning of the continuing, and periodically controversial, programme of listing twentieth-century buildings of architectural interest, it is significant that the first list was almost exclusively devoted to the Modern movement. Despite a new-found credibility among collectors, artists and enthusiasts, the architectural establishment was not prepared to admit Art Deco was worth saving. Perhaps the fact that the popular revival was driven largely by fashion, music and film enhanced the frivolity of the style, making it unsuitable for the serious business of preserving buildings for the good of the nation.

An ambivalence to the cult of authenticity did thrive, ambivalence which is contrasted by Raphael Samuel with, 'restoration and conservationism, the cultural phenomena with which retrochic is frequently bracketed'.

Retrochic differed from 'the pioneer preservationists of the late 1940s, drooling over the spectacle of pleasing decay', but it was not long before the burgeoning architectural heritage movement, itself stimulated by the crisis in Modernism, set its sights on the buildings of the inter-war period, with their offer of a historical alternative to Modernist rhetoric. J. Mordaunt-Crook saw the uncompromising self-belief of Modernism as the beginning of a disillusionment with the present and a passion for the past:

> More than anything, it was the traffic engineering of the 1960s – Spaghetti Junction, Birmingham most famously – which turned a whole generation into conservationists. By the end of the 1970s there were about 300,000 members of conservation societies in England, not to mention 1,000,000 members of the National Trust.[19]

Yet it was not until the end of the 1970s that an Art Deco preservation movement evolved as a powerful lobby. The outrage at the destruction of the Firestone Factory was an indication of the strength of feeling Art Deco could arouse. As a result, in the same year, 1979, the Thirties Society (now the Twentieth Century Society) was set up in Britain to protect all significant buildings of the decade, not solely the work of the pioneers of Modernism.

The debate as to whether or not the concern with 'heritage' exemplifies an unhealthy obsession with a rose-tinted, semi-fictional past and a lack of faith in the present is complex; yet the expansion of the conservation movement to the point where it would campaign for a building like the Firestone Factory offers an interesting comment on the heritage industry itself. Tom Paulin has dismissed the 'loathsome collection of theme parks and dead values' rampantly polluting English culture and its perceptions of history, yet the failed attempt to save a building which was firstly, a factory and secondly, in a style loathed by the architectural establishment of its day, presents an example of the plurality of motives driving architectural conservation. If anything, by the late 1970s the Firestone Factory represented a set of values which were very much alive. It represented architectural narrative and an attempt to engage with modernity in an invigorating and adventurous manner; it represented an attempt to introduce the styles of European and American commercial architecture to Britain; it represented the prosperous suburban reality of many Londoners in the inter-war years. Most of all, it represented the decorative tradition in architecture which had been selectively erased from architectural history from the mid-1930s onwards in a manner that would have gained a nod of approval in George Orwell's fictional Ministry of Truth. The Firestone Factory was radical, populist and conservative all at the same time. It was a collection of contradictions, and others of its genre which survive serve to remind us that history is never a

seamless narrative. The fact that the conservation movement embraces modern industrial architecture, and architecture that was dismissed at the time as sham, suggests there is more to it than the preservation of an old feudal 'Middle England'. The motives of the conservationist might be vastly different from those of the historian, but does this ultimately matter? – the preservation of Art Deco confirms the pluralism of both history and heritage.

As with Art Deco architecture itself, the move towards conservation can be seen as part of an international trend. As the styles of the 1920s and 1930s began to be appreciated once more, societies sprang up across the world to preserve the newly discovered heritage of their towns and cities. In terms of inspiring international Art Deco preservation, the most influential, and ultimately successful, campaign was to save and economically regenerate the Old Beach area of Miami, Florida. Barbara Capitman, a design journalist in New York, was the woman who claimed, 'Art Deco is my whole life'; through her work, initially in Miami, she did more than anyone to encourage world-wide movements for Art Deco architectural conservation. Her collaborators, Michael Kinerk and Dennis Wilhelm, explained the genesis of her campaign:

> The lingering grandeur of sand and sea and dressing for dinner had nearly faded into oblivion in 1976, when Barbara Capitman stumbled onto a fantastic concentration of hundreds of small buildings in south Miami Beach. Barbara saw that they must be saved … Until then, architectural history had ignored most Art Deco work … but in 1976, Barbara Capitman decided it must be preserved and treasured. She began trumpeting this decision to the world.[20]

In 1979, Capitman founded the Miami Design Preservation League and began her crusade to 'celebrate the visual heritage of inter-war America'. As a result of extensive lobbying of local and national government agencies, the Miami Beach area was added to the National Register of Historic Places on 14 May 1979, the first district on the register as a result of its twentieth-century architecture. By the time the district featured on the opening title sequence of *Miami Vice* in 1984, Miami Beach was becoming an increasingly popular backdrop for an army of fashion photographers and models. More recently, the area has become home to Barbara Hulanicki whose work has continued the tradition of Art Deco as retrochic, following the collapse of her London store in 1974. Turning from fashion to interior design, her first commission was a night-club owned by Rolling Stones guitarist Ron Wood. In 1989, Hulanicki designed the interiors of the Marlin Hotel – her brief to 'think Jamaica' while preserving the hotel's Art Deco aesthetic – and she has since worked on the renovations of the Cavalier and Leslie Hotels on Ocean Drive, continuing her gaudy 'Jamaican-Deco' interiors.[21] It seems Art Deco retrochic is alive and well in Miami, but it is the promotion of this very Miami Beach 'experience' which would appear to confirm the worst fears of British and European historical purists. For them, preservation is all very well, but not *celebration*. Celebration is emotive and non-analytical; it breeds retrochic rather

220

than research. It commercializes the past, distorts it to pursue a financial agenda and repackages it as a commodity.

In 1978, the Miami Design Preservation League staged its first annual Art Deco Weekend. Eighteen years later the weekend was still going strong: the theme in 1995 was Latin American Art Deco, and the event unashamedly celebratory. History was conveniently doctored so that the politically, economically and stylistically diverse inter-war years became the 'Art Deco era'. Dealers descended to peddle their wares, and weekend 'delegates' could recover from the academic papers at the 'Moon over Miami Beach' Ball. 'I understand this event celebrates a step back in time to the Jazz age,' admitted Governor Chiles of Florida, before pointing out the event's more easily quantifiable success: 'The Art Deco weekend began to attract national attendance in 1986, and this year we look forward to hosting some 500,000 people from all over the world.' Here we return to Raphael Samuel's idea of retrochic which 'ministers to the appetite for objects of fantasy and desire'. Here too is the colourful spectacle of Art Deco as entertainment, and in the eyes of the hoteliers, restaurateurs and period souvenir manufacturers, here is Art Deco as commodity.

But is any of this really surprising, inappropriate, or indeed problematic? Not if it is recognized and indulged in for what it is. The Miami Beach experience does not attempt to celebrate at the expense of more serious analysis, as its lecture series proves. There is a connoisseurial concern with authenticity, and to suggest that those attending were unaware where the authenticity stopped and the fantasy began is patronizing. People will get what they want out of the past and if a desire for romance preserves the artefacts of an era for consideration and reconsideration, then all the better.

In the 1980s, throughout America, Art Deco Preservation Societies were formed, instantly revealing the largely forgotten extent of the style. The unrivalled Art Deco heritage of New York provided an almost unending source of inspiration for local enthusiasts, an enthusiasm which quickly achieved official endorsement when its international historical significance, and more importantly popularity, became apparent. Barbara Capitman was involved in the foundation in 1980 of the Art Deco Society of New York, which soon evolved into one of the most successful and active societies in the world. Art Deco festivals, like those in Miami Beach, were staged and by 1984, the city's Mayor, Ed Koch, was officially declaring 'New York City Art Deco Week'.[22]

The international dimension of Art Deco heritage and conservation is emphasized by the biannual World Congress of Art Deco, again inaugurated by the Miami Design Preservation League. The Congress attracts delegates from around the world to 'celebrate the architecture and design of the inter war years'.[23] 1995 saw the the first Third World Congress of Art Deco, and with it a gathering of the Deco tribes. Largely from Oceania and North America, they descended on Brighton and London to listen to academic papers and, perhaps

The Marlin Hotel, Miami Beach, Florida, 1939. Architect: L. Murray Dixon. Owned by the Rolling Stones' Ronnie Wood, the interiors were redesigned in 1989 by Barbara Hulanicki. Art Deco retro-chic is big business in Miami Beach, a ready-built Moderne 'theme-park'.

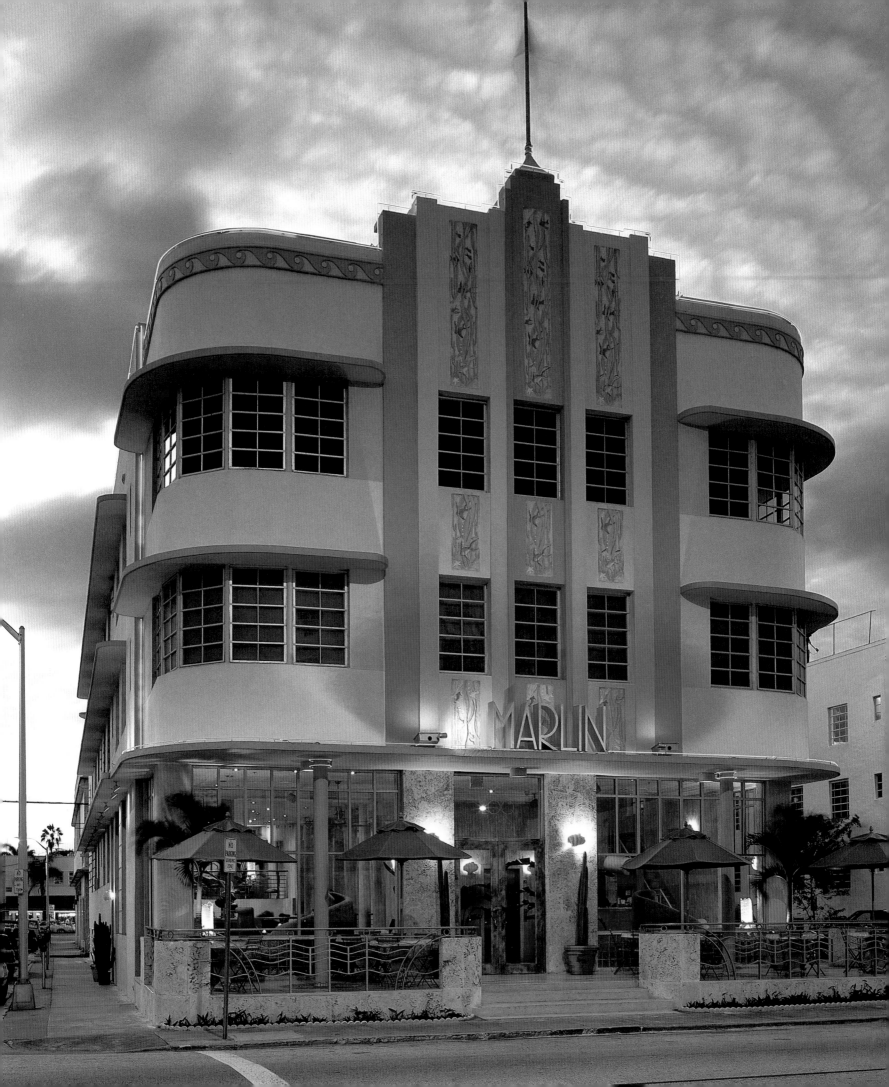

more enthusiastically, feast their eyes on as much Art Deco as the Twentieth Century Society could offer, while swapping tips on how to run a successful conservation crusade. In Australia, Victoria and New South Wales both have societies, and the success of Napier in New Zealand in turning its buildings into a heritage attraction has provided an inspiration to the conservationists. There, the Art Deco Trust promotes Napier as the 'Art Deco City', the Southern Hemisphere's answer to Miami Beach.

The collapse of Communism at the end of the 1980s provided the impetus for a revival of interest in Eastern European Art Deco. In Communist Poland the Constructivist heritage of the 1920s was celebrated at the expense of Art Deco, a situation not dissimilar from the post-war privileging of Modernism over Art Deco in the West up until the mid-1960s. Since the late 1980s, exhibitions in Poland and Hungary have attempted to identify Art Deco as a specifically national tradition, a quest easily politicized as part of the search for pre-Communist tradition placing these countries in a European historical perspective.[24] A 1992 exhibition in Cracow included many of the items displayed in Paris in 1925; these objects once again fulfilled the purpose of illustrating both European modernity and national tradition, nearly seventy years after they were designed. Here as much as anywhere it is clear that, whatever the motivation behind revivalism or heritage, the process undeniably reveals previously forgotten objects and buildings. The need to be aware of any political or financial agenda of the preserver or exhibitor is a small price to pay for the recovery of artefacts from the periphery of history.

The general revival of interest in Art Deco in the 1960s is a particularly pertinent example of how a popular, fashionable retrochic revival encourages more serious consideration of the material it draws on. Bevis Hillier's pioneering 1968 book initiated a process of gradually more probing and informed criticism. In a review of the book in *Architectural Design* in 1969, Janet Street-Porter bemoaned the 'academicising' of the 'romance of the Art Deco era'.[25] Despite subsequent criticism for being 'journalistic',[26] Hillier's book was undoubtedly the point where retrochic gave way to historical inquiry. Indeed, in many ways both historical study and conservation can be seen as a reaction, enforced or otherwise, to the commercialization of collecting. As buying authentic Art Deco becomes more expensive, the heritage and conservation of Art Deco works in the public domain has increasingly become a focus for the enthusiast. As wealthy American collectors such as Mitchell Wolfson Jr begin to institutionalize the display of Art Deco, heritage and conservation become the most democratic form of collecting, a form which does not involve personal ownership, but nevertheless results in continued public enjoyment.

As well as fuelling historical inquiry and the nostalgia industry, the Art Deco revival also had an impact on the design world. Charles Jencks, the critic who did much to promote the notion of 'post-modernism' in architecture, argued

Postcard by Christopher Matthews for the Art Deco Trust, Napier, New Zealand. Napier has been heralded as the Miami Beach of the Southern Hemisphere.

223

that, 'Modern Architecture died in St Louis, Missouri on July 15, 1972 at 3.32pm (or thereabouts) when the infamous Pruitt–Igoe public housing project was given the final coup de grace by dynamite.'[27] In contrast to the more radical connotations which the term had acquired in literary criticism, Jencks's post-modernism was an espousal of profoundly conservative values: 'I used the term to mean … the end of avant-garde extremism, the partial return to tradition and the central role of communicating with the public'.[28] Given this strong element of conservatism, it may not seem surprising that, along with classicism, Art Deco was one of the vocabularies of design most often utilized by post-modern designers. Yet this phenomenon was under way some years before the date Jencks advocated for the death of Modernism. According to the *Daily Mail* in 1969, Art Deco was being 'revived by young designers here and in America for almost everything from shoes to lampshades.'[29] Architecture, it seems, was the slowest of the visual arts to adapt to the changing climate.

Art Deco was not only a style to be plundered, it offered an ideology which added up to more than just modern decorative eclecticism. In *Design* in 1968, Corin Hughes-Stanton offered an often ignored definition of post-modernism as 'the equal importance of ergonomic and psychological fulfilment in design'.[30] In other words, post-modernism was not a *carte blanche* rejection of everything that Modernism stood for, rather a modification of its aims. Functionality was displaced, not discarded. What was discarded was the belief that functionality alone defined good architecture and design and that architecture by its very nature had to have a moral and social dimension. But the Modern movement had been more than just another style; it had been an attempt to redefine notions of beauty. 'The associational thinkers of the eighteenth century,' suggested J. Mordaunt-Crook,

> … had argued for extrinsic beauty, so on the whole had Pugin and Ruskin. For the first time since the disintegration of Palladianism, the Modern movement put the case for intrinsic beauty. In that respect it marked a return to classicism: a return to new objective criteria, in this case the authority of function.

Art Deco was Modern architecture that rejected the authority of pure functionalism, recognizing that a building's function went beyond ergonomics. It embraced imagery, metaphor, symbol and memory. It was in the romantic tradition. It offered at once a romantic vision of modernity and a vocabulary of modern decoration. This is the synthesis that post-modernism began searching for, and both Art Deco and Art Nouveau were guiding lights. Once again, it is significant that the most prominent post-modern advocates of a reappraisal of the modern decorative tradition were not architects but furniture and interior designers. In 1986, both Paulo Portoghese and Hans

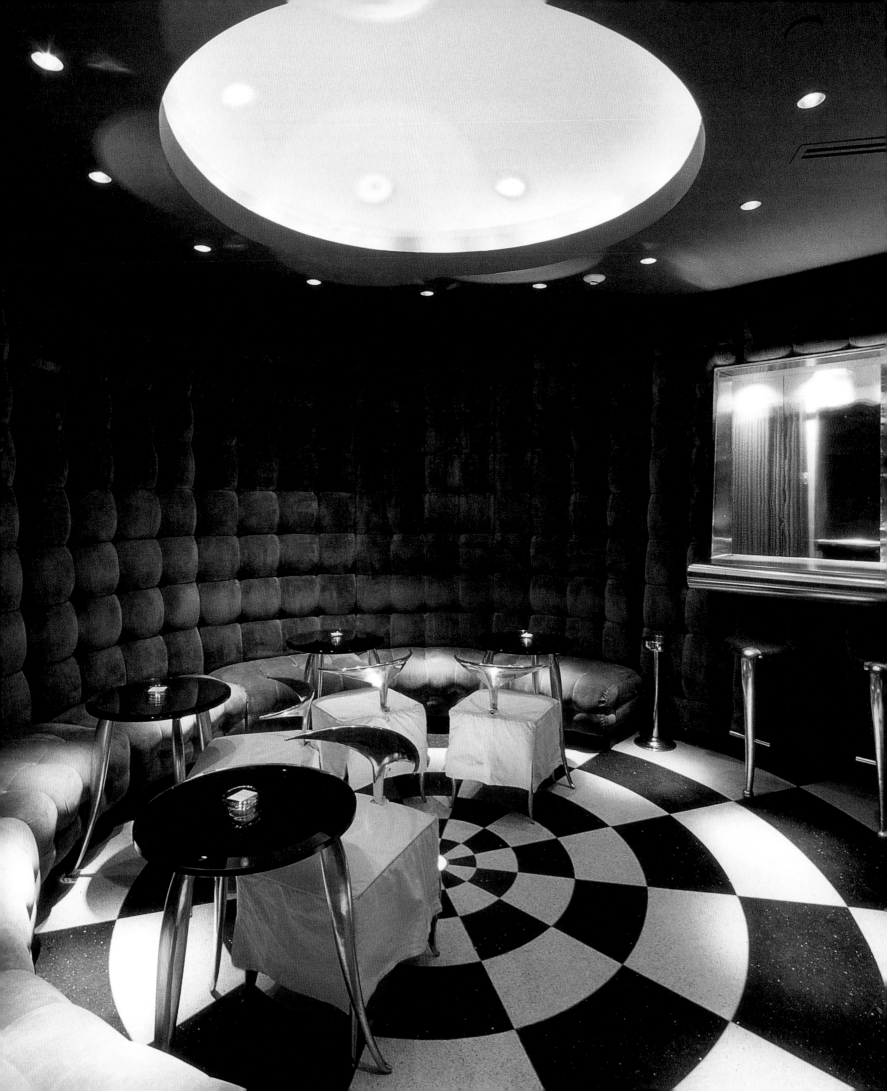

Padded Bar at the Royalton Hotel, New York. Originally built in 1898, it was refurbished in 1988 by Ian Schrager and Steve Rubell in consultation with Philippe Starck.

Hollein contributed introductions to an Italian reprint of French interiors from 1928–9. Their comments exemplify the change in attitude towards Art Deco:

> Le Corbusier was right: Art Deco lasted for no more than a season, whereas the abstract and functional 'modern' had all the premises for enduring with only a few modifications. It has done so to the point of becoming identified so totally with the adjective 'modern' as to remove from this word its destiny of encompassing in its changing concept of the flux of time and taste, and eventually forcing us – so as to give back the modern its freedom – to invent that linguistic paradox, the word post-modern.[31]

Here Portoghese is turning to Art Deco to illustrate the pluralism which he believes is integral to modernity. Art Deco was the style which was neither purely historicist nor rigidly dogmatic. Its evolution and contradictions encompassed the flux of time and taste: the only requirement at the 1925 Paris Exposition was to be modern. There was no prescription as to what modern should be, and the result was eclecticism. It is this freedom which many post-modern designers have sought. At the same time there was still a respect for the achievements of the Modern movement; Hollein had no interest 'in any way diminish[ing] the importance … of the omnipresent Le Corbusier'. Post-modernism, in this sense, shares with Art Deco a desire to combine 'ergonomic and psychological fulfilment in design'. For this reason, Hollein qualified his defence of Le Corbusier by arguing that, 'it is nonetheless essential to recognise the achievements, and to rediscover the works, of other contemporaries who did not enjoy the advantage of instant promotion.' Hollein continues by imploring us to embrace the work of specific designers:

> … whether immediate companions [of Le Corbusier] such as Charlotte Perriand, concurrently active personalities such as Gabriel Guévrekian and André Lurçat, or artists who adopted other positions and realised them in convincing endeavours, such as Robert Mallet-Stevens or Pierre Chareau in the field of architecture, or Jacques-Emile Ruhlmann and Jean Puiforcat in that of interiors, objects and the decorative arts.[32]

Turning to recent work, direct Art Deco influence can be seen in the form of pastiche and satire in Venturi's 'Art Deco Chair', and in contrast, a more serious interpretation of the style and ideology of the French décorateurs, in Hollein's 'Marilyn Chair'. Portoghese's critique of Modernism began in the late 1950s when he coined the phrase 'Neo-Liberty' to describe a tendency in furniture and interior design towards a Pop-inspired reworking of Stile Liberty, the Italian name for Art Nouveau. Like the later reworking of Art Deco, Neo-Liberty was born out of a desire to rediscover the plurality of modernity, both in terms of style and methods of production. In his own stylistic evolution, Portoghese includes the influence of the examples of decorative modernity we have explored earlier:

> I became a strong supporter of the so called neo-liberty, a trend that originated from the claim to a certain right: that of redesigning the boundaries of the Modern,

including ourselves in the rational radicalism, which imposed the tabula rasa affirmation of traditions, and also the attempts at the beginning of the century to find origins for the Modern in historical inheritance and local traditions.[33]

Although architecture may have been slower than other forms of design to embrace the new pluralism, by the 1980s the architectural establishment was reconciling itself to Art Deco, a process which – like Art Deco itself – was international. In 1985, the theme of the Institute of South African Architects Biennial National Congress was 'The Thirties – what happened next?' In 1983, *Architecture SA* had carried confessional accounts by contemporary South African architects admitting their previous errors of judgement regarding the Old Mutual Building in Cape Town. 'I hated it at first,' admitted John Wilmot, 'but could not fail to be impressed by evidence of so much innovation.'[34] David van den Heever was equally honest:

The building appeals to me in every way and after considering it, for years, as just another ugly 1930s pile, the joy of rediscovering it was immense. It of course has come back to prominence in this 'post modern' age, but it stands on its own merits … It is a well detailed building of great quality … Further the external sculptural panels form a warm combination of art and architecture.[35]

By the 1980s, the terms of architectural debate and criticism had altered sufficiently for 'a warm combination of art and architecture' to be a compliment rather than a slur. From the early 1970s Theo Crosby, an architect and, by this time, a founding partner of the design company Pentagram, had become increasingly distanced from the Modern movement through his advocacy of the importance of both monuments and monumental and decorative architecture. In 1987, an illustration of a doorway in The Rockefeller Centre was used by Crosby to accompany the campaign for a 'Percentage for Art', an attempt to promote decoration in the face of an architectural establishment dominated by the orthodoxy of Modernism, 'a remarkably simplistic theory of architecture, especially by the time it had been taught to three generations of students by teachers unconcerned with practice.'[36] It is significant in the context of this discussion about Art Deco revivalism that Crosby sees a more wide-ranging approach to decoration as central to his proposed new wave of architecture:

By the 1960s architecture had been reduced to the simple addition of identical modules … The conservationists have jolted architects out of this comfortable posture, and pointed to their professional responsibilities, their scholarly concerns. The message is taken seriously. There is now a profound concern for quality in building, a search for a new style or even to master an old one. It has become clear that a more complex language is required, rich, warm and decorative that can take its place next to the buildings of the past.[37]

Crosby goes on to discuss a return to a classicism exemplified by the stylized classicism of Art Deco (he conceded that one reason for the hostility towards the revival of classicism is that, 'it was appropriated

Moulded, laminated plywood chairs designed by Venturi, Scott Brown and Associates for Knoll International, 1984.

BATTLE OF BRITAIN
MONUMENT

A proposed monument to the Battle of Britain designed in 1986 by Theo Crosby of Pentagram; it is executed in a bombastic Art Deco idiom that leans unfortunately towards the stylized classicism of Nazi Germany.

by both the Nazis and the Russian Communists and still carries something of the overtones of their brutal authority'). Indeed, Crosby's own use of the classical alongside Art Deco ziggurats on the proposed but unrealized Battle of Britain Monument serves as an illustration of the historical association between the two styles as well as of the use of the Art Deco style for decorative effect in the 1980s.

It is perhaps no coincidence that an interior such as Theo Crosby's refit of Unilever House in London, which draws so heavily on the tradition of the glamorous Art Deco foyer, was created on the eve of the 1980s, a decade with so many parallels to the 1920s. The rampant economic growth of the mid-1980s proved to be as stylistically intoxicating as the post-war boom in 1920s America. In Britain, the work of architects such as Terry Farrell, Piers Gough and Crosby, all drawing on Art Deco motifs, is testimony to this. Gough openly admits to pilfering elements from the exuberant canon of Art Deco,[38] while the writings of Crosby in the 1980s provide an illustration of the post-modern rationale which involved a re-evaluation of Art Deco. The renewed architectural interest in Art Deco in the 1980s was more than a legacy of Robert Venturi's praise of the kitsch and the popular in *Learning from Las Vegas*. There was certainly an element of cheap pastiche in many buildings that passed for post-modernism in the 1980s, but it was the freedom which Art Deco had afforded that was its central appeal. As J. Mordaunt-Crook observed, in the final analysis post-modernism is eclectic in both its influence and ideology, and 'eclecticism … is the vernacular of sophisticates, the language of freedom'.[39] Crook described the post-modern project as 're-learn[ing] what the nineteenth century had painfully discovered: architecture begins where function ends.'[40] But, as the vast international array of decorative artists and decorative architects working in the inter-war years reveals, this maxim had not been forgotten. It was merely ignored by the Modern movement and those writing histories under its influence. The combined forces of retrochic revival, heritage and preservation, and post-modernism, have ensured that Art Deco is no longer on the periphery of history. If Robert Venturi's post-modern reversal of Mies van der Rohe's quintessential Modernist soundbite, 'Less is More' had been coined in the 1920s, it would have been a motto for the modernistic and the Moderne: 'Less is a Bore'.

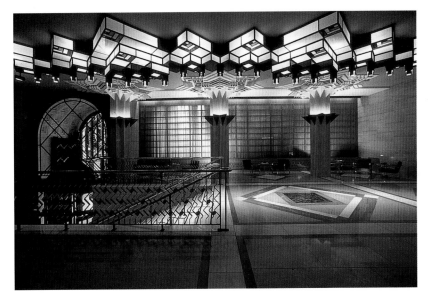

Staircase and lobby of Unilever House, London, refurbished in 1979–80 in the Art Deco style by Pentagram under the direction of Theo Crosby. It is typical of the Art Deco revival which surfaced in the early 1980s.

INTRODUCTION

1 Lancaster, 1967, p.115.
2 Sontag, 1994, p.18.
3 *Architectural Review*, Vol 72, July 1932, p.40.
4 *Architectural Forum*, 1940, p.41.

CHAPTER ONE

1 Quoted in Greenhalgh, 1990, p.70.
2 'Decorative Art at the Paris Exhibition', *Vogue*, August 1925, p.38.
3 *Vogue*, August 1925, p.38.
4 'The Paris Exhibition of Modern Decorative and Industrial Art', *Drawing and Design*, June 1925, p.16.
5 'The Birth of Pallas', *Country Life*, 25 July 1925, p.116.
6 *Vogue*, August 1925, p.38.
7 *Country Life*, 25 July 1925, p.116.
8 Hillier, 1968, p.9.
9 *L'Intransigeant*, Paris, 29 November 1913; quoted in Bouillon, 1989, p.70.
10 Lancaster, 1939, p.58.
11 Bouillon, 1989, p.85.
12 Klein et al., 1987, p.160.
13 U.S. Department of Commerce, 1926, p.14.
14 Quoted in Troy, 1991, p.169.
15 Troy, 1991, p.164.
16 Troy, 1991, p.57. The report was written by the sculptor and furniture-maker Rupert Carabin.
17 Troy, 1991, p.59: 'Between 1909 and 1913, German sales in France increased from 378 million francs to 572 million francs; French sales in Germany also rose during these years but less dramatically.'
18 Troy, 1991, p.165.
19 Troy, 1991, p.66.
20 US Department of Commerce, 1926, p.15.
21 US Department of Commerce, 1926, p.15.
22 *Commercial Art*, July 1925, p.179.
23 Bouillon, 1989, p.25.
24 A predisposition to geometry permeated the Werkstätte. Even the full stops on the typewriters were replaced with tiny squares.
25 Volker, 1994, p.203.
26 Bouillon, 1989, p.53.
27 Bouillon, 1989, p.53.
28 Margolius, 1979, p.45.

29 'Cubismo Ceco: Magical Prague', *Abitare*, September 1992, pp.189–95, 274.
30 Neither Janák or Gočár warrant a mention in Pevsner's *Pioneers of Modern Design*.
31 P. Janák, in *Ulmelecky Mesicnik*, 1, 1911–12, Vol. p.148; quoted in Margolius, 1979, p.82.
32 Etlin, 1991, p.166.
33 Etlin, 1991, p.189.
34 L.L. Ponti, 1990, p.25.
35 *Domus* 4, 1928, pp.29–30, quoted in Ponti, 1991, fn to p.25.
36 Ponti, 1991, p.25.
37 Borsi, 1987, p.132.
38 Derwig and Mattie, 1991, pp.14–15.
39 De Wit (ed.), 1983, p.32.
40 De Wit (ed.), 1983, p.123.
41 Z.Corak, *Journal of Decorative and Propoganda Art*, Fall 1990.
42 Studio Yearbook of Decorative Art 1926, p.3.
43 Department of Overseas Trade, 1925, p.10.
44 U.S. Department of Commerce, 1926, p.21

CHAPTER TWO

1 Interview by Mordaunt Hall, *New York Times*, 24 March 1929; reprinted in Silvester (ed.) 1993.
2 Quoted in Klein et al., 1987, p.158.
3 Genauer, 1942, p.14.
4 Genauer, 1942, p.15.
5 Fischer, 1985, p.7.
6 Wright, 1977, p.187.
7 Wright, 1957, p.132.
8 *Architectural Record*, August 1928, p.137.
9 Biographical details and further details of Urban's work in American cinema in Albrecht, 1987.
10 Albrecht, 1987, pp.39–41.
11 Fahr-Becker, 1995, p.236.
12 Quoted in T. Rub, *International Design*, Jan/Feb 1988, pp.60-63.
13 Park, 1927, p.188.
14 Wallace Laidlaw, 'The Metropolitan Museum of Art and Modern Design: 1917–1929', *Journal of Decorative and Propoganda Art*, Spring 1988, p.88.
15 Wallace Laidlaw, 'The Metropolitan Museum of Art and Modern Design: 1917–1929', *Journal of Decorative and Propoganda Art*, Spring 1988, p.101.

16 M. Wilcox, in *Architectural Record*, LXIX, February 1926, p.102.
17 Heide and Gilman, 1991, p.59.
18 Park, 1927, p.170.
19 Heide and Gilman, 1991, p.53.
20 H.R. Hitchcock and P. Johnson, *The International Style*, Museum of Modern Art, New York, 1932, p.72.
21 Heide and Gilman, 1991, p.53.
22 *Architectural Record*, January 1928, p.66.
23 Quoted in Albrecht, 1987, pp.44-5.
24 For a more detailed analysis of these and other examples of Art Deco in cinema see Albrecht, 1987.
25 Albrecht, 1987.
26 Art Directors Club of New York, 1927.
27 Heide and Gilman, 1991, p.74.
28 Genauer, 1942, p.13.
29 Frankl, 1930, p.13.
30 Le Corbusier, 1987, p.103.
31 Bel Geddes, 1932, p.35.
32 Bel Geddes, 1932, p.3.
33 See Sparke, 1992, and Heskett, 1984.
34 H. Van Doren, 'Streamlining: Fad or Function?', *Design*, October 1949, p.2.
35 *Fortune Magazine*, April 1934, p.40.
36 Heide and Gilman, 1991.
37 Duncan, 1986, p.63.
38 Henry Crews, *A Childhood: The Biography of A Place*, London: Borse, 1993, pp.17–170.
39 Vitrolite advertisement, *Architectural Record*, July 1939, p.9.
40 *Fortune Magazine*, April 1934, p.94.
41 *Fortune Magazine*, April 1934, p.94.
42 J. McArthur, Bulletin of the Museum of Modern Art, December 1938; quoted in Duncan, 1986, p.271.
43 Smith, 1993, p.380.
44 Forty, 1992, p.244.
45 L. Mumford, 'The American Dwelling House', *American Mercury*, April 1930, pp.469–71; quoted in Gebhard, 1970, p.16.
46 Henry Dreyfuss, *Designing for People*, 1955.
47 W.D. Teague, in *Art and Industry*, April 1939, p.133.
48 W.D. Teague, in *Art and Industry*, April 1939, p.124.
49 W.D. Teague, in *Art and Industry*, April 1939, p.133.
50 'A Century of Progress' in *Architectural Record*, May 1933, p.363.

51 *Art and Industry*, April 1939, p.126.
52 *Architectural Record*, January 1928, p.80.
53 *Architectural Record*, April 1928, pp.289–97.
54 *Architectural Record*, September 1927, pp.186–7.
55 L.V. Solon, 'The Park Avenue building, New York City', *Architectural Record*, April 1928, p.297.
56 Bel Geddes, 1932, p.139.
57 Gebhard, and Von Bretton, 1975, p.113.
58 Frankl, 1928, p.160.
59 *California Arts and Architecture*, 1938; quoted in Albrecht, 1987, p.110.
60 C.W. Short, and R. Hanley Brown, *Public Buildings: A Survey of Architecture of Projects Constructed by Federal and other Governmental Bodies between the Years 1933 and 1939 with the Assistance of the Public Works Administration*, Washington D. C., 1939, p.1.
61 Frankl, 1930, p.13.
62 Capitman, Kinerk and Wilhelm, 1994, p.112.
63 *American Magazine of Art*, 1940; quoted in D. Gebhard and H. Von Breton, 1975.
64 H.R. Hitchcock, 'Some American Interiors in the Modern Style', *Architectural Review*, August 1928, p.242.

CHAPTER THREE

1 Paul Iribe, 'Profits and Losses', 1931.
2 Quoted in Bouillon, 1989, p.221.
3 Quoted in J.P. Bouillon, 1989, p.238.
4 *L'Illustration*, 'La Normandie' Special Issue, 1935.
5 Quoted in Bouillon, 1989, p.234
6 Mouron, 1985.
7 Medenhall, 1991, p.10
8 Taylor, 1992, p.12.
9 Troy, 1991, pp.55.
10 Quoted in Bruhnhammer and Tise, 1990, p.138.
11 McMillan, 1992, pp.101–103
12 McMillan, 1992, pp.101–103.
13 Ades, Benton, Elliot and White, 1995, p.113.
14 Quoted in Bouillon, 1989, p.221
15 See Ades, Benton, Elliot and White, 1995.
16 Ades, Benton, Elliott and White, 1995, p.261.

17 Heller, 1993, pp.13–15.
18 Ponti, 1990, p.47.
19 Ades, Benton, Elliot and White, 1995, p.181.
20 Purvis, 1992, p.168.
21 Buch, 1994, p.265.
22 Buch, 1994, p.176.
23 Buch, 1994, p.177.
24 Kallir, 1986, p.34.
25 Kallir, 1986, p.106.
26 Chruscicki, 1994, p.16.
27 Chruscicki, 1994, p.17.

CHAPTER FOUR

1 Harbison, 1977, p.58.
2 'The Paris Exhibition of Modern Decorative Art and Industrial Art', *Drawing and Design*, July 1925, p.44.
3 Department of Overseas Trade, 'Reports on the Present Position and Tendencies of the Industrial Arts as Indicated at the International Exhibition of Modern Decorative and Industrial Arts', London: DOT, 1925, p.9.
4 'The Paris Exhibition of Modern Decorative Art and Industrial Art', *Drawing and Design*, July 1925, p.44.
5 Scarlett and Townley, 1975, p.66.
6 Jackson, 1991, p.vii.
7 Lancaster, 1938, p.68.
8 Lancaster, 1939, p.70.
9 Lancaster, 1939, p.70.
10 Lancaster, 1938, p.62.
11 Fry, 1915, p.2.
12 Brett, 1992.
13 Quoted in L. Campbell, 'A Model Patron: Basset-Lowke, Mackintosh and Behrens, in *The Journal of The Decorative Arts Society*, Vol.10, Brighton: The Decorative Arts Society, 1986, p.3.
14 *Listener*, 28 November, 1934.
15 Oliver Hill in Abercrombie (ed.), 1939, p.227.
16 A. Powers, 'Charm of the Chameleon', *Country Life*, 1 October 1987, p.161.
17 Lancaster, 1938, p.80.
18 Quoted in Ward, 1978, p.52.
19 R.E. Gane Ltd., Catalogue, E.K. Cole Collection, Victoria and Albert Museum.
20 R.E. Gane Ltd., Catalogue, E.K. Cole Collection, Victoria and Albert Museum.
21 R.E. Gane Ltd., Catalogue, E.K. Cole Collection, Victoria and Albert Museum.

22 R.E. Gane Ltd., Catalogue, E.K. Cole Collection, Victoria and Albert Museum.

23 R.E. Gane Ltd., Catalogue, E.K. Cole Collection, Victoria and Albert Museum.

24 R.E. Gane Ltd., Catalogue, E.K. Cole Collection, Victoria and Albert Museum.

25 B. Joel, 'At Last a Modern Period', *Colour*, 2 December 1929, p.23; quoted in C. Wilk, *Apollo*, July 1925, p.9.

26 Wilk, *Apollo*, July 1925.

27 *Cabinetmaker and Complete House Furnisher*, 7 March 1931, p.734.

28 *Cabinetmaker and Complete House Furnisher*, 23 May 1931, p.385.

29 P. Meyer, 'Modern Carpet Designs', in *The Carpet Annual 1935*, London: British-Continental Press, 1935, p.29.

30 Oliver et al., 1994, p.190.

31 P. Meyer, 'Modern Carpet Designs', in *The Carpet Annual 1935*, p.31.

32 R. B. Simpson, 'Designs for the New Season', in Arnold and Tyser, 1937, p.29.

33 Quoted in Spours, 1988, p.32.

34 Lamb Fireplaces for Beauty and Quality, catalogue, E.K. Cole Museum, probably 1937.

35 J.B. Priestley, English Journey, Penguin, 1984, p.10.

36 The factory was actually built in 1932.

37 Jackson, 1991, p.73.

38 The Firestone Tyre Factory, London, 1928; Pyrene Building, London, 1929–30; India Tyre Factory, Inchinnan, Scotland, 1930–1; Hoover Factory, London, 1932; Hall & Co. Building, London, 1932; Freeder Brothers Factory, Enfield, 1938–9; Burtons Factory, Lancashire, 1938–9.

39 *Architect and Building News*, 4 January 1929, p.9.

40 *Architect and Building News*, 4 January 1929, p.29.

41 *Architect and Building News*, 12 April 1929, pp.423–4.

42 Epstein, 1940, p.159.

43 *Architect and Building News*, 8 May 1928, pp.188–92.

44 Collins, 1991, p.21.

45 E. Gill, 'The Future of Sculpture'; reprinted in Collins, 1991, pp.65–7.

46 Karol, and Allibone, 1988, p.25.

47 See work by Alan Powers on both

Hill and Goodhart-Rendel. As well as a number of articles, two short books by Powers provide excellent surveys of the careers of both men: *Oliver Hill: Architect and Lover of Life 1887–1968* (London, 1989) and *H.S. Goodhart-Rendel* (London, 1987).

48 Powers, 1989, p.62.

49 Powers, 1989, p.12.

50 Quoted in Dean, 1983, p.22.

51 Two of the most notable examples are those in Finsbury Park (now the Rainbow) and Brixton (now the Academy). The interior of the Brixton Academy is now somewhat dilapidated but is a good example of a surviving 'atmospheric' interior.

52 Atwell, 1980, p.159.

53 See D. Atwell, *Cathedrals of the Movies* for a comprehensive account of British cinema building between the wars, including a chronological list of surviving cinemas and their architects.

54 Orwell, 1962, pp.78–9.

55 'Simpsons New Window Display', *Art and Industry*.

56 *Commercial Art*, Vol XV, 1933, p.238.

57 'Modernist Display', *Menswear Organiser*, May 1930, p.254; quoted in H. Andrassy, 'Smart But Casual', unpublished MA thesis, RCA/V&A, London, 1995.

58 *Commercial Art*, Vol. XV, 1933, p.252.

59 J. Compton, 'Night Architecture of the Thirties', *Journal of the Decorative Arts Society*, Vol 4, 1979.

60 'Shops', *Architectural Journal*, March 1937. Quoted in J. Compton, 'Night Architecture of the Thirties'.

61 J. Compton, 'Night Architecture of the Thirties', *Journal of the Decorative Arts Society*, Vol 4, 1979, p.44.

62 *Architect & Building News*, 1929, p.639.

63 *Commercial Art*.

64 *Commercial Art*.

65 *Commercial Art*.

CHAPTER FIVE

1 H.R. Hitchcock, and P. Johnson, *The International Style*, Museum of Modern Art, New York, 1932.

2 R. White, 1981, p.146; quoted in Cochrane, 1992, p.36.

3 Cochrane, 1992, p.35.

4 G. Serle, 1987, p.123; quoted in Cochrane, 1992, p.36.

5 Cochrane, 1992, p.44.

6 Freeland, 1968, p.258.

7 Freeland, 1968, p.251.

8 *Royal Victoria Institute of Architects Journal*, May 1929, p.33.

9 *Royal Victoria Institute of Architects Journal*, June 1930, p.65.

10 *Royal Victoria Institute of Architects Journal*, April 1929, p.19.

11 Advert in *Home* magazine, 1929, quoted in D. Thomas, 'Art Deco in Australia', in *Art and Australia*, Vol. ix, 1971–2, no.4, p.349.

12 *Royal Victoria Institute of Architects Journal*, September 1929, p.72.

13 D. Thomas, 'Art Deco in Australia', *Art and Australia*, Vol. ix, 1971–2, no.4, p.338.

14 M. Nillson, 'Art Deco in New South Wales', unpublished paper given at the 3rd World Congress on Art Deco, Brighton, July 1995.

15 D. Thomas, 'Art Deco in Australia', *Art and Australia*, Vol. ix, 1971–2, no.4, p.345.

16 D. Thomas, 'Art Deco in Australia', *Art and Australia*, Vol. ix, 1971–2, no.4, p.345.

17 Shaw, 1990, p.21.

18 Shaw, 1991, p.95.

19 Shaw, 1990, p.14.

20 Shaw, 1991, p.34.

21 E. Rosenthal, *The South African Builder*, June 1939; quoted in M. Martin, 'Art Deco Architecture in South Africa', *JDAPA*, 1994.

22 M. Martin, 'Art Deco Architecture in South Africa', *JDAPA*, 1994, p.15.

23 Federico Freschi, 'Big Business Beautility: The Old Mutual Building, Cape Town, South Africa', *JDAPA*, 1994, pp.39–43.

24 M. Martin, 'Art Deco Architecture in South Africa', *JDAPA*, 1994, p.24.

25 M. Martin, 'Art Deco Architecture in South Africa', *JDAPA*, 1994, p.31.

26 M. Martin, 'Art Deco Architecture in South Africa', *JDAPA*, 1994, pp.12–13.

27 *Cabinetmaker and Complete House Furnisher*, 11 April 1931, p.60.

28 *Cabinetmaker and Complete House Furnisher*, 7 March 1931, p.558.

29 R. Sisson, 'Rio de Janeiro 1875–1945: The Shaping of a New Urban Order', *JDAPA*, 1995, p.146.

30 R. Sisson, 'Rio de Janeiro 1875–1945: The Shaping of a New Urban Order', *JDAPA*, 1995, p.146.

31 R. Sisson, 'Rio de Janeiro 1875–1945: The Shaping of a New Urban Order', *JDAPA*, 1995, p.139.

32 R. Sisson, 'Rio de Janeiro 1875–1945: The Shaping of a New Urban Order', *JDAPA*, 1995, p.151.

33 A. Belluci, 'Monumental Deco in the Pampas', *JDAPA*, 1992, pp.90–121.

34 A. Guido, 'La Decoracion en la Arquitectura', *Revue de Arquitectara*, 258 (October 1944), p.444; quoted in A. Belluci, 'Monumental Deco in the Pampas', *JDAPA*, 1992, p.108.

35 Le Corbusier, 1991, p.200.

36 J. R. De Dios, 'Latin American Architecture in the Art Deco Era', *Art Deco Weekend Magazine*, Miami, January 1995, pp.33–4.

37 J. R. De Dios, 'Latin American Architecture in the Art Deco Era', *Art Deco Weekend Magazine*, Miami, January 1995, p.32.

38 J. R. De Dios, 'Latin American Architecture in the Art Deco Era', *Art Deco Weekend Magazine*, Miami, January 1995, p.32.

39 J. R. De Dios, 'Latin American Architecture in the Art Deco Era', *Art Deco Weekend Magazine*, Miami, January 1995, p.32.

40 Evenson, 1989, p.180.

41 Evenson, 1989, p.180.

42 Evenson, 1989, p.174.

43 *Cabinetmaker and Complete House Furnisher*, 28 February 1931, p.60.

44 Quoted in Evenson, 1989.

45 Quoted in Evenson, 1989.

46 Quoted in Evenson, 1989, p.180.

47 Le Corbusier, 1990, p.245.

CHAPTER SIX

1 Quoted in Haegeney (ed.), 1986, p.xi.

2 See Foreword p.6.

3 *Minneapolis Star*, 15 July 1971, p.1B.

4 *Daily Express*, 15 May 1969.

5 G. Clarke, *Time*, 3 May 1971, p.77.

6 G. Clarke, *Time*, 3 May 1971, p.77.

7 *Sunday Times*, 13 June 1969.

8 Compton, 1970, p.183.

9 Compton, 1970, p.183.

10 *Daily Express*, 15 May 1969.

11 Hulanicki, 1983, p.111.

12 Samuel, 1994, pp.111–12.

13 Samuel, 1994, p.112.

14 Samuel, 1994, p.113.

15 D. Stratton, 'Art Deco? Its All Cubes of Course ... or is it

Triangles?', *Art and Antiques Weekly*, 21 November 1970.

16 D. Stratton, 'Art Deco? Its All Cubes of Course ... or is it Triangles?', *Art and Antiques Weekly*, 21 November 1970.

17 J. Truman, 'Deco', *The Face*, Number 25, May 1982, pp.39–42.

18 *The Times*, 4 February 1970, p.10.

19 Mordaunt-Crook, 1988, p.262.

20 Capitman, et al., 1994, p.2.

21 *Vogue*, September 1994, p.145.

22 Capitman, et al., 1994, p.169.

23 Promotional leaflet for the Third World Congress of Art Deco, Brighton, 1995.

24 D. Crowley, 'Market Moderne', *Things* 2, 1995, pp.103–5.

25 *Architectural Design*, 1969, p.231.

26 P. Garnier, in the Introduction to Battersby, 1988, p.9.

27 C. Jencks, 1987, p.9.

28 C. Jencks, 1987, p.6.

29 *Daily Mail*, 8 May 1969.

30 Whiteley, 1987, p.227.

31 P. Portoghese, in Haegeney, 1986, p.ix.

32 H. Hollein, in Haegeney, 1986, p.xi.

33 Collins and Papadakis, 1989, p.205c.

34 John Wilmot, *Architecture SA*, March/April 1983, quoted in M. Martin, *JDAPA*, 1994, p.14.

35 David Van den Heever, *Architecture SA*, March/April 1983; quoted in M. Martin, *JDAPA*, 1994, pp.14–15.

36 Crosby, 1987.

37 Crosby, 1987.

38 Piers Gough's (unpublished) address to the Third World Congress of Art Deco, De La Warr Pavilion, Bexhill-on-Sea, June 1995.

39 Mordaunt-Crook, 1988, p.270.

40 Mordaunt-Crook, 1988, p.270.

230

André-Leon Arbus (1903–1969)
After graduating from the Ecole des Beaux Arts, Arbus joined his father's Toulouse cabinet-making firm, which he later headed. Exhibiting in the Paris Salons from 1926 onwards, he moved to the capital in 1930. Arbus was awarded the Prix Blumenthal in 1935 and exhibited at the great International Exhibitions in Brussels (1935), Paris (1937) and New York (1939). Although he ended the firm's production of furniture in eighteenth-century styles, his own designs were very much inspired by the more stylized classicism of the French Empire. He rejected the rhetoric of the UAM, continuing his workshop system and incorporating luxurious veneers, bleached animal hide vellum and gilt mounts in his furniture.

Norman Bel Geddes (1893–1958)
After studying briefly at the Art Institute of Chicago, Bel Geddes worked in a Chicago advertising agency designing posters for General Motors and Packard. In 1918 he began a successful career as a stage set designer before turning to industrial design in 1927. Despite commissions for the Toledo Scale Co. (1929), and the Standard Gas Equipment Corp. (1932), it was as polemicist of Modernity that Bel Geddes gained greatest recognition. His book *Horizons* (1932) was a manifesto for Modern streamlining which promoted a series of futuristic designs for buildings and transport systems. Bel Geddes' positivist vision of a streamlined future reached its apogee with his 'futurama' 'Metropolis of Tomorrow' for the General Motors Highways and Horizons Pavilion at the 1939 New York World's Fair.

A.M. Cassandre (1901–1968)
Born Adolphe Jean-Marie Mouron, Cassandre studied painting and was a friend of many leading figures in Parisian *avant-garde* society of the 1920s, including Apollinaire, Fernand Leger and Erik Satie. His posters combined bold images with a stylized simplicity and Modern typefaces. In 1927 he founded an advertising agency, Alliance Graphique, with Charles Loupot and Maurice Moyrand. Cassandre designed three typefaces: Bifur (1929), L'Acier (1930) and Peignet (1937).

Pierre Chareau (1883–1950)
Born in Bordeaux, Chareau first exhibited at the Salon d' Automne in 1914. Trained as an architect, he exhibited in the 1925 Paris Exposition as both an architect and a decorator. The bold curves and luxurious contrasting of exotic woods in his earlier furniture gave way in the later 1920s to a more functionalistic-inspired aesthetic. As a founder member of the UAM, Chareau's belief in the relationship between form and function was reaffirmed, and from 1932 to 1938 he undertook detailed research into the development of mobile room partitions. Chareau received commissions to design interiors from, among others, Mallet-Stevens, and his most celebrated architectural work was his 1931 collaboration with the Dutch architect Bijvoet on the Maison de Verre, famed for its revolutionary use of glass-brick walls and mobile room partitions.

Serge Chermayeff (b.1900)
Born in the Caucasus, Chermayeff was educated in England. His career from 1924 until his emigration to America in 1939 illustrates the gradual hardening of Modernist attitudes in Britain in the 1930s. Nevertheless, Chermayeff's work always retained a lyrical quality which set it apart from many of his less inspired contemporaries. From 1924 to 1927, Chermayeff was chief designer to the London decorating firm E. Williams Ltd before progressing to be director of Waring & Gillow's 'Modern Art Studio', for which he designed luxurious 'modernist' furniture. He joined the Modernist group MARS in the early 1930s, and worked with the German emigré Erich Mendelsohn, with whom he designed the celebrated De La Warr Pavilion at Bexhill-on-Sea, Sussex. His pioneering designs for the furniture manufacturer PEL introduced the use of tubular steel in Britain. During the same period Chermayeff also designed radio cabinets for Ecko.

Clarice Cliff (1899–1972)
Cliff began her career as an enameller at the age of thirteen and by 1916 her long-standing collaboration with A.J. Wilkinson Ltd had begun. After studying at the RCA in London, in 1927 she returned to Wilkinsons, who introduced her celebrated 'Bizzare' wares in 1929. At first, the Bizzare line consisted of Cliff's colourful painting on standard forms, though, by the early 1930s, new geometric forms were evolved to accommodate her innovative style. She produced a number of other lines for Wilkinsons in the 1930s; however, after the Bizzare wares were discontinued in 1941 she became involved in Wilkinsons' administration.

Susie (Susan Vera) Cooper (1902–)
Despite early ambitions to become a fashion designer, Cooper emerged as one of the most important ceramic designers and producers of the century. Her interest in ceramics was awakened in 1922 and she initially worked with A.E. Gray & Co. In 1929 she established her own atelier, and her factory produced breakfast sets, tea sets and dinner ware for a largely middle-class market. Her designs are reported to have caused a sensation at the 1922 British Industries Fair where she sold a triangular lamp base, decorated with a clown, to the Royal family.

Michel de Klerk (1884–1923)
After collaborating with J.M. van der Mey and Piet Kramer on the Scheepvaarthuis in Amsterdam, de Klerk went on to establish himself as perhaps the most prominent architect of the Amsterdam School. In his celebrated housing schemes, such as Het Scheep in Amsterdam, de Klerk married an adventurous plasticity and strong sense of geometry with an appreciation of traditional Dutch forms and shapes. Unlike his architecture, de Klerk's furniture was luxurious and expensive, and of 200 pieces made, only about 25 are known to survive. A suite designed in 1916 was exhibited posthumously at the 1925 Paris Exposition. De Klerk's importance to contemporary design was reflected in the fact that the Dutch magazine *Wendingen* devoted six special issues to his work.

Sonia Delaunay (1885–1979)
Born in Ukraine, Sonia Delaunay (née Stern, Terk) trained as a painter before moving to Paris in 1905 and she married the painter Robert Delaunay (1885–1941) in 1910. As early as 1912 Sonia was designing embroidery and bookbindings alongside her abstract paintings, and after the loss of her private income in 1917 (as a result of the Russian Revolution) she became more preoccupied with her design work. After spending time in Madrid during the First World War, she opened her Atelier Simultané in Paris, designing fashion, textiles and interiors. At the 1925 Paris Exposition she ran the Boutique Simultanée where she achieved fame as a designer of modern fashions. In the 1930s the Delaunays concentrated on public art and advertising, and at the 1937 Paris Exposition they designed a series of large murals.

Donald Deskey (1894–1989)
Deskey was unusual among the leading proponents of Art Deco design in America in that he was actually born there rather than arriving as an emigré from Europe. A visit to Paris in 1925 led Deskey to focus on interior and furniture design. His early successes were designs for screens, and in 1927 he entered into partnership with Phillip Vollmer, creating the decorating firm Deskey-Vollmer Inc. Working for wealthy private clients in the 1920s, Deskey became more interested in designs for mass production in the 1930s. Archives suggest that some 400 designs for furniture, rugs and textiles by Deskey were put into production.

Djo-Bourgeois (1898–1937)
Djo-Bourgeois was part of the youngest generation of French Art Deco designers who were subsequently attracted to the ethics and aesthetics of Modernism towards the end of the 1920s. Born in Bezons (Seine et Oise), Djo-Bourgeois graduated from the Ecole Spéciale d'Architecture in 1922. In 1923 he joined Le Studium Louvre and began exhibiting at the Salon. Le Studium Louvre saw his adventurously Modern designs as providing an opportunity to compete with the work of Charlotte Perriand and Mallet-Stevens. At first Djo-Bourgeois preferred lacquered wood and glass, but soon discovered steel, aluminium and concrete. He left Le Studium Louvre in 1929. His last exhibit before his death was a dining room with moveable partitions at the 1936 Salon.

Maurice Dufrène (1876–1955)
A founder member of the Société des Artistes Decorateurs, Dufrène, with Leon Jallot, was among the group of French designers which became known as the *Constructeurs*, before the First World War. Dufrène had worked on Meier-Graefe's 'La Maison Moderne' around 1900 designing in the Art Nouveau style. By 1910, his work adapted more simplified forms using more substantial materials and construction. Dufrène's open acceptance of mass production in the 1920s, when he became the artistic director of the studio La Maîtrise, led to a prolific output. At the 1925 Paris Exposition, as well as the La Maîtrise pavilion, Dufrène designed the 'petit salon' in the 'Ambassade Française', a boutique for the furrier Jungman, and the row of shops on the Pont Alexandre III. Dufrène's stylistic development continued into the 1930s when he experimented with steel and glass.

Jean Dunand (1877–1942)
Although he began his career as a sculptor and producer of decorative objects, Dunand became interested in lacquer from 1909 and it is for his lacquered panels, furniture and interiors that he is best remembered. He exhibited throughout the interwar years, co-designing the smoking room of the Ambassade Française at the 1925 Paris Exposition. By 1921 he was producing and exhibiting large pieces of lacquer furniture. Dunand contributed to the three great French ocean liners of the period, the *Ile de France* (1928), the *Atlantique* (1931) and the *Normandie* (1935).

Paul Follot (1877–1941)
Like Dufrène, Follot was part of the older generation of Art Deco designers who had developed their style from Art Nouveau. Follot worked at La Maison Moderne between 1901 and 1903. He became independent in 1904, designing furniture, lighting, carpets, clocks and jewellery. His style combined simplified traditionally inspired forms with rich decoration, and his work before the First World War represented an exercise in modern decoration which provided a blueprint for much of the more traditional French Art Deco which reached its apex at the 1925 Paris Exposition, to which Follot made a large contribution. In 1923 Follot became director of design at the Pomone studios of Au Bon Marche before moving to Waring and Gillow's Paris office in 1928 where he worked with Serge Chermayeff. After 1931 Follot returned to independent practice and in 1935 he received a commission for the ocean liner *Normandie* as well as exhibiting at the Brussels Exposition.

Paul Theodore Frankl (1886–1962)
Born in Prague, Frankl, together with his fellow European Joseph Urban, was one of the pioneering Modern designers working in America before 1925, who laid the foundations of the American tradition of modern decoration. After spending some time in Berlin and Copenhagen, Frankl left for America in 1914 and set up in business in New York. Although at first describing himself as an architect, in 1922 he opened a gallery at 4e, 48th Street which sold a variety of his designs for furniture, as well as modern textiles and wallpapers imported from Europe. His influence as a designer was compounded by his polemical pro-Modern publications: *New Dimensions, Form and Re-Form, Machine Age Leisure, Spaces for Living,* and *Survey of American Textiles.* In 1926 he introduced his celebrated skyscraper furniture, before turning to metal furnishings in the 1930s.

Eric Gill (1882–1940)
Despite a diverse body of work, Gill is best remembered for his sculpture and his typography. His sans serif typeface, designed in 1928 for the Monotype Corporation, became synonymous with Modern graphic design, ironically so given that Gill's work and philosophy was based on craft and catholicism. Gill's stylized sculpture was also chosen to adorn another monument to the modern age, BBC Broadcasting House in Portland Place, London (1929–31). In 1937 Gill was elected associate of the Royal Academy and awarded honorary apprenticeship of the Royal Society of British Sculptors.

Josef Gočár (1880–1945)
Gočár was a leading exponent of Czech cubist design in the 1910s, co-founding the Prague Artistic Workshops in 1912. He had trained at the School of Decorative Arts in Prague between 1906 and 1908 after which he worked for Jan Kotěra, 'the founder of modern Czech architecture'. Between 1922 and 1939, Gočár was Professor at the Academy of Fine Arts and in 1925 he was awarded the Grand Prix for the design of the Czechoslovak Pavilion at the Paris Exposition. Gočár's furniture is among the most exciting and original of the period, with a literal attempt to translate the idea of cubism into three dimensions at its heart.

Eileen Gray (1879–1976)
From County Wexford, Ireland, Eileen Gray was born into an aristocratic family. She entered the Slade School of Art in London in 1898 and moved to Paris in 1902 where she spent the rest of her life, interrupted only by the two world wars. She was celebrated for her exotic use of lacquer, the technique of which she had learned from Sougaware, a Japanese master. Although Gray did not exhibit consistently at the Salons, she ran her own establishment, the Jean Désert Gallery, from 1922 until 1930. Gray's furniture has been characterized as 'luxurious and theatrical' and the gallery never achieved commercial success, although it was supported by sales of her popular carpets. Between 1927 and 1934 she undertook three architectural projects, two villas for herself and a studio for Badovici in Paris.

Oliver Hill (1887–1968)
Hill attended evening classes at the Architectural Association, London. After the First World War he returned to practice becoming a fashionable society architect working predominantly in the neo-Georgian and neo-vernacular styles. After 1930 Hill designed a number of buildings in the modern style, although his ambiguous relationship with the more doctrinaire elements in the Modern Movement is embodied in his use of decoration. While Joldwynds (1933) and his scheme for Frinton (1933) appear to belong firmly to the Modern Movement, at the Midland Hotel, Morecambe (1934), he used Eric Gill and Eric Ravilious for decorative assistance. Hill also designed the British Pavilion for the Exposition Internationale in Paris, 1937.

Josef Hoffmann (1870–1956)
In 1903 Hoffmann co-founded the Wiener Werkstätte, and his stewardship of the workshop lasted until 1931. Hoffmann studied under Otto Wagner at the Academy of Fine Arts in Vienna and had also been a founding member of the Vienna Secession in 1897. His influence on the Wiener Werkstätte was all-pervasive. He designed its most celebrated architectural achievements, the Purkersdorf Sanatorium (1902–3) and the Palais Stoclet in Brussels (1909–1911), as well as designing for all the branches of the decorative arts. The strict grid pattern which formed the

basis to many of his designs, as well as being a favoured decorative motif, earned him the nick-name 'Quadrutl Hoffmann' (Little Square Hoffmann). His work for the Wiener Werkstätte was a pivotal element in the development of a European tradition of decorative modern design, to which the Parisian Art Deco of the 1920s provided a continuation.

Charles Holden (1875–1960)
The architecture of Charles Holden exemplifies the pragmatic compromise that was British Art Deco. Included in Holden's early career was a spell as an assistant to C. R. Ashbee. After the First World War he became a member of the Design in Industries Association, through which he met Frank Pick who commissioned him to build new facades for existing London Underground stations and for new stations on the extended Northern Line. He travelled with Pick throughout Northern Europe and his work on the new stations on the Piccadilly Line established a brick-built, modern house style for the Underground which echoed the work of architects in Holland such as Dudok. From 1931, Holden was involved in the scheme to centralize London University, the most prominent monument of which is the University's Senate House in Bloomsbury.

Raymond Hood (1881–1934)
Educated at the Massachusetts Institute of Technology and the Ecole des Beaux Arts in Paris, the early years of Hood's architectural career were spent in obscurity. He was catapulted to fame in 1922 when, together with John Mead Howells, he won the competition to design the Chicago Tribune Tower. Despite the fact that the building was neo-Gothic rather than Art Deco, his remaining twelve years of practice included work on some of the most significant American buildings of the age: the American Radiator Building in New York (1925), which combined a more subdued Gothic with a more confident modernity; the Rockefeller building (1931), which he co-designed and remains an icon of Art Deco, and the McGraw Hill Building with its terracotta exterior. His last commission was to design the Electricity Building at the 1933 *Century of Progress* exhibition in Chicago.

Pavel Janák (1882–1956)
After studying under Otto Wagner at the Academy of Fine Arts in Vienna (1906–8), Janák returned to his native Prague, where he was to design some of the most remarkable furniture and ceramics of the Czech cubist movement. In 1908, he co-founded the Artěl Co-operative, which proved so crucial to the realisation of many of the cubists' designs. Janák joined the Group of Plastic Artists in 1911 and was one of the editors of *Umělecky Měsičnik,* as well as being a founder member of the Prague Artistic Workshops in 1912.

Betty Joel (1894–1985)
Born Mary Steward Lockhart in Hong Kong, Betty Joel was educated in England and met David Joel while he was in the navy serving in the Far East. They married in 1918 and, although neither had any formal design training, they began manufacturing furniture under the name Betty Joel Ltd. Early work was in a modernized Arts and Crafts idiom, however, by the late 1920s and early 1930s French Art Deco influences were clear. Betty Joel's London showroom was first at 177 Sloane Street and then 25 Knightsbridge. The firm's clients were wide ranging, both corporate and private. Furniture was manufactured for the Savoy and St James' Palace hotels and for many of H.S. Goodhart-Rendel's projects, including Hays Wharf. Her more celebrated private clients included Lord Louis Mountbatten and the then Duchess of York.

Francis Jourdain (1876–1958)
One of the founders of the UAM, Jourdain had always held an ambivalent attitude towards decoration. His relatively austere, angular work exhibited at the Salon d'Automne in 1902 had effectively renounced the Art Nouveau style of his contemporaries. For clients demanding luxury, his concession might be the use of a rich veneer. As a result of his sparse style, many of his early commissions were for public spaces rather than private interiors. Jourdain exhibited at the 1925 Paris Exposition and from then onwards he began to use steel, aluminium and lacquer. Jourdain retired in 1939 in order to spend more time writing.

Ely-Jacques Kahn (1884–1972)
After graduating from the Architecture School of Columbia University in 1907, Kahn spent four years in Paris studying at the Ecole des Beaux Arts. He became a partner in the firm Buchman & Fox, which he eventually dominated, and was thus well placed to play an influential role on the New York architectural scene between 1925 and 1930. As well as exhibiting in *The Architect and the Industrial Arts* at the Metropolitan Museum in 1929, Kahn was responsible for some of the great decorative buildings of the 1920s, such as 261 Fifth Avenue and 2 Park Avenue with its brightly-coloured terracotta exterior by L.V. Solovon.

Piet Kramer (1881–1961)
Kramer met Michel de Klerk while working in the office of the Amsterdam architect Eduard Cuypers. He collaborated with J.M. van der Mey, another leading figure of the Amsterdam School, on the Scheepvaarthuis in Amsterdam. Kramer took part in five of the Amsterdam social housing projects which characterized the work of the school in the years 1915–25. This use of brickwork to carry the abstract geometric decoration on the facades of his buildings proved an antecedent to some of the more flamboyant decorative exercises in Art Deco architecture, while his use of brick also provided inspiration for the more pragmatic approach of the suburban Art Deco of Britain. Kramer was also a notable furniture designer.

René Jules Lalique (1860–1945)
Lalique's professional career, first as a goldsmith and then, more famously, as a glassmaker, spanned both the Art Nouveau and the Art Deco eras. Lalique rented his first glassworks in 1909, at Combs-la-ville near Fontainebleau. Initially the factory produced only perfume bottles, but by the 1920s Lalique began to manufacture other works in glass such as jewellery, mirrors, lamps, chandeliers and tableware. When he exhibited at Paris in 1925, his celebrated glass fountain provided both a centrepiece for the Perfume Pavilion as well as a defining symbol of French Art Deco of the 1920s. By the 1930s, Lalique's innovation was challenged by other makers such as Sabino, although, despite the fact that he was in his seventies, Lalique continued his stewardship of the firm which, by this time, had grown to employ 600 people.

232

Le Corbusier (1887–1965)
Born in La Chaux-de-Fonds, Le Corbusier worked under his real name, Charles-Eduard Jeanneret until the early 1920s. In 1907 he travelled Europe, meeting Josef Hoffmann in Vienna. Between 1908 and 1909 he worked for the Paris architect Auguste Perret, and in 1910–11 in the Berlin office of Peter Behrens. In 1911, the publication in France of his *Etude sur le Mouvement d'art decoratif en Allemagne*, associated Jeanneret's name with debate about the role of national identity and the decorative arts in France. Indeed it was as a decorator that Jeanneret became known in the Parisian art world, working with such designers as André Groult and Paul Poiret. However, through his involvement with the Purist painter Amédée Ozenfant, Jeanneret, by now known as Le Corbusier, developed the anti-decorative theory for which he became famous. His Pavillon de L'Espirit Nouveau at the Paris Exposition in 1925 became an icon of the burgeoning Modern Movement, and his books *The Decorative Art of Today* and *Towards a New Architecture* showed that his ability as a polemicist matched his skill as a designer. A founder member of the UAM, Le Corbusier is often portrayed as representing the antithesis of Art Deco (his pavilion was marginalized at the 1925 exhibition), yet his work before 1920 and the influence of the Modernist aesthetic on the development of Art Deco in both Europe and America from the late 1920s make him an important figure in the history of the style.

Raymond Loewy (1893–1986)
Loewy studied electrical engineering in his native France before emigrating to America after serving in the First World War. Following a brief spell as window dresser at Macy's, he worked as a fashion illustrator on *Harpers Bazaar*. He recognised the potential of applying the principles of commercial art to the actual products of industry and in 1929 was commissioned to modernize the Gestetner mimeograph machine. In 1930 he set up his own design consultancy and in 1935 he revamped the Sears Roebuck refrigerator, signing the 'Coldspot', and in doing so brought the streamlined, white curves of the moderne style into kitchens across America. He also published influential futuristic designs for taxis, cars and trains

as well as designing locomotives for the Pennsylvanian Railroad and the distinctive Greyhound Coach (1940).

Charles Rennie Mackintosh (1868–1928)
Apprenticed in his native Glasgow to the architect John Hutchinson between 1884 and 1889, Mackintosh travelled widely in Europe in the 1890s. He designed posters from the mid-1890s, and also exhibited at the 1896 Arts and Crafts exhibition. In 1897 Mackintosh began the first phase of his work on the Glasgow School of Art, which he also extended in 1907. Other work in Scotland included the Willow Tea Rooms (1903) and Hill House (1904). Despite international acclaim, Mackintosh never achieved commercial success. He left Glasgow in 1914, and between 1915 and 1920 he carried out work for the industrialist W.J. Bassett-Lowke, most notably at 78 Derngate, Northampton. After travelling France in the mid-1920s, Mackintosh died of cancer in London in 1928.

Robert Mallet-Stevens (1886–1945)
Trained at the Ecole Spéciale d'Architecture (1905–10), Mallet-Stevens built little until after the First World War. His work at the 1925 Paris Exposition included the cubist concrete trees by the Martel Brothers in his Winter Garden and the distinctive tower for his 'Pavillon du Tourism', both of which established him as the archetypal maverick Modernist, setting an international mould for Art Deco architects of the 1920s and 1930s. His most celebrated commissions were the Villa for the Viscount de Noailles in Hyères (1923–5), the Rue Mallet-Stevens in Auteuil (1926–7) and the Casino at Saint Jean-de-Luz (1928). His disregard for the social dimension of Modernism did not prevent him assuming the presidency of the UAM in 1930, and although he undertook commissions at the 1935 Brussels exhibition and the 1937 Paris Exposition Universalles, his work never eclipsed the triumphs of the 1920s.

Edward McKnight Kauffer (1890–1954)
A poster designer and illustrator, Kauffer was an American who settled in England. His first commission to design a poster for the Underground Railway Co. came in 1915. In 1921 he gave up painting and became devoted to commercial art. His

commissions reveal a portfolio of celebrated modern commercial graphic design, his clients including: the London Transport Board, Shell, BP, the Great Western Railway, the General Post Office, and the Gas, Light & Coal Co. A fellow of the British Institute of Industrial Art and member of the Council for Art and Industry, Kauffer was married to the celebrated textile and carpet designer Marion Dorn, another American who came to England in the early 1920s. The two exhibited together in 1929.

Koloman Moser (1868–1918)
Studying under Otto Wagner at the Academy of Fine Arts in Vienna, Moser, together with Hoffmann, was a founder of both the Secession and the Wiener Werkstätte. Although trained as a painter, by the late 1890s Moser was active in the decorative arts winning a prize at the Paris Exposition Universalle in 1900. His major contribution to the Werkstätte came in his design of the interiors of Hoffmann's Purkersdorf Sanatorium in 1905. It was Moser's departure in 1908 which heralded a move away from the strict geometry of the Werkstätte's early and most influential work.

Dagobert Peche (1887–1923)
Berta Zuckerkandl described Peche as, 'the greatest genius of ornament that Austria has possessed since the Baroque'. Peche trained at the technical college in Vienna and at the Academy of Fine Arts from 1908 to 1911. He joined the Werkstätte in 1915, and his work characterized, and indeed influenced the shift towards a more whimsical, folk-inspired aesthetic in the workshop. Peche designed the Wiener Werkstätte's Zurich branch, where he was based from 1917 to 1918. Although Peche's work was not confined to any one branch of the applied arts, it is for his delightfully ornamented small objects that he is best remembered. His ornamental objects in chased silver from the earlier 1920s illustrate how far the Werkstätte had moved from Moser's geometry in the years since his departure.

Paul Poiret (1879–1944)
The son of a Parisian shopkeeper, Poiret became a dress designer in 1896 after meeting Jacques Doucet. In 1910 he visited Vienna, met Josef Hoffmann and took inspiration from the textile and

fashion designs of the Wiener Werkstätte. He founded his Atelier Martine in 1911 and his Maison Martine on Fauborg Saint-Honoré sold rugs, carpets and wallpapers. Together with his long-term collaborator, the painter Raoul Dufy, Poiret began a studio for printing textiles, La Petite Usine. In 1908 and 1911 Poiret published volumes of his designs, which was in itself an innovative step, and as a result he was received warmly when he visited America in 1913. Although he continued work in the 1920s and 1930s, his contribution to the 1925 Paris Exposition, three decorated barges, brought Poiret to the edge of financial ruin.

Gio Ponti (1891–1979)
After studying architecture at the Polytechnic in Milan (1918–21), Ponti became a designer for Richard Ginori, the Doccia ceramics firm. His work, often in a stylized and humorous classical idiom, gained him the Grand Prix at the 1925 Paris Exposition. As a result of the exposure he received at Paris, he was asked to design a range of cutlery for Christofle and a villa for the firm's chairman. In 1927 he left Ginori to set up an architectural practice with Emilio Lancia, and a year later he became the founder-editor of *Domus*, a journal which promoted the work and ideas of the Novecento movement. The Novecento, which Ponti founded together with other architects such as Giovanni Muzio, combined tradition, decoration and a striking modernity providing a starting point for Italian designers who, keen to absorb what they had seen in Paris, were inspired to produce decorative and modern pieces.

Jean Puiforcat (1897–1945)
Puiforcat joined the family firm of silversmiths while he was studying sculpture with Louis-Aimé Lejeune. After setting up his own workshop in 1922, Puiforcat's work came to embody the simple geometric wing of the Art Deco idiom. Puiforcat's objects relied on a purity of line and mathematical proportions as opposed to applied decoration. In 1929 he was a founding member of the UAM; however, despite his aesthetic similarities with the Modern Movement, his refusal to compromise in his use of silver ensured Puiforcat maintained his status as a designer of luxury items. Indeed in 1934 his work

took a new direction when he began to produce liturgical objects for the Catholic Church. By 1937 he had become disillusioned with the UAM, and he left France at the beginning of the Second World War, returning shortly before his death in 1945.

Jacques-Emile Ruhlmann (1879–1933)
In 1900 Ruhlmann joined his father's decorating business and by 1903 he was producing his first furniture designs. After his father's death in 1907, he began to display his work at the Paris Salons, his first pieces of furniture being exhibited in 1913. Escaping military service for medical reasons, Ruhlmann spent the war refining his classically-inspired style before entering into partnership with Pierre Laurent in 1919. Together their business expanded, Laurent's decorating work providing a secure base for Ruhlmann's less profitable luxury furniture. Characterized by its exotic use of veneers and perfectly-proportioned forms, Ruhlmann's furniture remains for many the apogee of French Art Deco, a sentiment reflected in the soaring prices paid at auction for his pieces today. Ruhlmann's most celebrated ensembles were for his 'Hôtel du Collectionneur' at the 1925 Paris Exposition and his office for Marshall Lyautey at the 1931 Exposition Coloniale.

Süe et Mare
Louis Süe (1875–1968)
André Mare (1887–1932)
André Mare was an artist, and studied at the Académie Julian; Louis Süe also trained as a painter, but turned to interior design as early as 1905. This lack of a design or craft training led both Süe and Mare to be grouped with the Coloristes in Paris before the First World War. Mare was involved with Duchamp-Villon's Maison Cubiste in 1912, while Süe worked with Poiret until the founding of La Maison Martine in 1912. In the same year, Süe set up his own decorating firm, L'Atelier Français, and began his association with Mare in 1914. This association became a partnership in 1919 with the foundation of La Compagnie des Arts Français which lasted until 1928. Süe et Mare worked across the spectrum of the decorative arts from wallpapers to furniture. Their furniture used exotic woods and was clearly inspired by

traditional French styles. At the 1925 Paris Exposition their pavilion, Un Musée d'Art Contemporain, rivalled Ruhlmann's and the firm also exhibited furniture in the Ambassade Française and the Parfums d'Orsay boutique among other pavilions. The partnership ended in 1928 and Süe continued work in France throughout the 1930s.

Walter Dorwin Teague (1883–1960)
After moving to New York in 1902, Teague joined the advertising agency Calins and Horden in 1908. By 1927 he was a freelance artist and typography expert, however, he began to apply this advertising expertise to the products of the manufacturing industry. His clients included Kodak, Westing House and Steinway and Sons. Teague did much to bring the aesthetic of streamlining to everyday American life through products such as the Bantam Special Camera for Kodak. His pioneering system designs for Texaco, which were used to build over 10,000 roadside petrol and service stations in the 1930s, did much to ensure that the streamlined moderne style became the architectural idiom of the highway. At the 1939 World's Fair, Teague carried out commissions for Ford, Kodak and the National Cash Register Co. among others.

Joseph Urban (1872–1933)
Born in Vienna, Urban studied at the Imperial and Royal Academy of Fine Arts and the Polytechnium, and first visited the USA in 1901 to prepare his designs for the Austrian Pavilion at the forthcoming St Louis Exposition. In 1911 he settled in the US, and in doing so provided a vital link between the Viennese tradition of modern decoration, and the evolving idiom of American Art Deco. He exhibited at the 1929 Metropolitan Museum show 'The Architect and the Industrial Arts'. Urban was celebrated for his theatre designs, most famously his building for Ziegfeld's troupe for which he also designed most of its Broadway shows. He ran his own 'Decorative and Scenic Studio' in New York, as well as opening the Wiener Werkstätte's New York Branch on Fifth Avenue in 1922, for which he designed the interiors and some of the furniture. Urban also started an artists' fund to support the Werkstätte's activities. His archives at Columbia University contain details of a wide variety of furnishings that he designed for hotels and restaurants in New York and the Midwest.

Ralph T. Walker (1889–1973)
Walker trained at the Massachusetts Institute of Technology (1909–11), and after a series of apprenticeships he joined the New York architects McKenzie, Voorhees & Gmelin in 1919. Walker became a partner in 1926, and as Voorhees, Gmelin & Walker, the firm were responsible for some of the most decoratively adventurous skyscrapers of the 1920s, including the Barclay-Vesey Telephone Building (1923–6) and the Western Union Building (1928–9). After becoming Voorhees, Walker, Foley & Smith in 1939, the firm undertook several commissions to design buildings for the 1939 New York World's Fair.

Thomas Wallis (1873–1953)
Perhaps the most decoratively adventurous inter-war British architect, Wallis became a consultant to Kahncrete, an American engineering company specializing in reinforced-concrete industrial buildings. In 1917 he set up practice as Wallis, Gilbert and Partners specializing in industrial buildings, often for American clients. The firm was responsible for many of the factories in west London, where the stylized facade ornament may be atypical, but has made them icons of British Art Deco. The firm's most distinctive work included the Firestone Factory (1929) and the Pyrene Factory (1930), both in Brentford, the Albion Car Works and India Tyre and Rubber Co., Glasgow (1930), the Hoover Factory in Perivale (1932) and London's Victoria Coach Station (1932).

Kem (Karl Emanual Martin) Weber (1889–)
Weber was born in Berlin and studied under Bruno Paul between 1908 and 1910. Finding himself stranded in San Francisco at the outbreak of war in 1914, he eventually joined the Los Angeles design studio Baker Bros. where he became director. After visiting Paris in 1925, he became committed to Modern design, and his subsequent repertoire of furniture mirrors the evolution of American Art Deco from the 'zig zag' style of the late 1920s to the streamlined moderne aesthetic of the 1930s. He was one of the few American designers to contribute to Macy's first International Exposition of Arts and Trades. In the 1930s Weber developed furniture in plywood, a medium ideal for the streamlined style. His most famous work was his 1935 design for an airplane chair for the Airline Chair Co. in Los Angeles, which has been described as 'the most striking interpretation of the streamline ethic to emerge in the USA'.

Frank Lloyd Wright (1867–1956)
Perhaps America's most influential twentieth-century architect and design theorist, Wright was instrumental in fashioning a specifically American tradition of modern decoration upon which American Art Deco was built. This is particularly true of the horizontal style of his domestic architecture of the first two decades of the century inspired by both European Modernists and the practitioners of the moderne in America. Wright had received his architectural education in the Chicago office of Louis Sullivan, a pioneering theorist of functionalism. Between 1901–13 Wright designed a series of 'Prairie Houses', while his Unity Temple of 1906 stands as one of the pioneering examples of Modern American decoration. After visiting Japan several times after 1905, Wright designed Midway Gardens in Chicago (1913–14) which although later demolished marked a move towards a greater decorative emphasis in his work, typified by the Imperial Hotel in Tokyo (1919–21) and the Barnsdall House in Los Angeles (1916–22). Although Wright remained intellectually aloof from what became known as Art Deco, he shared its roots in Vienna and was living proof that America did have a tradition of Modern decoration before 1925.

BOOKS

Abercrombie, Patrick (ed.)
The Book of the Modern House, London: Batsford, 1939.

Adams, S.R.
Modern Decorative Art: A Series of Two Hundred Examples of Interior Decoration, Furniture, Lighting Fittings and other Ornamental Features, London: Batsford, 1930.

Ades, Dawn, **Benton**, T,, **Elliottt**, D. & **Whyte**, I.
Art and Power: Europe under the Dictators, 1930–45, London: Thames and Hudson, 1995.

Albrecht, Donald
Designing Dreams: Modern Architecture in the Movies, London: Thames and Hudson, 1987.

Arnold, R.J. & **Tyser**, H.F.
The Carpet Annual, London: 1935.

Arnold, R.J. & **Tyser**, H.F.
The Carpet Annual, London: 1937.

Atwell, David
Cathedrals of the Movies: A History of British Cinemas and their Audiences, London: Architectural Press, 1980.

Baker, Eric & **Bilk**, Tyler
Trade Marks of the 1920s & 1930s, London: Angus & Robertson, 1989.

Battersby, Martin
The Decorative Twenties, (revised and edited by Philippe Garnier), London: Herbert, 1988.

Battersby, Martin
The Decorative Thirties, (revised and edited by Philippe Garnier), London: Herbert, 1988.

Bayer, Patricia
Art Deco Architecture, London: Thames and Hudson, 1992.

Bayer, Patricia
Art Deco Interiors, London: Thames and Hudson, 1988.

Bel Geddes, Norman
Horizons, Boston: Little, Brown & Co., 1932.

Berman, Marshall
All That Is Solid Melts Into Air: The Experience of Modernity, London: Verso, 1987.

Billcliffe, Roger
Mackintosh Furniture, Cambridge: Lutterworth Press, 1984.

Borsi, Franco
The Monumental Era: European Architecture and Design 1929–1939, London: Lund Humphries, 1987.

Bossaglia, Rossana
Il Deco Italiano: Fisionomia Dello Stile 1925 In Italia, Milan: Rizzoli, 1975.

Bouillon, Jean-Paul
Art Deco, New York: Rizzoli, 1989.

Boston, Richard
Osbert: A Portrait of Sir Osbert Lancaster, London: Collins, 1989.

Breeze, Carla
LA Deco (Introduction by David Gebhard), New York: Rizzoli, 1991.

Breeze, Carla & **Whiffen**, Marcus
Pueblo Deco: The Art Deco Architecture of the Southwest, Alberquerque: University of New Mexico Press, 1984.

Brett, David
Charles Rennie Mackintosh and the Poetics of Workmanship, London: Reaktion, 1992.

Bruhnammer, Yvonne & **Tise**, Suzanne
French Decorative Art: The Société des Artistes Décorateurs, London: Flammarion, 1990.

Buch, J.
A Century of Architecture in the Netherlands 1880–1990, Amsterdam: NAI, 1994.

Camard, Florence
Ruhlmann: Master of Art Deco, London: Thames and Hudson, 1993.

Capitman, Barbara, **Kinerk**, M.D. & **Wilhelm**, D.W.
Rediscovering Art Deco USA, New York: Viking, 1994.

Cerwinske, Laura
Tropical Deco: The Architecture and Design of Old Miami Beach, New York: Rizzoli, 1991.

Chruscicki, Tadeusz
Art Deco in Poland, Cracow: 1994.

Cochrane, Grace
The Crafts Movement in Australia, Kensington N.S.W.: New South Wales University Press, 1992.

Cohen, Judith Singer
Cowtown Moderne: Art Deco Architecture of Fort Worth, Texas, College Station: Texas A & M University Press, 1988.

Collins, Judith
Eric Gill: Sculpture, London: Lund Humphries/Barbican, 1991.

Collins, Michael & **Papadakis**, Andreas
Post Modern Design, London: Academy, 1989.

Crosby, Theo
Let's Build a Monument, London: Pentagram Design Limited, 1987.

Crosby, Theo & **Sandle**, Michael
The Battle of Britain Monument, London: Pentagram Design Limited, 1987.

Dean, David
The Thirties: The English Architectural Scene, London: RIBA, 1983.

Dehairs, Léon
Modern French Decorative Art: a Collection of Examples of Modern French Decoration, London: Architectural Press, 1926.

Delhaye, Jean
Art Deco Posters and Graphics, London: Academy, 1977.

Derwig, Jan & **Mattie**, Erik
The Amsterdam School, Amsterdam: Architectura Natura, 1991.

De Wit, Wim
The Amsterdam School: Dutch Expressionist Architecture, 1915–1930, London: MIT Press, 1983.

Dufrène, Maurice
Authentic Art Deco Interiors from the 1925 Exposition, Woodbridge: Antique Collectors' Club, 1989.

Duncan, Alastair
Art Deco / Art Nouveau Bookbinding, London: Thames and Hudson, 1989.

Duncan, Alastair
American Art Deco, London: Thames and Hudson, 1986.

Duncan, Alastair
Art Nouveau and Art Deco Lighting, London: Thames and Hudson, 1978.

Duncan, Alastair
Art Deco Furniture: The French Designers, London: Thames and Hudson, 1992.

Edwards, Clive D.
Twentieth Century Furniture, Manchester: MUP, 1994.

Epstein, Jacob
Let There Be Sculpture: An Autobiography, London: Michael Joseph, 1940.

Etlin, Richard A.
Modernism in Italian Architecture 1890–1940, Cambridge, Mass.: MIT Press, 1991.

Etlin, Richard A. (ed)
Studies in the History of Art 29: Nationalism in the Visual Arts, Washington: National Gallery of Arts, 1991.

Evenson, Norma
The Indian Metropolis: A View Toward the West, New Haven: Yale, 1989.

Exton, E. Nelson & **Littman**, Frederic
Modern Furniture, London: Boriswood, 1936.

Fahr-Becker, Gabriele
Wiener Werkstätte, London: Taschen, 1995.

Fischer Fine Art Ltd.
Frank Lloyd Wright: Architectural Drawings and Decorative Arts, London: Fischer Fine Arts, 1985.

Follot, Paul
Intérieurs Français au Salon des Artistes Décorateurs, Paris: 1927.

Forty, Adrian
Objects of Desire, London: Thames and Hudson, 1992.

Frankl, Paul
Form and Re-Form: A Practical Handbook of Modern Interiors, New York: Harper & Bros, 1930.

Frankl, Paul
New Dimensions: The Decorative Arts of Today in Words and Pictures, New York: Payson & Clarke, 1928.

Freeland, J.M.
Architecture in Australia, Melbourne: Cheshire Publishing, 1968.

Fry, Roger
Omega Workshops Ltd, Artist Decorators, London: Omega Workshops, 1915.

Gebhard, David
Tulsa Art Deco: An Architectural Era, 1925–42 (contemporary photographs by David Halpern), Tulsa: Junior League of Tulsa, 1980.

Gebhard, David and **Von Bretton**, Harriette
LA in the Thirties, Santa Barbara: Art Galleries of the University of California, 1975.

Genauer, Emily
Modern Interiors Today and Tomorrow, Cleveland & New York: The World Publishing Company, 1942.

Greenhalgh, Paul
Struggles within French Furniture in Greenhalgh (ed.) Modernism in Design, London: Reaktion, 1990.

Greenhalgh, Paul
Ephemeral Vistas: The Expositions Universelles, Great Exhibitions and World's Fairs, 1851–1939, Manchester: MUP, 1988.

Haegeney, W. (ed.)
Repertoire: Modern Interior Design 1928–29, Rome: Belvedere, 1986.

Harbison, Robert
Eccentric Spaces, London: André Deutsch, 1977.

Haslam, Malcolm
Art Deco, London: Macdonald, 1987.

Heide, Robert & **Gilman**, John
Popular Art Deco: Depression Era Style and Design, New York: Abbeville Press, 1991.

Heller, Steven & **Fili**, Louise
Dutch Moderne, San Francisco: Chronicle Books, 1994.

Heller, Steven & **Fili**, Louise
Italian Art Deco: Graphic design Between the Wars, San Francisco: Chronicle Books, 1993.

Heller, Steven & **Fili**, Louise
Streamline: American Art Deco Graphic Design, San Francisco: Chronicle Books, 1995.

Heskett, John
Industrial Design, London: Thames and Hudson, 1984.

Hillier, Bevis
Art Deco of the Twenties and Thirties, London: Studio Vista, 1968.

Hulanicki, Barbara
From A to Biba, London: Comet, 1983.

Jackson, Alan A.
Semi-Detached London, Didcot: Wild Swan Publications, 1991.

Jencks, Charles
The Language of Post Modernism, London: Academy, 1987 (fifth edition).

Kallir, Jan
Viennese Design and the Wiener Werkstätte, London: Thames and Hudson, 1986.

Kaplan, Wendy (ed.)
Designing Modernity: The Arts of Reform and Persuasion 1885–1945, London: Thames and Hudson, 1995.

Kaplan, Wendy (ed.)
Charles Rennie Mackintosh, London: Abbeville Press, 1996.

Karol, E., & **Allibone**, F.
Charles Holden: Architect 1875–1960, London: RIBA, 1988.

Kenna, Rudolph
Glasgow Art Deco, Glasgow: Drew, 1985.

Kery, Patricia Franz
Art Deco Graphics, London: Thames and Hudson, 1986.

Klein, Dan, **McClelland**, Nancy and **Haslam**, Malcom
In the Deco Style, London: Thames and Hudson, 1987.

Kiesler, Frederick
Contemporary Art Applied to The Store & Its Display, London: Pitman & Sons, 1930.

Lancaster, Osbert
Home Sweet Homes, London: John Murray, 1939.

Lancaster, Osbert
Pillar To Post: the Pocket Lamp of Architecture, London: John Murray, 1938.

Lancaster, Osbert
Progress at Pelvis Bay, London: John Murray, 1936.

Lancaster, Osbert
With an Eye to the Future, London: John Murray, 1967.

Le Corbusier
Precisions: On the Present State of Architecture and City Planning, Cambridge, Mass.: MIT Press, 1990.

Le Corbusier
The Decorative Arts of Today, London: Architectural Press, 1987.

Light, Alison
Forever England: Femininity, Literature and Conservatism Between the Wars, London: Routledge, 1991.

MacKenzie, John M.
Orientalism: History, Theory and The Arts, Manchester: MUP, 1995.

Mackeritch, T. & P.
Facade: A Decade of British and American Commercial Architecture, London: Matthew Mills and Dunbar, 1976.

Margolius, Ivan
Cubism in Architecture and the Applied Arts: Bohemia & France 1910–1914, North Pomfret, Vermont: David & Charles, 1979.

McCready, Karen
Art Deco and Modernist Ceramics, London: Thames and Hudson, 1994.

McMillan, J.F.
Twentieth Century France: Politics & Society 1898–1991, London: Edward Arnold, 1992.

Mendenhall, John
French Trademarks of the Art Deco Era, San Francisco: Chronicle Books, 1991.

Messler, Norbert
The Art Deco Skyscraper in New York, Frankfurt am Main: Lang, 1983.

Mordaunt-Crook, J.
The Dilemma of Style, London: John Murray, 1987.

Mouron, Henri
Cassandre, London: Thames and Hudson, 1985.

Myers, Eric
Screen Deco, Bromley: Columbus, 1985.

Neuwrith, Waltraud
Wiener Werkstätte: Avant Garde, Art Deco, Industrial Design, Vienna: Austrian Museum of Applied Art, 1984.

Noever, Peter (ed.)
Josef Hoffmann Designs, Munich: Prestel, 1992.

Oliver, Paul, **Davis**, Ian & **Bentley**, Ian
Dunroamin: The Suburban Semi and Its Enemies, London: Pimlico, 1994.

Orwell, George
The Road to Wigan Pier, London: Penguin, 1962.

Ostergard, Derek
Art Deco Masterpieces, New York: Hugh Lauter Levin Associates, 1991.

Park, Edwin Avery
New Backgrounds for a New Age, New York: Harcourt Brace & Co., 1927.

Ponti, Lisa Licitra
Gio Ponti: The complete work 1923–1978, London: Thames and Hudson, 1990.

Powers, Alan
H.S. Goodhart-Rendell 1887–1959, London: Architectural Association, 1987.

Powers, Alan
Oliver Hill: Architect and Lover of Life, London: Mouton, 1989.

Powers, Alan
Shop Fronts, London: Chatto & Windus, 1989.

Prokopoff, Stephen S. (ed.)
The Modern Dutch Poster: The First Fifty Years 1890–1940, Cambridge, Mass.: MIT Press, 1987.

Purvis, Alston W
Dutch Graphic Design 1918–1945, New York: Van Nostrand Reinhold, 1992.

Robinson, Heath & **Browne**, K.R.G
How To Live in a Flat, London: Hutchinson & Co., 1937.

Rosenthal, Rudolp & **Ratzha**, Helena
The Story of Modern Applied Art, New York: Harper & Bros., 1948.

Scarlett, Frank
Arts Decoratifs 1925: A Personal Recollection of the Paris Exhibition, London: Academy Editions, 1975.

Shand, Morton P.
Modern Theatres and Cinemas, London: Batsford, 1930.

Sharp, Dennis
The Picture Palace and other Buildings for the Movies, London: Evelyn, 1969.

Shaw, Peter
Art Deco Napier, Styles of the Thirties, Napier: Cosmos Publications, 1990.

Shaw, Peter
New Zealand Architecture From Polynesian beginnings to 1990, Auckland: Hodder & Stoughton, 1991.

Silvester, C.
The Penguin Book of Interviews, London: Penguin, 1993.

Smith, Terry
Making the Modern: Industry, Art and Design in America, London: University of Chicago Press, 1993.

Sontag, Susan
Against Interpretation, London: Vintage, 1994.

Sparke, Penny
An Introduction to Design and Culture in the Twentieth Century, London: Routledge, 1992.

Spours, Judy
Art Deco Tableware, London: Ward Lock, 1988.

Steele, Valerie
Fashion and Eroticism: Ideals of Feminine Beauty from the Victorian Era to the Jazz Age, Oxford: OUP, 1985.

Svestka, Jiri
Kubismus in Prag 1909–1925, Stuttgart: Hatje, 1991.

Taylor, Brian Brace
Pierre Chareau: Designer & Architect, Köln: Taschen, 1992.

Troy, Nancy J.
Modernism and the Decorative Arts in France: Art Nouveau to Le Corbusier, New Haven and London: Yale, 1991.

Urban, Joseph
Theatres, New York: Theatre Arts Inc., 1929.

Vegesack, A. (ed)
Czech Cubism: Architecture, Furniture and Decorative Arts, 1910–1925, Montreal: Lawrence King, 1992.

Volker, Angela
Textiles of the Wiener Werkstätte 1910–1932, London: Thames and Hudson, 1994.

Ward, Mary & Neville
Home in the Twenties and Thirties, London: Ian Allan, 1978.

Whiteley, Nigel
Pop Design: Modernism to Mod, London: Design Council, 1992.

Wright, Frank Lloyd
An Autobiography, London: Quartet, 1977.

Wright, Frank Lloyd,
A Testament, New York: Horizon Press, 1957.

Wurts, Richard
New York World Fair 1939–1940 in 155 Photographs, London: Constable, 1977.

ARTICLES

Adams, Brooks
'Urban Renewal', *Art in America*, April 1988, Vol. 76 No.4, pp.43–7.

Bellucci, Alberto
'Monumental Deco in the Pampas: The Urban Art of Francisco Salamone', *JDAPA*, 1992.

Campbell, Louise
'A Model Patron: Basset Louke, Mackintosh & Behrens', in *The Journal of the Decorative Arts Society*, Volume 10, 1986, pp.1–9.

Compton, J.
'Night Architecture of the Thirties', in *Journal of the Decorative Arts Society*, Volume 4, 1979, pp.40–47.

Corak, Zeljka
'The 1925 Yugoslav Pavilion in Paris', *JDAPA*, Fall 1990, p.37.

De Dios, Jorge Ramos
'Latin American architecture of the Art Deco Era', *Art Deco Weekend Magazine*, Miami, 1995, pp.30–34.

Duncan, Alastair
'Art Deco Lighting', *JDAPA*, Spring 1986, pp.20.

Dunlop, Beth
'Interview: Timothy Rub on the Work of Joseph Urban', *JPADA*, Spring 1988, pp.104–119.

Freschi, Fredrico
'Big Business Beautility: the Old Mutual Building', Cape Town, South Africa, *JDAPA*, 1994, p.39.

Groenberg, Tag
'Cascades of Light: The 1925 Paris Exhibition as *ville lumiere*', *Apollo*, July 1995, pp.12–16.

Krečič, Peter
'Jože Plečnik and Art Deco', *JDAPA*, Fall 1990, pp.27–32.

Manevic, Zoran
'Art Deco and National Tendencies in Serbian Architecture', *JDAPA*, Fall 1990, p.71.

Ward, Mary & Neville
'Art Deco Architecture in South Africa', *JDAPA*, 1994.

Parker, Eileen
Working for Oliver Bernard and the early days of PEL Ltd, *The Journal of the Decorative Arts Society*, Volume 8, 1983, pp.50–57.

Payne, Rodney
Bath Cabinet Makers, *The Journal of the Decorative Arts Society*, Volume 5, 1980, pp.23–30.

Powers, Alan
'Art Deco: An image problem?', *Apollo*, July 1995, pp.3–6.

Rub, Timothy
'Joseph Urban', *ID: The Magazine of International Design*, Jan/Feb 1988, Vol. 35 No.1, pp.60–63.

Simon, Robin
'Napier, New Zealand: Art Deco capital of the Southern Hemisphere', *Apollo*, July 1995, pp.17–19.

Sisson, Rachel
'Rio de Janeiro 1875–1945: The Shaping of a New Urban Order', *JDAPA*, 1995, pp.139–55.

Thomas, D.
'Art Deco in Australia', *Art and Australia*, Vol. ix, 1971–2.

Tilson, Barbara
The Modern Art Department, Waring and Gillow, 1928–1931, *The Journal of the Decorative Arts Society*, Volume 8, Brighton; *The Decorative Arts Society*, 1983, pp.40–49.

Wallace Laidlaw, C.
'The Metropolitan Museum of Art and Modern Design: 1917–1929', *JDAPA*, Spring 1988, pp.88–103.

Wilk, Christopher
'Who was Betty Joel? British furniture design between the wars', *Apollo*, July 1995, pp.7–11.

EXHIBITION CATALOGUES

American Art Deco Architecture, Finch College Museum of Art, 6 November 1974–5, January 1975.

Magyar Art Deco, Imparmuveszeti Museum, Hungary.

Tempo Dos Modernistas, Museu de Arte de Sao Paulo Assis Chateaubriand, 1974.

Art in our Time, MOMA, New York, 1939.

Everyday Things, RIBA, London, c.1936.

Modern Art in French & English Decoration, Waring & Gillow Galleries, London, 1928.

CONTEMPORARY JOURNALS

The Architect and Building News (Britain)
The Architectural Record (USA)
The Architectural Review (Britain)
Art and Industry (Britain)
Art et Décoration (France)
The Cabinet-Maker and Complete House Furnisher (Britain)
The Carpet Annual (Britain)
Commercial Art (Britain)
Country Life (Britain)
Drawing and Design (Britain)
L'Illustration (France)
Royal Victoria Institute of Architects Journal (Australia)
The Studio (Britain)
The Studio Yearbook of the Decorative Arts (Britain)
Vogue (Britain)
Vogue (France)
Yearbook of the Design in Industry Association (Britain)

OTHER CONTEMPORARY SOURCES

Department of Overseas Trade: *Advisory Council Report on the 1925 Exhibition of Modern Decorative and Industrial Arts in Paris*, London, 1925.

U.S. Department of Commerce: *Report of Commission Appointed by the Secretary of Commerce to visit and report upon the International Exposition of Modern Decorative and Industrial Arts in Paris*, 1925. Published March 1926.

The E.K. Cole collection of 1930s English Trade Catalogues and associated ephemera at the National Art Library, Victoria & Albert Museum, London.

PHOTOGRAPHIC CREDITS

This edition published 1997
by BCA by arrangement with
Phaidon Press Limited

Reprinted 1999

© 1997 Phaidon Press Ltd

Printed in Italy

Illustrations, pages 1–5
p1: Side table by Kem Weber, 1928–29.
Mirror, burl walnut, glass, silvered and
painted wood, chromium-plated metal,
maple and cedar;
p2: A detail from the bronze double
doors designed by Walter and Donald
Gilbert in the cabin-class restaurant of
the *Queen Mary*, launched in 1936;
p4: Swimming pool at the Residence
Palace (architect Michel Polak), Rue
de la Loi, Brussels, c.1922–27;
p5: Black formica and chrome console
designed by Donald Deskey, c.1930.

Acknowledgements
Stephen Escritt: I owe a great debt to the
people who have taught me history of
various types over the years, in
particular David Jones, Dave Holt,
Mark Goldie, Amanda Vickery, John
Styles, Jeremy Aynsley, Gillian Naylor and
Clive Wainwright. I am also grateful to
Carlton Hobbs and Stafanie Rinza for
giving me the flexibility to finish this
book while working for them. Above all
else, the constant and invaluable
support, encouragement and friendship
of Hannah Andrassy has made this book
possible. Finally, I would like to dedicate
Art Deco Style to my parents, Michael
and Margaret Escritt, who have always
been an inspiration to me.